Global Pandemic Threats

Recent Titles in the

CONTEMPORARY WORLD ISSUES
Series

Books in the **Contemporary World Issues** series address vital issues in today's society such as genetic engineering, pollution, and biodiversity. Written by professional writers, scholars, and nonacademic experts, these books are authoritative, clearly written, up-to-date, and objective. They provide a good starting point for research by high school and college students, scholars, and general readers as well as by legislators, businesspeople, activists, and others.

Each book, carefully organized and easy to use, contains an overview of the subject, a detailed chronology, biographical sketches, facts and data, and/or documents and other primary source material, a forum of authoritative perspective essays, annotated lists of print and nonprint resources, and an index.

Readers of books in the Contemporary World Issues series will find the information they need in order to have a better understanding of the social, political, environmental, and economic issues facing the world today.

Global Pandemic Threats

A REFERENCE HANDBOOK

Michael C. LeMay

An Imprint of ABC-CLIO, LLC

Santa Barbara, California • Denver, Colorado

Library of Congress Cataloging-in-Publication Data

Names: LeMay, Michael C., 1941– author.
Title: Global pandemic threats : a reference handbook / Michael C. LeMay.
Description: Santa Barbara, California : ABC-CLIO, [2016] | Series: Contemporary world issues | Includes bibliographical references and index.
Identifiers: LCCN 2016016079 | ISBN 9781440842825 (alk. paper) | ISBN 9781440842832 (ebook)
Subjects: | MESH: Pandemics
Classification: LCC GB5014 | NLM WA 105 | DDC 363.34/9—dc23
LC record available at https://lccn.loc.gov/2016016079

ISBN: 978-1-4408-4282-5
EISBN: 978-1-4408-4283-2

20 19 18 17 16 1 2 3 4 5

This book is also available as an eBook.

ABC-CLIO
An Imprint of ABC-CLIO, LLC

ABC-CLIO, LLC
130 Cremona Drive, P.O. Box 1911
Santa Barbara, California 93116-1911
www.abc-clio.com

This book is printed on acid-free paper ∞

Manufactured in the United States of America

5 DATA AND DOCUMENTS, 221

Global Pandemic Threats: A Reference Handbook offers answers to essential questions about global pandemic threats that are accessible to high school and undergraduate students, as well as general readers interested in the discourse about the topic. Despite great advances in modern medicine and scientific medical technology, mankind around the world still faces a very real threat of pandemic diseases. Past and present outbreaks of epidemics and pandemics are studied so as to better prepare for the fight against future pandemics.

Global Pandemic Threats explores in detail the variety of pandemic threats facing the global population today, as well as issues arising in the aftermath of pandemics. It discusses a host of diseases such as Ebola, influenza, Middle East respiratory syndrome (MERS), cholera, methicillin-resistant *Staphylococcus aureus* (MRSA), HIV/AIDS, and others that have the potential to become pandemics, as well as vaccination campaigns aimed at eradication or the mitigation of the impact of those diseases. The book highlights efforts that have been undertaken to contain them. A perspectives chapter allows a broad range of voices in the pandemic discourse to be heard, allowing for crucial viewpoints to be articulated to round out the author's expertise on the subject.

This volume addresses a number of questions about pandemic threats and related issues. What diseases present the biggest threat and why? What can be done to stop or contain outbreaks of epidemics of dangerous contagious diseases before they become pandemic in nature and scope? How can

the medical profession and medical science prepare the public to deal with such epidemic diseases? What are the social, economic, and related long-term impacts of pandemics? What can be done to minimize such impacts? What can we learn from pandemics of the past centuries to better prepare for those to come?

The global nature of pandemics also raises certain issues that are examined herein. What diseases pose the greater threat and why? What can be done to prevent pandemics? How can such organizations as the Centers for Disease Control and Prevention or the World Health Organization better prepare the public to deal with pandemic diseases? What will be some social, economic, and political long-term impacts of pandemics, and what measures can be taken to mitigate such impacts?

Global Pandemic Threats is organized into eight chapters. Chapter 1, "Background and History," introduces the readers to major pandemics in human history and examines the social and cultural context in which these outbreaks occurred. The chapter highlights key moments along the global pandemic timeline, including a review of the work of the pioneers in the development of modern medicine and of medical science. Its historical overview provides readers with the context in which to assess current pandemic threats, addressing the importance of this subject matter. The chapter synthesizes the extensive body of literature on the subject. Its review of the discourse is comprehensive and presented in an unbiased manner, presenting the topic for the reader's consumption.

Chapter 2, "Problems, Controversies, and Solutions," outlines the most controversial events related to global pandemic threats and how governmental and nongovernmental organizations comprising the medical professions and related health-care providers have addressed them. It details the scientific controversies related to how these organizations and actors cope with pandemics. Finally, the chapter discusses some of the proposed solutions to those problems and controversies.

Chapter 3, "Perspectives," is comprised of eight essays by scholars and medical professionals, and other nongovernmental organizational personnel. These short essays provide diverse perspectives on the issue of global pandemic threats that go beyond the expertise of the author.

Chapter 4, "Profiles," provides descriptive bio-sketches of more than 50 key individuals and over 50 organizations involved in the global pandemic discourse.

Chapter 5, "Data and Documents," collects and provides insights gathered from the global pandemic threat discourse. It is comprised of 12 tables, 1 map, 4 figures (line and bar graphs), and synopsis or excerpts of a dozen documents on the topic. These data and documents answer such questions as: Which diseases are more likely to become pandemics and why? Who is most likely to be affected by pandemics? What areas or regions of the world are the most vulnerable and why? What, if anything, can be applied from examination of those data and documents from previous outbreaks to minimize the impact of future pandemics?

Chapter 6, "Resources," provides an annotated bibliography of print and electronic resources that comprise the body of literature on the subject. It presents 125 books and 42 scholarly journals from the fields of various disciplines related to the topic. It annotates 7 films and 43 videos that give life and a "face" to the subject.

Chapter 7, "Chronology," offers a brief but comprehensive chronology of pandemics and what became defining moments for good or ill in pandemic history.

The book closes with a glossary containing definitions of key terms and concepts used in a discussion of pandemic threats around the world and a comprehensive index.

Global Pandemic Threats

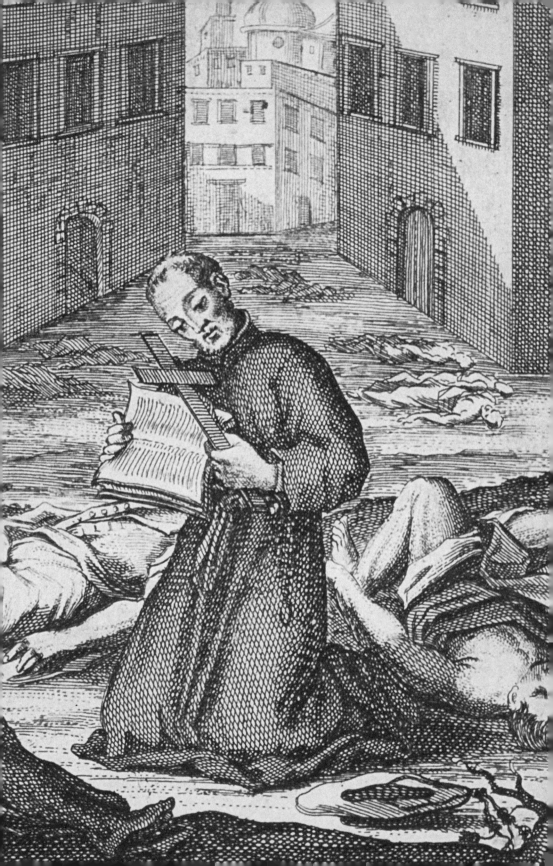

Introduction

For much of human history, epidemic diseases have hung like an executioner's sword over mankind. Most of the time, human migration was sufficiently restricted that major killing epidemics remained localized to a region or a country. However, on occasion, usually as invading armies marched across large sections of the world, epidemic diseases traveled with the armies, and an epidemic became a pandemic. Perhaps one of the most striking examples was what became known as the "Plague of Justinian," likely a bubonic plague, that in 541–542 swept from the eastern Roman Empire to Western Europe, killing perhaps as many as 100 million people (www.news.nationalgeographic .com/news/2014/10/141025-ebola-epidemic-perspective-history-pandemic). Sweeping across the globe, plagues of various maladies killed millions, and no one had a clue as to what caused them, how they spread, how they could be cured, or how they could be prevented. Unknown to them, as people traveled in mass movements they carried with them pathogens of infectious diseases that spread worldwide. Another historic example is the Black Plague, 1346–1350. It spread through Europe, killing

A priest administers the last rites to a plague victim. No one knew the actual cause of the Bubonic plague pandemic, which took an estimated 25 percent of the European population. It was often referred to as the Black Death, and many attributed it to a wrathful God punishing a sinful mankind. (National Library of Medicine)

an estimated 50 million (www.news.nationalgeographic.com/news/2014/10/141025-ebola-epidemic-perspective-history-pandemic; Willrich, 2011: 119). In prior centuries, diseases most often spread internationally as armies moved, since war was the most common cause of large-scale migration. In the 19th century, disease typically killed twice as many soldiers as did combat. Where soldiers went, plagues followed (Willrich, 2011: 119). What was new to the 19th century was that tens of millions of ordinary people moved from nations of origin to nations of resettlement, unknowingly carrying diseases with them, causing a series of pandemics. There were so many pandemics that the 19th century became known as the "Age of Pandemics" (Guillet, 1937; LeMay, 2015). Fear of epidemics was a major concern among policy makers. Such fear was well-founded and increased as incidents of epidemics became more frequent and deadly. In the 19th century, three epidemic diseases causing the greatest fear were smallpox, cholera, and typhus.

Fortunately for humankind, for the immigrants, and for receiving countries, the late 19th century was the critical period when medicine became modern. Medical researchers developed a new theory about disease—germ theory and bacteriology—and with them, science-based, practical ways to better cope with epidemics.

It is useful to define a few key concepts here. Most diseases are **endemic**, that is, native to a particular area, country, or region. They are always present, but under control. Endemic diseases are not highly contagious because so many in the population have a high degree of immunity to them. As a result, they are far less deadly. Endemic diseases are also called chronic. Sometimes this distinction between endemic and epidemic disease can be blurred. Some diseases, for example, malaria, syphilis, and tuberculosis, may be both chronic and epidemic. Although endemic to a country, they may break out in places in which they were not previously common, or have rather sudden increases in morbidity and mortality rates. When that happens, they are considered epidemics.

An **epidemic** disease is prevalent among a people or community at a given time, typically produced by some special causes not generally present in the affected locality, often resulting in morbidity and/or mortality rates significantly in excess of normal. Epidemic diseases are also referred to as "contagions," "infections," and "plagues." Today we know such diseases are the result of an invasion by a pathogen—an infectious agent such as a bacterium or virus. Many epidemics, but not all, are contagious—that is, spread directly or indirectly from one person to another. Epidemic diseases are typically associated with three terms: "acute," "high morbidity," and "high mortality." In contrast to chronic diseases, acute diseases are characterized by rapid onsets, severe symptoms, and relatively short durations. Morbidity refers to the rate of incidence of the disease—how many persons in the population contract it. Mortality refers to the death rate of the disease. Epidemic diseases have soaring morbidity and mortality rates (Hayes, 2005: 5–6). Geddes Smith notes:

> Epidemics are like waves: they rise and fall. Sometimes they seem to be spaced at fairly regular intervals of time. Measles may rise to a peak every second or third year. . . . Topography and climate seem to have something to do with both epidemics and endemics. . . . Ophthalmia is traditionally associated with Egypt, malaria with the Mediterranean shores, plague with the East, yellow fever with the tropics of America. Moreover some diseases spread and become threatening at one season of the year, some at another. Pneumonia is a winter disease, measles seem to reach its peak in the spring, babies die of diarrhea in the hot summer months, and one fears poliomyelitis most in the late summer. Some diseases, again, fall upon people of all ages, some upon children, some most severely on the old. (1946: 122)

A **pandemic** refers to when an epidemic spreads to entire countries, or regions, and becomes multinational and on occasion

even global in scope. Pandemics have been called "plagues," "contagions," and "pestilences" (Byrne, 2008; Cook, 1995; Karlen, 1995; Kelly, 2005; Kohn, 2008; Little, 2006; McNeill, 1989; Moote and Moote, 2004; Oldstone, 1998; Oppong, 2011; Smith, 1946; Walters, 2004). Plague typically refers to conditions causing very high morbidity or mortality and is accompanied by social dislocation. The historic outbreaks of plagues, like the Black Death of the 13th and 14th centuries in Europe, the recurrences of cholera spreading globally, and the 1918–1919 influenza (also known as the Spanish Flu), are reminders that these periodic outbreaks of horrific disease are like nature holding a sword over the heads of mankind—suggesting a battle or warfare metaphor.

Epidemiology is the study of epidemic and pandemic disease. Its province is the broad mass phenomena of health and disease: how these are distributed in groups of people, the causes and consequences of diseases, and how they can be prevented and controlled (Abdel Omran, 1977: 3).

With the development of modern medicine, first medical scientists and then practitioners increasingly understood, controlled, managed, and began to prevent incidences of the most dreaded epidemic diseases. Epidemics of the past came to be replaced by chronic and degenerative diseases resulting from stress or human-made causes. Typhoid fever, tuberculosis, cholera, diphtheria, bubonic plague, and smallpox declined as the leading diseases and causes of death. They were replaced in those roles by heart diseases, cancer, strokes, diabetes, gastric ulcers, and the like (Omran, 1977: 4).

Five exemplary epidemic diseases, each of which caused especially deadly pandemics in the 19th and early 20th centuries, are yellow fever, smallpox, cholera, the bubonic plague, and influenza. Another nondeadly but highly contagious disease was trachoma. In its severe stage, trachoma causes blindness and still is a leading cause of blindness worldwide. It was considered "loathsome" and was a leading cause for exclusion from entrance and permanent residence status in the United States

(LeMay, 2013, v. 2: 66). A number of doctors and medical scientists played key roles in discovering the causes of the diseases, or in developing important protocols for mitigating their morbidity or mortality rates. They were instrumental in the development of public health as a distinct subfield of medicine (LeMay, 2015).

Notable Epidemic/Pandemic Diseases of the Past

Diseases that were scourges in the 17th and 18th centuries are less well known today because they have been eradicated or so reduced in their threat to life as to be considered almost commonplace childhood disease or ones rarely seen today. In the developed world, for example, measles is today seldom life-threatening. Much of the population alive today is either immune, having contracted mild cases of the disease as young children, or has been immunized by vaccination of an antimeasles serum. In the 17th century, however, it was a major killer. When European settlers brought measles to the Americas, it spread and killed enormous numbers of Native Americans, who had no immunity to it and among whom it proved to be especially deadly.

Typhoid fever is an acute infectious disease caused by the bacillus *Salmonella typhi*. It is most often acquired by ingesting food or water contaminated by excreta. It is frequently considered a form of typhus and is characterized by high fever and intestinal disorders. Typhoid fever was a deadly killer in Philadelphia in 1837, in many sections of the United States between 1865 and 1873, and finally in another epidemic that struck Pennsylvania in 1885. Recent research indicates that the infamous Athenian plague was in fact a typhoid epidemic (http://sciam.com/article/cfm?articleID=oooBF19-9878-13D6-9B788341BF0135ref=sciam&chanID=sa003). Today it is easily treated, and in many places where it previously was epidemic, it has now been largely wiped out by improvements in basic hygiene and the decontamination treatment of the water supply.

Tuberculosis is an infectious disease caused by the tubercle bacillus. It is characterized by the formation of tubercles in various soft tissues of the body, specifically, tuberculosis of the lungs. In the 19th century, it was commonly known as consumption. Since its bacillus was discovered by Robert Koch in 1882, essentially confirming the validity of germ theory, effective treatment has greatly reduced its morbidity and mortality (Barry, 2005: 51). In the early 19th century, however, it killed at a rate of 300 to 500 per 100,000 in population and was one of the greatest epidemic killers of the early 19th century (LeMay, 2013: 51).

Yellow Fever

Yellow fever is sometimes called the American plague. It is a viral disease that is a hemorrhagic illness still prevalent in Africa and South America despite an effective vaccine. It is a tropical disease spread by infected mosquitoes. The disease has dramatically reemerged since the 1980s, and as of 2001, the World Health Organization (WHO) estimates it still causes over 200,000 illnesses and 30,000 deaths annually among unvaccinated populations.

There are two kinds of yellow fever. *Jungle* yellow fever is mainly a disease of monkeys spread from infected mosquitoes to monkeys in tropical rain forest areas and rarely to humans caught in the cycle and bitten by infected mosquitoes. *Urban* yellow fever is a disease of humans spread by *Aedes aegypti* mosquitoes infected by other people. This type of mosquito has adapted to living in human cities, towns, and villages where they breed in brackish water found in discarded tires, flower pots, oil drums, and water storage containers located near human dwellings. Urban yellow fever is the type that causes epidemics. These infections are often mild, but the disease can cause severe, life-threatening illness—accompanied by high fever, chills, headaches, vomiting, and backache. The severe type often leads to shock, bleeding, and kidney and liver failure. Liver failure causes jaundice (a yellowing of the skin and the

whites of the eyes) from which the disease acquired its common name. Symptoms start three to six days after being bitten by an infected mosquito.

The mosquito crossed the ocean aboard ships, riding in water casks. It then established itself ashore in places where temperatures stayed about 72°F. Its affinity for water casks enabled mosquitoes carrying yellow fever from sailor to sailor to remain aboard ship for weeks and even months. This distinguished it from most other infections that usually broke out on ships (like typhoid fever, often called "ships fever") but then burned out. People tended to get sick pretty much together and recovered about the same time, and thereby acquired immunity. With yellow fever, reinfections could take place, so ships could suffer a seemingly unending chain of attacks. No one understood who would get sick next and die in his turn. "Yellow jack" was especially dreaded by sailors of the Caribbean and other tropical seas where the temperature-sensitive *Aedes aegypti* mosquito flourished. It soon became endemic in the American South (McNeill, 1989: 222).

Yellow fever was the source of several devastating epidemics. Havana, Cuba, suffered one in 1762–1763 and Philadelphia in 1793. In Haiti, in 1802, Napoleon's troops suffered an epidemic that wiped out more than half the army—killing far more than enemy combatants. It was so severe that it forced Napoleon to withdraw his army and give up the campaign, thereby assuring Haiti's independence in 1803. There were notable outbreaks in the Western Hemisphere in 1805, 1822, and 1870. In the South of the United States, an epidemic spread in 1820–1823 and 1841. A particularly nasty outbreak occurred in New Orleans in 1847, and again in 1852—when 8,000 died in one summer (LeMay, 2006: 41). It struck in the south of the United States again in 1855, centered in Virginia. It devastated American troops in 1871 at Fort Columbus, New York, and in 1873–1875 among the troops at Barrancas, Florida. A yellow fever epidemic struck New Orleans again in 1877, in Memphis, Tennessee, in 1878, and in Jacksonville,

Florida, in 1886. The fear yellow fever instilled in the population led to the quarantine responsibility of the Marine Hospital Service, as described by Mullan:

> A yellow fever epidemic in New Orleans in 1877 that spread quickly up the Mississippi valley riveted national attention on quarantine policy and forced congressional action. The Quarantine Act of 1878 was a victory for the Marine Hospital Service, conferring upon it quarantine authority—its first mission beyond the care of merchant seamen in the eighty years of its existence. (1989: 25; see also Willrich, 2011: 222–223)

Epidemics among troops were so devastating that the U.S. Army established a Yellow Fever Commission, commonly known as the Reed Commission, after its leader Major Walter Reed. The commission did a vector or epidemiological analysis of the spread of the disease during an outbreak in Havana, Cuba, in 1900. That study proved that the *Aedes aegypti* mosquito was the true source in the spread of the disease, disproving the then popular notion that it was spread by direct contact with infected people or contaminated objects like bedding or clothing. The army was an occupation force in Cuba after the Spanish-American War of 1898. During that war, far more American troops died from yellow fever, malaria, and dysentery than were killed by bullets. The American government in Cuba, under Governor-General Leonard Wood, realized something had to be done if the occupation were to last years. Cuba was a primary breeding ground for yellow fever in the Western Hemisphere, and the military reasoned it was an excellent base to study and possibly eradicate the disease.

Doctor William Gorgas, later surgeon general of the U.S. Army, is world renowned as the conqueror of the mosquito and the malaria and yellow fever it transmits. His pioneering effort in halting epidemics of yellow fever enabled the United States to build the Panama Canal. A Cuban physician, Carlos

Juan Finley, first suspected and postulated the mosquito as a carrier of the disease. Havana suffered about 500 deaths per year for a decade preceding his discovery. Finley identified the wrong breed of mosquito as the likely carrier and did not understand its incubation and cycle. However, the Reed Commission's study identified the correct mosquito, confirmed Finley's suspicions, experimentally proved the connection, and analyzed its life cycle. William Gorgas had the insight that the way to eradicate the disease was to exterminate the mosquito that carried it. He undertook the task in Havana and later in Panama. Gorgas and his team disinfected gutters and puddles, screened and oiled cisterns and water barrels, and persuaded Cuban housewives to empty jugs and pitchers of water every day. Yellow fever patients were quarantined and put behind screens to prevent fresh infection. "The results were amazing: in 1896 there had been 1,282 deaths from yellow fever; in 1900 there were 310, in 1901 eighteen, in 1902 none. Gorgas had abruptly ended a century and a half of yellow fever in Havana" (Geddes Smith, 1946: 17, 186; NARA archives RG 90: Boxes 169–178).

Smallpox

Smallpox is a highly contagious viral disease unique to humans and for which there is no known cure. The only way to deal with the disease is through prevention by vaccination. It is a serious, contagious, and deadly infectious disease. Its name came from the "spotted" look of raised bumps that appear on the faces and body of an infected person. U.S. immigration law categorized it as a "loathsome and contagious" disease and banned entry to persons suffering from the disease. "At the end of the nineteenth century, smallpox was still regarded as the most infamous and loathsome infectious diseases. . . . It killed an estimated 300 million people in the 20th Century alone" (Willrich, 2011: 20–22).

It comes in two clinical forms. *Variola major* is the severe and unfortunately more common type. It has a mortality rate

of 20 to 40 percent. Victims exhibit an extensive rash covering much of their bodies and suffer high fever. **Hemorrhagic** is rare but fatal in about 96 percent of cases. In this form, the skin does not blister. Bleeding occurs under the skin making the skin look charred and black (hence, this type is often called black pox). The eyes hemorrhage. Death occurs from fatal levels of bleeding, often as brain hemorrhage, but can also result from multiorgan failure. This form accounts for 3 to 25 percent of fatal cases of the disease, depending on the virulence of the strain (Willrich, 2011: 4). *Variola minor* is a milder, less serious presentation of the disease, with death rates historically at about 1 percent of cases (Willrich, 2011: 43).

Smallpox became more deadly over three centuries leading up to the 1800s. Today medical scientists believe that smallpox appears to have entered Europe around 581, in what is known as the Justinian Plague. Details about early epidemics have been lost due to the scarcity of surviving records of early medieval society. In Italy, a smallpox epidemic between 1424 and 1458 killed only 84 persons. In the mid-17th century, an outbreak in London killed about 7 percent of its victims. A famous outbreak in Boston, in 1721, had a mortality rate of 15 percent, and in 1792 another Boston outbreak claimed 30 percent. A Scotland smallpox epidemic in 1787 killed a third of its victims. An isolated Japanese village, "virgin soil to the disease," experienced an epidemic in 1790 killing 38 percent, and in Madras, India, a similar epidemic claimed 43 percent of its victims (Fenn, 2001: 21, 81). Historical studies of smallpox show the disease claims higher mortality rates among the very old and the very young, with the highest rates among those under age one and over age fifty. "The story of the smallpox epidemics is a history of violence, social conflict, and political contention" (Willrich, 2011: 14). The battle to control it through compulsory vaccination in the United States was one of the most important civil liberties struggles of the 20th century.

Survivors of smallpox infections are often left blind in one or both eyes due to corneal ulcerations. Many surviving victims

retain persistent skin scarring—pockmarks. During the 20th century, the disease killed an estimated 300 to 500 million people globally. In 1967, the United Nations' WHO estimated two million people died among the nearly 15 million people who had contracted the disease that year.

In the mid-18th century, outbreaks in Europe occurred in five-year cycles. Exposure in early life left many survivors with a natural immunity. Transmission is generally by direct, sustained contact with infected bodily fluids or contaminated objects such as bedding and clothing. Humans are the only natural hosts of the virus. Persons with smallpox are sometimes contagious with the onset of fever, but its most contagious stage comes with the onset of the rash, and the infected person remains contagious until the last smallpox bump (pustules) is gone and all the scabs have fallen off (generally, three weeks after the rash appears). The incubation period is commonly 12 to 14 days, but the range is 7 to 17 days. Fever brought on by the disease ranges from 101 to 105°F and lasts until the scabs are gone. The incubation period became more problematic when the speed of ships' travel by the late 1880s greatly increased the latent contagion issue, making it more difficult for the health inspectors of the U.S. Marine Hospital Service (USMHS) to spot carriers, or for medical officers required to be onboard ships of the steamship lines by the law of 1882 to note smallpox among the steerage passengers during the transatlantic crossing trip itself (Willrich, 2011: 219–220; NARA, RG 90, file 425).

Native Americans were decimated by diseases against which they had no immunity, brought by Euro-American settlers. Smallpox was a chief culprit of that decimation. Fenn counted 33 smallpox epidemics (2001: 28–29).

Smallpox is transmitted human to human, and naturally the public health service, when screening immigrants, watched for smallpox symptoms, especially on ships coming from places abroad where an epidemic outbreak had been reported. From 1898 to 1903 a five-year epidemic of smallpox spread across the country with an official count of 164,283 cases, although the

actual number may have exceeded five times that figure. Since it was mostly of the milder form of the disease, the epidemic, particularly prevalent in the South, resulted in only 5,627 fatalities. Racial attitudes were a factor that stymied smallpox control. The five-year pandemic, however, launched the first great massive compulsory vaccination campaign. Opposition to compulsory vaccination spurred litigation that went all the way to the U.S. Supreme Court in 1905 (Willrich, 2011: 11–12).

The 1898–1903 series of epidemics was important in expanding the role and work of the USMHS. Founded in 1798, it initially served as sentinels at the nation's borders and overseas outposts to assist sailors and to examine immigrants to prevent their bringing diseases to American soil. In 1878 the National Quarantine Act conferred upon the service enforcement power over quarantine regulation. During the smallpox epidemic campaign, Surgeon General Walter Wyman sent Service surgeon C.P. Wertenbaker to assist communities throughout the South to cope with smallpox outbreaks. He soon established himself as the service's foremost smallpox expert, known to state governors, city mayors, and various state and local health officials as a master diagnostician of smallpox, and as a man with a proven strategy for stamping out the disease (Willrich, 2011: 78–85). Charles Poindexter Wertenbaker and his colleagues in the USMHS became the vanguard of a modern, national public health system. In 1902 it was renamed the U.S. Public Health and Marine Hospital Service, and in 1912, the U.S. Public Health Service (Mullan, 1989; Willrich, 2011: 76).

In 1913–1914 another series of outbreaks of smallpox occurred in U.S. ships, particularly military ships. A ship traveling the Mississippi River brought the 1913 epidemic to Memphis, Tennessee. In 1914, the battleship *Ohio* had an outbreak that totaled 21 cases. In 1915, U.S. Public Health Service doctors were sent north to Maine to deal with an outbreak brought overland from Canada. In 1917, an outbreak in Minnesota numbered 11 deaths among the 58 cases reported.

On July 28, 1917, there was an epidemic numbering 38 cases in Worcester, Massachusetts, resulting in 9 deaths. The source of that outbreak was traced to a Swedish immigrant coming into the United States from Norway via Ellis Island on the ship "Kristianafjord." These spurred the surgeon general to call for reports from all stations of the Public Health Service on outbreaks and on methods of vaccination being used to cope with epidemics or to prevent their onset (NARA, RG 90, File 2796, Smallpox, boxes 250–254).

The idea of inoculation to fight smallpox came to Europe in the early 1700s. Its practice is now known to have been used as early as 1000 BCE. Asian Indians rubbed pus into skin lesions. Chinese blew powdered smallpox scabs up the noses of the healthy. These practices resulted in patients developing a mild case of smallpox after which they were immune. The process of inoculation spread to Turkey where an Italian doctor, Emmanuel Timoni, attached to the British Embassy in Istanbul, aided the family of Lady Mary Wortley Montagu, wife of the British Ambassador. She had the procedure performed on her children, aged 5 and 4. They both recovered quickly, and Timoni reported the process to the Royal Society in England, of which he was a member. He published an account in 1713. When another epidemic hit London in 1721, inoculation was tried on prisoners, all of whom recovered in a few weeks. The royal family was then inoculated and this reassured the English that the procedure was safe. That same year, a smallpox epidemic broke out in Boston. The famous Reverend Cotton Mather learned of the procedure from one of his slaves and began promoting it. When the population, which had fled the city, returned in 1722, Mather was called a hero. Out of Boston's population who were not inoculated, 7 percent died of the disease, but among 300 persons who had followed his advice and were inoculated, only 2 percent died. Inoculation, however, was far from a perfect process. It was difficult to administer and infected patients had to be quarantined to prevent its spread. Fenn notes that

despite grave misgivings, General George Washington ordered inoculation of his troops during the Revolutionary War when a virulent outbreak occurred in 1777 (Fenn, 2001: 81).

The process of **vaccination** provided a better preventive method. An English doctor, Edward Jenner, observed that people who had caught cowpox while working with cows were known not to catch smallpox. While in London to attend medical school, a smallpox epidemic struck his home town of Berkeley. He advised local cow workers to be inoculated, and they informed him that cowpox prevented smallpox. He studied cowpox further and developed a process, in 1796, when a patient, a local milkmaid, developed cowpox and sought treatment from him. He inoculated the 8-year-old son of his gardener with cowpox taken from the milkmaid. The boy suffered an extremely weak bout of cowpox and then recovered. Jenner then inoculated him with smallpox but the boy did not develop even a mild case. He was immune. From this insight, Jenner treated 23 more cases, including his son, and none suffered from smallpox. In 1798, Jenner's vaccination was used in Boston, and the innovation spread. Jenner published his work in numerous major European languages, and the process was performed all over Europe and the United States by the early 1800s. With Jenner's process, which became known as vaccination after the Latin word for cow—vacca—the death rate was zero.

Jenner's dream was the eradication of smallpox by vaccination—a dream eventually realized. In the mid-1950s, about two million people died annually from the disease. In 1958 the WHO began a global campaign of vaccination. Troop movements and crowded encampments had long been associated with spread of disease, including smallpox. The WHO teams began vaccinating troops. Then entire civilian populations followed. The last major European outbreak occurred in 1972 in Yugoslavia after a pilgrim returned from the Middle East. That epidemic infected 175 people, with 35 deaths. Massive vaccinations halted that epidemic. The last naturally occurring case was diagnosed in Somalia in October 1977. The WHO had

successfully eradicated the disease. The United States had con-tributed US$300 million to the eradication effort (Bazin, 2000).

Today, the disease exists only in viral research laboratories. Post 9/11, fears have been raised that stockpiles of the disease could be stolen and used as a bioterrorist weapon. In March 2003, the accidental discovery of scab tissues of smallpox found tucked in a Civil War medicine book in Santa Fe, New Mexico, raised concern at the Centers for Disease Control and Preven-tion (CDC) that these and other like scabs could be used to extract smallpox DNA and used in a biological attack.

Cholera

Bubonic plague was *the* pandemic disease of the 14th century. Yellow fever and smallpox were *the* prevalent pandemic diseases of the 17th and 18th centuries. Cholera was *the* classic epi-demic disease of the 19th century, during which time six great pandemic outbreaks occurred. It was also *the* epidemic disease of the United States during the 19th century. Rosenberg notes, "Cholera . . . appeared in almost every part of the country in the course of the century. It flourished in the great cities, New York, Cincinnati, Chicago; it crossed the continent with the forty-niners; its victims included Iowa dirt farmers and New York longshoremen, Wisconsin lead miners, and Negro field hands" (1987: 1).

Global outbreaks of cholera, smallpox, and other diseases kept their control central to the administrative processes of immigration. In 1891 and 1893, Congress enacted laws giving the USMHS primary responsibility for keeping immigrants with contagious diseases from entering the United States, and by 1894, vaccination became a legal prerequisite for entry (Willrich, 2011: 222–223).

Cholera, also known as Asiatic cholera, is a water-borne dis-ease caused by the bacterium, *Vibrio cholerae*. Infection comes from drinking contaminated water, or eating improperly cooked fish and shellfish. The disease produces potentially lethal secre-tory diarrhea. Genetic research has shown an individual's

susceptibility to cholera is affected by blood type. Rosenberg describes the dreaded disease as follows:

> Cholera could not have thrived where filth and want did not already exist; nor could it have traveled so widely without an unprecedented development of trade and transportation. The cholera pandemics were transitory phenomena, destined to occupy the world stage for only a short time— the period during which public health and medical science were catching up with urbanization and the transportation revolution. Indeed, cholera was to play a key role in its own banishment from the Western world; the cholera epidemics of the nineteenth century produced much of the impetus needed to overcome centuries of government inertia and indifference in regard to problems of public health. (1987: 2)

Cholera is transmitted through ingestion of fecal matter contaminated with the bacterium. This typically occurs when untreated sewage is released into waterways, affecting the water supply, any foods washed in that water, and fish and shellfish living in the affected waterways. It is rarely spread directly from person to person.

Cholera was originally endemic to the Indian subcontinent, where the Ganges River served as a contamination reservoir. It spread by both land and sea trade routes first to Russia, then to Western Europe, and then to North America. Geddes Smith vividly describes its worldwide march:

> The rise and fall of cholera as a world disease belongs to the story of a single century—the nineteenth. Before 1817 . . . it was a local disease in India. In that year, no one knows why, it started a slow march which carried it over most of India in 1817, over the frontier in 1818, and by 1823 eastward to Japan and westward to the threshold of Europe. In 1826 it traveled again with traders and pilgrims, found its

way overland to Russia in 1830, to Germany and England in 1831, to Ireland in 1832, took ship that year with hungry Irish emigrants, crossed to Canada and the eastern states, and pushed into the western states in 1833. This march was over in 1836, and for ten years the disease remained at home. In 1846 it was abroad again, moving more quickly, and for the next sixteen years it was present intermittently in Europe, North America, and part of South America, reaching its height in the United States in 1849 and 1850. In 1865 it crossed by sea from India to Mecca and the Mediterranean, reaching Halifax, New York, and New Orleans the next year, and spreading twice through the Mississippi basin before it retreated in 1874. Cholera never ranged so far again. Between 1884 and 1887 it visited France, Spain, and Italy. In 1892 it swept across Russia and killed eighty-five hundred in Hamburg. Later waves of infection for the most part fell short of western Europe, and except for a few centers of persistent infection, cholera continues to afflict only its Indian homeland. There, however, it killed more than seven million people in twenty years of the present [20th] century. (Geddes Smith, 1946: 16)

Asiatic cholera first came to North America (to Canada) in June of 1832 aboard the vessel *Carricks* out of Dublin. After embarking, 39 of its 172 passengers developed the violent vomiting, spasms, and severe diarrhea that are its characteristic symptoms. Due to the apparent symptoms detected on board, the ship and its passengers were quarantined at Grosse Ile, the island quarantine station in the St. Lawrence, below Quebec, Canada. A total of 133 passengers survived their bouts of fever and were released after disinfection. Soon after they arrived in Quebec City, a grave epidemic broke out. During the course of the epidemic, it progressed from Quebec to Montreal. Approximately 3,000 succumbed to the disease in Quebec, 4,000 in Montreal, and about 12,000 throughout the rest of Canada

(Chartre, 1995: 35–36). It is probably through that outbreak that it spread to New York and Ohio in 1832–1834 (LeMay, 2006: 41).

Before its cause was discovered, the disease struck terror as it spread its rapid and erratic course. It was unmanageable and incurable in nature, dreadful in its fatality, and devastating in its consequences. When it struck New York, it became entrenched in the slums where the wretched houses north of Canal Street looked out on the dead strewn about like slaughtered victims on a battlefield. Always a disease striking most often the poor, in New York City it killed thousands in the city's tenement neighborhoods in a three-month epidemic in 1849. Conditions favorable to its spread were not confined to city slums. In epidemic years, Mississippi River boats became moving "pest houses," and infection ran riot among poor travelers between decks, driven incessantly to the stool by the cruel purging, which characterizes the disease. The *Peytonia* lost 50 passengers between New Orleans and Louisville on a single trip in 1849 (Rosenberg, 1987: 104).

The New York City epidemic outbreak in 1832 was severe. The mayor had proclaimed a blanket quarantine against almost all of Europe and Asia in June of 1832, when a steamboat from Albany brought word that cholera had broken out in Quebec and Montreal, showing that the disease had crossed the Atlantic— the nation's last barrier of defense against the disease (LeMay, 2013, v. 2: 51). New York City designated a Board of Health comprising the health officer of the port, the resident physician, and the city inspector and appropriated $25,000 for them to erect hospitals and take other measures to alleviate and prevent cholera. The board had the day-to-day responsibility of keeping a city of a quarter of million residents healthy. The cholera epidemic that quickly ensued was beyond their capacity to cope (Rosenberg, 1987). Soon dead bodies lay unburied in the gutters of the city's slum streets. Coffin makers could not keep up with the demand. Churches closed and their ministers fled the city and its epidemic. Physicians and city officials were

sometimes attacked and beaten. The cholera epidemic soon spread to other cities. New Orleans lost an estimated 5,000. In Chester, Pennsylvania, persons suspected of carrying the pestilence were murdered, as was the local resident who gave them shelter. Newly arrived immigrants, especially the Irish, were particularly feared. They occupied the foulest slums of the cities and suffered far out of proportion to their numbers. To respectable Americans, their premature deaths seemed inevitable consequences of a misspent life. The disease was viewed as God's vengeance on them for their drunkenness and their lives as paupers and beggars. They were widely perceived as having brought cholera with them, a classic case of blaming the victims (Geddes Smith, 1946: 18–20, 63).

The disease hit disproportionately the poor in large cities. In Hamburg, Germany, in its epidemic in 1892, those whose income was less than 1,000 marks were 19 times more likely to fall victim to the disease than those whose income exceeded 50,000 marks. In New York City, in the 1832 epidemic, of 100 cholera victims who died in a single day in July, 95 were buried in the city's Potter's Field. In Richmond, Virginia, the poor-house graveyard was used for 90 percent of those who died of cholera. New York City's black population was especially hard hit (Rosenberg, 1987: 57).

In the mid-1800s, quarantine was the only known policy to deal with the spread of infectious diseases like cholera. Unfortunately, it was not effectively enforced. From the early days of the republic until the 1880s, quarantine policy was an issue left to the states. It became a virtual battleground for the contending forces for the expansion of federal public health. In the 1830s, the enforcement of quarantine regulations was inconsistent from locality to locality and so variable as to be, in effect, almost nonexistent (Mullan, 1989: 22).

In 1832, the idea that disease was a specific, well-defined biological entity was controversial and highly suspected. Disease was viewed as being a lack of balance or disorder in the person. Yellow fever and its black vomit seemed noncontagious.

Cholera, like yellow fever, seemed to start simultaneously in widely separated parts of the city. Many doctors suspected an atmospheric origin. They noted that cholera could be contracted more than once, while a contagious disease, like smallpox, could not.

Quarantine measures were the most often used practice against cholera in the 1832 pandemic. The city of Troy, New York, along the Erie Canal, was forced to provide quarantine provisions for 700 immigrants. Hospitals, nurses, and doctors were soon overwhelmed. At New York City's Greenwich Hospital, 14 of 16 nurses died of cholera contracted while caring for patients (Rosenberg, 1987: 95). In Philadelphia, Baltimore, Louisville, St. Louis, and Cincinnati, the cholera hospitals were staffed by the Sisters of Charity. The quarantine procedure proved ineffective in treating or containing the epidemic, since the true cause of the disease was unknown and ineffectively addressed. The filth of New York City was unabated when another epidemic broke out in 1848.

On December 2, 1848, the ship *New York* rode anchor off Staten Island with 300 steerage passengers aboard, all of whom had been exposed to cholera below decks. Quarantine was demanded. That raised the question—where to put them? None of America's port cities had facilities adequate to quarantine 50 persons, let alone 300. After 15 years without cholera or yellow fever, New York's quarantine was no more than a gesture. In less than a month, 60 immigrants had fallen ill, half of whom died. A new cholera epidemic ensued. Cities to the south fared even worse. Vessels from Hamburg and Bremen brought cholera to New Orleans from which the disease spread as the immigrants carried cholera with them to steamboat landings along the Mississippi, the Arkansas, and the Tennessee rivers (Rosenberg, 1987: 105). As in 1832, the working class was the most severely affected by the epidemic, which fortunately subsided fairly quickly. New York City, however, suffered over 5,000 deaths from the disease. By April, cholera spread to dozens of American cities and villages as river and lake streamers

sowed cholera at scores of landings, and as railroads, which by then crisscrossed the Northwest, discharged cholera-carrying passengers to even remote points (Rosenberg, 1987). Along the rivers, steamboat passengers who died from cholera were unceremoniously dumped overboard and drifted ominously past river and lake towns. Gold seekers carried cholera with them across the continent, where many a forty-niner died without physician, minister, or friend. Newly established cities in the West, with inadequate water supplies, primitive sanitation, and crowded with a transient population, suffered severe outbreaks. St. Louis lost 10 percent of its population to cholera. Cincinnati suffered almost as bad, and Sandusky even worse than St. Louis (Rosenberg, 1987: 115). In city after city, the poorest and most wretched were those who were most often killed by the disease.

The connection between cholera and vice became a verbal reflex, firmly established in the culture of the time. The Christian Revivalist movement spread the view that cholera was an exercise of God's will, a chastisement to a nation sunk in materialism and sin. Asiatic cholera was a disease of "filth, of intemperance, and of vice" (Rosenberg, 1987: 121). In 1849, as in 1832, cholera was seen as a chronic malady associated with immigrants who were viewed as a permanent threat to American institutions. The Irish were seen as the greatest menace. German and Scandinavians were viewed positively as thrifty, hard-working, church going, and an asset to the nation (Rosenberg, 1987: 183).

In the summer of 1849, Dr. John Snow, a prominent London physician, published a pamphlet, *On the Mode of Communication of Cholera*. In it, he argued that cholera was a contagious disease caused by a poison reproducing itself in the bodies of its victims. This poison was in the excreta and vomit of cholera victims. When the city was struck again, in 1854, Dr. Snow used painstaking correlation of the incidence of cholera to subscribers of the city's two water companies and was able to trace cholera to a specific city water company whose users suffered cholera far more frequently than did the users of the other. That

company drew its water from the lower Thames, after it had been contaminated with London sewage. His study was the first that proved a link between the disease and contaminated water supplies, even though his idea of a specific poison was not readily accepted by the medical profession. It represents the first use of epidemiology. It led in part to Robert Koch's discovery of the cholera vibrio in 1883. Snow's work proved the value of the model of water-borne transmission. He is also noted for his development of chloroform anesthesia to replace the use of ether (Bynum and Bynum, 2007, V. 4: 1167–1169).

When a cholera epidemic struck New York again in 1866, the leading medical professionals were still unwilling to accept the theory as to the specific cause of the disease (germ theory), but were accepting of the practical recommendations of Dr. Snow who had shown that boiling water and disinfecting clothing and bedding were measures that greatly reduced the incidences of cholera during an outbreak.

On April 18, 1866, the steamship *Virginia* arrived in New York City harbor. Thirty-seven of her passengers had succumbed to cholera during the voyage, and another lay dying. There were 1,080 steerage passengers (and 14 cabin passengers) presumed to have been exposed. More infected ships were expected, so the city decided a permanent quarantine had to be established. The first cholera victims in the city appeared on May 1, 1866. Another was reported on May 2, and four days later, a third. By June, scores of others developed. The cases, however, were scattered and relatively few—nothing like the explosions of cholera experienced in 1832 and 1849. The mildness of the epidemic was due to careful planning and hard work by the new Health Board, which had done much to clean up the worst sections of filth. The Battery Barracks were used as a hospital, and another to store chemicals to disinfect the excreta and personal effects of cholera victims. City streets, for the first time, were cleaned. Some 160,000 tons of manure were removed from vacant city lots. Thousands of yards were ordered cleaned, over 700 cisterns

emptied, and 6,500 privies disinfected. The new Metropolitan Health Board effectively turned away a major cholera epidemic from the largest and most congested city in North America. In cities throughout the country, prominent citizens called for creation of health boards similar to that which was credited with saving New York City. No other city had a board of health with nearly the powers of New York City's, however, and few such cities escaped the 1866 epidemic of cholera as lightly. But New York City had demonstrated that a public health campaign could drastically reduce the mortality rate of a cholera outbreak (Rosenberg, 1987: 205).

Then, in 1883, German scientist Robert Koch, directing a German scientific commission in Egypt, isolated the germ that causes cholera—*Vibrio comma*, mobile, comma-shaped bacteria (Magill, 1991: 71–78). Once these entered the human intestine, they produced an acute disease which, untreated, killed half of those who contracted it. Cholera, like typhoid, could be spread by any pathway leading to the human digestive tract: unwashed hands, uncooked fruit and vegetables, sewage-contaminated water supplies, and so on. More will be discussed about Koch and other scientists and doctors who led the way in modernizing medicine in the closing section of this chapter. What is notable is that the discovery of the bacillus that caused cholera was a medical breakthrough that paved the way for more effective treatment and preventative measures that were used in the United States during the cholera epidemics of the early 20th century. Although the outbreaks were frequent, none approached the deadly pandemics of the 19th century (NARA, RG 90, files 375–397, boxes 52–57).

When in 1893 an outbreak in Asia spread to Russia, and then to Western Europe, Congress passed the Act of February 15, 1893. It authorized the detailing of medical officers to the offices of the U.S. Consuls to enforce Treasury regulations relating to vessels, their cargoes, passengers, and crews. These medical officers were sent to fourteen principal ports

of embarkation in Europe. The policy was generally credited with having prevented an epidemic in the United States in 1893 (letter from Surgeon General Walter Wyman, September 5, 1905, to the Secretary of the Treasury, in NARA, RG90, File 397, Box 53).

Once the disease was understood, the public health service (then still called the USMHS) took measures to establish, in effect, an early warning system regarding epidemic outbreaks so that corrective measures could be put in place. Consular clerks in foreign cities from which immigrants came were instructed to alert the secretary of state and the surgeon general's office of any such outbreak or suspected epidemic of cholera. Reports from Manila noted cases with incidents and deaths in the thousands. Hong Kong reported outbreaks of both cholera and bubonic plague there. In August, cholera outbreaks were reported in Bremen, in Cairo, Egypt (with over 1,800 cases and nearly 1,500 deaths), thousands in Japan, 10,000 victims with 3,000 dead in China, others in Naples, Italy, and Batavia, Java (RG90, File 397, Box 53).

In 1904, similar reports were filed from Batum, Russia, and Teheran, Persia, where the American Vice Consul General noted the death rates were very high. Restrictions on ships from those ports were immediately ordered. In 1904, Egypt suffered an outbreak, as did Baghdad, Iraq, where thousands of cases and hundreds of deaths were reported. In Russia, the epidemic was especially severe. Hamburg ordered the quarantine against *all* emigrants from Russia in 1905. The Cunard Steamship Lines wrote a letter to the U.S. Department of State in September 1905, noting that all Russian emigrants were being detained for five days under strict medical inspection and that such measures were being enforced at Cunard Line operations in the ports of Liverpool, Southampton, Hamburg, Bremen, Antwerp, Rotterdam, and Havre. A USMHS doctor from Naples was sent to Hamburg to investigate the situation. By June 1906, the special cholera restrictions were removed. In January 1908, the quarantine restrictions were removed for the

ports of Hamburg, Bremen, Rotterdam, Antwerp, Liverpool, Hull, Southampton, Glasgow, and other English ports of embarkation (File 8143, dated January 17, 1908). Despite that lifting of restrictions, the quarantine station at Staten Island, New York, declined to take any steps to remove restrictions it was enforcing against Russian immigrants.

Another outbreak of cholera hit Manila in 1908, but it was quickly eradicated from the lessons learned in how to disinfect for cholera bacilli. The U.S. Marine Hospital and Public Health Service led a campaign to disinfect water closets where the bacilli were spread. Disinfecting squads totaling 600 men were put to work immediately for the exclusive duty of disinfecting closets. They used 150,000 pounds of lime per day, and 700 gallons of carbolic acid daily, or its equivalent in creolin, tricresol, or formalin. Over 4,000 gallons of Jeyes fluid secured from Hong Kong and Japan were spread, using ordinary street pumping water wagons converted into disinfecting wagons. A report on the campaign in Manila noted that ordinary chemical fire engines made excellent disinfecting apparatus (Cholera report, J. C. Perry, folder 397, Box 53). They used 80 gallon tanks charged by CO_2 to spread a mixture of bicarbonate of soda and sulfuric acid, which made an efficient disinfection solution. The Manila campaign used 11 such wagons. The report noted four things of prime importance for the suppression of cholera:

1. Good water supply for all the people
2. Safe disposal of defecations
3. Prompt discovery of cholera cases, suspects, or bacilli carriers with immediate isolation and disinfection
4. Habits of cleanliness.

The report noted related bacilli carriers to be eradicated: flies, cockroaches, and other insects or animals having access to the stools of infected persons. These vermin carry the infection to food and drink (File 397, Box 53).

The 1902 cholera outbreak in the Philippines was extensive, with tens of thousands of cases and thousands of deaths.

In October 1909 cholera broke out in Rotterdam. Assistant Surgeon R.A.C. Wollenberg was sent from Naples to Rotterdam to monitor the episode. He cabled New York City to alert them to the vessel, *Cheyenne*, bound for the port, which had two suspected cases of the disease on board (File 397).

In December, 1910, H. D. Geddings, posted in Naples, Italy, worked with his British counterpart, Consul Churchill, to monitor the health situation in Italy. They expressed a deep lack of confidence in Italian medical authorities accurately reporting cases (File 397, Box 53). December of 1910 saw outbreaks of cholera in St. Petersburg, Russia, and Yokohama, Japan. By mid-December, the quarantine station at Grosse Isle, Quebec Province, Canada, received its first suspected cholera carriers from Russia, and reports of Asiatic cholera outbreaks in Madeira and Lisbon, Portugal. These were passed on to the United States. Reports in December were also received regarding outbreaks in Japan and in Turkey.

In 1911, Surgeon Geddings, at Naples, confirmed outbreaks of cholera in Naples, and in south Italy more generally. The Director of the Municipal Laboratory in Quebec, Canada, Dr. Vallee, reported cholera carrier cases from Russia, as did reports from Norway. In April 1911, the Honolulu station reported cases and some deaths, and elaborated on measures being taken to deal with the outbreak (File 397, Box 55). In May, Honolulu reported on the outbreak in extensive detail in hundreds of pages about the cases and the disinfecting measures being taken. On May 29, 1911, Dr. Vallee, at Grosse Isle, Quebec, reported that the tenth exam for bacilli among carriers quarantined at the station found no evidence of cholera using refined new tests (Box 55).

September 1911 saw confirmed reports of outbreaks in Naples, Italy, with 664 cases and 280 deaths; and cholera in Europe—in Austria/Hungary, Italy, Russia, Rumania, and Turkey. Havana, Cuba, reported cases aboard a ship arriving from

Spain with some deaths on board. Egypt reported cases in late September 1911. In August, a full report from Naples noted 1,691 cases and 659 deaths, and from Russia a report noted 84 cases and 54 deaths (Box 56).

The year 1912 saw cases reported in Shanghai, China, with numerous cases and deaths, and in which the Consul's office suspected there were many more cases and deaths than were being reported. Outbreaks occurred in Tobago, near Trinidad in the British West Indies, and vessels from Messina and Genoa were quarantined in June 1912. Cagliari and Sardinia, Italy, had outbreaks. By February 1912, ports from which cholera outbreaks requiring passengers from Eastern Russia be quarantined included ports in France and Norway (File 397, Box 57). British ports detained for five days all persons, foodstuffs, and baggage of emigrants from Russia.

In October 1916 the station at Angel Island in San Francisco sent an elaborate report on the steps being taken to deal with possible cholera carriers from China and Japan. In November, the surgeon general received an extensive report from Vancouver, B.C., on procedures for inspection, disinfection, and treatment of detainees at the quarantine station at Williamshead, B.C. (the Canadian Pacific Coast equivalent of Angel Island) and emphasizing the ability of the United States to accept their certificates of inspection as being equally thorough and efficient as those used in the United States (File 397, Box 57).

In December 1919, the Department of State posted reports of cholera in Korea, in Vladivostok, in Poland, in China, and in Singapore (Box 57). Similar sporadic reports continued to come in to the surgeon general's office throughout 1921–1923 regarding cholera outbreaks in Italy, Korea, Poland, China, Japan, Baghdad, Teheran, and Russia. These reports served as an early warning system for increased vigilance and inspection of ships, passengers, and crews from any port where cholera was suspected or confirmed. The surgeon general's office stressed the need of screening returning U.S. military servicemen who had been posted in those countries

to guard against their bringing in cases of cholera, typhus, and plague (Borowy, 2009).

Plague

Plague was the classic pandemic of the 14th century. Its first outbreak has been attributed to 1338 near Genoa, Italy. Others put it in Sicily in October of 1347. Nearly all agree the massive pandemic that ensued killed an estimated 30 to 40 percent of the European population of the time (Hayes, 1998: 37; Kelly, 2005: 18–19). It was called the Black Death. In terms of the percent of the population decimated by it, and "with an estimated mortality rate of 90 percent, the Black Death was the greatest calamity in recorded history" (Nohl, 2006, v). Nohl describes the pandemic in sweeping and stark terms:

> No greater calamity has ever fallen on Mankind. In the next fifty years, the Black Death killed more than one-third of the total population of Europe! Outbreaks of the plague were recorded in Russia, Italy, Germany, England and France over five centuries. At the height on one epidemic, more than 200,000 market towns in Europe were completely depopulated. . . . Today the plague is virtually unknown. But for 500 years it stalked the world, and its influence may be seen in politics, religion, folklore, economics, music, and art. (Nohl, 2006: i)

Plague is caused by a microorganism, *Yersinia pestis* (formerly known as *Pasteurella pestis*), a parasite found in various burrowing rodents and typically carried from rodent to rodent by fleas, which bite infected rodents and carry the bacteria to other rodents. Plague carriers include marmots, ground squirrels, prairie dogs, and most especially, the black rat (*Rattus rattus*), the urban rat most at home in human dwellings. A number of diseases are transmitted to humans by vermin: schistosomiasis is transmitted via snails, typhus by human fleas and lice, plague by rats.

Plague is among the slowest moving of wandering diseases. Whereas strains of influenza can travel around the world in a year or two, *Yersinia pestis* can take decades to unfold. The rodent flea is the original host. When the rodent host dies, the flea hops to a new host, transferring the plague bacillus. It infects the new host by a skin bite. Humans get infected by one of many flea species that prey on wild rodents, but most often by the black rat flea, *Xenopsylla cheopis.* Plague jumps from rat to humans in desperation. As the plague kills off the local rat community, the flea's alternatives are starvation or *Homo sapiens.* Once embedded in a human population, the rat flea becomes a very effective vector. *Xenopyslla cheopis* can survive up to six weeks without a host, so it can travel hundreds of miles in grain or cloth shipments—hence the concern to disinfect shipments of rags so common in the 19th century. It is an efficient vector because the infected flea builds up plague bacilli in its foregut, producing a blockage. The blockage slows nutrients to the flea's stomach making it exceedingly hungry. When the flea finds a new host and bites, the plague in the foregut quickly passes to the new host in large numbers, hastening onset of the disease (Davies, 2000: 47). McNeill describes the role of insect carriers:

> Typhus is a particularly instructive case. The same or closely similar strains of the rickettsial organism responsible for typhus inhabit certain species of ticks in a stable fashion, i.e., pass from generation to generation with no apparent ill effect upon the tick or the parasite. Rats and their fleas, however, react to typhus infection by recovering, i.e., they reject the invading organism from their systems after a period of illness. When, however, typhus parasites transfer their activity to human lice and to human bodies, the result is lethal to the louse and often lethal to the person. Such a pattern suggests successive transfers, from a stable co-existence with ticks to a less stable adjustment to rats and rat fleas, to a highly unstable

and presumably, therefore, recent transfer to humans and to human lice. (1989: 31)

Yersinia pestis is an effective killer. It kills nearly anything put in front of it: rats, gerbils, squirrels, prairie dogs, camels, chickens, pigs, dogs, cats, humans, and so on. It is a major pathogen precisely because it is such an adaptable killer. It can be transmitted by 31 different flea species, including *Xenopyslla cheopis*, the most efficient vector in the human plague.

Vermin carriers of disease to humans are called vectors. When a flea transmits the microorganism to humans, bubonic plague results. Bubonic plague depends on having a continuing source of infected rodents during which humans accidentally get in the path of the rodent–flea–rodent transmission. Some scholars, therefore, argued that bubonic plague is an unlikely candidate for human epidemics on a pandemic scale. Plague, however, may pass from one human to another by the human flea, *Pulex irritans*. This makes the spread of bubonic plague possible without the constant rodent reservoir. All scholars agree that the pneumonic form of plague requires no vector, which results when the *Yersinia pestis* settles in the lungs, from whence it spreads by drops of saliva that enter into the respiratory tracts of others. Pneumonic plague was almost certainly the important element in the great pandemic of 1347–1350. Its very fatality, however, as Hayes notes, lessens its diffusive power since so many of its victims perish before they can travel far or infect many others (1998: 38).

Bubonic plague takes its name for its manifestation in buboes, the large, hard, painful swellings in the groin, armpit, or neck formed when the infection reached the lymphatic system. Headaches, blackouts, and serious digestive disorders follow. Death typically occurs within a week of onset. When the microorganism causes blood poisoning, it is called septicemic plague. Of those infected with bubonic plague, 60 to 80 percent died within a month. Pneumonic plague is even more terrifying. When untreated with antibiotics, it is nearly always fatal, with

death occurring in two to three days of the initial infection, after which fever, coughing, and progressive asphyxiation follows.

Survivors of the plague pandemics of the 14th century invented the term, Black Death, for the epidemic. Historians conjecture they may have had in mind the dark blotches on the skin from hemorrhaging. Others conjecture a "black death" was the only term adequate to picture so calamitous an event (Moote and Moote, 2004: 7, 272–273).

Plague-carrying fleas find ideal conditions in terms of temperature and humidity within the burrows of rodent colonies and in human clothing and bedding. Infected colonies may persist in one territory for years and through all seasons. While rodents transfer from one territory to another very slowly, fleas conveyed by human traffic may transmit the disease over considerable distances. Grain mills probably played an important transmission role as they were sites where rats gathered and human traffic originated. The European black rat, *Rattus rattus*, is exceptionably companionable with humans and their dwellings. During the 19th century, the population of black rats exploded as did that of human cities.

Progress in the battle against the plague made great strides in the late 1800s when the germ theory was proven, and as scientists began to identify the bacilli of various diseases. The first breakthrough came in the mid-1850s when a French professor of chemistry, Louis Pasteur, stumbled upon the realm of bacteriology. From the spoilage of beer and wine, Pasteur was led to disease-producing organisms in animals and humans, including anthrax, chicken cholera, and rabies. In 1885 he produced a preventative vaccine for rabies, and in 1889 he established the Pasteur Institute in Paris.

Robert Koch, a German country doctor two decades younger than Pasteur, set up a laboratory in a friend's garden shed. In 1876 his findings on the life cycle of the anthrax bacillus were published. He refined techniques to identify bacilli, and by 1880, he was attracting young assistants from around the globe. Koch and his associates identified the bacilli that caused

tuberculosis and cholera, and within a few years, medical scientists had identified the pathogens for anthrax, cholera, diphtheria, leprosy, malaria, pneumonia, strep sore throat, tetanus, tuberculosis, and typhoid, leading the way to new therapies and eventually the wonder drugs of the 20th century. New and refined bacteriological techniques led to the discovery, between 1880 and 1900, of 21 organisms that caused specific human diseases: typhoid, typhus, and malaria in 1880, tuberculosis in 1882, cholera in 1883, tetanus and diphtheria in 1884, salmonella in 1885, influenza in 1892, plague in 1894, botulism in 1896, whooping cough in 1896, and dysentery in 1898.

In 1894, during an outbreak of the plague in China, two biologists, one Japanese and one French, studied the disease and identified the plague bacillus. Although little awareness occurred at the time, they noted a suspected linkage to rat fleas. In 1885, the San Francisco Board of Health formed an ad hoc committee of physicians and prominent businessmen to investigate conditions in Chinatown in the wake of a devastating epidemic of smallpox that issued an unequivocally damning report (Craddock, 2000: 2, 127; much of this section is drawn from Craddock). Cultural differences between Chinese immigrants and the Euro-American native stock contributed to racial attitudes that influenced the report and efforts to deal with epidemic outbreaks (tuberculosis, smallpox, and plague). David Rosner notes: "Disease intensifies the rhetoric of hatred, fear, and blame utilized against undesirable populations" (1995: 4).

Plague arrived in San Francisco in March 1900. The first fatality from it was a Chinese resident of San Francisco whose corpse was discovered in the basement of the Globe Hotel. The San Francisco city bacteriologist, Dr. Wilfred Kellogg, suspected plague because of the appearance of the corpse. He took samples from the lymph glands and brought them to the laboratory of the USMHS facility located on Angel Island, directed by Dr. Joseph Kinyoun, who confirmed plague. An epidemic ensued that did not end until 1904. The initial outbreak

had 124 confirmed cases (there were likely many more uncon-
firmed) and 112 deaths, most of them among the Chinese.

Dr. Kinyoun had been sent to Angel Island by Dr. Walter
Wyman, Surgeon General of the Marine Hospital Service. As
bacteriology expanded its knowledge of disease, Dr. Wyman
and others used medical science and laboratory procedures to
manage epidemic outbreaks. Although the plague bacillus had
been identified, how it was propagated was as yet little under-
stood. The bacillus was thought to be transmitted through the
air into the lungs or into the stomach. Craddock notes that
the rat was known to have some connection with plague out-
breaks, but its critical role in harboring plague-infested fleas
that in turn bit humans was not known until the research and
campaign conducted to cope with the 1900 epidemic in San
Francisco (2000: 127).

Dr. Kinyoun initially led the campaign against the plague
outbreak. Using then standard USMHS protocols, Kinyoun
imposed strict quarantines on Chinatown. Moving most of the
residents of Chinatown was seriously considered by Kinyoun,
and after exploring several sites, he concluded that Angel Island
would likely be best for transporting Chinese having or sus-
pected of having the plague. Kinyoun's worst case scenario
of the epidemic's spread projected the potential movement
of thousands of Chinese to be accommodated on the island.
Kinyoun's diagnosis of the plague, and especially of the quar-
antine he imposed, soon raised fears and opposition to his plan.
Influential Chinese businessmen alleged Kinyoun's real plan was
the removal of the Chinese to the island while Chinatown was
burned to the ground and rebuilt (McClain, 1994: 447–470).
As McClain describes it:

By June, 1900, the board of health was making plans to
evacuate fifteen hundred Chinese to Mission Rock, hav-
ing received permission from the California Dry Dock
Company to use its docking facility on the island.

Discussions were still underway to get permission from the federal government to vacate a much larger number of Chinese to Angel Island. (1994: 135)

Opposition to Dr. Kinyoun soon led his political opponents to pressure for his removal. Surgeon General Wyman responded and transferred Dr. Kinyoun. Wyman replaced Kinyoun with Dr. Rupert Blue. Although Blue was not nearly the scientist as was Kinyoun, he was certainly more diplomatic in dealing with the Chinese and with the local business and political community. More importantly, reports coming in on the suspected role the rat played in transmission of the disease provided Dr. Blue the insight to focus on eradication of the rats rather than on an oppressive quarantine of the Chinese. He was helped by the fact that by the time he took over the campaign against the plague epidemic in San Francisco, cases of non-Chinese residents had developed, and its spread convinced all that they were, in fact, dealing with the plague. His efforts to eradicate the rats of the city took a few years, but ultimately turned the tide on the outbreak, and he was hailed the hero of the day and went on to become surgeon general. His report on the rat eradication program was published by the service, and his procedures soon spread to other cities.

By 1908–1909, when a severe outbreak struck Honolulu, the Marine Hospital Service contracted to clear rats and mice from various government buildings and the fumigation contracts killed nearly 1,000 rats (File 544, Box 65). The service soon required reports from many stations and cables, and reports in the hundreds came in detailing their rat proofing and rat destruction in various ports. The numbers of rats trapped and found dead, the numbers of traps set daily, the numbers of rats examined, and the numbers infected, and the hundreds of extermination efforts filled these reports. All major ports sending ships to the United States from Europe, Asia, Africa, and South America were asked to make such rat reports. Cabled reports from steamship line companies soon became routine as well.

They reported on the number of vessels fumigated, especially in rat-plague-infested ports. By 1912–1914, reports on devices to better trap rats, and on more effective trap guards on ships and ship cables (so the rats could not debark into a new port) became routine and were widely circulated by the service. From 1909 to 1923, the service conducted an ongoing warehouse rat control program in port cities (File 544, Boxes 66–67).

> Between 1880 and 1900, the mystery of the etiology of such perennial killers as typhoid, tuberculosis, cholera, malaria, leprosy, tetanus, and plague yielded to the probing intelligence of the new science of bacteriology. The recognition of carrier states in cholera, diphtheria, and typhoid as well as the discovery of insect and animal vectors in plague, malaria, and yellow fever rounded out the germ theory of disease and gave physicians and public health workers a vastly improved position in the battle against disease. (Mullan, 1989: 32)

It made lesser strides, however, in understanding the etiology of virus-caused disease, such as influenza. The beginnings of international attempts to deal with infectious diseases centered on a series of international sanitary conferences that spanned the years 1851 to 1938. They served as precursors to the establishment of the Health Organization within the League of Nations (in 1924), and ultimately to the WHO of the United Nations. A number of voluntary international cooperation efforts were funded by the Rockefeller Foundation in partnership with the International Red Cross organizations (Borowy, 2009; Farley, 2004; Gill, 1996; Howard-Jones, 1975; Macleod and Lewis, 1988; Ostower, 1996; Rosen, 1993; Weindling, 1995).

Influenza

The pandemic disease of the 20th century was influenza; its status confirmed by one pandemic outbreak of the disease—the

1918–1919 pandemic commonly although erroneously known as "the Spanish Flu." In the succinct words of Kolata:

> The 1918 flu epidemic puts every other epidemic of the century to shame. It was a plague so deadly that if a similar virus were to strike today it would kill more people in a single year than heart disease, cancer, strokes, chronic pulmonary disease, AIDS, and Alzheimer's disease combined. The epidemic affected the course of history and was a terrifying presence at the end of World War I, killing more Americans in a single year than died in battle in W. W. I, W.W. II, the Korean War, and the Vietnam War. (1999: ix–x; see also 38)

The pandemic struck in three waves. The first, a less deadly outbreak, occurred in the spring of 1918 and spread mostly among military camps. It was not immediately identified as a deadly epidemic, as it seemed like just another outbreak of the flu. The second wave was the truly devastating one, occurring in the fall of 1918. The third assault broke out in the spring of 1919. This last wave was more severe than the first wave, but not as deadly as the second (Davies, 2000: 47). This particular pandemic is officially estimated to have claimed 20 to 50 million lives worldwide, and some scholars believe it may have killed closer to 100 million (Barry, 2005: 4; Davies, 2000: 48; Kolata, 1999: 7). In the United States alone, it has been variously estimated that between a half million to 650,000 people perished (Barry, 2005; Crosby, 1989; Davies, 2000; Getz, 2000; Kolata, 1999; LeMay, 2015; Osborne, 1977). It killed more people in one year than have died from the HIV pandemic in two decades. In 1918, in India, perhaps as many as 17 million died. The epidemic in India took more lives in October of 1918 (during its second wave) than were lost to cholera in 20 years' time. Influenza is a viral disease.

> The virus is the only known life-form that does not eat, drink, breathe, or produce waste. Viruses cannot

reproduce or travel by themselves. They must be forcibly sent from one victim to another. . . . The flu virus travels in droplets of mucus that come from the throats and noses of infected people. Influenza is usually innocuous, coming around every winter, endemic to an area. Most people come down with it and suffer a week or so of misery. It seems unavoidable. Since it is spread through the air, there is little that can be done to prevent it. Perhaps because the flu is so familiar, its terrors in 1918 were all the more dreadful. It is like a macabre science fiction tale in which the mundane becomes the monstrous. (Kolata, 1999: 6)

The 1918 strain was especially mysterious in that it reacted in ways different from previous experiences with the flu virus. Influenza has been around for centuries. In 1580, a pandemic of the disease began in Asia and spread throughout Europe, Africa, and America. It nearly wiped out entire villages in Spain and Italy. Similar outbreaks have occurred in every century since then, although none with as devastating a result as the 1918 strain (Getz, 2000: 4). One anomaly of the 1918 strain was that it killed young, healthy adults at far higher rates than ever before (or since) seen. Most influenza viruses are more life-threatening to infants and very old people who are already ill. In the past, and really in outbreaks of influenza since the 1918 strain, young adults and children tended to quickly get over the flu. They are less likely to contract it, and experience lower mortality rates. By contrast, the 1918 flu's most likely victims to die were young adults between 20 and 40 years (Dr. Jeffrey Taubenberger, cited in Getz, 2000: 4). The death curve for the second wave outbreak was W-shaped, with peaks for babies and toddlers under 5 and the elderly aged 70 to 74, and the largest-middle part of the curve for people aged 20 to 40 (Kolata, 1999: 5).

Another anomaly of the 1918 strain was its far higher morbidity rates. In the October 1918 wave, an estimated 20 to 25 percent of the population contracted the disease, and in a third to half of the cases it was fatal (File 3655, Box 363). In his

definitive study of the pandemic, John Barry estimates that 8 to 10 percent of all young adults may have been killed by the virus (2005: 4). The 1918 strain was 25 times more deadly than ordinary influenzas (Kolata, 1999: 7). This strain had a much higher morbidity rate as well. An estimated one-fifth of the world's population contracted the illness during the 1918–1919 pandemic, including 28 percent of Americans. So many lives were taken by the epidemic that the average life span in the United States fell by 12 years in 1918. "In 1918, there was little anybody could do. There were no medicines and no medical treatments that could stop what many soldiers had begun calling "the Purple Death" (Getz, 2000: 7). Barry notes that another anomaly was its ferocity and speed:

> Although the influenza pandemic stretched over two years, perhaps two-thirds of the deaths occurred in a period of twenty-four weeks, and more than half of those deaths occurred in even less time, from mid-September to early December 1918. Influenza killed more people in a year than the Black Death of the Middle Ages killed in a century; it killed more people in twenty-four weeks than AIDS has killed in twenty-four years. (2005: 5)

In Augusta, Georgia, at Camp Hancock, by early October there were 3,000 cases, and doctors noted incubation rates as short as *six* hours (File 1622, Box 144)! In El Paso, Texas, and Charlotte, North Carolina (Camp Greene), so many cases broke out that temporary hospitals had to be set up in public schools, with school teachers serving as nurses, cooks, and clerks. By October 28, Charlotte reported 2,600 cases and 65 deaths. The surgeon general's office sent out letters to army posts to counter rumors that whiskey would prevent influenza. These alerts countered the rumors with the fact that alcohol did not prevent and may even hasten susceptibility. In a letter dated November 10, 1918, the office had to counter even silly reports, for example, the "Connection of Epidemic of Influenza

with the Motion of the Planet Jupiter," or that the epidemic was the work of "huns" (i.e., Germans who were spreading the disease) (NARA, RG 90, File 1622, Box 144; see also Barry, 2005; Crosby, 1989).

In mid-November 1918, the Metropolitan Life Insurance Company sent letters to the surgeon general's office offering to support a national conference of statisticians (which it did) to develop methods to establish uniform reports on the vital statistics (age, sex, race) of persons who were taken ill, mortality rates, and so on. Rupert Blue, by then surgeon general of the United States, issued a report dated November 8, 1918, stating the influenza outset had been in Europe (hence, the Spanish Influenza) and noting that pandemic procedures were being put in place to guard against its spread. These procedures were those used against cholera, the plague, yellow fever, and typhus fever. The first recognized outbreaks of what was by then actually the second wave in the United States were in Boston and Philadelphia, and from there it spread throughout Massachusetts, then along the Atlantic seaboard. It quickly threatened war production of munitions, the mining of war-related ores, and shipbuilding.

On October 1, 1918, Congress granted $1,000,000 to the Public Health Service to combat "the Spanish Influenza" after it spread to New York, New Orleans, and Mobile. In the ensuring months, the service assigned one-third of its commissioned officers to the battle, and hired more than 2,000 doctors, nurses, and clerks to influenza duty. It seemed impervious to their efforts. According to Mullan, the epidemic struck an estimated five million Americans with 500,000 dead (1989: 74–75).

Epidemiologists now believe the disease actually began in Haskell County, Kansas. It traveled east to a huge army base, and from there to Europe. The first epidemic-level outbreak of the disease struck Camp Funston in March 1918, from where it quickly spread to military camps all over (Getz, 2000: 14; Barry, 2005: 92). Some of the military camps, assembling soldiers to be sent to Europe to fight in World War I, had morbidity

rates as high as 90 percent (File 1622, Box 144). Infected American troops brought it to Europe. It was called the Spanish Influenza because in the United States, France, Great Britain, and Germany, strict censorship was imposed during World War I, and the outbreak of the disease among troops and then civilian populations in those countries was censored. Spain was officially neutral and had no censorship. When the epidemic broke out there (brought in by U.S. military troops in transit to the front), Spanish newspapers reported widely on the strange, new disease that seemed like no other flu before it in its swift spread and high mortality rate. Because Spanish newspapers were the first to report on it, it became known as the Spanish Flu.

> In Europe the disease had been labeled the Spanish Influenza, and from that beleaguered continent the germ spread to every part of the world. In a short period of time, twenty million people succumbed to the dread disease. . . . By the time peace negotiations commenced in November 1918, every state in the U.S. had been invaded by the epidemic. In fact, more than ten times as many Americans were killed by the disease as were killed by German bombs and bullets during World War I. In the nation's cities, the disease struck quickly. In a week in October, 4,500 died in Philadelphia, and 3,200 died in Chicago. (Luckingham, 1984: 1; Surgeon General Rupert Blue Report, November 8, 1918, File 1622, Box 144)

From Europe it spread eastward and westward until it covered the globe. By October 1918 it was everywhere in Europe and North America and in many parts of South America. By November it was in India, China, Persia, and South Africa. By late November it ravaged the islands of the South Sea and pierced deep into the heart of Africa. By January, it invaded Australia.

The disease was mysterious and dreadful in its virulence. At the time, nobody knew where it came from or how it was

communicated. In Nashville, Tennessee, 40,000 people contracted it between late September and the end of October, among whom 15,000 died. In New York City, in the 1918 outbreak, 800 people a day were dying, and the city lost over 19,000 to the disease that year (i.e., from October to December). In its initial month of outbreak in New York City (October), 4,925 cases were reported and 200 died. In Philadelphia that month, it killed 700 in the first week, 2,600 in the second week, and 4,500 in the third (Luckingham, 1984: 3–5; Getz, 2000: 17–20). During the second wave outbreak in the United States, that is in Fall 1918, an estimated one-third of the population was infected. There were massive shortages of medical care of all kinds, of coffins, undertakers, and gravediggers. In Philadelphia, 200 bodies were crowded into a morgue built for 36. A street railway repair shop was turned into a coffin manufactory. In New York City, street cleaners were assigned to the city's cemeteries to help dig graves (Geddes Smith, 1946: 28–29).

The second wave in the United States saw it move from East to West in a pattern akin to the pioneers. Although the disease arrived later and ended later in the cities of the West, it was no less devastating. In Denver and Seattle, Los Angeles, and San Francisco, city officials tried every technique, procedure, and remedy that had been used in eastern cities (and recommended in the Rupert Blue Report of November 8) in a futile effort to slow the advance of the deadly malady. In San Francisco, for example, there were 50,000 reported cases and 3,500 deaths from the disease. It seemed to move from the east coast to the west coast spreading first to military camps and then to cities near them. In West Point, the college and army barracks reported 90 percent of the troops contracted it and 19 percent died; in the civilian population, 20 percent had influenza, and nearly one-half of the cases proved fatal (report of October 22, 1918, File 1622, Box 144).

What accounts for the extraordinarily high rates of morbidity and mortality of the influenza pandemic of 1918–1919?

Two variables seem critical: one natural, one human-made. The natural variable has to do with the adaptability of the flu virus and its capacity and tendency to mutate. The human-made variable has to do with the policies and procedures associated with the exigencies of a global war and the lack of understanding, at the time, of the nature of viruses.

Among infectious diseases, influenza seems special for causing pandemics because it is transmitted so effectively that it spreads virtually unabated until it exhausts the supply of susceptible hosts. Influenza viruses, moreover, mutate constantly. There are three basic types of viruses: A, B, and C. Only influenza virus A causes epidemics and pandemics (Barry, 2005: 101–102). Most mutations are minor, and the immune system recognizes the invading virus, bonds to them, and overcomes them before they become lethal. Sometimes, the mutation causes what is known as antigen drift. When this happens, the mutated virus is not quickly recognized by the immune system. The invading virus can establish a foothold even among people whose immune systems are loaded with antibodies for flu, but those antibodies are shaped to bind with older version of the virus. Antigen drift can create epidemics, as Barry notes:

> One study found nineteen discrete, identifiable epidemics in the United States in a thirty-three year period—more than one every other year. Each one caused between ten thousand and forty thousand "excess deaths" in the United States alone—an excess over and above the death toll usually caused by the disease. As a result, influenza kills more people in the United States than any other infectious disease, including AIDS. (2005: 110)

Pandemics develop when the mutation involves an antigen change so radical that the shape of the new antigen bears little resemblance to the old. This is called "antigen shift." With antigen shift, the immune system does not recognize the virus at all. The human population is essentially "virgin territory" to the

newly mutated virus. In 1847–1848, in London, more people died from influenza than during the great cholera epidemic of 1832. In 1889–1890, influenza struck again, although not as deadly as in 1918. We now understand that each of these was caused by an antigen shift.

> When even normally mild diseases such as whooping cough, chicken pox, and mumps invade a "virgin" human population, a population not previously exposed to them, they often kill in large numbers, and young adults are especially vulnerable. In the Franco-Prussian War in 1871, 40 percent of those who contracted measles died . . . in 1911 a measles epidemic in the U.S. army killed 5 percent of all the men who caught it. (Barry, 2005: 136)

Measles became deadly because of a complication of the disease—pneumonia. From September 1917 to March 1918, as the country built up for war, 30,784 soldiers became ill of measles at Camp Shelby, and 5,741 of them died of pneumonia following measles. A staggering 46.5 percent of *all deaths* at the camp—those from all diseases, car wrecks, work accidents, and so on—were from pneumonia brought on by measles. In 1918, pneumonia was the leading cause of death around the world—greater than tuberculosis, greater than cancer, greater than heart disease, greater than the plague. Like measles, when influenza kills, it usually does so through pneumonia (Barry, 2005: 151). In 1918, when the swine flu jumped from animals to humans and then mutated to infecting its new hosts, it turned lethal. The large army encampments became virtual "killing fields" for the disease. As soldiers spread from camp to camp, from America to France, the mutated flu virus kept finding ever new virgin hosts, and the pandemic ensued.

The second variable—the exigencies of a worldwide war—enabled that spread on a worldwide and nearly unprecedented scale. During the first wave of the disease, its lethal nature was not yet recognized. War policy dictated sending millions

of men to military camps. They kept sending them even after epidemic disease broke out because of the need for troops to be trained for war and pressure to send more and more troops to the battlefields. The truly global scope of the war and the transportation of troops and supplies spread the infection at an unprecedented scale and speed. The state of war necessitated and justified censorship of the press as never before and was condoned or supported by the population and the media itself. News of the disease and the extensiveness of its outbreak were suppressed. The wartime administration, the medical profession, and even the military medical profession simply did not understand the nature of the medical threat they faced. And so they were slow to respond. The lack of knowledge about viral disease and how it spread (by air) contributed to the slowness in developing protocols. The medical weapons that worked against bacterial diseases, serums and vaccines, were powerless against the newly mutated virus.

The American Expeditionary Force jammed millions of men into extraordinarily tight quarters. War production needs drew millions to the factories in cities where density increased the pool of virgin hosts. They worked in shifts, for long hours, where people shared beds, cups, knives, forks, and the like with strangers. This wartime effect enabled the pandemic to develop and spread on an unprecedented scale. The very regimentation of society (in America, in Britain, in Canada, in France, in Germany) meant the populace bore the hardships of war— including epidemic disease outbreaks—with astounding stoicism. When in June 1918, the British freighter *City of Exeter* docked in Philadelphia, the U.S. Public Health Service issued no orders to maritime service to hold the influenza-ridden ship in quarantine, and she was released and the troops and passengers fanned out to return home. As Barry so aptly describes it, soon from Boston to San Francisco, the lethal virus exploded with a killing rate more than double that of the serious epidemic of bubonic plague that struck San Francisco in 1900 (2005: 193).

The war made President Wilson decide to militarize the Public Health Service. Wartime needs trumped policy dictated by a medical profession researching the disease in a nonwartime era. Supplies, troops, and people continued to be shifted about the world even after the lethal nature of the pandemic became apparent. The U.S. Public Health Service entered into contracts with a host of companies and laboratories to develop and supply various serums. The U.S. Army even developed its own manufacturing capability for diphtheria antitoxin, typhoid serum, smallpox vaccines, meningitis serum, tetanus serum, tuberculosis serum, and salvarsan (a treatment for syphilis). The service inspected horses and barns used in the manufacturing of virosi serums and bacterial toxins and sent these various sera in large quantities to the various army camps throughout the 1918–1919 pandemic, largely to no avail. In 1917–1920 it developed and supplied huge quantities of anti-pneumonococcus serum, anti-rabies treatments, anti-smallpox and typhoid vaccines, and so on (RG 90, File 3655, Box 363).

Trachoma

The final disease to be discussed here is one that pales in comparison to the influenza pandemic. Trachoma is nondeadly. However, it is a highly contagious infection of the conjunctiva and cornea. Caused by the bacterium *Chlamydia trachomatis*, if untreated, trachoma results in chronic scarring and blindness. It has an incubation period of 5 to 12 days. It begins slowly as conjunctivitis (an irritation near the eye, also known as "pink eye"). As it advances, the eyelids are severely irritated, and the eyelashes may turn in and rub against the cornea, causing eye ulcers, further scarring, and eventually a loss of vision.

The disease is one of the earliest recorded eye diseases. It is the leading cause of blindness worldwide, having afflicted over 400 million people in mostly underdeveloped countries in Africa, the Middle East, and Asia. It is still endemic there and among aboriginal communities in Australia. The WHO estimates 84 million people in 55 countries have active trachoma.

Trachoma is preventable with adequate diet, proper sanitation, and education. It progresses through three stages: the conjunctival tissues become follicular, heal, and finally scar. The glands and ducts of the eye become affected. The upper lid turns inward, and the lashes then abrade the cornea. If untreated, corneal ulceration becomes infected and scars. Blindness results when scarring is extensive. The disease is spread by contact, often from children to the women who care for them. Women are two to four times as likely as men to contract the disease and suffer blindness as a result. Repeated episodes of reinfection within a family can cause the chronic follicular or intense conjunctivitis condition. It can also be transmitted by flies and gnats.

The disease was once endemic in North America and Europe, but has disappeared in those locations with the improvement in living standards and basic hygiene. The scarring process can be treated surgically to prevent the progression to blindness. If treated early with antibiotics (usually tetracycline drugs or sulfonamides), the prognosis is excellent. Trachoma became one of the leading diseases characterized as "loathsome and contagious," used as the medical basis to bar entrance to immigrants. This designation was frequently used during the period 1900 to 1920. In the United States, 1 to 4 percent of immigrants were debarred from entering for any reason. Medical reasons were the basis used to debar entrance between 1898 and 1924 in a range from 8 to 58 percent of the time. Among those debarred for a "dangerous and loathsome disease," between 1898 and 1924, trachoma was the basis from 6 to as high as 86 percent of the time. Combating trachoma was a near crusade of the Public Health Service, particularly at Ellis Island, as Mullan notes:

> The conquest of trachoma, a chronic, debilitating and, ultimately, blinding infection of the eyes, was the chosen cause of John McMullen. A large and affable man reared in the South, McMullen was schooled in trachoma surgery—the only curative treatment at the time—on

Ellis Island where he served from 1904 to 1911. McMullen began his twelve-year war on trachoma when he was sent to Kentucky in 1912 to conduct a trachoma survey in response to a request for assistance from the state. The survey showed some 8 percent of the 18,000 people examined to be infected—figures dramatic enough to warrant special language in the 1913 Federal Appropriations Act authorizing the Public Health Service to treat trachoma patients. (1989: 65)

Germ Theory and Medical Science Developments to Cope with Pandemics

The 19th century was one of pandemics because the mass movement of people spread them, and medical science and public health had to catch up with the capabilities of disease to become pandemic. This closing section discusses six persons who made truly significant contributions to catching up. A couple of these pioneers are well known, but all played heroic roles in the war against pandemic diseases.

The first breakthrough involved the very concept of disease—germ theory. Until late in the 19th century, most people, including the medical profession, thought of disease as an imbalance in the individual, or due to "miasma," a sort of putrefaction in the atmosphere, or the result of some sort of chemical process, or simply the effect of "filth." Many thought pandemics were the retribution of God for sin and vice and lives of debauchery. As one scholar notes:

> The idea of specific disease entities played a relatively small role in this system of ideas and behavior. Neither learned physicians nor educated laymen saw most illness as having a discrete cause and characteristic course. Not surprisingly, early nineteenth century hospital case records often failed to record a diagnosis, for disease was seen as a general state of the organism in relation to its

environment—as a disordered individual adjustment, not as a patterned and predictable response to a particular cause. (Rosenberg, 1987: 72)

Germ theory conceived of disease as an *invasion* of the body by a foreign substance.

Simply put, the germ theory said that minute living organisms invaded the body, multiplied, and caused disease, and that a specific germ caused a specific disease. There was need for a new theory of disease as the Nineteenth Century progressed, as autopsy findings were correlated with symptoms reported during life, as organs from animals and cadavers were put under a microscope, as normal organs were compared to diseased ones, as diseases became more defined, localized and specific, scientists finally discarded the ideas of systems of illness and the humors of Hippocrates and Galen and began looking for better explanations. (Barry, 2005: 49–50)

Once proven, germ theory demonstrated a specific connection between infectious ills and particular microorganisms. It explained disease patterns already demonstrated, but little understood, by several generations of clinicians and pathologists. Germ theory changed public perceptions and attitudes toward disease and toward the medical profession. It raised expectations that laboratories could transform the shape of the everyday practice of medicine.

The "Father of Germ Theory," of bacteriology, is the French chemist Louis Pasteur. Pasteur proved that most infectious diseases are caused by germs. It was among the most important breakthroughs in medical history, and his work became the foundation of microbiology and a cornerstone of modern medicine. He moved from diseases of the crops used in beer and wine brewing and fermentation processes to study diseases of animals and then of humans. He first discovered the cause

of rabies. Pasteur was the first to prove that weakened forms of a microbe could be used to immunize individuals against more virulent forms. He proved that rabies was transmitted by agents so small they could not be seen even under a microscope (a virus). He developed a serum to vaccinate dogs against rabies and to treat humans bitten by rabid dogs. Pasteur developed "pasteurization" by which harmful microbes in perishable foods could be destroyed using heat, without destroying the food. He discovered germs could live without air, leading the way to the study of germs that cause septicemia and gangrene and similar infections. He devised techniques to kill microbes and control contamination. In demonstrating how to prevent contagion and infection, his method of sterilization revolutionized surgery and obstetrics (Bynum and Bynum, 2007: 978–979).

One of his disciples, Charles Chamberland, a French physician and bacteriologist working in the Pasteur laboratory between 1875 and 1879, demonstrated the effectiveness of an idea of British doctor, Charles Bastian, of sterilization. In his 1879 doctoral thesis, Chamberland researched and provided detailed diagrams for a device for the steam-sterilization of surgical instruments, the steam chamber or autoclave (in French, *etuve*) which would efficiently and effectively kill microorganisms. This concept was later developed by others to engineer large steam chambers to disinfect, rather quickly and effectively, the baggage of entire shiploads of passengers.

In March 1887, Pasteur founded his institute. It became a clinic for rabies treatment, a research center for infectious diseases, and a teaching center drawing brilliant young scientists from around the world. He went on to discover three bacteria responsible for human illnesses: staphylococcus, streptococcus, and pneumonococcus. He developed vaccines against chicken cholera, anthrax, and swine erysipelas. His research techniques revolutionized medicine by using the scientific methodology of experimentation to prove concepts, ideas, and theories of disease and of medical therapies to treat them (Bynum and Bynum, 2007: 978–998).

Another pioneer of microbiology was Robert Koch. He studied medicine at the University of Gottingen, then studied chemistry in Berlin, and began practicing medicine in Hamburg, and then in Posen. He served in the Franco-Prussian War where he began his epoch-making research in scientific medicine that ultimately led to a Nobel Prize for medicine (Magill, 1991: 71–78; Fox, Meldrum, and Rezak, 1990: 312–315).

At the time of his research, anthrax was prevalent among farm animals in the region and he began to study the disease. The anthrax bacillus had been discovered earlier, and Koch set out to prove scientifically that the bacillus caused the disease. Koch inoculated mice with anthrax bacilli taken from the spleens of farm animals that died of anthrax and found all the inoculated mice died from the disease, whereas mice inoculated with blood from the spleen of healthy animals did not suffer from the disease. His experiments confirmed that the disease could be transmitted by means of the blood of animals suffering from it. He obtained pure cultures of the bacilli and experimented on conditions that promoted their multiplication or were unfavorable to them. He found that they resisted certain conditions by forming spores. The spores survived the lack of oxygen, and when put in suitable conditions, the spores gave rise to the bacilli again.

His work was published in 1876 and brought him immediate fame. He went on to be called "the most notable medical scientist of his time, and the Father of the Science of Bacteriology" (Fox et al., 1990: 313).

He laid down the conditions for obtaining pure cultures, known as Koch's postulates. These must be satisfied before it can be accepted that a particular bacteria cause a particular disease. He identified the complete life cycle of the anthrax bacillus. As Barry notes, his 1882 discovery of the tubercle bacillus confirmed germ theory (2005: 51; see also Fox et al., 1990: 314).

Koch discovered the tubercle bacillus, and published the work in 1882. In 1883 he was sent to Egypt to lead the German Cholera Commission. His research led to a vaccine against tuberculosis, which was developed by 1893 (Barry, 2005: 53; McNeill,

1989: 278). Koch proved that the cholera bacteria lived in human intestines and that they were transmitted in water. He did pioneering work on immunology of diphtheria, studied malaria, blackwater fever, surra of cattle and horses, and plague. His discovery of the tuberculosis bacilli won him instant fame in 1882, and by 1921, an effective vaccine against it was developed and deaths from the disease declined dramatically. His work on typhus led to the idea, then a new one, that the disease was spread from drinking water more often than from a person to person. This insight led to new control measures (decontamination). His work helped develop a vaccine against typhoid by 1896, and mass inoculation against typhoid was proven capable of checking the disease in epidemics during 1900 to 1910 (McNeill, 1989: 279). Koch's pioneering work led to dramatic drops in mortality rates of tuberculosis and measles (Kolata, 1999: 47). He was awarded the Nobel Prize for Medicine in 1905 (http://nobelprize.org/medicine/laureates/1906/koch-bio.html. Accessed June 1, 2006).

Another doctor who made important contributions to modern medicine and the fight against epidemic and pandemic diseases was an English physician, Edward Jenner. His important contribution was the development of the smallpox vaccine. He tested a process he called vaccination (from the Latin word for cow, vacca) in which he inoculated his gardener's son with cowpox taken from an young milkmaid. Jenner proved that vaccination with cowpox prevented infection by smallpox. Based on his work, a vaccine was developed. Compulsory vaccination was used in Bavaria, Denmark, and Prussia, and the practice soon became widespread throughout Europe, but outbreaks of the disease continued to spread when travelers not vaccinated brought the disease after visiting places where smallpox was endemic. His work on vaccination paved the way for modern immunology. Ultimately, a campaign by the WHO eradicated the disease by 1977.

Similarly, Lord Joseph Lister, a British surgeon, made the important contribution of developing effective antiseptic surgery. Lister, like all the surgeons of his time, struggled with

surgical sepsis. Lister developed carbolic acid sprays and compresses to combat infection during and immediately after surgery (Nuland, 1988: 345).

Another pioneer was George Miller Sternberg, a hygienist, epidemiologist, and army surgeon general of the United States. With the outbreak of the Civil War, Sternberg was appointed assistant surgeon in the U.S. Army. He contracted typhoid fever in 1862. He recovered and continued his military medical service. While serving as post surgeon at Barrancas, Florida, he contracted yellow fever in 1875, but survived it. He was a member of the Havana Yellow Fever Commission. In 1893 he was appointed surgeon general of the U.S. Army (Kaufman, Galishoff, and Savitts, 1984: 716–717).

Sternberg's work on the etiology of yellow fever disproved its being caused by two then commonly believed causes. He organized and appointed Major Walter Reed to head the U.S. Army Yellow Fever Commission. This commission proved that the *Stegomyia* mosquito was the true carrier of the dreaded disease (Garraty and Carnes, 1999: 1158–1159).

Dr. Walter Reed first came to medical fame as the discoverer of the mode of propagation of the disease. In 1898, when the Spanish-American War broke out, he was appointed chairman of the commission to investigate the cause and mode of propagation of the epidemic of typhoid fever, and the report brought him further attention as a ground-breaking researcher. Their investigation proved the two bacilli then thought to be the cause of the disease were not the true bacilli of the human disease (one was of the hog-cholera). In June 1900 he proved the disease was not transmitted by contact or by contaminated clothing, bedding, and such, but rather by a mosquito. The commission report showed that the mosquito was capable of infection for at least 57 days after its contamination, and possibly longer. The Reed Yellow Fever Commission built on the pioneering work of Sir Ronald Ross, Nobel Laureate in 1902, who proved that the mosquito was the carrier of malaria. Once he proved it was the vector spreading the disease, "what he now realized

was that the way was clear to prevent malaria, since the anopheles mosquito bred chiefly in stagnant water. Malaria could be controlled by destroying the pools and puddles. Here was an opportunity to become a leader in a campaign to eradicate malaria" (Magill, 1991: 46). Dr. Reed went on to investigate typhoid fever (Garraty and Carnes, 1999: 1018–1020).

William Crawford Gorgas is famous as the pioneer who halted the epidemics of yellow fever and malaria and the conqueror of the mosquito that transmitted the diseases. In 1898, an English scientist, Sir Ronald Ross, showed that certain mosquitoes could transmit malaria to birds. His pioneering work on malaria won him the Nobel Prize in 1902 (Fox et al., 1990: 474–477). Once the Reed Commission's study proved the connection between the mosquito and the transmission of yellow fever to humans, Dr. Gorgas was transferred to Panama, where he implemented a far-reaching sanitation program. He made the linkage that the best way to stop these diseases was to exterminate the mosquito that carried them. It was a Herculean task of inspecting and controlling every possible breeding place in the city. Gorgas's work stopped the spread of the diseases (yellow fever and malaria) in the Isthmus of Panama, instrumental in the construction of the Panama Canal. He was later appointed surgeon general of the Army and was heavily involved in its attempt to cope with the 1918–1919 influenza pandemic (McCullough, 1977).

The Pandemics of the 20th Century

In the first few decades of the 20th century as the bacilli causing the major epidemic diseases were discovered and effective sera or germicides developed, medical scientists began to dream about and even speculate that diseases that so long plagued humanity could be eradicated. By 1920, with the establishment of the League of Nations and its International Health Organization (the precursor to the WHO of the UN after World War II), medical scientists began to think they had or soon could

conquer all infectious diseases. For half-a-decade they began to drop their guard against age-old diseases. "The medical revolution wrought by vaccines and antibiotics lulled many physicians in the developed world into thinking of quarantines and isolation wards as bygone features of the medical dark ages" (Leslie Lobel, Ebola researcher at Ben Qurian University in Israel, quoted in *Time*, 2014: 27).

Their optimism, however, was short-lived, as newly emerging pathogens were discovered, and "super-bugs" developed drug resistance to germicides. The growing global connectedness brought about by jet airline travel makes humans all the more vulnerable to new diseases. AIDS, for example, was likely active in Central Africa decades before it spread to the West aided by air travel and the changing sexual mores and exchanges of syringes among drug users. Like so many of the newly emerging viral pathogens, it likely jumped from primates to humans. An estimated 20 percent of all major infectious diseases in humans began in primates. Viruses can leap between species when bodily fluids are shared, as when one animal hunts, kills, and eats another. Then the virus mutates and can make the leap from animals to humans (Wolfe, *The Viral Storm*, 2012). Hunters of wild animals (bush meat hunters) are essentially sentinel populations regarding primate retrovirus that make the jump from primates to humans. HIV began in monkeys in Africa, was acquired by chimps that ate the monkey meat, and the first humans contracted HIV by butchering infected chimps. Similarly, SARS began in China, among bats, then infected cats sold in markets, and jumped from civet cats to humans, and soon was spread by air travel to more than 25 countries (*Time*, 2014: 42–45).

As humans increasingly clear forests and expand ever-deeper into what was once unexplored wilderness, they expose themselves to new animals and to their microbes. Once a virus, especially the newly emerging viruses for which we have no immunities or effective vaccines or antibiotics, reaches and begins to spread in cities, and especially highly populated ones,

it is difficult to ring it off and stop its spread. Ebola, for example, has no vaccine or cure, only supportive therapy. The 2014–2015 outbreak of Ebola became pandemic in West Africa once it arrived in major cities from which it quickly spread to neighboring countries. Middle East respiratory syndrome (MERS) began in Saudi Arabia in 2012, likely jumping from bats to camels to humans. It is now found in 23 countries—the most recent and largest outbreak outside of the Middle East is in South Korea, and in 2015 it spread to Thailand, brought by an air traveler.

Today "microbe, or virus-hunters" gather blood from animals to screen for pathogens. They are on the frontlines of a revolution in epidemiology, one that seeks to predict and prevent rather than simply to react to pandemics (*Time*, 2014: 40). Human behavior is the biggest variable whenever an epidemic outbreak arises.

As mankind used, and clearly overused, antibiotics, drug-resistant bacteria developed into "super-bugs." Perhaps as importantly and dangerously for the reemergence of diseases, like measles, which was on the verge of extinction, is the development of the antivaccination movement (Newton, 2013). For most diseases controlled by vaccination, 95 percent or more of the population must be vaccinated to establish what is known as "herd-immunity," the protection provided by the entire community to the handful of people who cannot be vaccinated because of a demonstrable medical condition. In many affluent states in the United States, the antivaccination movement is becoming sizable enough as to lower the rates of vaccination below that "herd-immunity" threshold (*Time*, 2014: 78–83).

Conclusion

The pioneering efforts discussed in this chapter paved the way for modern medicine, for bacteriology and immunology. They greatly limited the number, duration, and mortality rates of numerous pandemic diseases, particularly bacterial ones. Their work demonstrated that findings in bacteriology grew out of

the research conducted in laboratories and such research was an effective investment in the war on disease. They contributed greatly to the prestige of certain research institutes and hospitals, paying great dividends on the money invested in them and on the hospitals that supported them (Rosenberg, 1987: 163; Winslow, 1971).

> No less important, they demonstrated the value of investing in public health. Public health was and is where the largest numbers of lives are saved, usually by understanding the epidemiology of a disease—its patterns, where and how it emerges and spreads—and attacking it at its weakest points. This usually means prevention. Science had first contained smallpox, then cholera, then typhoid, then plague, then yellow fever, all through large-scale measures, everything from killing rats, to vaccinations. Public health measures lack the drama of pulling someone back from the edge of death, but they save lives by the millions. (Barry, 2005: 86)

References

Barry, John. 2005. *The Great Influenza: The Epic Story of the Deadliest Plague in History.* New York: Penguin Books.

Bazin, Herve. 2000. *The Eradication of Smallpox: Edward Jenner and the First and Only Eradication of a Human Infectious Disease.* Waltham, MA: Academic Press.

Borowy, Iris, ed. 2009. *Uneasy Encounters: The Politics of Health and Medicine in China, 1900–1939.* Frankfurt am Main: Peter Lang Publications.

Bynum, W. F. and Helen Bynum, eds. 2007. *Dictionary of Medical Biography.* Westport, CT: Greenwood Press.

Byrne, Joseph. 2008. *Encyclopedia of Pestilence, Pandemics and Plagues.* Westport, CT: Praeger.

Charte, Christine. 1995. "La Disinfection Dans le Systeme quarantenaire maritime de Grosse Ill: 1832–1937," Internal Research Reports, Parks Canada.

Cook, Robin. 1995. *Contagion.* New York: G. A. Putnam's Sons.

Craddock, Susan. 2000. *City of Plagues: Diseases, Poverty and Deviance in San Francisco.* Minneapolis: University of Minnesota Press.

Crosby, Alfred W. 1989. *America's Forgotten Pandemic.* Cambridge: Cambridge University Press.

Davies, Pete. 2000. *The Devil's Flu.* New York: Henry Holt and Company.

Farley, John. 2004. *To Cast Out Disease: A History of the International Health Division of the Rockefeller Foundation, 1913–1951.* Oxford: Oxford University Press.

Fenn, Elizabeth. 2001. *Pox Americana: The Great Smallpox Epidemic of 1775–1782.* New York: Hill and Wang.

Fox, Daniel, Marcia Maldrum, and Ira Rezak, eds. 1990. *Nobel Laureates in Medicine and Physiology: A Biographical Dictionary.* New York: Garland Press.

Garraty, John A. and Mark C. Carnes. 1999. *American National Biography, vols. 1–12.* New York: Oxford University Press.

Getz, David. 2000. *Purple Death: The Mysterious Flu of 1918.* New York: Henry Holt and Company.

Gill, George. 1996. *The League of Nations: From 1929 to 1946.* Garden City Park, NY: Avery.

Guillet, Edwin C. 1937. *The Great Migration.* Toronto: Thomas Nelson and Sons.

Hayes, J. N. 1998. *The Burden of Disease: Epidemics and Human Response in Western History.* New Brunswick, NJ: Rutgers University Press.

Hayes, J. N. 2005. *Epidemics and Pandemics: Their Impact on Human History.* Santa Barbara: ABC-CLIO.

Howard-Jones, Norman. 1975. *The Scientific Background of the International Sanitary Conferences, 1851–1938*. Geneva: The World Health Organization. http://www.sciam.com/article/cfm?articleID=000BF619-9878-13D6-98788341BF01355ref=sciam&chanID=sa003. ("Ancient Athenian Plague Proves to Be Typhoid.")

Karlen, Arno. 1995. *Man and Microbes: Diseases and Plagues in History and Modern Times*. New York: Touchstone Books.

Kaufman, Martin, Stuart Galishoff, and Todd Savitts, eds. 1984. *Dictionary of American Medical Biography, v. II*. Westport, CT: Greenwood Press.

Kelly, John. 2005. *The Great Mortality: An Intimate History of the Black Death, The Most Devastating Plague of All Time*. New York: Harper Collins.

Kohn, George C. 2008. *Encyclopedia of Plague and Pestilence from Ancient Time to the Present*. New York: Infobase Publishing.

Kolata, Gina. 1999. *Flu: The Story of the Great Influenza Pandemic of 1918 and the Search for the Virus That Caused It*. New York: Touchstone Books.

LeMay, Michael. 2006. *Guarding the Gates: Immigration and National Security*. London and Westport, CT: Praeger Security International.

LeMay, Michael, ed. 2013. *Transforming America: Perspectives on U.S. Immigration, 3 vols*. Santa Barbara: ABC-CLIO.

LeMay, Michael. 2015. *Doctors at the Borders: Immigration and the Rise of Public Health*. Westport, CT: Praeger Press.

Little, Lester K., ed. 2006. *Plague and the End of Antiquity: The Pandemic of 541–750*. Cambridge: Cambridge University Press.

Luckingham, Bradford. 1984. *Epidemics in the Southwest, 1918–1919*. El Paso: The University of Texas at El Paso.

Macleod, Roy and Milton Lewis, eds. 1988. *Disease, Medicine, and Empire: Perspectives on Western Medicine and the Experience of Western Expansion.* London: Routledge.

Magill, Frank, ed. 1991. *The Nobel Prize Winners: Physiology or Medicine, 1901–1944.* Englewood Cliffs, NJ: Salem Press.

McClain, Charles. 1994. *In Search of Equity: The Chinese Struggle against Discrimination in Nineteenth Century America.* Berkeley: University of California Press.

McCullough, David. 1977. *The Path between the Seas.* New York: Simon and Schuster.

McNeill, William. 1989. *Plagues and People.* New York: Anchor Books.

Moote, Lloyd and Dorothy Moote. 2004. *The Great Plague: The Story of London's Deadliest Year.* Baltimore: The Johns Hopkins University Press.

Mullan, Fitzhugh. 1989. *Plagues and Politics: The Story of the United States Public Health Service.* New York: Basic Books.

Newton, David. 2013. *Vaccination Controversies: A Reference Handbook.* Santa Barbara, CA: ABC-CLIO.

Nohl, Johannes. 2006. *The Black Death: A Chronicle of the Plague.* Yardley, PA: Westholme.

Nuland, Sherwin. 1988. *Doctors: The Illustrated History of Medical Pioneers.* New York: Black Dog and Laventhal Publishers.

Oldstone, Michael. 1998. *Viruses, Plagues and History.* New York: Oxford University Press.

Omran, Abdel. 1977. "Epidemiology Transition in the U.S.: Health Factor in Population Change," *Population Bulletin,* 32 (2) May, Washington, DC: The Population Bureau.

Oppong, Joseph R. 2011. *Pandemics and Global Health.* New York: Chelsea House.

Osborne, June E., ed. 1977. *Influenza in America, 1918–1976.* New York: Prodist.

Ostower, Gary B. 1996. *The League of Nations: From 1919 to 1929.* Garden City Park, New York: Avery.

Rosen, George. 1993. *A History of Public Health.* Baltimore: The Johns Hopkins University Press.

Rosenberg, Charles E. 1987. *The Cholera Years: The United States in 1832, 1849, and 1866.* Chicago, IL: University of Chicago Press.

Rosner, David, ed. 1995. *Hives of Sickness: Public Health and Epidemics in New York City.* New Brunswick, NJ: Rutgers University Press.

Smith, Geddes. 1946. *Plagues on US.* New York: Oxford University Press.

Time. 2014. *The Science of Epidemics: Inside the Fight against Deadly Diseases from Ebola to AIDS.* New York: Time, Inc.

Walters, Mark J. 2004. *Six Modern Plagues and How We Are Causing Them.* Washington, DC: Island Press.

Weindling, Paul, ed. 1995. *International Health Organizations and Movements.* Cambridge: Cambridge University Press.

Willrich, Michael. 2011. *Pox: An American History.* New York: Penguin Press.

Winslow, Charles E. 1971. *The Conquest of Epidemic Disease: A Chapter in the History of Ideas.* Madison: University of Wisconsin Press.

Wolfe, Nathan. 2012. *The Viral Storm: The Dawn of a New Pandemic Age.* New York: St. Martin's Press.

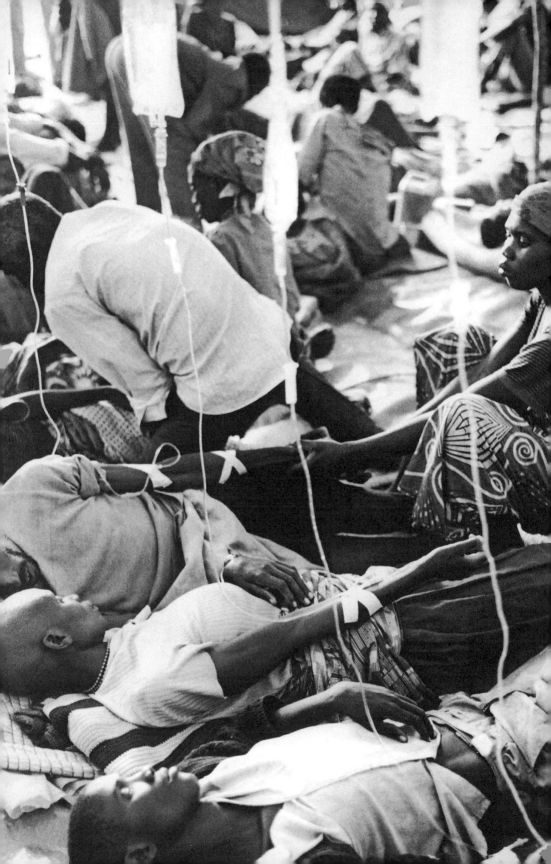

Introduction

A good reason to study the historical background of pandemic diseases is to glean insights from the past—to better understand the nature of the problems associated with epidemic and pandemic disease outbreaks, to delve into the controversies surrounding public policy efforts to cope with pandemic threats, and to explore possible solutions to them. The historical record of coping with epidemics and pandemics can help future policy makers and implementers.

This chapter discusses the major problems associated with the threat of pandemic diseases, a threat all the more real as developments in passenger air travel mean anyone from anywhere can bring along pathogen fellow travelers with them to anywhere on the globe. There are an estimated 20 million refugees worldwide. Many are potential migrants seeking entry to the United States. Many are willing to enter illegally if legal immigration policy prevents their entrance and push factors are sufficiently compelling. The economy of the United States, a first-world economy directly adjacent to a Third World economy, has enormous drawing power. Both the northern and

Rwandan refugees suffering from cholera receive vital fluid replacement at an emergency hospital near Goma, Zaire, in 1994. Cholera is spread by fecal-contaminated water and is all too common in Africa and other underdeveloped countries lacking a reliable source of pure water. (Howard Davies/Corbis)

southern borders are highly porous, stretching over 2,000 miles to the south and over 3,000 miles to the north. They are ineffective barriers to highly motivated, would-be illegal migrants. Of the estimated half-million or more immigrants who annually come to the United States illegally, about 40 percent enter with documents (temporary visas), that is, as nonimmigrants (students, tourists, business visitors, and so on) who then simply overstay and go underground and thereby become illegal immigrants. About 60 percent of unauthorized immigrants are undocumented (enter without papers) (LeMay, 2015a).

Whatever their legal status, all immigrants travel with microscopic fellow-travelers that may be pathogens—the agents of disease outbreaks. In this global age, when the means of international travel are so fast that they are shorter than the incubation period of any illness, it is all the more challenging for public health policy makers and implementers, and for immigration authorities to stand as barriers against outbreaks of epidemic disease with the potential to become pandemics. In this period of massive undocumented, and therefore uninspected, immigration, the danger posed by such microscopic fellow-travelers is greatly increased. In this period of international terrorism, the threat of intentional bioterrorism is all the more serious and difficult to defend against.

Problems

This section highlights ten major problems.

The Inevitability of a Future Pandemic

Medical scientists proved beyond doubt the validity of germ theory. Microscopic agents of disease, germs and viruses, are silent travelers accompanying humans as they migrate. We cannot prevent their migration as humans move from place to place. Medical science has shown that when natural agents of disease—pathogens—migrate to new areas and essentially confront a "virgin" population (one with little or no

immunity), they can cause epidemics with severe morbidity and mortality rates. They become killers on a grand scale. Even diseases we now think of as common childhood illness, such as measles, were and still are deadly when they spread to populations with no natural immunities, as the decimation of Native American Indians amply illustrates. As one scholar of killer plagues puts it:

> We can be certain that there will be many outbreaks of serious infections. . . . The exact timing of such pandemics cannot be predicted. But the consequences are all too tragically obvious: there will be great suffering and a great many deaths . . . by . . . the threat from mankind's most ancient enemy, disease causing microbes. (Ryan, 1997: 381)

The historical record demonstrates that agents of human disease are often spread through vectors—through mitigating sources of disease commonly referred to as vermin. Among the most common such vermin are fleas on rodents. On the death of their rodent host, they jump to the next nearby source of blood, usually another rodent, but sometimes a human. Rats are efficient fellow-travelers with humans, and were and are effective agents for the spread of the plague. The tiny, lowly but prolific mosquito is an effective vector of malaria and yellow fever. While we can control the incidents of human transfer of mosquito-borne infections, we simply are unable to eradicate them. There are too many of them. Mosquitoes are too dispersed, and they reproduce too fast and too much. Human-borne lice, another common vermin, are a principal vector for typhus. Water, *the* necessity for life, is easily contaminated by microscopic life. Humans ingesting contaminated water become victims and carriers of highly contagious and deadly diseases, such as cholera.

The speed and ease with which humans travel today mean that human carriers of diseases can quickly spread infection across wide expanses of space. Oceans are no barriers in the day

of jetliner traffic. We simply cannot prevent these microscopic fellow-travelers from spreading as humans migrate (Kraut, 1994; Oldstone, 1998). At best, we can only react to their spread; to mitigate the incidence of *epidemic* outbreaks. We can only lessen the duration and intensity of outbreaks and, hopefully, contain them enough to prevent them from becoming pandemics. At best, medical science can reduce the morbidity and mortality rates of epidemic outbreaks but cannot prevent their occurring.

In our myopic view, we tend to believe that certain epidemic diseases are events of the distant past. Bubonic plague, cholera, smallpox, typhus, and yellow fever are contagious diseases conquered by modern medicine. They are the stuff of the 19th century. Surely they are of little threat today. Experience, such as the recent Ebola pandemic, shows that we delude ourselves with such thinking.

The World Health Organization (WHO) was launched in 1948 with 55 national signatories. Its lofty, stated goal was to establish "a state of complete physical, mental, and social well-being and not merely the absence of disease or infirmity." Today, the WHO has 192 member states and regional offices in Africa, the Americas, South-East Asia, Europe, the Eastern Mediterranean, and the Western Pacific. The WHO funded campaigns to immunize the world's children against six dreaded diseases that for ages have plagued humanity: diphtheria, tetanus, whooping cough, measles, poliomyelitis, and tuberculosis. Working with the UN's International Children's Emergency Fund (UNICEF) and the UN Educational, Scientific and Cultural Organization (UNESCO), and in close cooperation with organizations like the International Red Cross and the World Bank, and led by experts from the Centers for Disease Control and Prevention (CDC), the WHO-led campaigns of epidemic intervention (Porter, 1999: 485–486; LeMay, 2015a).

As McNeill concludes, the WHO scored its most notable success in those campaigns when it eradicated smallpox in 1976–1977 (1989: 9). A decade earlier, smallpox infected an

estimated 10 million people and killed two million among them in outbreaks occurring within 33 countries. Though falling short of eradication, other diseases against which notable strides were made include malaria, tuberculosis, measles, whooping cough, diphtheria, and polio. Yet these diseases still kill millions worldwide every year. One difficulty in coping with these contagions is their uncanny ability to develop resistance to modern bacteriological treatments. Between 1985 and 1991, after having been beaten back to the point where some scientists believed eradication was imminent, tuberculosis made a comeback. Since 1991, in the United States, cases of tuberculosis increased by 12 percent. In Europe, it increased by 30 percent. In parts of Africa, where tuberculosis and HIV frequently go together, it increased by 300 percent! In 2006, an estimated 10 million people had active tuberculosis. Today it kills three million annually, 95 percent of who reside in Third World countries (LeMay, 2006a: 99).

Cholera is yet another disease thought to have been near eradication that has reemerged in epidemic proportions. The seventh recorded cholera *pandemic* occurred, initially, in Indonesia. It then quickly spread through Asia and Africa, eventually attacking 29 countries in a virulent two-year outbreak. It reached Peru in 1991. From there it spread rapidly through Chile, Colombia, Ecuador, Bolivia, Brazil, Argentina, and Guatemala. As Porter notes, by 1992, it had infected an estimated one million globally, and 400,000 persons in Latin America alone, accounting for some 4,000 deaths there.

A mutation of the cholera bacillus led to a new strain of this old enemy, called El Tor. It is believed to have spread to Latin America in the ballast tanks of a ship from China that discharged its pestilential cargo in Peruvian waters, thereby infecting shellfish, lobsters, and fish, and, in turn, humans. El Tor killed quickly, causing massive dehydration from diarrhea. While health officials around the world fought to contain the El Tor pandemic, a new strain of the classic cholera germ, named *Vibrio cholerae* non-01 CT+, emerged in Bangladesh and India.

This new germ exhibited "the potential of becoming the agent of an eighth pandemic of human cholera" (Porter, 1999: 491).

Yet another old enemy, bubonic plague, struck India in 1994 in a massive outbreak. In 1995, much of the world was struck by the "superbug," **methicillin-resistant *Staphylococcus aureus***, known more simply by its acronym MRSA (Ryan, 1997: 115–133). The "staph" germ is very common, carried on the bodies of about a third of the healthy population. It can cause boils and disastrous infection in bone and can be blood-borne. It is among the most common causes of serious hospital infection. The elderly and persons recovering from surgery are the most at risk. A drug-resistant (hence "superbug") strain of so common a germ gives rise to serious problems, especially in intensive care facilities.

In recent years, another common germ, *pneumococcus*, appears to have acquired resistance to penicillin. A frequent cause of bacterial meningitis in children, it can only be treated with vancomycin, requiring unpleasant injections directly into the spinal canal.

Poliomyelitis had been nearly wiped out. In 1995, the WHO immunized 300 million people. Yet in 1996 it still reported 2,200 cases worldwide. WHO set a goal of 2005 for its eradication, but it was unable to achieve that goal.

WHO estimates that during the 1980s and 1990s, some 2.5 million children died annually from measles because of the failure to vaccinate. While its global eradication is projected by 2020, rapid travel to all parts of the globe from persons coming from areas where measles is still endemic poses a very real hazard to susceptible people in distant lands. WHO indicates measles still infects 40 million children and kills about 1 million per year (Oldstone, 1998: 88–89; Rotary International, http://www.endpolio.org/stories/posts/rotary-celebrates-three-decades-of-polioplus; see also Newton, 2013).

Viruses mutate even more frequently than do germs. The experience with the pandemic of the "great influenza" of 1918–1919 shows how deadly such a pandemic can become.

That particular mutation caused a pandemic estimated to have killed globally 50 to perhaps 75 million persons, and an estimated 500,000 to 650,000 in the Unites States (Barry, 2005; Davies, 2000; Getz, 2000; Kolata, 1999). It was an especially virulent mutation that remained a medical mystery until 2005, when its genetic code was finally deciphered by Dr. Jeffrey Taubenberger of the Armed Forces Institute of Pathology. As we have seen, it was spread by troop movements during World War I. The flu virus mutates somewhat every year and the CDC has to constantly modify the flu vaccines in an attempt to keep up with the variety of strains that circulate in any given flu season (http://www.everydayhealth.com/news/cdc-tweaking-flu-vaccine-for-better-protection). The first major change in the flu virus that caused an influenza pandemic (though far less lethal than was that of 1918–1919) occurred in 1957–1958. Another was the Hong Kong flu of 1968.

Dr. Nancy Cox, of the Atlanta CDC, keeps an eye on flu outbreaks around the world. She identifies certain conditions under which a flu pandemic could arise: the DNA of the flu virus must mutate and change sufficiently that people around the world have little immunity to the new strain (an antigen shift); the new strain must be sturdy and contagious, capable of traveling easily from person to person; and finally, it must reproduce well in epithelial cells (http://www.cdc.gov/flu/pan demic/phases.htm). A new flu strain meeting those conditions could produce a pandemic killer on the scale of the 1918–1919 pandemic. That is certainly the basis for the high level of fear aroused by the swine flu pandemic outbreak of April 2009, which had infected thousands worldwide and killed hundreds (LeMay, 2015a; Caller, 2015; Doherty, 2013; Neustadt and Finbery, 1983; Silverstein, 1981).

World conflicts help to spread outbreaks as well. The Vietnam War spread malaria in the late 1960s. After the first Gulf War, in 1991, puzzling symptoms of illness among returning soldiers became known as the Gulf War syndrome. Medical scientists have yet to determine its nature. Recent and current

conflict in the Middle East could be the proximate cause for the spread of some other viral infection, like Middle East respiratory syndrome (MERS).

The AIDS pandemic continues to spread. It illustrates how difficult it is to develop a vaccine against viral diseases that mutate rapidly and affect the immune system of the body, the natural first barrier against infectious disease. By 1996, AIDS killed an estimated 1,390,000 people. AIDS first appeared in Africa at the same time that the WHO was eradicating smallpox. That may be more than coincidental. During the 1970s campaign to eradicate smallpox, the WHO teams reused needles 50 to 60 times. Live vaccines, such as smallpox, directly provoke the immune system and can awake sleeping giants such as viruses (LeMay, 2006a: 100).

DNA research into viruses holds great promise for medical science's battle against future pandemics, but to date, the viruses are winning the battles as ever-new "hot viruses" emerge on the world scene. Among emerging and widely feared viruses is the avian flu, commonly called bird flu. It has spread from Asia to Western Europe and has been found among dead birds in the United States. In 2015, efforts to contain it required the euthanization of some 49 million chickens and turkeys in 15 states from the Pacific Northwest to the Midwest, making it the worst outbreak the United States has experienced (http:// www.aol.com/article/2015/06/15/bird-flu-likely-spread-on-equipment-workers-rodents-wind). The European Union (EU) announced in February 2006 that it had detected the deadly H1N5 strain of the virus in dead swans. The strain is pandemic among domestic fowl in much of Asia. Since it has obviously moved to birds in the wild, it is all the more dangerous of traveling around the world with the migration of those birds. The avian flu strain has so far infected several hundreds of people, mostly in Asia, and killed close to one hundred. It has raised medical concern, and economically it has ravaged poultry stock across Asia (millions of domestic fowl have been killed in the effort to stop its spread, with limited success) and now, as we

have seen, in the United States. The infection seems to spread only from birds to humans, and only when humans have close and sustained contact with infected birds. Regular influenza spreads quickly and easily because the virus attaches to receptors in the throat and lungs. To date, avian flu attaches to receptors located only deep in human lungs, requiring close, personal contact with infected persons, hence limiting person-to-person transmission. But there is evidence that it spreads from birds to birds on equipment, by workers at chicken and turkey farms, by infected rodents found in poultry barns, and perhaps even by wind (http://www.aol.com/article/2015/06/15/bird-flu-likely-spread-on-equipment-workers-rodents-wind). Should the avian flu strain mutate so that it can be spread directly from human to human carriers, it could become a devastating pandemic. Medical science does not yet clearly understand how viral mutation occurs (http://www.who.int/vaccine_research/diseases/zoonotic/en/index4.html).

Epidemiologists warn of an inevitable pandemic on the scale of the great influenza of 1918–1919. "Warning" episodes include the HIV/AIDS pandemic, the SARS virus epidemic in 2002, the Ebola hemorrhagic fever outbreak, in 2009 and again in 2014, a new strain of Lyme disease, the April 2009 swine flu pandemic, and the MERS outbreak in South Korea in 2015 (Walters, 2004: 148–151; Ryan, 1997: 13; *Time*, 2014; Porta, 2008).

Of particular concern with respect to the massive rate of unauthorized immigration today is the potential for its use by international terrorists to intentionally spread infectious diseases as agents of bioterrorism. Richard Preston, in his book, *The Hot Zone* (1994), discusses the new viral diseases that spread naturally. He offers a chilling fictional account of bioterrorism in *The Cobra Event* (1997). While fictional, the latter is based on real science and portrays a very plausible scenario. The CDC has identified a number of diseases as potential bioterrorism threats: anthrax, botulism, *Chlamydia psittaci*, cholera, Ebola virus hemorrhagic fever, plague (*Yersinia pestis*),

Escherichia coli 015H7, food safety threats (e.g., various salmonella species), Lassa fever, Marburg virus hemorrhagic fever, Q fever, Ricin toxin, smallpox (*Variola major*), and typhoid fever (*Time*, 2014: 46–51).

Dr. D. A. Henderson, first director of the CDC's Smallpox Eradication Program and later director of WHO's global smallpox eradication program, became founder of the Center for Civilian Biodefense Strategies (Etheridge, 1992: 189). In 2001, he was named director of the Office of Public Health Preparedness (OPHP) in the United States Department of Health and Human Services (HHS). OPHP was established after the anthrax attack via the U.S. Postal Service in November 2001. OPHP was created to defend against bioterrorism, the danger of which is very real, not science fiction. The extraordinary potential of bioweapons has long been recognized by the U.S. military. During World War II, the U.S. Army experimented with bioweapons and concocted a botulinum toxin so potent that one pound of it, if expertly dispersed, could kill 1 billion people. The botulinum toxin is the most lethal compound known. It is 15,000 times more lethal than nerve gas and 100,000 times more so than the sarin toxin used in the 1995 Tokyo subway terrorist attack. If properly aerosolized, one gram could kill 1.5 million people. Ricin, another toxin, extracted from castor beans, can be aerosolized. If breathed in or ingested, it kills through severe respiratory distress in a matter of a few days and has no known treatment (Bertolli and Forkiotis, 2003: 8).

Dr. Henderson was among the leaders of the CDC/WHO team that helped eradicate smallpox and knows the virus better than almost anyone else. He sees it as potentially one of the deadliest bioterrorism agents. Today the virus is sequestered in two facilities sanctioned by the WHO: the CDC in Atlanta and in Novosibirsk, Russia, at the State Center of Virology and Technology. The WHO approved the destruction of all other smallpox stock, allowing these two approved sites for scientific study to develop antiviral therapies, vaccines, and rapid diagnostic and analytic devices. Dr. Henderson, however, opposes

maintaining even the two stocks of smallpox, arguing that there is little scientific insight that cannot be gained using other orthopoxviruses. His recommendations simply cannot be ignored (http://www.upmc-biosecurity.org).

Smallpox is considered one of the most dangerous of the top 50 bioweapon pathogens, only 13 of which have vaccines or treatments. It typically kills about 30 percent of its unvaccinated victims, and in the case of an epidemic outbreak among a virgin population, it is known to have killed as many as 50 percent of cases. Smallpox spreads rapidly, radiating in ever-widening waves. In the first wave, every infected person infects 10 to 15 more, each of whom—unless quarantined—infects 10 to 15 more. If the initial or first generation of infected victims numbered 200 to 300 persons, the next would be 2,000 to 3,000, and so on, if the population is not rapidly vaccinated and the sick isolated. Smallpox immunity wanes after about a decade, and thus it means much of the world's population is once again essentially a virgin population, since the last person to be vaccinated in the United States received the shots in 1972, and worldwide the last vaccination campaign ended in 1976 (Bazin, 2000). While its eradication is good news, it has been long enough since the last cases that virtually all the world's population is now once again virgin-soil. According to Drexler, there is less immunity to smallpox today than ever before in human history (2002: 239–240).

Smallpox has been menacing humanity since at least 1000 BCE (the mummy of Ramses V shows evidence of smallpox). In the 1990s, U.S. intelligence agencies reportedly suspected that the virus was in less secure, less friendly hands (North Korea, Iraq, al Qaeda). In 1972, a smallpox aerosol release indicated that either an accidental or a purposive (a test-run) incident had occurred. A former Soviet Union weaponized or genetically altered form of the deadly virus was reportedly transported to Iraq in 1990 (Drexler, 2002: 238; LeMay, 2006a: 103; see also Koplow, 2002; Ellisson, 2007; Alibeck and Handelmann, 1999).

Of particular threat would be bioterrorists manipulating several deadly agents, like those listed above, so that they work together, one enabling its rapid spread (its morbidity rate) and another increasing its lethality—its mortality rate (Drexler, 2002: 242–243). In 2001, an accidental discovery by Australian researchers proved such a possibility. They were attempting to make a mouse contraceptive for pest control. They inserted into a mouse-pox virus a gene that makes a large quantity of interleukin-4, a molecule produced naturally in mice and humans. Their "designer virus" crippled the immune system and 100 percent of the mice died. The new virus resisted vaccination. In 1998, Russian scientists inserted genes from harmless bacterium into anthrax bacterium and inadvertently created a new form of anthrax that was resistant to both penicillin and vaccines (Drexler, 2002: 243).

The Soviet bioweapons program was experimenting with combining smallpox with Ebola hemorrhagic fever virus or Venezuelan equine encephalitis virus. Such a genetically altered or "engineered" virus is called a "chimera," after the Greek mythological creature that had the head of a lion, the torso of a she-goat, and the tail of a dragon. "This same civilian technology is theoretically able to make this pox virus [the mouse-pox virus] deadly to humans as well. This is an example of the availability of genetic technology that could very well be used utilized by unfriendly forces" (Bertolli and Forkiotis, 2003: 9; Walters, 2004; Wolfe, 2012).

"Agro-terrorists" could target agricultural crops or animals. The increasing centralization and globalization of the food supply renders it vulnerable to attack at numerous points along the chain. Three multinational corporations process about half of all U.S. meat. A planned attack of foot-and-mouth disease, the highly contagious infection that shook the British and European livestock industry in 2001, could cripple the U.S. meat industry. Contamination of seed supplies with spores of soybean rust, for example, would have global repercussions since the United States raises about half of the world's

soybean crop. From wheat or rice rust, to the intentional spread of avian flu among poultry, the potential of agro-terrorism is considerable (http://www.aol.com/article/2015/06/15/bird-flu-likely-spread-on-equipment-workers-rodents-wind).

Political Exigencies Tend to Trump Medical Advice

The needs of local politics, politicians, and economic concerns distort perspectives. As the cliché puts it, "all politics is local." Call it wishful thinking or the "head-in-the-sand" effect, policy makers who ought to know better and have initial political power with respect to an outbreak of an epidemic are often the most reluctant to recognize and admit it even when the disease is staring them in the face and killing persons they are charged to protect.

World War I exigencies dictated the censorship of news about the beginnings of the great influenza of 1918. Even after medical scientists and public health officers, and a few army medical officers urged a halt in the deployment of recruits to military camps to avoid spreading the influenza outbreak, and even long after the death rate skyrocketed among them, troops were moved all over the world. Military necessity overpowered medical advice. What began as an epidemic at one military camp in Kansas became, in a matter of months, one of the deadliest pandemics in human history. Governments in the developing Third World, especially in Africa and Asia, were often suspicious of health care efforts of Western nations, which they saw as interference or extensions of Western imperialism (Borowy, 2009; Macleod and Lewis, 1988; Ostower, 1996; Gill, 1996; Weindling, 1995, 2000).

National government policy makers often ignore confirming and confronting an epidemic outbreak in order to save money, to save face, or in the name of national security. The government of the former Soviet Union hid the truth about the Chernobyl disaster rather than admit to the world its failure to prevent the disaster, and many died of radiation poisoning as a result. For months the government of China hid the

existence of avian flu and the world lost precious time when other countries could have been alerted and forearmed. Nearly a hundred lives were lost to the disease, undoubtedly including some who could and would have avoided that fate if preventative measures had been enforced against the spreading avian flu pandemic. Governments far more often seek to evade blame for global health threats within their borders than they seek to promote transparency (*Time*, 2014: 92).

Myopia is commonplace. Government policy makers seem prone to dream up reasons to suppress the truth rather than to admit to an epidemic. They want to avoid panic. They need to prevent hysteria. They need time to be absolutely sure before they commit to spend millions on what might turn out to be a false alarm. The reasons justifying inaction are legion. The deaths that result from inaction and delay are all too real and all too many. A future epidemic will become pandemic in no small measure because governments will hide the truth about an original outbreak; the epidemic will be lied about, explained away, and the truth about the outbreak, about its very nature, suppressed until the epidemic has spread beyond the boundaries of the original outbreak and developed into a pandemic. The Ebola spread in West Africa in 2014 remains a classic example of this problem.

Ebola is not easily transmitted, but it has a higher mortality rate than most other diseases. It is Ebola's gruesome symptoms and high death rate that is truly frightening. Influenza's mortality rate is 0.026 percent. Even the deadly 1918 strain killed about 2.5 percent of those infected. The latest Ebola epidemic was initially estimated to have a 50 percent mortality rate, but that estimate has since been increased to 70 percent (http://www .aim.org/special-report/ebola-pandemic-risks-and-realities. Accessed May 14, 2015).

While Preventive Medicine Is Best, It Is Too Often Ignored

There can be no doubt that preventive medicine is best. It is better in terms of lives saved and of costs to taxpayers to

prevent an outbreak from occurring than to treat persons once they have contracted a contagious disease. Public health efforts save many more lives by prevention than do heroic doctors dramatically saving the life of a patient on his or her "death-bed." The need to develop the epidemiology of the new "hot viruses" is essential to control and preventing their outbreak. A clear understanding of the nature of a particular disease enables public health practitioners to discern its cycle. As in any war, the adage "know thy enemy" is paramount. Success in battle depends on attacking the enemy at their weakest point. That is no less true in the battle with epidemic and pandemic diseases. Attacking the disease by intervention in the natural cycle of the disease, by eradication or control of the vector, is the most effective and cost-efficient approach (LeMay, 2006a; Walters, 2004; Wolfe, 2012).

Public health campaigns to wipe out mosquito carriers of yellow fever, and more recently of malaria, proved highly effective and clearly the most efficient method to cope with epidemics of those diseases that until the 20th century were scourges on mankind and the source of periodic pandemics. Eradicate the mosquito from locations near dense human habitation, and you effectively stop the epidemic nature of the disease. The experience gleaned from the battle against yellow fever and malaria led directly to the establishment of the federal Communicable Disease Center in 1946, now known as the Centers for Disease Control and Prevention (CDC) (Etheridge, 1992: 11).

Immunization, the prevention of epidemic disease by inoculation to induce immunity, has been proven to be even more effective. While expensive, massive inoculation campaigns are still the most cost-effective way to cope with some diseases. To date, only smallpox has been eradicated globally through immunization (Bazin, 2000). The U.S. government, as well as France, Russia, and other European governments, working through the CDC and in conjunction with the WHO, and a few nongovernmental organizations (NGOs) who assisted with funding, developed the administrative processes to launch

a global vaccination campaign. Its smallpox campaign, fully successful in 1976 and at a cost only of several hundreds of millions of dollars, proved that a highly contagious and deadly disease could be fully eradicated. The U.S. Public Health Service (PHS) developed a host of sera and toxins to vaccinate against diseases, some to immunize, some to effectively treat cases of contagious diseases. In the 1960s, the CDC managed the PHS's tuberculosis control program, an effort in which many state and local public health organizations vigorously fought tuberculosis. Then in 1966, the CDC launched its most ambitious and triumphant project, the eradication of smallpox through immunization. In a second phase, after success of the smallpox campaign had demonstrated the worthiness of a global immunization of children approach, the CDC targeted measles (Etheridge, 1992: 153). In the 1980s it began the campaign to eradicate poliomyelitis (http://www .endpolio.org/stories/posts/rotary-celebrates-three-decades-of- polioplus).

Mission Complexity Hampers Effective Response

A factor of any bureaucratic organization that influences its effectiveness has been referred to as "mission complexity" (Etheridge, 1992: 18–19; LeMay, 2006b: 295; Mitchell, 2003: 15–18; Kraus, 2003: 57–58). Administrative problems develop when a bureaucracy tries to do too much and too varied an array of tasks. In its early years, the PHS undertook an astonishing spectrum of tasks. It was crucial in developing the public health service approach. It played an effective and critically important role as primary barrier against outbreaks of pandemic episodes at the end of the 19th century and into the first decades of the 20th century. Its mission complexity is clearly evident. Consider the fact that by the 1880s the service was managing and operating a substantial string of hospitals, both general and contagious disease hospitals, at numerous stations across the country. It provided medical services for merchant

seaman, federal prisoners, coast guardsmen, lepers, and narcotic addicts. It conducted medical examinations for immigrants, federal employees, and longshoremen. The PHS administered public health grants to states and conducted venereal disease and tuberculosis control programs. It administered the Biologics Control Act, the cancer program, and intramural research at the National Institutes of Health (NIH). It conducted epidemiology studies of cancer in various hospitals around the country. It developed and ran biological laboratories at a national site (the NIH), and at all of its immigration stations. It developed and carried out basic biological research in all the labs it operated to test for and confirm the diagnosis of various contagious diseases. It developed research programs for sera and toxins to treat infectious diseases as well as managing contracts with numerous private businesses to develop sera and toxins. The PHS tested and approved sera and toxins, and inspected facilities developing them. It tested food additives that might pose dangers to public health. It ran extensive public education efforts to inform citizens about numerous infectious diseases and popularized simple measures the public could take to protect against and reduce the spread of contagious diseases. It set up administrative procedures at ports in many nations abroad and across the country to monitor epidemic disease episodes around the world and across the nation to serve as an early warning system about epidemic disease outbreaks. It published manuals for its doctors and for other public health-care professionals on effective treatments and procedures to cope with a wide variety of infectious diseases. The PHS organized and ran extensive rat eradication campaigns. It developed and administered extensive inoculation campaigns and efforts. It spread knowledge within the medical profession on the importance of sterilization procedures. The service developed and improved on the design of various devices and apparatus to disinfect and fumigate against vermin, purchased those devices and promoted their use at stations and at hospitals and the major ports of embarkation around the world. It virtually invented the

concept and the practice of vector control. A complex mission indeed (Mullan, 1989)!

Success in controlling the bubonic plague epidemic in San Francisco in 1900 to 1908 proved the value of the rat eradication campaign and was critically important to the very development of the PHS and to the appointment of Dr. Rupert Blue as surgeon general of the United States. It was one of the first examples of the effectiveness of vector control and proved to be a model for that approach being applied against other diseases.

Yet mission complexity was, without question, a factor in the inability of the PHS to cope adequately with the great influenza pandemic of 1918–1919. When the epidemic erupted, the PHS frantically tried to develop a serum to treat its victims. Research scientists strove heroically to understand this new viral infection that was so puzzling and so quickly lethal. But as an organization leading the battle, the PHS was inundated with cases at hospitals it operated across the nation. It struggled simply to provide doctors and nurses to cope with the pandemic. At first, wartime censorship prevented the PHS from conducting a public education campaign to inform the public on measures to prevent the spread of the "Spanish influenza." By mid-1919 it launched an effort to do so, but the advice was too little, too late, and next to useless in its suggestions. The PHS simply tried to do too much, too quickly, under the additional stress of wartime constraints and in the face of a baffling pandemic that stubbornly defied the best that medical science offered at the time. It had never before faced a flu virus with the morbidity and mortality rate of the 1918 mutation. While medical science was beginning to understand the basics of germs and how they caused diseases and the role they played in the spread of contagious diseases, it did not yet understand well the role of the virus. It understood even less about the incredible ability of the virus to mutate. Its efforts were futile in the face of this most deadly of pandemics. In hindsight, the pandemic seems inevitable, but mission complexity was a factor

in its extraordinary global lethality (Barry, 2005: 299–300; Fettner, 1990).

The PHS learned from the tragic experience of the great influenza pandemic of 1918–1919. Its mission complexity was reduced as it gradually "spun off" responsibilities and as other organizations, both public and private, took on some of its pioneering responsibilities. In 1906 the federal government created the Food, Drug, and Insecticide Administration to administer the Food and Drugs Act of June 30, 1906. That act was passed to protect the consuming public against misbranded or adulterated food, drugs, naval stores, insecticides and fungicides, and the honest producer against enforced competition with such commodities—later becoming the FDA (Weber, 1928: 36).

In 1946, the PHS established the Communicable Disease Center that in 1968 morphed into the National Communicable Disease Center and eventually into today's Centers for Disease Control and Prevention. These took over malaria control and typhus work, and linked epidemiology in CDC labs to training and education. The scope of the CDC's work expanded from its original emphasis on tropical diseases with insect vectors to ones with zoological origin: malaria, amebiasis, the schistosomiases, hookworm disease, filariasis, yellow fever, dengue, certain neurovirologic disorders, various forms of typhus and plague, sand-fly fever, and diverse diarrheas and dysenteries. The CDC supplied state and local health units with the support they needed to cope with communicable diseases, although that role developed slowly and sometimes in opposition from other better-established wings of the PHS that resented the intrusion of the newcomer (the CDC). In 1948 the NIH did basic research, and the CDC was given responsibility to help states recognize and control communicable diseases. The lines of responsibility were blurred, however, as the National Microbiological Institute served as reference serologists and entomologists, and used field work to support and clarify laboratory work. At the CDC, in contrast, its primary

role was to control disease, but bench work was necessary to back that up (Etheridge, 1992: 30).

With the outbreak of the Cold War in the 1950s, and the military's biological warfare programs, the CDC increasingly became disease detectives. In the mid-1950s the increasing incidence of poliomyelitis and the Asian flu pandemic of 1957 moved the CDC, in a five-year period, from a position of relative obscurity in public health, to one with major responsibilities for epidemic control.

With the establishment of the United Nations and through it the WHO, much of the global monitoring of pandemic and epidemic disease efforts shifted to the WHO, which worked in conjunction with the CDC to establish an international system with over 100 stations around the world to monitor epidemics and to help administer its campaigns to eradicate contagious diseases like smallpox, diphtheria, tetanus, whooping cough, measles, poliomyelitis, and tuberculosis.

Rather than one agency trying to do basically all things, numerous agencies—both public and private, including research conducted by NGOs organized on the basis of specific diseases—took up parts of the struggle to research, prevent, control, treat, or monitor the various epidemics and especially the deadly contagious diseases. That diversification of effort became all the more important as global monitoring stations watch for newly emerging variants of the influenza virus and for the return of well-known types, and the appearance of the hemorrhagic fevers and HIV, which challenge a new generation of microbe hunters as did smallpox, poliomyelitis, measles virus, and yellow fever the medical researchers of the past (Oldstone, 1998: 191; Drexler, 2002; Ellisson, 2007; Peters and Olshaker, 1997; Porta, 2008).

As Man Adapts to Nature, Nature Adapts to Man

Microscopic life is rich in its diversity, incredibly prolific in its ability to reproduce, and utterly fantastic in its adaptability.

The bacterium is the most common life form on earth. Modern science has found microscopic life miles deep in the oceans where no light penetrates and where the pressure is incredible. Scientists have found bacteria living where there is no oxygen. Some forms of microbes withstand vast extremes of temperatures. Microbes have been discovered in the frozen tundra of Antarctica and in the most scorching and arid deserts on earth. Scientists in labs have cultured microbes from fossil samples that seem to have survived in dormancy for millions of years.

As medical science unlocked some of nature's secrets and developed sera and other bacteriological tools to fight disease, the organizations of modern medicine developed increasingly elaborate practices and methods to cope with epidemics. Local public health programs were assisted by national programs, and then even multinational/international programs. After World War II modern medical science dared to dream of, and organized to fund and administer, ambitious programs whose goal was no less than the global eradication of pandemic disease. When the WHO, and importantly the CDC, succeeded in the eradication of smallpox in 1976, many dreamed of the similar defeat of most other pandemic diseases that for much of human history were scourges that periodically became pandemics killing thousands and even millions of people. The WHO then launched eradication campaigns against diphtheria, tetanus, whooping cough, measles, poliomyelitis, and tuberculosis.

That optimism faded when confronted with the reality of how difficult an enemy microscopic life was to battle and defeat. Mankind learned that even as we adapted to nature and developed increasingly ingenious methods to manipulate and control it, germs and viruses proved even more adept at adapting to mankind's efforts. Germs and viruses developed drug resistance to the germicides that humans concocted. They mutated into new strains—superbugs—that defied human effort to eradicate them (Fettner, 1990).

Today's outlook with regard to microbial threats to health is bleak on a number of fronts. . . . Pathogens—old and new—have ingenious ways of adapting to and breaching our armamentarium of defenses. We must also understand that factors in society, the environment, and our global interconnectedness actually increase the likelihood of the ongoing emergence and spread of infectious disease. (Walters, 2004: 147)

Epidemiologists warn a pandemic as lethal as the great influenza will arise from among a number of newly emerging pathogens medical science continues to identify. When it was first discovered, many feared that HIV/AIDS would be the source of such a pandemic. While it has killed in the millions to date, its rate does not portend global deaths on the scale of the 1918–1919 pandemic. In 2001, another previously unknown virus struck—in the form of severe acute respiratory syndrome, or SARS. The WHO considered SARS "the first severe and easily transmissible new disease to emerge in the 21st century." It joined a list of newly emerging epidemic diseases: HIV/AIDS, Ebola hemorrhagic fever, Lyme disease, and so on. The WHO sent the director of its Western Pacific Region to investigate the new disease. On March 12, 2001, the WHO declared SARS a virus that was a "world-wide heath threat." The virus seemed to kill about 7 percent of those infected. At that rate, if it spread in China where one in ten could become infected, its death toll would exceed 30 million, on the scale of the Spanish influenza. A SARS outbreak in Hong Kong, while fortunately contained rather quickly, was found to have a death toll of 15 percent among those under 60 years of age, and more than 45 percent among those older than age 60 (Walter, 2004: 148–150).

There is a bewildering list of newly emerging pathogens. "In the fall of 1999, the list of identified arboviruses numbered 538. Of this list, those known to cause human disease ran to 110" (Drexler, 2002: 38; see also Wolfe, 2012).

Myriad new viruses, viral strains, and new germs have emerged since the 1930s. Several of these new diseases have become endemic in different regions around the globe. For many of them, known or suspected vector carriers have been identified. Some of these new viral agents are especially worrisome because epidemiologists have yet been unable to determine their origin or their vector or carrier. The Sin Nombre (No Name) virus, for example, suddenly appeared on the Navajo reservation in New Mexico. It killed several natives and eventually was identified as a new form of hantaan virus. Previously, that virus was located in Europe and caused kidney and liver failure (Walters, 2004: 113–126). Sin Nombre took some time to diagnose because it appeared suddenly in New Mexico among victims who had no known travel to or contact with Europe. More puzzling still, Sin Nombre virus caused pulmonary disease, attacking the respiratory system rather than the kidneys or liver (Peters and Olshaker, 1997: 7–40). Other newly emerging pathogens are frightening in the speed with which they are spreading. The West Nile virus, for example, assisted by migrating birds, international travel, and perhaps climate changes due to global warming, has begun spreading from West Africa to become a global threat, spreading "Like a smoke plume swept into a wind" (Walters, 2004: 146).

Some new viruses are of special concern because they are highly lethal. The Eastern Equine Encephalitis virus, for example, kills over 30 percent of its victims by acute infection of the brain and central nervous system. Hantaviruses are another highly lethal pathogen. Then there are the many types of hemorrhagic fever virus that exhibit high lethality: Junin virus, Machupo virus, Marburg virus, Lassa virus, the various strains of Ebola (Sudan, Zaire, etc.) virus, the Seoul virus, Sin Nombre virus, and Sabia virus. Until fairly recently, AIDS was nearly always fatal and almost untreatable since it attacked the human immune system itself (AIDS is the disease caused by the human immunodeficiency virus, or HIV as it is commonly known).

Some are especially scary (although less lethal) because of the nature of their symptoms and the difficulty medical science has to treat them. An example of that type is one among the new "superbug" pathogens of emerging bacteria, the so-called flesh-eating bug that emerged in 1994.

Still others are yet so puzzling because they have no known origin or animal host, or their vectors are uncertain. Examples of these include Mayaro virus (identified in 1954), O'nyong-nyong virus (1959), La Crosse encephalitis (1960), Rotaviruses (1973), Parvovirus B19 (1974), the various Ebola viruses (whose suspected animal host are primates), human herpesvirus-6 and human herpesvirus-8, and the hepatitis E virus.

The outbreak of MERS, first identified in 2012, is caused by a coronavirus in the same family as the severe acute respiratory syndrome (SARS). SARS killed an estimated 800 people world-wide after it first appeared in China in 2002. In 2015, MERS spread from Saudi Arabia to South Korea, and to Thailand. The WHO data indicated 1,257 cases of MERS globally, with 448 deaths and a mortality rate of 30 percent (http://www.who.int/csr/disease/coronavirus_infections/archive; and http://www.cdc.gov/mmwr/preview/mmwhtml/mm6403a4.htm).

Humankind Is Its Own Enemy

Patterns of human behavior contribute significantly to the development and spread of disease. Human culture and customs are closely linked to disease cycles. Human intervention in nature, through widespread agriculture, for example, and through massive inroads into the rain forests to support ever more and larger urban habitation centers, disturbs the natural environment in ways that seem to spread the incidence of human disease and contributes to the emergence of new diseases, which may have been endemic for ages but rarely infected human beings. One of the strongest aspects of human culture, religious beliefs, sometimes obstructs good medical practices designed to prevent the spread of diseases, or delay or even stop outright basic research against them.

Take, for example, human sex practices. Long after AIDS was identified and shown to be transmitted from human to human through intimate sexual contact, and long after rather simple and inexpensive "safe-sex" methods were demonstrated effective against the spread of HIV/AIDS, millions of people continue to have unprotected sex. Millions have died from AIDS, yet humans persist in having unsafe sex (unprotected by use of a condom, for instance; or through a sexual practice known to be more likely to spread the infection—through oral or anal sex, for example). Incredibly, countless persons known to be HIV infected and therefore carriers of AIDS continue to practice unsafe, unprotected sex. Some religious movements still oppose safe-sex education campaigns and condom distribution programs among teens.

Another example concerns the burial practices prevalent among Muslims, which has figured in the spread of Ebola in West Africa. The Liberian Red Cross notes that dead body management teams used to stop the spread of Ebola (the dead bodies remain highly contagious for some days after death) are very labor intensive, emotionally exhaustive, and require a lot of resources—hundreds of millions of dollars. There can be no funerals for the deceased, which goes contrary to religious traditions in the region. The bodies of the dead—all the dead since workers cannot determine the cause of death—are cremated in Liberia, Sierra Leone, and Guinea (*Time*, 2014: 20).

Experience with past pandemics of cholera, for example, has shown how cheap and rather simple hygiene practices can effectively prevent the contamination of water so crucial in the life cycle of a highly contagious and deadly disease like cholera. Yet despite the knowledge and ready availability of simple and cheap methods to prevent contamination or to decontaminate water supplies, cholera remains endemic in many Third World countries. Mankind continues to spread cholera around the world, generally from the Third World to locations in the First World, either as human carriers of cholera infection, or as ready transporters of contaminates from the Third World country

source to elsewhere. The seventh cholera pandemic (El Tor) was carried from Asia to Latin America in contaminated bilge or ballast water and foolishly dumped in coastal waters resulting in the spread of cholera in modern times to infect more than a million and cause the death of many thousands of needless victims (http://www.cbc.ca/health/story/2008/05/09/f-cholera-outbreaks.html).

Bubonic plague is spread by rodent fleas. Like cholera, we know that bubonic plague is endemic in the rodent populations in many parts of the world, which therefore remain a potential source for epidemic outbreaks. Yet we launch rodent eradication efforts only *after* pandemic episodes, rather than preemptively.

Since the turn of the 20th century, we have known that typhus is spread by human lice. Yet in the first decades of the 21st century, thousands if not millions of humans fail to use even the most basic of hygiene practices that would easily and cheaply kill lice. Although typhus epidemics are rare today, because mankind does employ prophylactic measures when typhoid fever cases emerge, if a mutation should occur in the typhus bacillus, the potential for a renewed epidemic of that age-old enemy is possible.

We know many contagious diseases are spread when humans congregate in close proximity and high density and bring together large numbers of persons from distant places of origin where their natural immunities are quite varied. Religious customs like the hajj, a mandatory religious duty for all Muslims to carry out at least once in a lifetime if they are physically and financially able, result in the world's largest annual gathering of the faithful that becomes a virtual hotbed of infectious diseases as pilgrims from all over the world trek around barefoot in the heat and share tight sleeping quarters (*Time*, 2014: 84–93).

The military of many nations of the world persist in essentially creating virgin populations in military camps. Not even the warning experience of modern history's most deadly-ever pandemic seems to have taught us the danger of that human

folly. The need to wage war and the military necessity of camps to train and assemble large numbers of troops seem to be more important than the potential to prevent another deadly pandemic. And so many medical scientists believe another such episode is likely, if not inevitable.

Religious beliefs hamper attempts to control the spread of HIV/AIDS. Venereal disease continues to be epidemic, particularly among teenagers, due in part to religious beliefs and movements which oppose public education efforts aimed at promoting safe-sex practices. They have undermined, and sometimes prevented outright, public funding of condom distribution. Religious beliefs influence public policy about basic genetic research and stem-cell research, which hold potential for breakthrough therapies for any number of diseases.

Medical science itself is susceptible to manipulation by humans who actively develop biological agents as weapons. We may have eradicated the smallpox virus "in nature," but we keep it in labs. Its potential for being adapted for bioterrorism is quite real. Only *human behavior* accounts for biological weapons, biological warfare, and biological terrorism (Henderson, 1999; Kahn, 2009). Germs and viruses mutate naturally, and humans, in a very real sense, are in constant warfare with them when those mutations result in the germ or virus becoming infectious human diseases, but the next pandemic on a scale akin to the great influenza of 1918–1919 may be the result of bioterrorism rather than from natural development (Alibeck, 1999; Cecchine and Moore, 2006; Henderson, 1999; Kahn, 2009).

The Special Threat of Bioterrorism

The year 2001 proved to be a wake-up year in the United States to the threat of bioterrorism (http://www.house.gov/science/full/dec05/henderson.htm; LeMay, 2006a; Walters, 2004; Oldstone, 1998; Ryan, 1997; Drexler, 2002; Karlen, 1995; Peters and Olshaker, 1997). The attacks of September 11, 2001, on the Twin Towers of the World Trade Center in

New York City and the Pentagon in Washington, D.C., followed closely by the anthrax bioterrorist attack on Congress via the U.S. Postal Service, issued that warning call. Prior to those events, the Department of Defense (DoD) had developed defenses against biological warfare focused primarily on the U.S. military itself, on the troops and U.S. military bases—mostly on those abroad. DoD plans had little to no focus on the general civilian population or on domestic terrorist attacks. International terrorism was seen as something that happened "over there," not at home. In response to 9/11 and the anthrax terrorist attacks, the federal government established the OPHP, housed within the HHS, and directed by Dr. D.A. Henderson.

Among the first acts of the new office was to release, by early December 2001, a list of microbial pathogens considered to be the most likely threats from biological terrorism aimed at the civilian population. The civilian population as the target of such agents required a different approach than did the defense of troops in combat situations. The former include people of all ages and health status. The means of delivery are likely to be different. The possibility that such attacks might be aimed simultaneously at numerous urban centers of population dictated the need for HHS and the Department of Homeland Security (DHS) to develop partnerships with state and local governments and their first responders (police, fire, local public health departments, and hospitals). Even if an attack is aimed at only one large urban area, it is considered highly likely that the disease outbreak would be of such a magnitude as to overwhelm the effective response capabilities of local medical and public health professionals. This required the federal government to provide protective and responsive measures for the affected populations. The OPHP has developed plans to deal with the effects of biological, chemical, and similar terrorist acts (http://www.house.gov/science/full/dec05/henderson.htm).

Of particular concern is the possibility that bioterrorists might combine more than one agent in an attack. That possibility is not far-fetched. In Africa, tuberculosis and HIV/AIDS

combine as health threats to the many hundreds of thousands of victims. Some biological agents have been categorized by the DoD as high-priority organisms because (1) they can be easily disseminated or transmitted person-to-person; (2) they cause high mortality; and (3) they have the potential for high morbidity—that is, the potential for a major public health impact that might cause widespread public panic (always a goal of terrorism) and social disruption. A bioengineered virus with the characteristics of smallpox and Ebola or Marburg hemorrhagic fever, for example, would be an awesome bioweapon. The OPHP lists six emerging pathogens that could form the basis of such a bioengineered agent because of their availability, their ease of production and dissemination, and their potential for high morbidity and mortality and major health impact.

In 1995, the HHS developed a Metropolitan Medical Response System (MMRS) through its Office of Emergency Preparedness (OEP). This system of contractual relationships with existing state and local response agencies is aimed at responding to natural disease outbreaks or serious health risks following natural disasters beyond the capacity of the local resources of emergency management, medical and health-care providers, public health departments, law enforcement, fire departments, EMS services, and units of the National Guard. The MMRS is designed to link all those resources with HHS teams to provide an integrated, unified response to a mass casualty event. By September 2001, the OEP had contractual links with 97 municipalities to develop MMRSs. After the attacks in September and November of 2001, that system was expanded to add 25 additional cities and to incorporate bioterrorism planning and response to the MMRS.

HHS uses the OEP to manage a National Disaster Medical System (NDMS) in partnership with the DoD, the Department of Veterans Affairs (VA), the Federal Emergency Management Administration (FEMA), and the PHS Commissioned Corps Readiness Force. Depending on the severity of a national disaster event (natural or human-made), the NDMS can be

activated to assist in an event by providing additional services to aid disaster victims. The NDMS is comprised of more than 7,000 volunteer health and support professionals capable of being deployed anywhere in the United States when called upon to respond to an event that overwhelms the local response team, many of whom are likely to have been incapacitated (Kahn, 2009).

In response to the events of 2001, the HHS created the OPHP. The OPHP and HHS works with the VA, one of the largest purchasers of pharmaceuticals and medical supplies in the world, which means the VA has enormous buying power. They set up a National Pharmaceutical Stockpile (NPS) of antibiotics, antidotes, vaccines, and medical material to respond rapidly to an event to prevent further spread of a disease resulting from a terrorist threat agent. The NPS supplemented the types of material in its stockpile specifically as a result of the September 11, 2001, events, so it is now an "all-hazards" supply. It has stockpiles of 600 tons and plans to enable accelerated production of vaccines and antibiotics for those areas most critical to responding to bioterrorism, including over $500 million allocated to speed the development and purchase of smallpox vaccine.

HHS and the CDC developed an Agency for Toxic Substances and Disease Registry (ATSDR) to identify and clean up contaminated facilities. It refined methods of environmental sampling to assess whether contamination, such as an anthrax event, had occurred, and developed recommendations to conduct environmental sampling and cleanup and to better protect first responders, investigators, and cleanup personnel. These were broadly disseminated to federal, state, and local health and environmental agencies and are posted on the CDC bioterrorism website.

The Need for an Early Warning System in a Complex, Interconnected World

The threat of bioterrorism indicates the danger of biological pathogens being intentionally disseminated—it increases the

need for an early warning system. Unless forewarned and pre-
pared to respond quickly to an attack, an event of that nature
could precipitate an *epidemic* episode, the intent of a bioter-
rorist. Depending on the nature of the agent in such an attack,
if not quickly and effectively responded to, it could start a
pandemic.

Likewise, the 2014 outbreak of Ebola in Africa demon-
strated the need for nations of the developed world—most
importantly, the United States—to help combat, control, and
contain those epidemics in situ, and before they spread more
widely to the rest of the world. Those epidemics reminded
us, as well, on the need to develop protocols to contain Ebola
when it inevitably spreads cases to the United States, as it did
late in 2014. We cannot prevent cases from migrating to the
United States, but we can contain them from becoming epi-
demics here.

The very extensiveness of current illegal immigration increases
the likelihood of a natural outbreak of disease from one of the
newly emerging viruses or the reemergent epidemic disease
strains that are today referred to as "superbugs" because of their
resistance to multiple vaccines and antibiotic therapies. His-
torical analysis amply demonstrates how difficult, if not impos-
sible, it is to deal effectively with the illegal immigration flow
(LeMay, 2015b). Illegal immigrants tend to travel from third-
world nations, where those strains of disease are still endemic
and from which the reemergent and newly emerging strains of
pathogens are most likely to arise, to First World populations
often all the more susceptible today as natural immunity has
been lost or dissipated. Today illegal immigrants travel with
speed. Where they locate to reside is no longer confined to
and concentrated within six or ten "gateway" states (Zuniga
and Henderson-Leon, 2005; Chavez, 1992; Hammamoto and
Torres, 1997; Kraut, 1994; Lynch and Simon, 2003). The dis-
persal of illegal immigrants in the United States is far wider
than ever before, nearly nationwide. Migration for permanent
resettlement—both legal and illegal—is widely dispersed among

First World countries. Those facts establish the need for an effective global early warning system.

In part a response to the problem, a major NGO effort was launched in 2008 by Google.org, a philanthropic arm of Google.com. It seeks to identify "hot spots" of emerging threats from infectious diseases and has established and funded a "predict and prevent" effort using information and technology to empower a global system of local communities to predict and prevent emerging threats.

The CDC established a system of epidemiology laboratories that collectively form a surveillance system. It established the Health Alert Network—a nationwide electronic communication system. It established teams of expert epidemiologists who could be sent to states and cities to help them respond quickly to infectious disease outbreaks and other public risks. The CDC has a staff of more than 100 specially trained antiterrorist experts in epidemiology, surveillance, secure communications, and laboratory diagnostics (Henderson, 1999: 5). It awarded more than $130 million in cooperative agreements to 50 states, one territory, and four major metropolitan health departments for preparedness planning and readiness assessment, epidemiology and surveillance, improved laboratory capacity for biological or chemical agents, and the above-mentioned Health Alert Network, in which the federal government funded at least one epidemiologist position in every state who was trained in the CDC's Epidemic Intelligence Service (EIS) program.

The CDC and HHS created the Agency for Toxic Substance and Disease Registry (ATSDR) after the anthrax terrorist incident in November 2001. The CDC, ATSDR, and the Occupational Safety and Health Administration (OSHA) have developed exposure limits for fumigants and detection methods to determine when any residual fumigant is below established limits. After buildings are cleaned and postcleaning environmental sampling conducted, the CDC and ATSDR provide technical input to the incident command and other experts to determine when a building is safe and ready for reentry.

The FDA has the Center for Biologics Evaluation Research (CBER). It provides regulatory guidance to the DoD, CDC, and others conducting studies to develop new vaccines and drugs and to screen new and unusual ideas for developing products to treat diseases and to develop new diagnostic tools. According to Henderson, biowarfare defense vaccines and drugs undergo the same FDA review process as any other vaccines or drugs (1999: 8).

Public health programs have come a long way. In the 1890s, their staffs often wore no protective gear, sometimes being dressed simply in smocks or coveralls that could be easily washed but provided no barrier against contamination. By 1918–1919, medical personnel were wearing gauze masks which had proven effective against the spread of some germs (contained in saliva, for example), but were unfortunately far too porous to be effective against the airborne mutated influenza virus (Farley, 2004). In the past, various international sanitary conferences proved the value of international cooperation, but because they were all voluntary they were often too ineffectual to deal with controlling a pandemic disease (Howard-Jones, 1975; Macleod and Lewis, 1988; Ostower, 1996; Weindling, 1995). Today, medical scientists studying or combating proven or suspected outbreaks of highly contagious and deadly diseases wear biohazard suits that effectively encase them in sealed atmospheres.

Establishing International Cooperation to Face a Global Threat

It is an unfortunate but undeniable truth evident in the recent outbreaks of epidemic diseases that have or could have become global pandemics that governments of some countries hid the fact that epidemic diseases raged in their territories. The ad hoc nature of arrangements to serve as sentinels or early warning systems resulted in gaps and sometimes failures to forewarn the world.

As we have seen above, after World War I the international community organized the League of Nations, which in turn established one of the first public or governmental systems for international cooperation to confront pandemic diseases (Borowy, 2009; Farley, 2004; Gill, 1996; Ostower, 1996; Weindling, 1995). Various governments and NGOs organized various international sanitary conferences to promote public health cooperation on an international scale (Howard-Jones, 1975). After World War II, the international community went further by establishing the United Nations, with its ancillary agencies of international cooperation regarding threats to world health: WHO, UNESCO, UNICEF, and the United Nations High Commission for Refugees (UNHCR). The UN works closely with international NGOs, like the International Red Cross. Collectively, these agencies and organizations form an *international* system for the purpose of early warning about epidemic threats and to fund international efforts to eradicate diseases, such as the worldwide campaigns to vaccinate children against smallpox, measles, whooping cough, polio, and so on.

This international system of cooperation helps various governments fund basic research to study newly emerging viral and bacteriological disease threats to the international community and to world health. "The WHO is now *the* organization that monitors the global threat of infections; and that initiates and coordinates responses to such a threat" (Ryan, 1997: 149, my italics). While that role is critically important, it must be noted that WHO operates no diagnostic laboratories of its own. It relies on the charity and interest of a global network of collaborating scientists and their laboratories funded by national governments. The experience of such a "voluntary approach" to international efforts between World War I and World War II demonstrates the difficulties of that approach (Borowy, 2009: Gill, 1996; Weindling, 1995).

Given the effects of push factors that underlie international migration and contribute to mass refugee movements,

which contribute to the threat of an epidemic disease outbreak becoming pandemic, the system of international cooperation continues to be vitally important. Massive legal and illegal immigration increase the threat of a pandemic. Since the threat is global, the response needs to be global. The eradication of smallpox demonstrated that collectively the world community could raise sufficient funds to mount a global eradication campaign. The success of the campaign demonstrated what such cooperation could accomplish (Etheridge, 1992: 188–210).

The system of over 100 laboratories around the world to monitor and study pandemic health threats is vitally important to preparedness. Only the cooperative work of this system of research facilities can sufficiently increase human knowledge about new pathogens about which we now have limited knowledge (Ryan, 1997; Wolfe, 2012; Zimmerman and Zimmerman, 1996). This system is vital to increased knowledge of how such pathogens might be artificially dispersed (i.e., to protect against international bioterrorism). Newly emerging pathogens, and the reemergence of more drug-resistant strains of old enemies, underscore the need for international cooperation. Only an international response can confront international terrorism and bioterrorism.

The CDC's work with and through the WHO in the smallpox and measles eradication projects demonstrates the effectiveness of "piggy-backing" one immunization effort with another. In most of Africa, measles is a greater threat than smallpox. On the African continent measles killed 10 percent or more of children before their fifth birthday. Great inroads toward eradication have been made by combining the efforts of the CDC, the WHO, the Agency for International Development (AID), and EIS epidemiologists. For a relatively small additional cost, measles was greatly curbed as smallpox was eradicated from West and Central Africa, as part of the global smallpox eradication program (Etheridge, 1992: 192–193).

Cooperating in the effort were then otherwise Cold War rivals (the United States and the former Soviet Union), who

contributed hundreds of millions of dollars and donated millions of doses of smallpox vaccine. The smallpox eradication campaign showed that the WHO surveillance system was *key* to success in eradicating smallpox.

By 1980, the WHO funded the first global EIS program, begun with the cooperation of the World Bank, the AID, the Food and Agriculture Organization, and various regional health groups. The CDC supplied epidemiologists who ultimately trained scientists in other countries to achieve self-sufficiency. EIS programs were established in Thailand, Indonesia, Mexico, Taiwan, and Saudi Arabia. Within five or six years, the CDC's epidemiologist was moved out of the country, and the program stood on its own. In the 1980s the CDC set up international efforts in various refugee camps (beginning in Kampuchea), and CDC teams identified the principal causes of death and severe illness among refugees in the camps and initiated appropriate treatments and preventive measures. The Kampuchea experience was followed by a similar undertaking in Somalia. Between 1980 and 1983, the CDC used the surveillance program to make humanitarian efforts effective and proved its value to the WHO and the UN's Refugee Relief programs (Etheridge, 1992: 286–287).

The measles immunization program was expensive, but it attracted the resources and commitment of several international organizations that made the effort possible: the World Bank, the Rockefeller Foundation, the United Nations Development Programme (UNDP), and the United Nations International Children's Emergency Fund (UNICEF). Collectively, they organized the Task Force on Child Survival. They attracted the commitment of Rotary International, persuaded by Dr. Albert Sabin, to provide any country in the world with the polio vaccine it needed for five years. Rotary International committed to raise $180 million to the effort, but in four years raised $240 million and provided the catalyst toward the global effort at polio eradication (Etheridge, 1992: 293–294; http://www.endpolio .org/stories/posts/rotary-celebrates-three-decades-of-polioplus).

Today, trachoma is being targeted by a similar type of program launched by Lions Clubs International (its Campaign Sight First II), the largest NGO and a partner with the UN's WHO. Lions International raised nearly $210 million, a substantial portion of which will be aimed at eradication of trachoma and to fund its "One-Shot" campaign to vaccinate millions of children in the Third World against measles.

The Need for Elaborate International and National Planning

Medical science has learned much about the complexity of the threat of pandemic disease. Epidemiologists have learned about the cycles of many diseases, and that pandemics are complex *social phenomena* as well as health crises. They learned that the complexity of epidemic outbreaks requires careful and comprehensive planning. Medical personnel, health professionals, fire and police first responders have to be trained in advance to cope with particular epidemics. Epidemiologists need to train doctors to recognize the outbreak quickly. Vaccines and appropriate antibiotic supplies need to be developed, stockpiled, and be ready for distribution. Planning is needed for efficient dissemination of those supplies. Only carefully planned campaigns have a chance at success in the face of the global threat from pandemic diseases.

The CDC responded to this need in several ways. It has prepared Smallpox Response Team guides that it provided to every Department of Health in every state of the union, and every embassy mission. Months of local planning in many of the states established detailed courses of action for the all-volunteer response teams. Teams were constituted, as their name implies, to react to the threat of a smallpox terrorist attack (after 9/11 and the anthrax incident in 2001). The detailed plans they developed could be applied to other epidemic disease outbreaks, whether from bioterrorism or from naturally emerging incidents (Bertolli and Forkioti, 2003: 7).

The success of the smallpox eradication campaign reveals what careful planning can accomplish. The CDC worked out a master plan and convinced and got the approval of a host of participating agencies before the program began. Governments had to approve the enormous funding. The U.S. Congress had to be convinced of the value of preventive measures—that sufficient American lives and American children would be saved by massive, global immunization of children in far-off Africa and Asia to justify allocation of US$300 million to the effort. A smallpox eradication team had to be assembled at the CDC in Atlanta. Millions of doses of smallpox vaccine had to be created, stored, and distributed, including convincing officials in the Soviet Union to join in the effort. At the time, the WHO reported 131,418 cases of smallpox, but the real figure of victims was more like 10 to 15 million cases. The WHO planned on vaccination of 80 percent of children in Western Nigeria, at the start of the campaign, anticipating that improved surveillance would finish the effort. Religious opposition had to be overcome (in the local language, the word for smallpox was the same as the name of the local earth god, and people were at first incensed that foreign doctors were coming to make war on their deity). But careful planning, and continuing development of the master plan as various parts were accomplished, resulted in global eradication.

The need for elaborate planning is certainly evident with respect to the threat of bioterrorism. In the United States the NIH's bioterrorism research program involves both short- and long-term research targeted at the development, evaluation, and approval of diagnostics, therapies, and vaccines needed to control infections caused by microbes with potential for use as biological weapons, focused primarily on the threats by anthrax and smallpox, but increasingly on other newly emerging pathogens as well. Careful collaboration with other federal agencies has been developed. New vaccines are being developed and tested. Through interagency agreements, the National Institute of Allergy and Infectious Diseases (NIAID),

which spearheads national planning efforts, collaborates with the DoD's U.S. Army Medical Research Institute of Infectious Diseases (AMRIID) to develop a new vaccine using recombinant protective antigen vaccine to protect all ages of the American public, including military personnel. The CDC, FDA, and DoD work with the NIH to refine standard serological tests on the effectiveness of anthrax vaccines.

National research has been substantially expanded since 2002, and NIAID has solicited from the scientific community research proposals on anthrax and other bacteriological pathogens to encourage research toward better diagnosis, prevention, and treatment. The molecular mechanisms involved in the germination of anthrax spores *in vivo* have been used to develop novel and promising postattack strategies that promise to be more effective than the widespread use of antimicrobial drugs which are not specific to anthrax and must be given to large groups of exposed individuals that may inadvertently promote the development of antibiotic-resistant strains of other bacteria. NIAID and the Office of Naval Research are working to sequence the DNA of the chromosomes of anthrax, partially funded by the Department of Energy. NIH anticipates information derived from the genome sequencing project to substantially aid in developing rapid diagnostic tests, as well as new vaccines and antibiotic therapies against mutant strains of anthrax.

NIAID research on smallpox emphasizes extending existing vaccine stock to increase the number of available doses, to develop new vaccines and treatments, and develop new diagnostic tools to detect smallpox quickly. NIAID, DoD, CDC, and the Department of Energy have funded and planned research to (1) develop and evaluate at least three antiviral drugs with preclinical activity against smallpox and acceptable clinical safety; (2) extend the usefulness of the currently available stockpile of doses of older vaccine by conducting human studies to see if they can stretch available stocks by diluting it; (3) help develop a safe, sterile smallpox vaccine grown in cell

cultures using modern technology; (4) explore the development of a vaccine that can be used in all segments of the civilian population; and (5) increase basic knowledge of the genome of smallpox and related viruses.

In 2002, NIAID began clinical trials to evaluate the effectiveness of different strengths of vaccines in order to expand the now limited supply of smallpox vaccine. NIAID and the DoD's Advanced Research Projects fund collaborative efforts with four academic centers and with the CDC, AMRIID, and the American Type Culture Collection that focus on designing and implementing an Orthopoxvirus Genomics and Bioinformatics Resource Center to conduct sequence and functional comparisons of genes to provide insights for the selection of targets for the design of antivirals and vaccines. As Henderson notes, this new center will design and maintain databases to store, display, annotate, and query genome sequences, structural information, phenotypic data, and bibliographic information and construct and maintain a website to facilitate the availability of such data for other researchers (1999: 10–13).

Controversies

There are a number of controversies associated with the problems discussed in the section above. Ten such controversies are identified here.

The Antivaccination Movement

Are vaccines safe? Can we compel compliance? It is ironic that after history has shown overwhelmingly the efficacy of vaccination against communicable diseases, that in the United States, particularly in states with an affluent population, a social movement has developed that spreads the idea that vaccinations are neither safe nor effective and are pushed by government to benefit "Big Pharma" rather than protect public health. Lacking any evidence to substantiate their claims, and relying

solely on rumor, proponents of the antivaccination movement have claimed vaccination causes autism. They have been sufficiently influential that in a number of states they have caused the immunity rate in the population against diseases such as measles to fall below the herd rate of 95 percent.

Primitive Health Care in Developing Countries

The primitive or poorly functioning status of health care in many developing nations leads to health-care providers becoming infected as a result. Improper use or even nonuse of boots, gowns, gloves, masks, goggles, sterilizing equipment, and surfaces spreads communicable diseases and hampers efforts to contain epidemics. A typical set of such clothing costs US$75 and must be disposed of after one use. A major associated public policy controversy is who should pay for or fund improvement in health care in developing nations, such as those in West Africa, coping with the Ebola outbreak. African and Asian nations, given their historical experiences with imperialism, are sometimes cautious, even skeptical, about receiving health care from the developed nations (Borowy, 2009).

Large-Scale Urbanization Spreads Disease

What should be done about the increasingly large-scale urbanization, which spreads disease faster than if outbreaks occur in remote, rural villages? On the one hand, industrialization and corresponding urbanization are necessary to improve the economies of impoverished nations. World population growth is greatest in developing nations, pushing urbanization. But urbanization means epidemics spread further and faster. And air travel from Third World countries to the First World countries departs from the airports located in the largest urbanized areas of the Third World. A similar controversy is how comprehensively should the United States reform immigration law to better control illegal immigration and thereby lessen the threat of an epidemic

spreading to the United States from rural areas in Central and South America and through its southern border with Mexico?

Extreme Poverty in the Developing World

How can we resolve the extreme poverty of so much of the developing world? The developed nations support a degree of development through such international agencies as the World Bank and the International Monetary Fund. But funding for such agencies of international cooperation for development is nearly always politically controversial in the very nations who can most afford to assist such development. A case in point is illustrated by the UN's efforts to combat the Ebola epidemic in West Africa. The WHO, the public health arm of the UN, has 194 member governments which haven't raised their voluntary contributions to the UN and specifically to the WHO in decades. The WHO's campaign to contain the Ebola outbreak was severely underfunded.

Returning Health-Care Workers

Returning health-care workers and reporters from infected areas can bring infections to their nations of origin. Fear of the spread of an epidemic like Ebola results in significant political support for a ban on international travel from infected areas.

The Need for Clinical Trial Speedups

There are well-established scientific procedures for experimental treatments and vaccine. Epidemic outbreaks of deadly contagious diseases raise political support for the speeding up of the clinical trial processes for experimental treatments and vaccines and for using such procedures and vaccines before they can be scientifically proven to be safe and effective. The time needed for pharmaceutical firms to develop vaccines is greater than what becomes politically tolerable when the world is facing a pandemic or potential pandemic outbreak of a truly frightening and highly deadly contagion such as Ebola.

The Demand for Protective Clothing

Another controversy is the demand for protective clothing versus its cost and who will pay for it? When an epidemic outbreak occurs, it takes time to collect supplies even when donated by developed countries such as the United States, Great Britain, France, Germany, and so on. And often there are severe obstacles to the efficient distribution of those supplies once they do reach the infected region. Likewise, there are not enough resources in the school systems of infected regions to vaccinate everyone with an annual flu shot specific to the H1N1 strain. The 2009 pandemic is a virtual case study for the value of preparedness.

Economic Impacts of Pandemics

The devastating economic impact on the economies of infected countries often borders on bankrupting a developing country, such as those in West Africa impacted by the Ebola outbreak, the cost of which is estimated at US$3.8 billion to US$32.6 billion. Such an economic disaster can set back by decades the development of those countries. A severe outbreak in a developing nation can effectively destroy its health care system, and the development of its education system.

The Need for Pandemic Preparedness

Another controversy concerns the need for a pandemic preparedness plan for developing nations like India, Pakistan, China, and North Korea. Those nations, at best struggling democracies and at worst ruled by totalitarian regimes, are most likely to fail to plan for a pandemic, and to evade the blame for health threats emerging within them. Those nations are the ones wherein conditions are most likely for the emergence of the new hot viral diseases most at threat to become pandemics. China's keeping its deadly secret about the SARS outbreak (it imposed a news blackout to prevent media coverage which cut down on the huge sums that the Chinese spend on food

and travel during holiday festivals) exemplifies the problem and the resulting threat to the international community.

How Strong Should the Powers of the WHO Be?

Do we need a "world government" for medicine policy making? Instead of a voluntary system of governments contributing to fund the WHO, or to donate relief when an outbreak occurs, should an international body like the UN be given mandatory policy-making powers? Should the agency fund and maintain a permanent corps of medical scientists and caregivers trained to cope with epidemic outbreaks? Should they develop and maintain a permanent stockpile of medicine, vaccines, and the medical care supplies need to cope with an epidemic outbreak that has the potential to become pandemic?

Solutions

There are a similar number of proposed solutions to the problems, or resolutions to the controversies discussed above. The major issue or question concerning these solutions is whether or not there is the political will and support to achieve them.

1. International government-sponsored "virus hunters," so the science of epidemiology can be proactive and preventative rather than reactive and containing or curative.

2. Developing gene-specific therapies to attack and "cure" a disease when an outbreak occurs. Since the threat is global and the resources necessary to fund such research is well beyond the capacity of any single nation, a method to fund an international research effort would need to be developed, approved, and implemented.

3. Global education and awareness to change cultural, language, and denial barriers. Parent-to-parent peer pressure and persuasion is needed to counter social and cultural

barriers such as the antivaccination movement. Inoculation levels must be at or greater than the 95 percent of the population level needed to assure "herd immunity."

4. Developing more effective screening devices for international travelers.

5. Developing faster and more effective testing devices.

6. Developing more effective surveillance and contact tracking systems when an outbreak occurs.

7. Greater access to laboratory services (expand the current, largely voluntary system).

8. Develop and fund a WHO-based permanent stockpile of critical supplies to cope with a multinational outbreak (portable hospital facilities; facilities to safely cope with the disposal of infected bodies, etc.)

9. Develop a WHO-based permanent corps of medical caregivers specifically trained to deal with pandemic diseases to replace the now voluntary ad hoc system of Doctors Without Borders.

10. Develop a global system of hospitals that are specialized to treat epidemic disease-infected caregivers when they return from working in an outbreak country or region.

Conclusion

Unless lessons are learned from past battles with pandemic diseases, history will repeat itself. While future epidemics involving newly emerging pathogens or the mutated strain of an older, reemergent biological enemy may be inevitable, the pandemic spread of the disease need not be so. The problems, controversies, and possible solutions discussed here may enable planning for procedures, treatments, and antibiological therapies that can substantially mitigate or contain a new epidemic. While a new epidemic may be inevitable, its development into a global pandemic on the scale of the influenza pandemic of

1918–1919 may be avoidable. The threat of a future pandemic of that scale is serious and pressing. Given today's far greater global population, and given the evidence that human disease pathogens are developing that are increasingly drug-resistant to known antibacterial therapies, the experiences of coping with past pandemics must be applied if we are to avoid a death rate in excess of 50 million lives lost. To effectively combat that threat, public health policy makers must increasingly think locally, but act globally (Drexler, 2002: 275–277).

Our increasingly complex society means that humankind and pathogens will cross paths more often. The emerging threat, be it a pandemic flu, inhalational anthrax, food-borne illness, or insect-borne disease, requires keen surveillance and well-planned, rapid response. It necessitates a global web of health-care workers, bacteriological laboratories, and an elaborate communication system that can identify an aberrant infection or novel disease quickly and at virtually any place around the globe. Public health policy and programs have been proven to be effective prevention against epidemics and pandemics. Public health, in essence, is a rational, step-by-step process involving the application of the lessons learned in all previous outbreak investigations. It defines a problem, recognizes its true nature, finds out what causes or spreads it, and develops plans and programs to control or prevent it. Its *global* focus is increasingly necessary.

Doctors and nurses around the world must be trained in the practical aspects of public health and be welcomed into an international network of health care colleagues. Independent laboratories and timely electronic reporting systems must operate free of government interference. Meanwhile, researchers must keep tabs on conditions such as altered habitats or large population movements that give rise to emerging infections. How close are we to approaching such a system, a kind of global Epidemic

Intelligence Service akin to the CDC's elite corps of disease detectives? According to one U.S. government estimate, at least ten years away. (Drexler, 2002: 277)

The medical pioneers of the late 19th century enabled great strides to be made against pandemic diseases during the 20th century. Now in the opening decades of the 21st century, medical scientists and public health planners need to play a role as did those of more than a century ago. Perhaps the experience of past pandemics will enable policy makers to avoid some of the unanticipated consequences of policy. Hopefully, past experience will teach humankind to modify the customs of human behavior that contribute to the spread of pandemic disease. The experience of policy makers in the past will better inform current public policy to cope with pandemic disease during this renewed age of mass migration.

References

Alibeck, Ken and S. Handelmann. 1999. *Biohazard*. On-Line: Delta Press.

Barry, John. 2005. *The Great Influenza: The Epic Story of the Deadliest Plague in History*. New York: Penguin Books.

Bazin, Herve. 2000. *The Eradication of Smallpox: Edward Jenner and the First and Only Eradication of a Human Infectious Disease*. Waltham, MA: Academic Press.

Bertolli, E. Robert and Constantine Forkiotis. 2003. "Smallpox: Response Team Review." *The Forensic Examiner* 12(November/December): 7–12.

Borowy, Iris, ed. 2009. *Uneasy Encounters: The Politics of Health and Medicine in China, 1900–1939*. Frankfurt am Main: Peter Lang Publishers.

Caller, Anastasia. 2015. *A Possible Pandemic: Swine Influenza Encyclopedia*. On-line: Create Space.

Cecchine, Gary and Melinda Moore. 2006. *Infectious Disease and National Security: Strategic Information Needs*. Santa Monica, CA: Rand Corporation.

Chavez, Leo R. 1992. *Shadowed Lives: Undocumented Immigrants in American Society*. New York: Harcourt Brace Jovanovich.

Davies, Peter. 2000. *The Devil's Flu*. New York: Henry Holt and Company.

Doherty, Peter. 2013. *Pandemics: What Everyone Needs to Know*. New York: Oxford University Press.

Drexler, Madeline. 2002. *Secret Agents: The Menace of Emerging Infections*. New York: Penguin Books.

Ellisson, D. Hank. 2007. *Handbook of Chemical and Biological Warfare Agents*. On-line: CRC Press.

Etheridge, Elizabeth. 1992. *Sentinels for Health: A History of the Centers for Disease Control*. Berkeley: University of California Press.

Farley, John. 2004. *To Cast Out Disease: A History of the International Health Division of the Rockefeller Foundation, 1913–1951*. Oxford: Oxford University Press.

Fettner, Ann G. 1990. *The Science of Viruses*. New York: William Morrow.

Getz, David. 2000. *Purple Death: The Mysterious Flu of 1918*. New York: Henry Holt.

Gill, George. 1996. *The League of Nations: From 1929 to 1946*. Garden City Park, NY: Avery.

Hammamoto, Darrell and Rodolfo Torres, eds. 1997. *New American Destinies: A Reader in Contemporary Asian and Latin American Immigration*. New York: Routledge.

Henderson, D. A. 1999. "The Science of Bio-terrorism." *Science* 282(5406): 1279–1282.

Howard-Jones, Norman. 1975. *The Scientific Background of International Sanitary Conferences, 1851–1938.* Geneva: The World Health Organization.

Kahn, Laura H. 2009. *Who's in Charge: Leadership during Epidemics, Bioterror Attacks, and Other Public Health Crises.* Westport, CT: Praeger Security International.

Karlen, Anna. 1995. *Man and Microbes: Diseases and Plagues in History and Modern Times.* New York: Touchstone Books.

Kolata, Gina. 1999. *Flu: The Story of the Great Influenza Pandemic of 1918 and the Search for the Virus That Caused It.* New York: Touchstone Books.

Koplow, David. A. 2002. *Smallpox: The Fight to Eradicate a Global Scourge.* Berkeley: University of California Press.

Kraus, Elisha. 2003. "Building a Bigger Bureaucracy." *The Public Manager* 32(1): 57–58.

Kraut, Alan. 1994. *Silent Travelers: Germs, Genes, and the 'Immigrant Menace.* Baltimore: The Johns Hopkins University Press.

LeMay, Michael. 2006a. *Guarding the Gates: Immigration and National Security.* Westport, CT: Praeger Security International.

LeMay, Michael. 2006b. *Public Administration, 2e.* Belmont, CA: Wadsworth.

LeMay, Michael. 2015a. *Doctors at the Borders: Immigration and the Rise of Public Health.* Westport, CT: Praeger Press.

LeMay, Michael. 2015b. *Illegal Immigration: A Reference Handbook, 2e.* Santa Barbara, CA: ABC-CLIO.

Lynch, James P. and Rita Simon. 2003. *Immigration the World Over: Statuses, Policies, and Practices.* Lanham, MD: Rowman and Littlefield.

Macleod, Roy and Milton Lewis, eds. 1988. *Disease, Medicine and Empire: Perspectives on Western Medicine and the Experience of Western Expansion*. London: Routledge.

McNeill, William. 1989. *Plagues and People*. New York: Anchor Books.

Mitchell, Kenneth. 2003. "The Other Homeland Security Threat: Bureaucratic Haggling." *The Public Manager* 32(1): 15–18.

Mullan, Fitzhugh. 1989. *Plagues and Politics: The Story of the United States Public Health Service*. New York: Basic Books.

Neustadt, Richard and Harvey Finbery. 1983. *The Epidemic That Never Was: Policymaking and the Swine Flu Scare*. New York: Vintage Books.

Newton, David. 2013. *Vaccination Controversies: A Reference Handbook*. Santa Barbara, CA: ABC-CLIO.

Oldstone, Michael B. 1998. *Viruses, Plagues and History*. New York: Oxford University Press.

Ostower, Gary B. 1996. *The League of Nations: From 1919 to 1929*. Garden City Park, NY: Avery.

Peters, C. J. and Mark Olshaker. 1997. *Virus Hunters: Thirty Years of Battling Hot Viruses around the World*. New York: Anchor Books/Doubleday.

Porta, Miguel. 2008. *Dictionary of Epidemiology*. Oxford: Oxford University Press.

Porter, Roy. 1999. *The Greatest Benefit to Mankind: A Medical History of Humanity*. New York: Harper Collins.

Preston, Richard. 1994. *The Hot Zone*. New York: Anchor Books.

Preston, Richard. 1997. *The Cobra Event*. New York: Ballantine Books.

Ryan, Frank. 1997. *Virus X: Tracking the New Killer Plagues.* Boston: Little Brown.

Silverstein, Arthur M. 1981. *Pure Politics and Impure Science: The Swine Flu Affair.* Baltimore: The Johns Hopkins University Press.

Time. 2014. *The Science of Epidemics: Inside the Fight against Deadly Diseases from Ebola to AIDS.* New York: Time, Inc.

Walters, Mark Jerome. 2004. *Six Modern Plagues and How We Are Causing Them.* Washington, DC: Island Press.

Weber, Gustavis A. 1928. *The Food, Drug, and Insecticide Administration.* Baltimore: The Johns Hopkins University Press.

Weindling, Paul, ed. 1995. *International Health Organizations and Movements.* Cambridge: Cambridge University Press.

Weindling, Paul. 2000. *Epidemics and Genocide in Eastern Europe.* Oxford: Oxford University Press.

Wolfe, Nathan. 2012. *The Viral Storm: The Dawn of a New Pandemic Age.* New York: St. Martin's Press.

Zimmerman, Barry and David Zimmerman. 1996. *Killer Germs.* Chicago: Contemporary Books.

Zuniga, Victor and Ruben Henderson-Leon, eds. 2005. *New Destinies: Mexican Immigration to the United States.* New York: Russell Sage.

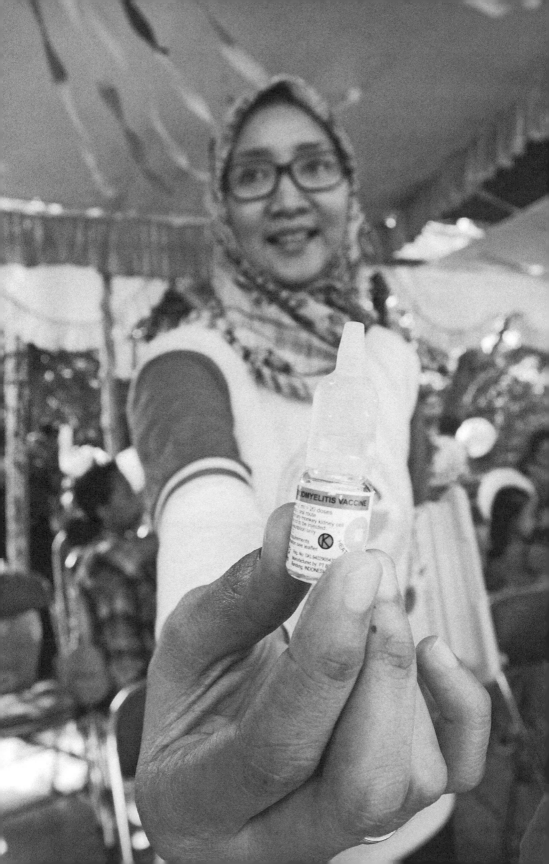

Introduction

This chapter presents eight original essays on the topic of global pandemic threats from a variety of viewpoints and professional affiliations and backgrounds providing expertise on the subject matter. It gives voice to activists on the need for additional legislation or policy and programs that address the problem of a looming global threat of pandemic outbreaks of various infectious diseases and by authors from various disciplinary perspectives. It provides readers with viewpoints beyond and different from the expertise of the author.

Perspectives on HIV/AIDS Pandemic in the United States, South Africa, and Sri Lanka
Liesl Nydegger

Introduction: HIV Basics

HIV infects CD4 or T-cells associated with the immune system by impairing or destroying their function. Consequently, people who are HIV-positive are more susceptible to developing infections because of an impaired immune system. If a

Medics prepare to administer polio vaccinations at a health clinic in the city of Solo, Central Java, Indonesia. The polio vaccine is highly effective in preventing polio, but is often not readily available in the developing world. (Suryo/Dreamstime.com)

person's CD4 cell count falls below 200/mm^3 of blood or they develop at least one opportunistic infection, then they are diagnosed with acquired immune deficiency syndrome (AIDS), the final stage of HIV (CDC, 2014). HIV is transmitted through blood, semen (including pre-seminal fluid), rectal fluid, vaginal fluid, and breast milk from someone who is HIV-positive. This means HIV can be transmitted via (a) sex (anal sex is the highest risk followed by vaginal sex and then oral sex), (b) sharing syringes and injection equipment, (c) from a mother to her baby during pregnancy, while giving birth, or breastfeeding, (d) blood transfusions, and (e) contact with an open wound. Risky behaviors that increase one's risk for contracting HIV are unprotected sex (CDC, 2015a), sharing syringes and injection equipment (CDC, 2015a), having multiple sex partners (CDC, 2015b), exchanging sex (CDC, 2015c), and substance use, which can lower inhibitions and lead to risky behaviors (CDC, 2015a).

Comparison of HIV among Three Countries

United States. In the United States, over 1.2 million people are living with HIV/AIDS with approximately 50,000 new infections occurring annually. Of people living with HIV/AIDS approximately 12.8 percent are unaware of their infection. While less than 1 percent of the population has contracted HIV, certain groups are disproportionately affected by HIV: men who have sex with men (MSM), injection drug users (IDUs), and blacks/African Americans (CDC, 2015d).

South Africa. In 2014, South Africa had approximately 6.8 million people living with HIV/AIDS, accounting for 19 percent of people 15 to 49 years old (UNAIDS, 2014a). HIV is predominately transmitted via heterosexual sex followed by mother-to-child transmission. The main risk behaviors contributing to the HIV epidemic are intergenerational sex, concurrent sex partners, low condom use, substance use, and low rates of male circumcision (Republic of South Africa, 2012).

Sri Lanka. Sri Lanka has approximately 3,300 HIV infections nationwide (<0.1 percent of the population; UNAIDS, 2014b) with approximately 200 new infections in 2013, which is a dramatic increase in less than 10 years (National STD/AIDS Control Programme, 2013). A majority of HIV transmission is heterosexual (78%), followed by MSM (16%), perinatal (5%), and IDU (1%). Sex workers play a large role in the transmission of HIV, partly because sex workers can get arrested for having condoms in their possession (National STD/AIDS Control Programme, 2013).

Comparison of HIV Prevention Efforts and Focus

United States. The United States' prevention efforts have focused on testing, preexposure prophylaxis (PrEP), and treatment as prevention. While the Affordable Care Act has increased access to free HIV testing, new technology has improved testing sensitivity so that HIV can be detected during the acute phase of infection, when HIV is most transmittable (Office of National AIDS Policy, 2015). PrEP uses highly tolerable antiretroviral medications to prevent HIV in people who are HIV-negative (Baggaley et al., 2015). In order to be as effective as possible, PrEP requires high levels of adherence (Daskalakis, 2014). PrEP is recommended for high-risk individuals, such as anyone in a relationship where one partner is HIV-positive and the other is HIV-negative, anyone who is not in a mutually monogamous relationship, MSM, heterosexual men or women who have frequent unprotected sex with partners of unknown HIV status, and IDUs (CDC, 2015e). It is recommended that anyone who is HIV-positive receive antiretroviral therapy (ART) immediately for their own health, and to decrease the amount of HIV in their body so they do not transmit HIV as easily (Office of National AIDS Policy, 2015). ART is effective when HIV infection is caught early and people engage in regular HIV care and adhere to ART (i.e., HIV treatment cascade) (Gardner et al., 2011).

South Africa. Current interventions focus on gender inequality, intergenerational sex (older men having sex with younger women/girls), poverty, substance abuse, gender-based violence, and sexual risk (Wechsberg and Myers, 2014; Fladseth et al., 2015). While some research supports that intergenerational sex is a key driver in the HIV epidemic, recent findings support that this is not the case. Rather, the younger generation, both males and females, are driving the HIV epidemic in South Africa (Balkus et al., 2015). Additionally, several PrEP trials in South Africa have been conducted, but adherence was very low (Murnane et al., 2013; Abdool Karim et al., 2010).

Sri Lanka. In 2013, Sri Lanka focused on the elimination of mother-to-child HIV transmission. The goal was to test pregnant women, and provide ART during and after pregnancy for anyone who tested HIV-positive. Infants would also receive ART, and formula feeding would be recommended. Another prevention effort was a life skills program developed for prisoners; officers and medical staff were trained in sexual health promotion. The officers and medical staff would select peers among the prisoners who would be trained and pass the information along to their fellow inmates. Another program for police offers aimed to improve officers' knowledge and attitudes regarding HIV prevention, promote positive attitudes about condom use, and encourage harassment-free enforcement for sex workers (National STD/AIDS Control Programme, 2013).

Where Do We Go from Here?

The HIV epidemic does not occur in isolation; there are numerous syndemic, structural, and personal factors that contribute to HIV. Presently, there is a push toward biomedical interventions such as PrEP in the United States and South Africa. In order to be as effective as possible, PrEP requires high levels of adherence (Daskalakis, 2014). However, adherence has been a major hindrance in research studies of PrEP, particularly in Africa, which has the greatest burden of HIV (Murnane et al., 2013; Abdool Karim et al., 2010). Future studies must address

PrEP adherence among men and women to decrease HIV incidence rates. Issues including delivery methods (e.g., injections) and education of PrEP for both people at risk and providers must be addressed. Future research should view PrEP as part of the solution. The structural and syndemic factors that contribute to HIV in every country must be understood in order to develop effective interventions.

While treatment as prevention may be an appropriate strategy in a resource-rich country such as the United States, it would be unsuccessful in countries such as South Africa and Sri Lanka where there are fewer resources for individuals with HIV. South Africa has the extra burden of needing to address both HIV prevention and treatment simultaneously due to the high incidence and prevalence rates. Sri Lanka is in a unique situation where HIV is not as large of a problem as other nearby countries. Thus, this creates the perfect opportunity to make HIV prevention a top priority and curb any increases in incidence and prevalence rates. In conclusion, HIV will remain a serious problem all over the world until we stop focusing on these factors in isolation and identify the complex nature of this epidemic.

References

Abdool Karim, Q., S. S. Abdool Karim, J. A. Frohlich, A. C. Grobler, C. Baxter, L. E. Mansoor, A. B. Kharsany, et al. 2010. "Effectiveness and Safety of Tenofovir Gel, An Antiretroviral Microbicide, for the Prevention of HIV Infection in Women." *Science* 329 (5996): 1168–1174. doi:10.1126/science.1193748.

Baggaley, R., M. Doherty, A. Ball, N. Ford, and G. Hirnschall. 2015. "The Strategic Use of Antiretrovirals to Prevent HIV Infection: A Converging Agenda." *Clinical Infectious Diseases* 60 (Suppl. 3): S159–S160. doi:10.1093/cid/civ091.

Balkus, J. E., G. Nair, E. T. Montgomery, A. Mishra, T. Palanee-Phillips, G. Ramjee, R. Panchia, et al. 2015.

"Age-disparate Partnerships and Risk of HIV-1 Acquisition among South African Women Participating in the VOICE Trial." *Journal of Acquired Immune Deficiency Syndromes* 70 (2): 212–217.

Centers for Disease Control and Prevention. 2014. About HIV/AIDS. http://www.cdc.gov/hiv/basics/whatishiv.html. Accessed January 8, 2014.

Centers for Disease Control and Prevention. 2015a. HIV/ AIDS: HIV Risk Behaviors. http://www.cdc.gov/hiv/ riskbehaviors/index.html. Accessed October 2, 2015.

Centers for Disease Control and Prevention. 2015b. HIV Basics: HIV Transmission. http://www.cdc.gov/hiv/basics/ transmission.html. Accessed October 2, 2015.

Centers for Disease Control and Prevention. 2015c. HIV/ AIDS: HIV Risk among Adult Sex Workers in the United States. http://www.cdc.gov/hiv/group/sexworkers.html. Accessed October 2, 2015.

Centers for Disease Control and Prevention. 2015d. HIV in the United States: At a Glance. http://www.cdc.gov/hiv/ statistics/basics/ataglance.html. Accessed August 26, 2015.

Centers for Disease Control and Prevention. 2015e. HIV Basics: PrEP. http://www.cdc.gov/hiv/basics/prep.html. Accessed August 21, 2015.

Daskalakis, D. C. 2014. "HIV Preexposure Prophylaxis in the Real World." *Topics in Antiviral Medicine* 22 (4): 670–675.

Fladseth, K., M. Gafos, M. L. Newell, and N. McGrath. 2015. "The Impact of Gender Norms on Condom Use among HIV-positive Adults in KwaZulu-Natal, South Africa." *PLoS One* 10 (4): e0122671. doi:10.1371/ journal.pone.0122671.

Gardner, E. M., M. P. McLees, J. F. Steiner, C. Del Rio, and W. J. Burman. 2011. "The Spectrum of Engagement in HIV Care and Its Relevance to Test-and-Treat Strategies

for Prevention of HIV Infection." *Clinical Infectious Diseases* 52 (6): 793–800. doi:10.1093/cid/ciq243.

Murnane, P. M., C. Celum, M. U. G. O. Nelly, J. D. Campbell, D. Donnell, E. Bukusi, A. Mujugira, et al. 2013. "Efficacy of Pre-exposure Prophylaxis for HIV-1 Prevention among High Risk Heterosexuals: Subgroup Analyses from the Partners PrEP Study." *AIDS* 27 (13): 2155–2160. doi:10.1097/QAD.0b013e3283629037.

National STD/AIDS Control Programme Ministry of Health Sri Lanka. 2013. *Annual Report 2013*. Sri Lanka. http://www.unaids.org/sites/default/files/country/documents/LKA_narrative_report_2015.pdf. Accessed October 2, 2015.

Office of National AIDS Policy. 2015. *National HIV/AIDS Strategy for the United States: Updated to 2020*. www.aids.gov/federal-resources/national-hiv-aids-strategy/nhas-update.pdf. Accessed October 2, 2015.

Republic of South Africa. 2012. *Global AIDS Response Progress Report*. South Africa. http://www.unaids.org/sites/default/files/country/documents//ce_ZA_Narrative_Report.pdf. Accessed October 2, 2015.

United Nations Programme on HIV/AIDS (UNAIDS). 2014a. South Africa: HIV and AIDS Estimates. http://www.unaids.org/en/regionscountries/countries/southafrica/. Accessed October 2, 2015.

United Nations Programme on HIV/AIDS (UNAIDS). 2014b. Sri Lanka: HIV and AIDS Estimates. http://www.unaids.org/en/regionscountries/countries/srilanka/#. Accessed October 2, 2015.

Wechsberg, W. M. and B. Myers. 2014. *Advancing HIV Prevention in South Africa: The CoOp Intervention Studies*. Triangle Park, NC. https://www.rti.org/pubs/adhivprevsouthafrica_8_12_14_final.pdf. Accessed October 2, 2015.

Liesl Nydegger earned her Ph.D. in Health Promotion Sciences with a concentration in Global Health, and her Master's in Public Health in Health Promotion, Education, and Evaluation from Claremont Graduate University, School of Community and Global Health. Dr. Nydegger was awarded a Fulbright-Fogarty Fellowship in 2012–2013 that took place in South Africa. In 2015, Dr. Nydegger was awarded a two-year Ruth L. Kirschstein Institutional National Research Service Award Postdoctoral Research Fellowship at the Center for AIDS Intervention Research at the Medical College of Wisconsin. Dr. Nydegger's research interests include HIV prevention among survivors of violence, people who use drugs, and international populations.

"Quick Response" Deployment Assists Ebola Crisis Humanitarian Mission
As told to the author by Staff Sergeant Jose Marquez and Specialist Rion McWilliams, U.S. Army

We were privileged to be an integral part of the 615th Engineer Company, 52 Engineer Battalion's "Operation United Assistance," which was deployed to Liberia, West Africa, to assist in support of the joint operation of the United Nations and the United States Agency for International Development (UASID) to confront and contain the Ebola pandemic outbreak in West Africa. More than 150 soldiers from the 615th Engineer Company from Fort Carson, Colorado, deployed to West Africa. From initial training, to the field effort in Liberia, to the period of controlled monitoring upon return to the United States, the mission ran from October 15, 2014, until February 18, 2015. Whereas a typical deployment abroad requires a six-month-long preparation, the "quick response" deployment in this case was conducted in about six weeks.

Operation United Assistance was a total army humanitarian effort that included units from the U.S. Africa Command, Active Army, Army Reserve, and Army National Guard, as well as units from other branches of the military services, including

the Marines, Navy, and Air Force, all in conjunction with the U.S. Army Public Health Command that utilized special personnel to mount the humanitarian mission to West Africa (Liberia, Guinea, and Sierra Leone). The specific mission of the 615th Engineer Company was to help construct facilities to support the effort to contain the spread of the Ebola virus in Africa, not to provide treatment to Ebola patients.

The Ebola pandemic that struck West Africa was most widespread in Liberia, Sierra Leone, and Guinea. Liberia suffered 10,675 cases with more than 4,800 deaths, and was not considered contained by the United Nations' World Health Organization (WHO) until December 14, 2015. Sierra Leone suffered more than 14,100 cases and nearly 4,000 deaths. Its outbreak was considered ended on November 7, 2015. Guinea reported 3,805 cases and 2,536 deaths before its outbreak was considered ended on December 16, 2015. Elsewhere, Nigeria reported 20 cases and eight deaths before its outbreak ended in mid-October 2014, and Mali had eight cases and six deaths in its outbreak that ended mid-January 2015. Worldwide, the Ebola pandemic reported more than 28,600 cases and 11,315 deaths as of mid-December 2015.

Our training began at Fort Carson, Colorado motor pool on October 15, 2014. It focused on personal protective equipment in preparation for deployment to West Africa. All troops deploying to Liberia received specific medical training, and how to utilize personal protective equipment (including the use of DeCon suits) to ensure they were protected from exposure to Ebola, and on the protection, prevention, detection, and treatment of the Ebola virus. All of Fort Carson pretty much stopped other work in order to get the unit off to West Africa. Operation United Assistance was literally given first priority. All nonessential training was stopped until we got off. In a normal deployment, the effort starts small and builds up gradually over several months. In the quick response approach, the humanitarian effort started large and was pulled back as was dictated by conditions on the ground. We went to classes before

we deployed and everybody at Fort Carson played a big part in managing the deployment. It was rough, however, and we sometimes worked until 4:00 a.m.

Before deploying our first units on November 13, 2014, we spent long nights and weekends in the Fort Carson Town Hall in meetings to help prepare our soldiers and their families for the "Quick Response Deployment," which was something new at Fort Carson. Captain Horton led the advance party about a week before we left and landed in Liberia on November 14, 2014. Liberia was devastated by some years of civil war and by the impact of the Ebola epidemic on the country's infrastructure. Even before the outbreak there were only 50 physicians in the entire country—one for every 70,000 Liberians. By September, some of its hospitals were abandoned. Its schools and its medical care system were strained to the point of complete breakdown. By mid-October 2014, Ebola cases were reported in all of the 15 Liberian districts. The country was literally close to collapse. There was very little organization done before our arrival, and we initially slept at the police academy in Monrovia (the capital city of Liberia). Conditions for the first few weeks were challenging to say the least. It was some time before concertina wire was delivered and deployed to control access to our work areas. There was none to very limited air-conditioning to cope with the excessive heat and humidity conditions that few of our soldiers had ever experienced. We were soon joined by a second group, from Fort Lewis and Fort Hood, the 36th Engineer Company. In addition to sleeping in the Old Barracks, Center City Monrovia, two units were located at Port Buchanan, Liberia, and the Ebola Treatment Unit at Cedar Crest, Liberia.

Much of our work consisted of constructing hard billets for the UN, in areas designated Red Zone and Green Zone. We did ground work, built laundry facilities for the staff, laid in a drainage system, and worked with the Liberian army. We only used about one-third of the equipment sent, going back and forth to the Port to bring the equipment we eventually needed.

In a quick response approach to deployment, we packed and sent more than we were likely to use because we tried to prepare for any eventuality with which we might be confronted. We cleared access roads and reconstructed roads (otherwise severely damaged during the rainy season) in Buchanan. The third platoon did road construction, repair, and the installation of a much-needed irrigation system. We also constructed staging areas.

For our own safety and to ensure we were not infected, our temperature was checked twice per day, and we all took malaria medicine daily. We frequently used hand sanitizers and regularly wore two sets of gloves and sometimes wore DeCon suits (aka hazmat suits). The Liberian government established a curfew, and we moved our equipment around at night. We drank tons of water we imported, put up portable tents and showers. We continued to train frequently, and we had to prepare all our equipment for pick up and go. We were in-country weeks before we received any soda to drink, or had videos to watch. We could not eat any local food—everything we consumed was army-supplied.

We were well-received by the local population, however, as they recognized they were safer and they felt safer with our arrival. The Liberian government had songs composed to make people aware of the epidemic, how to recognize Ebola symptoms, and when and where there were free medical units available. Everyone had and used transistor radios for that purpose.

After completing our construction mission, by January 3, 2015, we began returning to the United States. The first wave of 100 soldiers from the 615th Engineer Company, 4th Engineer Battalion returned to the states after two months in Liberia.

We had to pack up all the vehicles, and had to wash everything down three times before loading the equipment on boats for the return. No one else could touch the equipment we used.

The first wave of approximately 100 soldiers arrived on January 4, 2015, at a controlled monitoring area at Joint Base Lewis-McChord, Washington, for a 21-day controlled

monitoring period. This was a process where trained health-care professionals directly observed the soldiers, monitored their twice-daily temperature checks, and evaluated them daily for symptoms associated with the Ebola virus in a preestablished area. During this quarantine period the soldiers did not have physical contact with family members of any other nonmedical personnel, but had phone and e-mail access to their friends and families. A second wave of about 25 soldiers returned to Joint Base Lewis McChord on February 18, 2015, after almost three months in Liberia, for their controlled monitoring period.

Upon our return, in a final wave of about 10 soldiers arriving on March 4, 2015, after nearly four months of deployment in Liberia, we were sent to Fort Hood for the "controlled monitoring" period of quarantine. Accommodations at Fort Hood were very good. Although we couldn't leave Fort Hood, we were given games, could watch television and movies. Although it was somewhat frustrating to be confined to barracks, we could "order-in" almost anything we needed or wanted. We also used the time during the quarantine period for unit training, took classes, and did administrative activities as the army was reorganizing its engineering configuration.

We were glad to have experienced and participated in the humanitarian mission. Conditions in Liberia made us appreciate all we had, and it was overall a good experience. It was a huge morale boost when we returned to Fort Hood and got to watch the super bowl on T.V. We recognized that the controlled monitoring period was for our own safety and that of our families, and was also designed to reassure our fellow citizens, then experiencing something of a hysteria over the Ebola pandemic outbreak, that it was entirely safe for us to return to our normal life and routines. Our mission helped demonstrate that a severed Ebola pandemic outbreak could be contained and controlled and eventually ended. It was a very worthwhile mission.

About 150 Fort Carson engineers with the 615th Engineer Company, 4th Engineer Battalion, deployed in November 2014 to

West Africa in support of Operation United Assistance, the U.S. military's response to the Ebola crisis. The soldiers returned to Fort Carson by March 2015.

Fighting Measles at the Grassroots Level
Lions Clubs International Foundation

Measles is a highly contagious disease. The virus spreads quickly through coughing and sneezing. When one person has measles, 90 percent of the people they come into close contact with will become infected if they are not already immune. Measles immunity comes through either previously being vaccinated against the disease or through previously contracting it.

Measles remains a heavy public health burden in developing countries where parents do not have access to immunization services that could protect their children from the disease. Factors such as poverty, poor health systems, and a lack of information make it difficult for families to secure preventative medical care.

Every day, 400 people die from measles. That's more than 145,000 per year and more than one million in 10 years. It is the leading cause of death for children under the age of five. Those who do survive are at risk of severe complications, which may include pneumonia, blindness, diarrhea, and encephalitis.

In 2010, the Measles Initiative and the Bill & Melinda Gates Foundation approached Lions Clubs International Foundation (LCIF) with the idea of a partnership that would engage Lions worldwide in the fight against measles. The Measles Initiative, now known as the Measles & Rubella Initiative (M&RI), is a coalition of international partners dedicated to the elimination of measles and rubella. The Gates Foundation has a division dedicated to using science and technology to save lives in developing countries.

According to its website (www.measlesrubellainitiative.org), "the M&RI aims to reach the measles and rubella elimination goals of the Global Vaccine Action Plan by supporting

countries to raise coverage of measles, rubella and other vaccines; fund, plan, implement and monitor quality supplementary campaigns; investigate outbreaks and provide technical and financial support for effective outbreak response, propose and participate in solutions to strengthen immunization delivery; and support a global laboratory network for measles and rubella."

As of 2002, measles has been eliminated from the Americas and, with continued support, M&RI efforts will end the disease in Africa and India by 2020. Rubella was eliminated from the Americas in 2015.

Lions' involvement began in 2010, when LCIF received an initial grant from the Bill & Melinda Gates Foundation to help fight measles within four specific countries: Ethiopia, Madagascar, Mali, and Nigeria. In a survey of nearly 1,700 Lions before the pilot program began, 90 percent of Lions expressed support for the Lions Measles Initiative, and 90 percent of Lions indicated personal motivation to contribute to the program. Comments included: "This is an amazing opportunity to help eradicate a disease!" and "Measles affects children and sight, so it's a logical extension of what we already do."

Lions involved in the pilot initiative focused their efforts in three main areas: (1) advocacy at the local, regional, and national levels; (2) direct involvement in social marketing and mobilization; and (3) financial support. The efforts by Lions, local health-care professionals, and the Measles Initiative partners were tremendously successful, resulting in 41 million children being vaccinated within these four countries.

Because of the success of the pilot initiative and the role Lions serve within communities around the world, the Gates Foundation awarded LCIF a US$5 million challenge grant in October 2011. Lions and LCIF were asked to match this funding with US$10 million, providing a total of US$15 million for the fight against measles. Lions met this challenge in October 2012, even more quickly than anticipated. Those funds directly supported the vaccination of 15 million children.

In addition to providing financial support, Lion members began actively supporting vaccination campaigns within several countries, including Cameroon, Haiti, Kenya, Nepal, Uganda, and Zambia. Lions within the pilot areas continued their advocacy efforts and Lions clubs within many of the measles priority countries actively began planning for upcoming campaigns. This eventually led to the creation of the One Shot, One Life: Lions Measles Initiative.

Perhaps Lions' biggest contribution to the fight against measles and rubella comes in the form of social mobilization. M&RI partners provide technical assistance, but Lions live in and serve the communities at risk; they are the "boots on the ground."

Around the world, Lions are on the ground actively working to stop the spread of measles. Lions know their communities, and they know how to make an impact in those communities. Local Lions actively engage in social mobilization and advocacy to raise awareness about the dangers of measles and the benefits of vaccines. They go door-to-door, speaking to the parents of young children and educating them. Lions host parades and purchase radio advertisements to promote vaccination campaigns. They canvas their neighborhoods, affixing posters and passing out flyers. They speak to local and national officials, community members, and the clergy to increase the number of vaccination advocates in their areas, and work with our partners to reach even the most remote areas.

Lions and their partners form a global network focused on ending measles and rubella. Lions Clubs International (LCI) is deploying its network of 1.4 million members to raise US$30 million and to improve access to vaccines through Gavi, The Vaccine Alliance, a public–private partnership whose mission is to save children's lives and protect people's health by increasing access to immunization in the world's poorest countries. The funds raised by Lions will be matched by the United Kingdom's Department for International Development (DFID) and the Gates Foundation for

a total of US$60 million by 2017, LCI's centennial anniversary, to support Gavi's measles and rubella programs.

The partnership makes Lions clubs the largest member of the Gavi Matching Fund, which now has secured more than US$145 million in private sector gifts and donor matches.

According to the World Health Organization (WHO), measles deaths have been reduced by 71 percent since 2001. Gavi and Lions clubs have worked with M&RI to support this reduction. Recent experience shows that failure to vaccinate enough children against measles can result in serious outbreaks. As a result, the Gavi–Lions clubs partnership will include support of routine immunization and strengthening health systems going forward. By 2020, more than 700 million children in 49 countries are expected to be immunized against measles and rubella.

Malawi

In November 2013, Lions and Leos from five clubs in Malawi supported the national measles immunization campaign, which targeted two million children throughout the country. Lions sponsored public announcements and volunteered at vaccination sites throughout the five-day campaign.

> We will always be indebted to you Lions for your selfless spirit and supplements the government's efforts to serve people. Thank you for being part of the measles initiative. My government greatly appreciates this good work.
> —*Catherine Gotani Hara, minister of health, Malawi*

Botswana

In November 2013, Lions in Botswana helped the country's Ministry of Health with a five-day campaign to reach at least 95 percent of children under five years old with measles vaccinations, Vitamin A supplements, and deworming pills. Lions

went door-to-door encouraging mothers to vaccinate their children. Lions also helped fund a bus to bring families from remote areas to villages to be vaccinated and toured towns to publicize the importance of vaccines.

> The team here was absolutely great. They really took ownership of mobilizing people for the campaign, and as a government with limited resources, the extra mile that we were able to go with the vaccinations was really a lot to do with the Lions clubs.
> —*Shenaaz El Halabii, deputy permanent secretary, Botswana Ministry of Health*

Facts about Measles (WHO, 2015)

- About 400 people die from measles every day, or about 16 every hour.
- In 2013, about 84 percent of the world's children received one dose of measles vaccine by their first birthday through routine health services—up from 73 percent in 2000.
- Between 2000 and 2013, measles vaccination prevented an estimated 15.6 million deaths, making the measles vaccine one of the best buys in public health.
- Most measles-related deaths are caused by complications, which can include blindness, encephalitis, severe diarrhea and related dehydration, ear infections, or severe respiratory infections such as pneumonia.
- All children in developing countries diagnosed with measles should receive two doses of vitamin A supplements, given 24 hours apart. This treatment restores low vitamin A levels during measles that occur even in well-nourished children and can help prevent eye damage and blindness. Vitamin A supplements have been shown to reduce the number of deaths from measles by 50 percent.

Reference

World Health Organization. 2015. Measles Fact Sheet
 No. 286. http://www.who.int/mediacentre/factsheets/
 fs286/en/. Accessed October 2, 2015.

Lions Clubs International Foundation (LCIF) is the charitable arm of Lions Clubs International, the world's largest service club organization with more than 1.4 million members in more than 200 countries and geographical areas worldwide. Since 1968, LCIF has supported Lions by providing grant funding for their local and global humanitarian efforts, including treating and preventing avoidable blindness, empowering youth, and providing disaster relief on a global scale. Learn more at lcif.org. © 2015 Lions Club International. All rights reserved. Used by permission.

Samaritan's Purse International Relief Medical Responses: Haiti, Philippines, and Ebola
Bev Kauffeldt, Linda M. Mobula, and Lance Plyler

Samaritan's Purse International Relief (SPIR) is a faith-based international relief organization founded in 1970. Based on the Good Samaritan parable (Luke 10:35) and Jesus' statement to "go and do likewise," SPIR works to assist those in need and give people hope through Jesus Christ. The mission of Samaritan's Purse is:

> Samaritan's Purse is a nondenominational evangelical Christian organization providing spiritual and physical aid to hurting people around the world. Since 1970, Samaritan's Purse has helped meet needs of people who are victims of war, poverty, natural disasters, disease, and famine with the purpose of sharing God's love through His Son, Jesus Christ. The organization serves the church worldwide to promote the Gospel of the Lord Jesus Christ.

SPIR meets these needs through emergency disaster response as well as established field offices around the world engaged in a variety of projects in different humanitarian sectors.

Prior to the Ebola outbreak, Samaritan's Purse medically responded to many emergencies. The very first emergency response Samaritan's Purse ever launched was to Somalia in November 1992 and it was a medical response. Additionally we had emergency medical responses in South Sudan (1993 and again in 1997 and 2010), Bosnia (1993), Honduras (1998 through 1999), Albania (1999), Mozambique (2001 cholera and direct medical), and numerous others. Samaritan's Purse has a long history of medical response but in the last six years has set a deliberate course to improve its emergency medical capacity with the most recent disasters of Haiti, Philippines, and Liberia.

In Haiti, SPIR's medical response had two major projects. The first started in March 2010 in the slum area of Port au Prince, Cite Soleil. SPIR medical staff of doctors, physician assistants, and nurses undertook the management of a medical clinic in the heart of the slum to provide overall primary health care. On average the staff treated 100–150 patients a day for hypertension, diabetes, abscesses, acute diarrheal illness, acid reflux, acute infections, malaria, typhoid, open wounds, acute respiratory infections, and asthma. The clinic served as a malnutrition screening and referral center and provided maternal child health education for women. Additionally, SPIR provided maternal child health program training for community health workers and provided antenatal and postnatal care for women in the area of Petit-Goave. The second major medical service SPIR provided was in response to the cholera outbreak in Cite Soleil in late 2010. SPIR medical personnel treated 23,210 patients at four cholera treatment units: Bercy Colera Treatement Center, Cite Soliel CTC, Nazerene Cholera treatment Unit (CTU), and at the Villard CTU.

Samaritan's Purse arrived in the hardest hit area of Tacloban, Leyte Island, following landfall on November 8, 2013, of

Typhoon Haiyan in the Philippines. SPIR partnered with Schistosomiasis Research and Control Hospital through the establishment of a field hospital (with assistance of the U.S. military) on campus adjacent to the damaged facility. The hospital electrical grid and many other essential components and equipment of the hospital were likewise destroyed. The SPIR field hospital functioned to provide temporary residence for all outpatient medical services and inpatient pediatric care.

Samaritan's Purse also engaged in multiple mobile medical brigades each week. These mobile clinics brought services to otherwise untreated villages in obscure, remote regions throughout the island of Leyte. During these clinics numerous children requiring specialist surgery were identified and connected with national services able to conduct these necessary surgeries. Additionally, SPIR health-care workers expediently vaccinated vulnerable Filipino children with oral polio vaccine and measles vaccine supplied by UNICEF.

Samaritan's Purse Liberia (SPL) is an established field office implementing relief and development projects throughout Liberia since the end of the civil crisis in 2003. It is the main office in the coastal West Africa region with an extensive project portfolio including programs in the health sector, water and sanitation, agriculture, protection, ministry, and children's programs with funding from the United States Agency for International Development (USAID), UNICEF, Department for International Development United Kingdom (DFID), Canadian government, and internal Samaritan's Purse donors. Additionally, SPL is engaged in development of partnership projects with the Government of Liberia, namely the building of a new hospital (started in 2012) and renovation of destroyed airstrips. The medical branch of SPIR, World Medical Missions, also sent physicians to work at the ELWA (Eternal Love Winning Africa) mission hospital in Liberia as part of their postresidency program. It was through this program that Dr. Kent Brantly arrived in Liberia in 2013.

Samaritan's Purse Liberia first heard of the Ebola outbreak happening in neighboring Guinea in March 2014, as suspected cases were beginning to present themselves in Foya, Lofa County, and SPL's largest base of the past nine years. Just days after the outbreak was confirmed, SPL initiated a mass public education program and also incorporated Ebola messaging within their ongoing programs in the Lofa area. Over 250,000 persons were reached through that campaign in March and April. In June, Sierra Leone exploded with cases as well, with many sick persons traveling to the Case Management Center in Foya set up by Médecins Sans Frontières (MSF) in March 2014 when one case had crossed over from Guinea into Foya. In preparation for an expansion of cases through Liberia, SPIR, SIM, and ELWA converted the small chapel at ELWA hospital in Monrovia into a five-bed isolation unit. The Ebola awareness programming continued in Lofa and expanded into Gbarpolu, River Gee, Nimba, and Monrovia counties. Initially, it seemed that Liberia had evaded the same deadly path that Sierra Leone and Guinea were on; however, that was about to change on June 12, 2014.

On June 12, Ebola-positive patients from New Kru Town, a section of Monrovia, presented themselves to the ELWA 1 Ebola treatment unit. ELWA 1 was the chapel turned Ebola treatment unit (ETU) which Dr. Debbie Eisenhut, from Serving in Mission (SIM), along with Dr. John Fankhauser and Dr. Jerry Brown from ELWA had prepared to admit and care for these patients. Also on this team was Dr. Kent Brantly. Samaritan's Purse assisted SIM/ELWA with supplies and additional medical personnel to assist both at ELWA hospital and at the ETU. The situation began to deteriorate by the end of June in both Monrovia and Foya. On June 29 Samaritan's Purse made the decision to "stand up" a Disaster Assistance Response Team for the second time in three months to respond to the Ebola outbreak.

The first two weeks of July, an increase of medical staff, logisticians, water and sanitation, and supply support arrived

in Liberia. SPIR and SPL staff found themselves shoulder to shoulder with MSF Belgium staff (specialists in infectious hemorrhagic fever) clinically responding in the Ebola treatment units; collecting suspicious, possible Ebola deaths; spraying homes of those who tested positive; and still doing public awareness. Stretched to their capacity with no assistance from WHO or local governments, MSF requested that SPIR take over the management of the Foya unit (Foya is in the north of Liberia where SPL has a base). Official transition took place on July 8, 2014. The Foya treatment unit had Liberian nurses and hygienist who had been trained by MSF, working alongside SPIR and MSF nurses, doctors, logisticians and hygienists.

The Ministry of Health for Liberia asked SPIR and MSF to take on the responsibility of management for Ebola treatment units throughout the country. In Monrovia, ELWA 1 was now too small for the number of patients that were sick. JFK, the main government hospital in Monrovia, was neither equipped nor safe. It was decided that SPIR/MSF would build a larger unit in a nearby field on ELWA campus and in the interim, would turn the kitchen/laundry building for the new hospital that was being built on the ELWA campus into a 20-bed unit. On July 20, all patients were moved to the newly constructed "ELWA 2" reaching capacity within hours. SPIR, along with MSF and MoH nurses and hygienist, treated Ebola patients as the number of infections increased. The mortality rate during these first weeks was 79.6 percent.

It was during this time that Dr. Kent Brantly became ill along with SIM missionary Nancy Writebol. Many SPIR medical staff and hygienists now turned their attention to caring for them along with putting in long shifts at the ELWA 2 unit. On July 26, 2014, positive tests confirmed the dreaded news that Dr. Brantly and Nancy were sick with Ebola. MSF, understanding that SPIR/SIM had to turn all their attention to the care of these two patients, continued to work courageously at ELWA 2 with additional help from nurses and doctors from the ELWA campus hospital led by Dr. Jerry Brown.

On August 1, 2014, Dr. Brantly was evacuated out of Liberia to Emory University hospital where his care continued until he fully recovered and subsequently discharged free of Ebola on August 21. Nancy Writebol was evacuated two days later (August 3) to Emory and was discharged a couple of days earlier than Dr. Brantly. Later that year, *Time* magazine awarded all those involved in the Ebola response in Liberia, Sierra Leone, and Guinea "TIME persons of the year"—a deserved title for those first to respond to the largest, unprecedented Ebola outbreak in history.

Samaritan's Purse continues to build its medical capacity in emergency response and humanitarian aid, building upon the aforementioned activities, in order to continue meeting the needs of those around the world.

Bev Kauffeldt, Ph.D. Samaritan's Purse, Liberia Field Office Monrovia, Liberia/Disaster Response Unit.

Linda M. Mobula, MD, MPH Division of General Internal Medicine, Department of Medicine, Johns Hopkins University, Baltimore, MD.

Lance Plyler, MD, Samaritan's Purse, Disaster Response Unit, Boone, NC.

Dengue Fever
Amanda Naprawa

Dengue fever (also known as "break bone fever") is a serious disease. It is a leading cause of death in the tropics and subtropics. Dengue is estimated to affect 400 million people every year and nearly one-third of the human population live in areas at risk for dengue infection. In fact, dengue is the "most rapidly spreading mosquito-borne viral disease in the world." Dengue is now endemic in more than 125 countries and between 1960 and 2010, the incidence of dengue increased 30-fold. There are no vaccines for this disease, and it can be fatal: severe dengue

is a leading cause of death for children in Asian and South American countries. Knowing more about the disease and its transmission and methods for prevention is important for containing this global health threat.

What Causes Dengue Fever?

Dengue fever is caused by any one of four related dengue viruses (DENV1, DENV2, DENV3, or DENV4). These viruses are transmitted to humans through the bite of a mosquito. When a mosquito bites a human who is already infected with a dengue virus, that mosquito can then transfer the virus when biting a healthy person. Though rare, there have been known cases of transmission of dengue in health care settings (through needle sticks, for instance) and via pregnant mother to her unborn fetus.

In the Western Hemisphere, the primary mosquito of concern is the *Aedis aegypti*. This particular mosquito is worrisome because of its close proximity to humans and their homes. Human blood provides the mosquito with food, and household water-containing containers and structures provide just the place for the mosquito to reproduce (the female lays her eggs on the side of a water container and the larvae hatch at the next rain). Moreover, this mosquito enjoys the cool, dark places, such as closets, inside most of our dwellings. In addition to finding human habitats helpful to survival, the *Ae. aegypti* is also extremely adaptable in its own right. Mosquito eggs can lie dormant for long periods of time, during a drought for instance, until the rain returns and the larvae hatch.

Symptoms of Dengue Fever

The symptoms of dengue fever present themselves within 3–14 days after the infecting mosquito bite. Some individuals, particularly children or those with first-time infection, may have no symptoms at all. Others can present a wide range of symptoms, from mild fever to debilitating high fever with severe pain behind the eyes and with joint aches, rash, and low white

blood cell count. Some patients also report nausea and inability to eat. While the acute symptoms generally last for about one week, the weakness, malaise, and lack of appetite can linger for weeks. Complications of dengue include febrile seizure and dehydration.

Dengue Hemorrhagic Fever (DHF)

Dengue hemorrhagic fever (DHF) is a severe form of dengue fever that results in mild to severe (and even fatal) bleeding. First recognized in the 1950s, this potentially lethal form of dengue fever affects most Latin American and Asian countries. A person infected with DHF typically presents with the same symptoms as classic dengue. As the fever begins to subside (usually 3–7 days after onset), serious warning signs of DHF may appear. These include severe abdominal pain and vomiting, striking change in temperature (fever to hypothermia), change in mental status (confusion), and/or hemorrhagic manifestations (bruising, nosebleeds, bleeding gums). Severe hemorrhagic demonstrations include vaginal and intracranial bleeding.

Patients with severe DHF can develop a serious complication called dengue shock syndrome (DSS), which is evidenced by circulatory failure (such as weak pulse or low blood pressure). If untreated, DSS is fatal in about 10 percent of patients and can cause death within 12–24 hours of onset. However, with proper treatment, the fatality rate lowers to 1 percent.

Diagnosis and Treatment

Accurate diagnosis of dengue fever is important for early detection and care, as well as for surveillance and outbreak control purposes. Because early symptoms of dengue mimic those of other illnesses, clinical diagnosis alone is insufficient and unreliable. After onset of illness, laboratory testing of serum, plasma, blood cells, and other tissues should be used to confirm clinical diagnosis. The type of laboratory test used is dependent upon the circumstances, including whether there is an outbreak of disease and the health care services available in a given region.

There is no specific medication for treating Dengue fever. Rather, primary treatment consists of managing symptoms and ensuring adequate hydration for the patient. Patients who are able to tolerate fluids should be taught to continue hydration as well as how to monitor urine output to avoid dehydration. For patients with more serious illness who are unable to tolerate fluid, IV fluids may be necessary (though carefully controlled) to avoid dehydration. Patients should use acetaminophen to control the fever but must avoid aspirin and other nonsteroidal anti-inflammatories (such as Advil or Aleve) because these types of medication can increase the risk of bleeding.

During the early phase of fever, it is usually impossible to tell whether the infected person will progress to severe dengue. Health-care providers who suspect dengue in a patient should be alert for risk factors and signs of DHF. This may include increased liver size and tenderness, a decrease in white blood cell count, a decrease platelet count, and an increase in hematocrit (the proportion of red blood cells compared with blood cells). A test called the "tourniquet test" is specifically done for DHF. During this test, an initial blood pressure reading is made. The blood pressure cuff is then reinflated to exactly halfway between diastolic and systolic pressures and left on the patient for 5 minutes. After removal, the health-care provider looks for small red or purple dots that indicate bleeding (called petechiae). Ten or more of these spots in a one-inch square area is considered positive. It is important to note that the tourniquet test can be falsely negative, particularly early in the disease or in obese individuals.

Prevention

Although the World Health Organization views development of a dengue vaccine as a priority, there is currently no vaccine to prevent Dengue fever. The only preventive measure is to avoid mosquito bites. The best methods for reducing exposure to mosquitoes is by eliminating the places where mosquitoes

lay eggs (such as standing water), wearing long sleeves and long pants, and using insect repellent.

Impact of natural disasters

Natural disasters, such as floods, tsunamis, and earthquakes, often create the perfect conditions for the spread of dengue and outbreaks of infection are often seen after disasters occur. An epidemic of dengue followed a massive flood in Brazil in 2008, with over 57,000 reported cases and 67 deaths. Floods provide an increase in vector habitats, such as standing water and overflowing rivers, that allow for an explosion of mosquito breeding. This in turn increases the likelihood for infection of vector-borne disease such as dengue.

The risk of outbreaks also increases due to changes in human behavior that necessarily happen after natural disasters. For instance, after a serious disaster, more humans may be sleeping unprotected outside, and any typical disease prevention methods (such as spraying) may be temporarily interrupted. In addition, the combination of overcrowding in temporary living quarters and less than ideal sanitary conditions makes the perfect breeding grounds for disease-carrying mosquitoes.

Control and prevention of dengue outbreaks is an important and critical part of emergency preparedness planning. In regions with endemic dengue, priority should be given to creating a comprehensive outbreak response plan. Although the specifics of any plan will be dependent on the resources of the local region, all response plans should have coordinated methods for early detection of dengue outbreaks, clear statement when an outbreak has been detected, and an organized early response to the outbreak.

References

Centers for Disease Control and Prevention. 2009. "Dengue and Dengue Hemorrhaghic Fever: Information for Health Care Practitioners." http://www.cdc.gov/Dengue/resources/

Dengue&DHF%20Information%20for%20Health%20
Care%20Practitioners_2009.pdf. Accessed October 2015.

Centers for Disease Control and Prevention. 2012a. "Dengue:
Prevention." http://www.cdc.gov/Dengue/prevention/
index.html. Accessed October 2015.

Centers for Disease Control and Prevention. 2012b.
"Symptoms and What to Do If You Think You Have
Dengue." http://www.cdc.gov/Dengue/symptoms/.
Accessed October 2015.

Centers for Disease Control and Prevention. 2014. "Dengue:
Clinical Guidance." http://www.cdc.gov/dengue/
clinicalLab/clinical.html. Accessed October 2015.

Centers for Disease Control and Prevention. 2015. "Dengue:
Entomology and Ecology." http://www.cdc.gov/Dengue/
entomologyEcology/index.html. Accessed October 2015.

Harrington, J., A. Kroeger, S. Runge-Ranzinger, and
T. O'Dempsey. 2013. "Detecting and Responding to a
Dengue Outbreak: Evaluation of Existing Strategies in
Country Outbreak Response Planning." *Journal of Tropical
Medicine* 2013: 756832. doi:10.1155/2013/756832.

Kaur, P., and G. Kaur. 2014. "Transfusion Support in
Patients with Dengue Fever." *International Journal of
Applied and Basic Medical Research* 4 (Suppl. 1): S8–S12.
doi:10.4103/2229-516X.140708.

Kouadio, I., S. Alijunid, T. Kamigaki, K. Hammad, and
H. Oshitani. 2012. "Infectious Diseases Following
Natural Disasters: Prevention and Control Measures."
Expert Review of Anti-Infective Therapy 10: 1, 95–104.
doi:g/10.1586/eri.11.1.

World Health Organization. 2006. "Transcript of Audio-
visual Guide: Dengue Hemorrhagic Fever: Early
Recognition, Diagnosis and Hospital Management."
http://www.who.int/csr/don/archive/disease/dengue_fever/
dengue.pdf. Accessed October 2015.

World Health Organization. 2009. "Dengue: Guidelines for Diagnosis, Treatment, Prevention, and Control." http://www.who.int/tdr/publications/documents/dengue-diagnosis.pdf. Accessed October 2015.

World Health Organization. 2012. "Flooding and Communicable Diseases Fact Sheet." http://www.who.int/hac/techguidance/ems/flood_cds/en/. Accessed October 2015.

World Health Organization. 2015. "Dengue and Severe Dengue." http://www.who.int/mediacentre/factsheets/fs117/en/. Accessed October 2015.

World Health Organization. 2016. "Dengue." http://www.who.int/topics/dengue/en/. Accessed October 2015.

Amanda Naprawa has a JD from Ohio State University, a Master of Public Health from the University of California Berkeley, and is a public health writer and consultant with a passion for preventive medicine.

Vaccines Are the Key to Preventing Global Disease Pandemics
Angela Quinn

If you've ever seen an episode of *The Walking Dead,* you know all too well what the threat of a global, pandemic outbreak of a disease could mean for mankind. As world travel becomes more possible with the expansion of the airline industry and countries around the world continue to import one another's goods, diseases which were once endemic to one region of the world can quickly become a pandemic nightmare for the entire world. Vaccines are the key to eliminating communicable diseases and preventing such global pandemics. Every 20 seconds, a child in the world dies from a vaccine-preventable disease (United Nations Foundation, 2015a). Vaccines have been referred to as one of the most important innovations of

mankind. Vaccines have been responsible for eliminating one of the world's most harmful and deadly diseases, smallpox. Thanks to global vaccine programs, the World Health Organization declared the last case of smallpox in 1977 (CDC, 2002). Controlling a global pandemic through vaccination programs depends on a number of factors, including cost, access to vaccines, awareness of the risks of disease, and most importantly, the acceptance that vaccines are safe and effective in preventing global pandemics.

The Cost of Vaccination Programs

One of the most important aspects about global vaccination programs is that they are affordable enough to maintain. In 2011, the global cost of purchasing several of the vaccines included in the recommended childhood series was about $1.50. In 2016, that cost rose to more than $15 (Doctors Without Borders, 2012). The rising costs of vaccines are attributed to more effective vaccines and newer vaccines which are higher in cost than older vaccines. In many developed countries, families take for granted that vaccines are so readily available and affordable considering the sacrifices families overseas must make to get their children vaccinated.

In Africa, one in five children lack access to vaccines for a number of reasons, with costs falling at the top of that list. According to the World Health Organization, more than 300 million children under the age of five die in Africa each year and a significant portion of those deaths could be prevented by vaccines (World Health Organization, 2013). In the United States, children receive a measles, mumps, and rubella (MMR) vaccine at 12 months and again at 4 years. The MMR vaccine is covered by the majority of health insurance plans and there are countless programs available to provide this vaccine to families at a little to no cost. The incidence of measles is extremely low in the United States since families can afford the MMR vaccine and herd immunity, which means that measles cannot spread since so many people are vaccinated against it, remains strong

in most states. However, measles has contributed to more than 38,000 deaths annually in Africa and causes more than 145,000 deaths globally each year (World Health Organization, 2013). It is evident that these deaths could be prevented if the cost of vaccines were lower and more children could be vaccinated globally.

In January 2016, Brazil was faced with the challenge of lowering health care costs as the country slipped into a recession. In turn, Brazil chose to cut vaccine programs, which cost the country more than the equivalent of $720 million dollars annually (Reuters, 2016). The fact that Brazil has chosen to cut some vaccine programs is especially troubling when considering that the incidence of the Zika virus is on the rise and the need for funds to develop a vaccine are stronger than ever. The Zika virus, which spreads through mosquito bites, has been linked to microcephaly, a condition in which children are born with smaller than normal heads and brains. In many cases, this birth defect has been fatal. As of January 2016, there were more than 3,500 cases of microcephaly secondary to Zika virus exposure during pregnancy in Brazil, and cases of Zika virus appeared throughout South and Central Americas and even in the United States in Texas (U.S. News and World Report, 2016). After the World Health Organization declared the Zika virus a global emergency in January 2016, dozens of research groups began to work on a vaccine for the Zika virus and experts report that a vaccine could be ready for clinical trials by the end of 2016 (CBS News, 2016).

Access to Vaccination Programs

When considering how quickly a communicable disease can spread, access to vaccinations remains key. In order to increase global access to vaccines, advocacy groups must raise money from private donations and foundations to keep current programs afloat and expand into new regions. In 2011, the World Health Organization developed the Global Vaccine Action Plan (GVAP) which combines the support of 194 countries

to increase global access to vaccines and prevent more than 20 million deaths due to vaccine-preventable diseases by the year 2020 (World Health Organization, 2016). Gavi, the Vaccine Alliance, is an international organization formed in 2000 which advocates for global vaccine programs and helps increase access in lower-income countries. The Bill and Melinda Gates Foundation has donated more than 2.5 billion dollars to GAVI as of 2016 (Bill and Melinda Gates Foundation, 2012).

In developing nations, the last mile of vaccine delivery still remains the largest barrier to expanding global vaccine access. Vaccine clinics must be established in underdeveloped regions where roads are not paved and modern civilizations do not yet exist. Shot at Life, a division of the United Nations Foundation, has raised more than 6.4 million dollars and has increased global vaccine access to more than 30 million children by raising awareness of how important it is to focus on actually delivering the vaccines to the people who need them the most (United Nations Foundation, 2015b).

Awareness of the Seriousness of Communicable Diseases and the Need for the Vaccines That Prevent Them

One of the most important aspects of reducing the risk of global disease pandemics is educating the public on the importance of vaccines and the diseases which they prevent. As global vaccine programs increase and the incidence of preventable disease decreases, the seriousness of these diseases can be downplayed by some.

In December 2015, authorities in Plano, Texas, responded when tipped off that local mothers were hosting a chicken pox "party," in which they invited other unvaccinated children to come and play with a child infected with chicken pox in the hopes of spreading the highly communicable disease to the other children (Breitbart, 2015). Dr. Paul Offit, a pediatrician specializing in infection control at the Children's Hospital of Philadelphia, cautions against these types of "parties," as the

risk of serious complications of chicken pox are very real. "The thinking many parents have is that the natural infection is more likely to induce higher levels of antibodies and longer-lasting immunity than vaccines," Offit said. "That's generally true but the problem is if you make that choice you are also taking the risk of a natural infection, which can mean hospitalization and sometimes death" (ABC News, 2016). According to the Centers for Disease Control and Prevention (CDC), before the varicella (chicken pox) vaccine became widely available in the United States in 1995, more than 4 million people contracted chicken pox annually, which led to more than 10,000 hospitalizations and more than 100 deaths (CDC, 2015).

The fact that this group of mothers chose to downplay the seriousness of contracting chicken pox is concerning and highlights the need for additional public health advocacy in favor of vaccines. There are many organizations which help to educate the public about the importance of vaccines, including the Centers for Disease Control and Prevention (CDC) and the National Institutes of Health (NIH). Social media has proven to be an important vehicle for driving home the importance of vaccines and organizations such as Nurses Who Vaccinate, Voices for Vaccines, Every Child by Two, Kimberly Coffey Foundation, Northern Rivers Vaccination Supporters, and Vaccinate Nevada are just a few of the many examples of advocacy groups which utilize Facebook, Twitter, and Instagram to raise awareness for the seriousness of vaccine-preventable diseases and the vaccines which prevent them.

Acceptance of the Safety, Efficacy, and Necessity of Vaccines

Perhaps the most important facet of maintaining global vaccine programs in order to reduce the risk of global pandemics is that the public accepts that vaccines are safe, effective, and necessary. While mothers in Africa worry about how they'll afford the vaccines they must walk miles to obtain for their children, mothers in the United States willingly choose to forgo

the recommended vaccine schedule for their children despite the fact that the vaccines are not only affordable, but readily available. A report published in January 2016 in the *American Journal of Public Health* found that the majority of mothers who chose not to vaccinate their children in California were of higher income, chose private schools for their children, and were Caucasian (*New York Times*, 2015). The 2015 measles outbreaks in Disneyland, California, caused more than 40 cases of measles and the outbreaks were linked to families who chose not to vaccinate (*Time*, 2015).

Vaccines have been proven by thousands of studies to be safe and effective, yet there still exists a small subset of the population who believe that vaccines are "harmful." Science is not about believing, but rather it is about facts. The fact is that vaccines have saved millions of lives. According to the Centers for Disease Control and Prevention (CDC), in just two decades, vaccines will prevent more than 322 million illnesses, 21 million hospitalizations, and 732,000 deaths just in the United States alone (CDC, 2014). Despite the overwhelming support in favor of the science behind vaccines, some still cling to a theory that vaccines cause a multitude of problems, including autism, despite the fact that every single one of these claims has been refuted. One blogger has even compiled a list of over 100 studies which demonstrate no link between vaccines and autism (Just the Vax, 2014).

Vaccines Are the Key to Preventing Global Disease Pandemics

Getting vaccinated against communicable diseases is one of the best decisions you can make for yourself and your family as these vaccines reduce the risk of serious complications and death from otherwise preventable illnesses. As the threat of global disease pandemics continues to rise, the vaccines developed to prevent them are the key in maintaining public health.

References

ABC News.com. 2016. http://abcnews.go.com/Health/ story?id=6772216. Accessed December 24, 2015.

Bill and Melinda Gates Foundation. 2012. http://www .gatesfoundation.org/What-We-Do/Global-Development/ Vaccine-Delivery. Accessed May 2012.

Breitbart.com. 2015. http://www.breitbart.com/big-govcrnmcnt/2015/12/21/texas-cps-visits-home-mom-hosted-chickenpox-party/. Accessed December 24, 2015.

CBS News. 2016. http://www.cbsnews.com/news/how-far-away-is-a-zika-virus-vaccine/. Accessed December 24, 2015.

Centers for Disease Control and Prevention. 2002. "25th Anniversary of the Last Case of Naturally Acquired Smallpox." http://www.cdc.gov/mmwr/preview/ mmwrhtml/mm5142a5.htm. Accessed October 25, 2002.

Centers for Disease Control and Prevention. 2014. http:// www.cdc.gov/media/releases/2014/p0424-immunization-program.html, Accessed March 2014.

Centers for Disease Control and Prevention. 2015. http:// www.cdc.gov/chickenpox/vaccination.html. Accessed December 24, 2015.

Doctors Without Borders. 2012. http://www.doctors withoutborders.org/news-stories/briefing-document/ vaccines-price-protecting-child-killer-diseases. Accessed December 3, 2012.

Just the Vax Blogspot.com. 2014. "75 Studies That Show No Link between Vaccination and Autism." http:// justthevax.blogspot.com/2014/03/75-studies-that-show-no-link-between.html. Accessed March 2014.

New York Times. 2015. http://well.blogs.nytimes.com/ 2015/12/24/rich-white-and-refusing-vaccinations/?_r=0, Accessed December 24, 2015.

Reuters. 2016. http://www.reuters.com/article/us-brazil-health-vaccines-idUSKBN0UK1SU20160106. Accessed December 24, 2015.

Time. 2015. http://time.com/3664553/disneyland-measles-antivaxxers/. Accessed January 12, 2015.

U.S. News and World Report. 2016. http://www.usnews .com/news/articles/2016-01-14/zika-disease-credited-with-dramatic-rise-of-microcephaly-in-brazil. Accessed December 24, 2015.

United Nations Foundation. 2015a. "What We Do." http:// www.unfoundation.org/what-we-do/issues/global-health/. Accessed December 24, 2015.

United Nations Foundation. 2015b. http://www.shotatlife .org/shotlife-by-the-numbers/. Accessed December 24, 2015.

World Health Organization. 2013. http://www.afro.who.int/ en/media-centre/afro-feature/item/7620-1-in-5-children-in-africa-do-not-have-access-to-life-saving-vaccines.html. Accessed December 24, 2015.

World Health Organization. 2016. http://www.who.int/ immunization/global_vaccine_action_plan/en/. Accessed December 24, 2015.

Angela Quinn is a registered nurse in Long Island, NY. She is passionate about nursing and public health. She is an Executive Board Member for Nurses Who Vaccinate, an organization which positions nurses to be public health advocates to educate the public about the importance of life-saving vaccines. She is the founder of the professional blog, Correcting the Misconceptions of Anti-Vaccine Resources. She is also the creator of Future Nurse Abby, a character who aspires to be a nurse and uses her current experiences living in an antivaccine home to promote public health through vaccinations.

How to End a Disease: The Global Polio Eradication Initiative
John Hewko

What Is Polio?

> One evening, a child would go to bed feeling fine, and awake to discover that he or she had lost the use of their legs.

This is polio, a devastating disease, most common in children, that has existed for thousands of years. If you're reading this, you're probably wondering why we're still even talking about polio today. But thanks to an effective vaccine (which you would have received as a child) polio was eliminated from the Western Hemisphere in 1994.

Despite this milestone, polio is still a threat to global health, and epidemics from the late 19th century through the mid-20th century struck thousands of victims in Europe and North America, and caused widespread panic. There is no cure for polio, but it can be easily prevented through immunizations that are safe and effective.

Passed from person-to-person, it can strike young and old, rich and poor alike. Franklin D. Roosevelt, the United States' 32nd president, contracted polio in 1921, when he was 39 years old. For most people who get infected, it is a disease with no visible symptoms, and many recover fully. But for a small proportion of unlucky victims, it wreaks havoc on the human body, reaching the brain and spinal cord, causing paralysis, and even death.

At its peak in the United States, more than 21,000 paralytic cases of polio were reported in 1952, with more than 3,000 deaths. Fearful parents kept their children away from swimming pools and movie theaters in summers, which was the high season for polio.

But thanks to effective vaccines and a remarkable global partnership, its reign of terror is close to an end. This is the story of how we have reached this stage, what still needs to be done,

and the lessons we have learned to protect the world against other infectious diseases.

Finding a Vaccine

For a long time, little was known about the cause of polio, how the virus spread, and what could prevent it.

In Vienna in 1908, Dr. Karl Landsteiner, and his assistant E. Popper first discovered that polio was caused by a virus. This discovery, along with the invention of the electron microscope in 1931, facilitated the study of polio in the laboratory, and raised the possibility that a vaccine could be found to prevent it, like other viruses.

But progress in the search for this vaccine was slow, and many misunderstandings about polio's transmission resulted in strategic mistakes. In New York in the summer of 1916, tens of thousands of cats were put down, as health officials feared that they were carriers of the virus.

Two American scientists, both hailing from Russia, focused on two different kinds of potential vaccine for polio. Jonas Salk led research into a vaccine using a killed (inactivated) form of the virus (IPV) that was injectable; and Albert Sabin developed an oral vaccine (OPV) using a live but weakened form of the virus.

Salk was the first to create officially a safe and effective vaccine, conducting the largest medical experiment in history from 1954 to 1955, to test its effect on 1.8 million children in the United States, Canada, and Finland.

The Need for a New Partnership

Salk's vaccine was a triumph, and combined with Sabin's live vaccine (from 1961) mass vaccinations had a dramatic effect in reducing polio cases in the industrialized, wealthier nations in North America, Australasia, parts of South America, and Northern Europe.

Unfortunately, merely possessing a safe vaccine is not enough to eradicate a disease globally. Polio still devastated developing

countries, which possessed neither the health systems, infrastructure, nor resources to buy vaccines. By 1985, polio paralyzed about 400,000 children a year—nearly 1,000 children every day, and was endemic in 125 countries.

That same year, Rotary, a global, nonprofit membership organization, decided to launch its audacious PolioPlus program to take on polio through the mass vaccination of children.

The eradication of smallpox in 1979 proved that an infectious disease could be wiped out. An effective and safe polio vaccine already existed, and the World Health Organization's Expanded Programme on Immunization (EPI), launched in 1974 (and universally adopted by the early 1980s) intended to build on the smallpox infrastructure to target six diseases, including polio. So Rotary figured: Why not join forces and accelerate the efforts to end a deadly disease?

Rotary had already tested its capacity to work on a large-scale immunization campaign with other partners. Rotary worked closely with UNICEF to target polio when it led a program to immunize six million children in the Philippines in 1979, which then had the highest polio caseload in the western Pacific.

However, getting buy-in from other organizations was not easy. Many health experts thought that it was too costly to pursue the eradication of a single disease, when weighed against the benefits of boosting basic health services. But Carlos Canseco, then Rotary's President, saw no conflict between the two. The "plus" in Rotary's PolioPlus program reflects the idea also foreshadowed in the EPI, that by fighting infectious diseases such as polio, the global infrastructures to fight other diseases would also be strengthened. With persistent advocacy, Rotary leaders managed to gain the endorsement of other major players in the health and development world.

So in 1988, following the unanimous adoption of a World Health Assembly Resolution on "Global eradication of poliomyelitis," Rotary spearheaded one of the most successful public–private partnerships in history, the Global Polio Eradication Initiative (GPEI).

The Global Polio Eradication Initiative in Action

The GPEI spearheading partners faced a formidable task. To achieve the global eradication of polio, and to assist primary care services at the same time, had never been accomplished before on this scale.

The Initiative had to encompass research and innovation, advocacy, political leadership, and grassroots activism to raise awareness and ensure that every child, no matter how remote, was reached by vaccinators.

The project would not only have to win over heads of state, but populations of every culture, from the boat-dwelling fishing communities in Cambodia and Vietnam, nomads in Pakistan, Afghanistan and Somalia, to construction workers in Delhi, and even those who resisted the vaccine in wealthy countries.

Since the launch of the GPEI in 1988, more than 13 million people, mainly in the developing world, who would otherwise have been paralyzed, are walking because they have been immunized against polio. More than 2.5 billion children have received the oral polio vaccine, and the global polio caseload has been reduced by 99.9 percent, with only Pakistan and Afghanistan remaining as the last two polio-endemic countries.

To reach a point where we are on the cusp of eradicating a human disease for only the second time in history, the Initiative employed a variety of strategies:

- **Mass Vaccination Combined with Broader Health Interventions**

The aim of mass campaigns was to interrupt circulation of poliovirus by immunizing every child less than five years old. For example, in Pakistan, this meant five nationwide campaigns in 2015 targeting all of the more than 35 million children under the age of five.

In many countries polio vaccination campaigns were linked with other badly needed health interventions. In Nigeria and elsewhere, health clinics set up as part of the polio program infrastructure have served as a staging post for multiple medical

interventions, including measles vaccination, treatment of intestinal parasites, distribution of Vitamin A, and bed nets to protect against malarial mosquitoes.

- **Advocacy**

With competing priorities, not least other infectious diseases, it was imperative to keep polio eradication at the top of the agenda for heads of state, health ministers, and for multilateral organizations such as the UN. As the only GPEI partner which is comprised of citizens in more than 170 countries around the world, Rotary was uniquely positioned to urge officials from the local to national level to focus on polio eradication.

Advocacy has resulted in more than US$7.2 billion in contributions and commitments from donor governments to the GPEI. In combination with private sector partners, NGOs and development banks, over $11 billion has been invested in the Initiative. Rotary alone has contributed over $1.5 billion to the effort. Advocacy has also resulted in important declarations to bolster and extend support for eradication, from the European Union, the African Union, the Organization of the Islamic Conference, and many others.

Grassroots advocacy to reach local social, religious, and cultural leaders was also vital. Rotary and its partners have appealed to Ulemas (specialist bodies of Islamic scholars) to support polio vaccination. In Pakistan, Islamic leaders have issued 28 fatwas promoting the safety of the vaccine and the importance of vaccinating children.

- **Innovative Tactics**

The GPEI has also implemented innovative tactics to reach more children. For example, the creation of strategically placed Permanent Transit Posts (PTPs) at entry points to international borders, provinces, and big cities across Pakistan have reached mobile populations with the vaccine. Staffed by polio eradication teams, the Posts provide safe spaces to keep the vaccine, and immunize children in transit, reaching migratory and nomadic populations.

A carefully crafted communications strategy expressed the importance of frontline health workers to parents as vital for their children's health, and assuaged fears about the vaccine's safety.

And the Initiative has also overcome hurdles in reaching remote communities through its use of technology. In the age when high-quality data is of paramount importance, the GPEI has worked hard to replace traditional written paper reporting of polio and maternal and newborn health data from the field with cell phone reporting. The use of cell phones has facilitated communication with, and payment to, vaccinators, especially in remote communities. GPS monitoring of vaccination teams and missed communities has enhanced immunization coverage, and improved upon the hand-drawn maps that were previously used in house-to-house campaigns.

- **Female Health Workers**

Hundreds of thousands of health workers, mainly women, carried and delivered the vaccine to billions of children. Women had a greater level of trust with mothers and thus were able to enter households and have interactions with mothers and children necessary to deliver the polio vaccine. They also provided other services, such as health education, antenatal care, routine immunization, and maternal health. They worked bravely in difficult conditions, and persevered despite the threat of violent resistance to the polio vaccine. The Taliban in Pakistan and other extremists, such as Boko Haram in Nigeria, have waged a brutal campaign against vaccination teams. More than 70 polio workers (including several men and security guards) were killed in Pakistan from 2012 to 2016. The contribution of these health workers was a vital part of the success in fighting polio.

What's Next? Building a Legacy

The GPEI offers several valuable lessons for global health. It shows the value of finding good partners who persevere over

many years with disciplined adherence to a set of clearly defined roles. It shows the importance of constant communication and coordination between partners to track down a formidable threat to public health. It engages voluntary support with creative advocacy, extending its reach and appeal. It also uses clear metrics for success and independent oversight to keep a massive undertaking on track, with a singular focus.

True to the ambitions of the PolioPlus program, the global effort to eradicate polio, involving 200 countries, and 20 million volunteers, has strengthened routine immunization coverage against multiple diseases, trained thousands of health workers, and implemented infrastructures vital to national public health systems and built resilience against outbreaks.

We now have a global network of 145 laboratories established by the GPEI, which also tracks measles, rubella, yellow fever, meningitis, and other deadly infectious diseases, and will do so long after polio is eradicated.

The GPEI infrastructure is already being used to counter other health threats. For example, Nigeria managed to thwart the deadliest Ebola virus in history in 2014, by repurposing its polio eradication infrastructure and technology to track all cases, and implement a rapid and effective outbreak response.

A polio-free world will reap financial savings and reduced health care costs of up to US$50 billion through 2035. In fact, we've already saved $27 billion since the GPEI's inception, and low-income countries account for 85 percent of the savings. This achievement will prove what is possible when the global community comes together to improve children's lives.

If we succeed, we will have gifted the world a new blueprint for disease eradication, on a scale never before attempted. But if we don't see this effort through to the finish line, polio would easily see resurgence, leading to 200,000 cases of paralysis a year within 10 years.

The day will come soon, hopefully by the time you read this article, when we see no new cases and live in a polio-free world. That will be a day to celebrate. The feat of eradicating polio

will be one of the most important this century. But when it is defeated, it will also empower our belief in the potential to reach new milestones for global public health.

John Hewko is the general secretary of Rotary International and The Rotary Foundation, leading a staff of 800 at Rotary's World Headquarters in Evanston, Illinois, USA, and seven international offices. Before joining Rotary in 2011, he was vice president of operations and compact development at the Millennium Challenge Corporation (MCC), a U.S. government agency established in 2004 to deliver foreign assistance in a new and innovative manner.

An attorney, John was an international partner with the law firm Baker & McKenzie (B&M), specializing in international corporate transactions in emerging markets and resident in the firm's Moscow, Kyiv, and Prague offices. While working in Ukraine in the early 1990s, Hewko assisted the working group that prepared the initial draft of the new Ukrainian post-Soviet constitution.

Hewko holds a law degree from Harvard University, a master's in modern history from Oxford University (where he studied as a Marshall Scholar), and a bachelor's in government and Soviet studies from Hamilton College in New York. John is an emeritus trustee of the Ukrainian Catholic University in Lviv, Ukraine.

Air Travel and *Aedes* Mosquito-borne Diseases
Sahotra Sarkar

Mosquito species are among the most significant vectors of infectious disease in the world. Malaria is spread almost entirely by about 40 species from the genus *Anopheles*. West Nile virus is spread by species of the genus *Culex*. Lately, a lot of attention has been focused on Zika virus disease which is spread by mosquito species from the genus *Aedes*.

Zika virus is named after the forest of Uganda where it was first identified in 1947 in a *Rhesus* monkey. For the next 60 years it remained in Africa except for small and sporadic

outbreaks in Asia. In 2007 a major outbreak was reported from Yap Islands of the Federated States of Micronesia in the Pacific. The disease then spread across the Pacific to Easter Island in Chile by 2014 and to northeast Brazil by May 2015. In Brazil, by the end of 2015, there were more than 400,000 autochthonous cases of the disease (Mlakar et al., 2016). Since then its spread throughout the Americas has been relentless—WHO regards all countries in the Americas except Chile and Canada to be at risk. The main mechanism of the spread of the virus is air travel from Brazil and other source countries in Latin America where local transmission cycles have been established.

In the past, in adults, Zika was manifested by mild fever and skin rash, usually accompanied by conjunctivitis, and muscle or joint pain. However, recently, Guillain-Barré Syndrome (GBS) has been reported in patients infected with Zika, first in the 2013 outbreak in French Polynesia, and since in greater numbers in Brazil and other Latin American countries. Most importantly, in Brazil, the Zika virus has been linked to thousands of cases of microcephaly, a fetal brain condition that leads to diminished brain size in newborns. There is as yet no definitive proof that Zika causes microcephaly but the brain deformations have not been linked to any other factor; a pure coincidence is deemed unlikely by most epidemiologists and the evidence for a causal connection is getting stronger (Tang et al., 2016). Consequently, Zika virus disease has become a major health emergency.

There is no specific treatment for Zika, no medical intervention except for relief from pain and fever, and no vaccine. Even commercial tests for the disease are yet to be developed. Mosquito control is an obvious strategy to help control the spread of the disease. However, there is reason to worry that such control strategies will not be very effective. The reason for this is that the mosquito species that spread Zika are also well-known as vectors for several other diseases that have long been studied—yellow fever, dengue, and Chikungunya—and past vector control efforts have not been successful. This raises the

question of the importance of air travel patterns and whether airports with a high probability of disease importation should be put under surveillance to detect and treat people entering a region with the disease.

The *Aedes* species most clearly implicated in Zika transmission is *Ae. aegypti*. This species is also called the yellow fever mosquito because it is the major vector for that disease. It is largely restricted to areas with warm climates and some standing water (which may just consist of small containers) for the insects to breed. In the United States it is found along the southern boundary states. *Ae. aegypti* does not expand its range very easily. Because of that and because yellow fever runs its course very rapidly, the disease has not spread extensively in many decades. Yellow fever vaccination is also mandatory for travelers to most regions of the world from areas in which the disease is endemic (which are some African and Latin American countries).

Ae. aegypti is also the most efficient vector for dengue, which was the most rapidly spreading arthropod-vectored disease in the world before the onset of the Zika crisis (Gardner and Sarkar, 2013). A second species, the Asian tiger mosquito, *Ae. albopictus*, also spreads dengue but is less efficient as a vector. In the case of Chikungunya, *Ae. aegypti* is the most important vector but there has been a recent upsurge of outbreaks associated with *Ae. albopictus* because the virus itself seems to have undergone a mutation that makes it more efficiently transmitted by the latter species (Rowland-Jones, 2016). (It is possible that the Zika virus has recently begun to be causing much more severe health problems than earlier because of such a mutation.) In some ways, *Ae. albopictus* is more dangerous than *Ae. aegypti* because it can breed in temperate climates and disperses very easily. During the last 50 years it has spread to every continent from its Asian origins and established breeding cycles.

For dengue, Chikungunya, and Zika, the most important mode of global spread is through air travel by infected travelers. Given the burden posed by dengue, patterns of this spread

have been studied extensively for a decade (Tatem et al., 2006; Wilder-Smith and Gubler, 2008; Gardner et al., 2012; Gardner and Sarkar, 2013). Mathematical and computational models have been constructed to assess the relative risk of the importation of the disease and the establishment of an autochthonous transmission cycle in new areas. These models and risk analyses methods, originally devised for dengue, are equally applicable to the other diseases vectored by *Aedes* species.

There are two factors that determine risk of spread of a disease in almost all of these models: (1) the likelihood of an infected air traveler arriving at these areas from a region where the disease is already locally established; and (2) the abundance of vector mosquito populations at the destination which can then spread the disease. The first of these factors influences the probability that a disease agent will be introduced to a new region from an area of the world where there is already an autochthonous cycle. The second similarly shows the likelihood that it will become local, that is, a disease cycle will be established in that region that will persist independent of further reintroduction through air travel.

The first of these factors can be quantified using air travel data from a variety of sources such as the International Air Travelers Association (IATA) which track travel volumes per month. However, there are problems: it is hard to get data on chartered flights and the travel industry does not typically make public projected data such as a forecast of the likely travel volume to Brazil for the 2016 Olympic Games (which may pose the most significant threat for the spread of Zika in the near future). The second factor can be estimated using a variety of modeling techniques loosely called "species distribution modeling" which uses geographical records of a species' occurrence and environmental data to predict where else a species can be found (Franklin, 2010).

For diseases carried by *Aedes* mosquito species, a very critical factor has been the vector status of *Ae. albopictus* because of how widely this species has established itself across the world.

Dengue has probably not succeeded in spreading in temperate climates because of the relatively poor efficiency of this species as a vector. Travel records show that air travel from Latin America to North America and from Southeast Asia to Europe (including stopovers) pose the greatest risk. Chikungunya has not spread as much as it could partly because areas in which it is found are not as well-connected by air to temperate regions. For Zika, though there is good reason to believe that *Ae. albopictus* is capable of transmission, this has not been conclusively proved (and its relative efficiency as a vector is unknown).

If Zika is primarily vectored by *Ae. aegypti*, then the maximal threat is rather limited in North America, to Florida and Texas (thanks to both the climate and the importance of air travel from Latin America through Miami and Houston). Europe remains relatively unscathed as do the temperate areas of Asia and the southern hemisphere. If *Ae. albopictus* is also an efficient vector, then all of the Americas (including cities in Canada such as Montreal, Toronto, and Vancouver and cities in Chile such as Santiago) are at risk. Almost all of Western Europe (except most of Scandinavia) is also at risk. Right now it is critical to get a proper understanding of the efficiency of this species to spread Zika. Equally, it is important to have some quantitative extent of the spread of this disease through sexual and congenital transmission. (Here, Zika may well turn out to be different from other *Aedes*-borne diseases.)

References

Franklin, J. 2010. *Mapping Species Distributions: Spatial Inference and Prediction*. Cambridge: Cambridge University Press.

Gardner, L., and S. Sarkar. 2013. "A Global Airport-Based Risk Model for the Spread of Dengue Infection via the Air Transport Network." *PLoS ONE* 8 (8): e72129. doi:10.1371/journal.pone.0072129.

Gardner, L. M., D. Fajardo, S. T. Waller, O. Wang, and S. Sarkar. 2012. "A Predictive Spatial Model to Quantify the Risk of Air-travel-associated Dengue Importation into the United States and Europe." *Journal of Tropical Medicine.* doi:10.1155/2012/103679.

Mlakar, J., M. Korva, N. Tul, M. Popović, M. Poljšak-Prijatelj, J. Mraz, M. Kolenc, et al. 2016. "Zika Virus Associated with Microcephaly." *New England Journal of Medicine.* doi:10.1056/NEJMoa1600651.

Rowland-Jones, S. L. 2016. "Chikungunya: Out of the Tropical Forests and Heading Our Way." Transactions of the Royal Society of Tropical Medicine and Hygiene 110: 5–86.

Tang, H., C. Hammack, S. C. Ogden, Z. Wen, X. Qian, Y. Li, B. Yao, et al. 2016. "Zika Virus Infects Human Cortical Neural Progenitors and Attenuates Their Growth." *Cell Stem Cell.* doi:10.1016/j.stem.2016.02.016.

Tatem, A. J., S. I. Hay, and D. J. Rogers. 2006. "Global Traffic and Disease Vector Dispersal." *Proceedings of the National Academy of Sciences* 103: 6242–6247.

Wilder-Smith, A., and D. J. Gubler. 2008. "Geographic Expansion of Dengue: The Impact of International Travel." *Medical Clinics of North America* 92: 1377–1390.

Sahotra Sarkar is Professor in the Department of Integrative Biology and Philosophy at the University of Texas at Austin. Educated at Columbia University (BA, 1981) and the University of Chicago (MA, 1985; PhD, 1989), he has previously taught at McGill University and been a Fellow of the Wissenschantfskolleg zu Berlin.

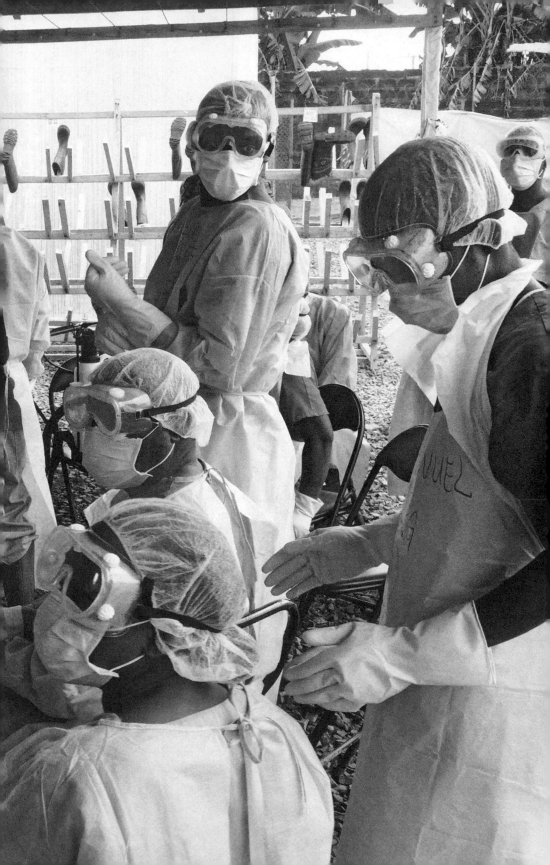

This chapter profiles a list of the organizations and people who are or were key players in the arena of coping with epidemics and potential pandemic threats.

People

This biographical selection is a partial list of the individuals who have been or are key players in the arena of coping with epidemic and pandemic threats. It covers both international and national governmental officials as well as scholars and nongovernmental organizational leaders. They are listed in alphabetical order by last name.

Anthony Banbury (1964–)

Since September 2014, Mr. Banbury serves as the Special Representative of the Secretary General of the United Nations Mission for Emergency Ebola Response. He is a United States citizen, born in 1964. Mr. Banbury took his political science degree from Tufts University, and his master's degree from the Fletcher School of Law and Diplomacy. He is also a diplomat

Health care workers prepare for work inside an USAID-funded Ebola clinic in Monrovia, Liberia, on January 30, 2015. Workers must wear elaborate protective gear to prevent infection from the highly contagious Ebola virus. (AP Photo/Abbas Dulleh)

of the Graduate Institute of International Studies in Geneva, Switzerland. A career diplomat with the United Nations, Mr. Banbury has held various positions with the organization. He served, from 1988 to 1995, with the United Nations Border Relief Operation in Thailand and with their Transnational Authority in Cambodia as well as the UN Protection Force in Bosnia-Herzegovina and Croatia. In 1996–1997 he worked in the UN's Secretariat, in the Executive Office of the Secretary-General, and in the Department of Humanitarian Affairs. From 2003 to 2009 he served as the Asia Regional Directors for the World Food Programme in Bangkok, from which office he managed relief and development operations in 14 countries, including for the 2004 tsunami and the 2008 Cyclone Nargis. He also worked for the U.S. government. From 1997 to 1999 he was an advisor on the Balkans in the Office of the Secretary of Defense, and from 2000 to 2003, at the National Security Council of the White House. Prior to his current position with the UN, he was Senior United Nations System Coordinator for Ebola, and from 2009 to 2014, as Assistant Secretary-General for Field Support, in which capacity he developed cross-cutting field support policies and strategies as well as supervising daily operations across the full range of mission support areas.

Emil von Behring (1854–1917)

Born in 1854 in Hansdorf, Germany, he attended the Army Medical College at Berlin, where he took his medical degree in 1878. He was stationed in Posen, Poland, where he pioneered work on septic diseases and demonstrated the antitoxin action of iodoform in 1882. He was sent to Bonn for pharmacology study in experimental methods. The army ordered him back to Berlin as an assistant at the Institute of Hygiene under Robert Koch, whom he followed to the Institute for Infectious Diseases, where he worked with Koch and Paul Ehrlich. In 1894 he became Professor of Hygiene at Halle, then moved to that chair at Marburg. His work was part of the epoch work of

Pasteur, Koch, Ehrlich, Loffier, Roux, Yersin, and others, laying the foundation of immunology of bacterial diseases. Behring is most noted for his work on diphtheria and tuberculosis. He researched whether a disinfection of the living organism might be obtained if animals were injected with material treated with various disinfectants, notably diphtheria and the tetanus bacilli, leading to a new kind of therapy of these two diseases. In 1890, he and S. Kitasata published their discovery that graduated doses of sterilized broth cultures of diphtheria and tetanus bacilli caused animals to produce, in their blood, substances that could neutralize the toxins, and showed the antitoxins produced by one animal could immunize another animal and could cure an animal showing symptoms of diphtheria. In 1913 Behring produced a mixture whose subsequent refinement resulted in the modern methods of immunization that largely banished diphtheria from the scourges of humankind. He regarded this as the crowning success of his life's work. In 1901 he was awarded the Nobel Prize. He died on March 31, 1917.

Seth Berkley (1956–)

Dr. Berkley is a medical epidemiologist born in 1956 in New York City. He is the CEO of the GAVI Alliance and a global advocate on the power of vaccines. He is the founder and former President and CEO of the International AIDS Vaccine Initiative (IAVI). He received a Bachelor of Science and medical degrees from Brown University and trained in internal medicine at Harvard University. In 2009 *Fortune* magazine named him one of its "Global Forum Visionaries." From 1984 to 1986 he worked as a medical epidemiologist at the CDC in Atlanta. He investigated an outbreak of Brazilian Purpuric Fever, a disease killing children in Brazil, and helped discover the etiologic agent. In 1986, on assignment from the CDC, he served as epidemiologist for the Massachusetts Department of Public Health on surveillance and outbreak investigations. In 1987, while working for the Carter Presidential Center in Atlanta, Dr. Berkley was assigned

as an epidemiologist at the Ministry of Health in Uganda, where he established and managed the Ugandan surveillance system for AIDS, and assisted with the conduct and analysis of the national HIV sero-survey, helped develop the Ugandan National AIDS Control program, and served as an attending internal medicine physician at Mulago Hospital in Kampala. He worked for the Rockefeller Foundation as Program Scientist for eight years, managing programs in epidemiology, public health, medical and nursing education, vaccination, AIDS and sexually transmitted diseases, and reproductive health in Africa, Asia, and Latin America. He joined the GAVI Alliance as its Chief Executive Officer (CEO) in 2011, a public–private partnership whose mission is to save children's lives by increasing access to immunization in developing countries. Since 2000, GAVI has prevented more than five million deaths and helped protect 288 million children with new and underused vaccines, and delivered vaccines to a quarter of a billion children and prevented an estimated four million more deaths by 2015. He has coauthored several books and scientific articles.

Kent Brantly

Dr. Brantly is a U.S. medical missionary with Samaritan's Purse, who contracted Ebola in July 2014 while working as a doctor in Liberia at the ELWA Hospital in Monrovia. He survived after treatment at Emory University Hospital in Atlanta. He testified before Congress at a joint Senate hearing examining the Ebola outbreak and the needs there. He criticized the WHO's slow response to the outbreak as painfully slow and ineffective. His blood serum, which had developed antibodies, has been used to treat other patients.

Larry Brilliant

President of Skoll Global Threat Fund and an MD and MPH who is board certified in preventive medicine and public health, Dr. Brilliant is founder and director of the Seva Foundation,

which works in dozens of countries around the world to eliminate preventable and curable blindness. He serves as a member of the strategic advisory committee for the Berkeley School of Public Health at the University of California, Berkeley. He cofounded *The Well*, a pioneering virtual community, in 1985 and holds a telecommunications technology patent, and has served as CEO of two public companies and other venture-backed startups. He has authored two books and dozens of articles on infectious diseases. He was a CDC "first responder" for smallpox bioterrorism response effort, volunteered in Sri Lanka for tsunami relief, and established "Pandefense," an interdisciplinary consultancy to prepare for a possible pandemic influenza. He played a key role in the WHO's smallpox eradication program, and worked on their polio eradication effort as well. At Skroll, he will develop the strategy and approach for the newly launched Fund, working with commercial and philanthropic entities to drive positive change on urgent social and environmental issues. He earlier served as the inaugural Executive Director of Google.org on its philanthropic efforts, including overseeing the Google Foundation, Google Grants, and other major social-change initiatives.

John S. Brownstein

Dr. Brownstein is a trained epidemiologist at Yale University, where he received his PhD. He is an associate professor, Harvard Medical School, Children's Hospital Informatics Program where his research focus is on computational epidemiology, health geographics, and population health information. He works on the design, evaluation, and implementation of public health surveillance systems, and on statistical modeling of public health surveillance data to improve prevention and control activities, focusing on a variety of infectious diseases, including malaria, HIV, dengue, West Nile virus, Lyme disease, RSV, salmonella, listeria, and influenza. His current focus is on predicting patterns of influenza epidemics and pandemics, the efficacy

of disease control strategies including vaccination, quarantine, and travel restrictions. He is leading the development of several novel disease surveillance systems, including HealthMap.org, an Internet-based infectious disease intelligence system, currently in use by the CDC, WHO, DHS, DOD, HHS, EU among others. He is vice president of the International Society for Disease Surveillance and author of over 100 articles in the area of disease surveillance.

Donald S. Burke

As a professor in the Department of Epidemiology at the University of Pittsburgh Graduate School of Publish Health, Burke serves as Director of the Center for Vaccine Research, and as Dean of the Graduate School of Public Health. He is also the Associate Vice Chancellor for global health and health sciences, and occupies the Jonas Salk Chair in Global Health. Born in Cleveland, Ohio, Dr. Burke attended Western Reserve University, from which he took his BA degree. He has a MD from Harvard Medical School. He interned and did his residency at Boston City and Massachusetts General Hospitals, and trained as a research fellow in infectious diseases at the famous Walter Reed Army Medical Center. He is an expert in the prevention and control of infectious diseases of global concern, particularly HIV/AIDS, influenza, dengue, and emerging infectious diseases. He developed new diagnostics, population-based field studies, clinical vaccine trials, computational modeling of epidemic control strategies, and policy analysis. His current research focuses on the virus transmissions to humans from animals among central African bush meat hunters.

Albert Calmette (1863–1933)

This noted French physician, bacteriologist, and immunologist associated with the Pasteur Institute was born in 1863 in Nice, France. He served in the French navy, having attended

the School of Naval Physicians and then in the Naval Medical Corps, stationed in Hong Kong, where he studied malaria, and after taking his doctoral degree in 1886, he served in West Africa, in Gabon and French Congo, where he researched malaria, sleeping sickness, and pellagra. He returned to France in 1890, and met with Pasteur and Emile Roux. He became an associate and in 1891 Pasteur sent him to direct a branch of the Pasteur Institute in Saigon (then known as French Indochina). He researched in the then nascent field of toxicology, and immunology, studying snake and bee venom, and plant poisons and their cures. He developed production of vaccines, most notably against tuberculosis, and the first antivenom for snake venom, the Calmette's serum. In 1894 he returned to France and took part in the development of the first serum against bubonic plague. In 1895 Roux appointed him director of the Pasteur Institute's branch in Lille, where he served for 25 years. In 1909 he helped establish the branch in Algiers, and in 1918, accepted the post as assistant director in Paris. In 1919 he was made a member of the Academie Nationale de Medecine. He died in 1933.

Ernst Chain (1906–1979)

Chain was born in Berlin in 1906 and attended the university there, studying biochemistry. In 1933, fleeing Nazi rule in Germany, he emigrated to England and worked at the School of Biochemistry, Cambridge. In 1935 he joined the School of Pathology at Oxford University in chemical pathology. In 1948 he was appointed Scientific Director at the International Research Centre for Chemical Microbiology in Rome. In 1961 he became professor of Biochemistry at Imperial College, University of London. He received many awards and medals, the most notable of which was the Nobel Prize in medicine in 1945, with Sir Alexander Fleming and Sir Howard Florey, for their work discovering and redevelopments of the chemotherapeutic action of penicillin. He died in 1979.

Margaret Chan

Chan, the WHO Director General, is from the People's Republic of China, having been elected as Director General in 2006 and reelected in 2012. She earned her medical degree from the University of Western Ontario in Canada, and joined the Hong Kong Department of Health in 1978. She was appointed Director of Health in Hong Kong in 1994, where she served for nine years and managed outbreaks of avian influenza and SARS. In 2003, she joined WHO as Director of the Department for Protection of the Human Environment, and in 2005, Director of Communicable Diseases Surveillance and Response, and Assistant Director-General for Communicable Diseases. Her latest term as Director General will continue until June 2017.

Nancy Cox

Dr. Cox serves as the Chief of Influenza Division at the Centers for Disease Control and Prevention in Atlanta. In 2008 she was honored as Federal Employee of the Year by the Partnership for Public Service for her work in the United States and with the United Nations' WHO for preparation to deal with a potential influenza pandemic. The Partnership has, since 2002, presented Service to America Medals to federal employees based on their significant contributions and commitment and innovation, as well as the impact of their work in addressing the needs of the nation.

In 1970, Dr. Cox earned her bachelor's degree in bacteriology from Iowa State University, and completed graduate school on a Marshall Scholarship at the Darwin College at the University of Cambridge, England, where she began her work on influenza research. She was a member of the editorial board for the prestigious journal, *Lancet Infectious Diseases*. She is a founding member of the International Society for Influenza and Respiratory Diseases. She is the author of 175 research articles, reviews, and book chapters. She did postdoctoral work as a Fellow at the University of Maryland. She joined the CDC

in 1975 where she has worked ever since. In 2006, *Time* magazine named her one of the 100 Most Influential People of the Year, and in 2008 *Newsweek* magazine honored her as one of its "15 People Who Make America Great."

Grace Eldering (1900–1988)

Dr. Eldering is noted for her pioneering pertussis (whooping cough) vaccine research work, with Dr. Pearl Kendrick, at the Michigan Department of Health's research laboratory. In the 1920s, pertussis was a greater killer, more than 6,000 children annually, than was diphtheria, scarlet fever, or measles. Dr. Eldering was born in eastern Montana in 1900 and studied at the University of Montana in Missoula, and taught biology at the Hysham High School for a year before joining the Michigan Bureau of Laboratories in 1928. She earned her Doctor of Science degree from Johns Hopkins University in 1942. In 1932, Eldering joined Kendrick in Grand Rapids, conducting whooping cough research. They developed and improved methods for growing the pertussis bacillus, inactivating it, and creating a safer and more effective vaccine, and pioneered work and directed the first large-scale controlled clinical trial for pertussis vaccine, hailed as one of the greatest field tests in microbe-hunting history. They authored more than 60 articles in various medical journals. They saved hundreds of thousands of lives at modest costs. Elderling died in 1988.

John Franklin Enders (1897–1985)

Enders, an American biomedical scientist and Nobel laureate, has been hailed as "the Father of Modern Vaccines." Born in Connecticut in 1897, he attended Yale University, then joined the Army Air Corp in 1918 as a flight instructor and a lieutenant. After World War I, he graduated from Yale, eventually gaining a PhD at Harvard in 1930 and choosing the biomedical field with a focus on infectious diseases.

In 1949 he, Thomas Weller, and Frederick Robbins reported successful in vitro culture of an animal virus—poliovirus. The three received the 1954 Nobel Prize in Medicine for culturing the poliovirus, and developing the measles vaccine. Enders was named a Fellow of the American Academy of Arts and Sciences in 1946, the Kyle Award from the U.S. Public Health Service in 1955; the Presidential Medal of Freedom and the Science Achievement Award from the American Medical Association in 1963; and was named a Foreign Member of the Royal Society of London in 1967. He died in 1985 at age 88, holding honorary degrees from 13 universities.

Paul Farmer (1959–)

Dr. Farmer was born in 1959 in Massachusetts. He is an American anthropologist and physician noted for his humanitarian work in health care for rural and underresourced areas in developing countries. He is cofounder of Partners in Health, an international social justice and health organization that first worked in Haiti. He is a professor at Harvard University and formerly Professor of Medical Anthropology in the Department of Social Medicine at the Harvard Medical School, and an attending physician and Chief of the Division of Global Health Equity at Brigham and Women's Hospital in Boston, Massachusetts. He was named Chair of the Harvard Medical School's Department of Global Health and Social Medicine in 2009, and in 2010 was named a University Professor, the highest honor the university can bestow on one of its faculty members. He resides in Rwanda as of 2008, where he is board-certified in internal medicine and infectious diseases. He is editor-in-chief of *Health and Human Rights Journal*. In 2009 he was named UN Deputy Special Envoy in Haiti.

Dr. Farmer attended Duke University, earning his BA in medical anthropology and graduating summa cum laude. He attended Harvard University, earning an MD and a PhD in medical anthropology. Farmer oversees projects in Russia,

Rwanda, Lesotho, Malawi and Peru. He has received numerous awards and four honorary doctorate degrees. He is the author of eight books.

Sir Alexander Fleming (1881–1955)

Born in Scotland in 1881, Fleming attended several schools in Scotland before entering St. Mary's Medical School, London University, where he qualified with distinction in 1906. He gained MB and BS, London, with Gold Medal in 1908, and became a lecturer at St. Mary's until 1914, when he served in World War I as captain in the Army Medical Corps. After the war he returned to St. Mary's, elected Professor in 1928, and Emeritus Professor of Bacteriology, University of London in 1958. He was made a Fellow of the Royal Society in 1943, and knighted in 1944. He developed penicillin to treat staphylococci. He authored numerous papers on bacteriology, immunology, and chemotherapy, including descriptions of lysozyme and penicillin, published in several medical and scientific journals. He was awarded the Nobel Prize in Medicine in 1945, and died in 1955.

Howard Florey (1898–1968)

Sir Dr. Howard Florey was born in Malvern, Australia, in 1898. He earned his BA in Surgery from the University of Adelaide in 1921, his MA in Physiology from Oxford University in 1924, and his PhD from Cambridge University in 1927. He taught at Cambridge, Sheffield, and Oxford Universities, and was an administrator at Australian National University, 1965–1968. In 1928, Alexander Fleming accidentally discovered a mold on some germ cultures. A decade later, Howard Florey and Ernst Chain, experimental pathologists and bacteriologists at Oxford, isolated the active substance of the mold, penicillin, eventually producing an effective and safe antibacterial agent, and went on to design methods to mass produce and bring their medicine to the public. Florey, Fleming, and Chain shared the

1944 Nobel Prize in Medicine. Until penicillin was discovered and mass produced as an antibiotic, infection and diseases like pneumonia, syphilis, gonorrhea, diphtheria, and scarlet fever were untreatable, and penicillin was considered miraculous. It is now prescribed a quarter-billion times annually world-wide, saving untold millions of lives. Florey was knighted in 1944, and his portrait appeared for many years on the Australian $50 bill. He was the recipient of many awards and honors, including a Rhodes Scholarship in 1921, Knighthood of the British Empire in 1955, the Nobel Prize in 1945, the French Legion of Honor in 1946, the Royal Medal in 1951, the Copley Medal in 1957, President of the Royal Society from 1960 to 1965, the Order of Merit in 1965, and a Life Peerage in 1965. He authored three books. He died in Oxford, England, in 1968.

Tom Frieden (1960–)

The director of the CDC, Frieden was born in 1960. He graduated from Oberlin College with a BA in 1982, Columbia University College of Physicians and Surgeons (MD) in 1986, and Columbia University Mailman School of Public Health (MPH) in 1985. He did his internal medicine training at Columbian-Presbyterian Medical Center and a subspecialty in infectious diseases at Yale University. He worked on tuberculosis in New York, helping control rapidly and reducing overall incidence for tuberculosis during an epidemic there. From 1996 to 2002, Dr. Frieden worked in India, assisting with a national tuberculosis control effort as a medical officer for the WHO on loan from the CDC. In 2008, an estimated eight million treatments for TB saved an estimated 1.4 million lives. He was appointed by Mayor Bloomberg to serve as head of New York City Department of Health and Mental Hygiene from 2002 to 2009. He introduced "Take Care New York," the city's first comprehensive health policy targeting preventable illness and death through a concerted public health effort,

and NYC made measurable progress in eight of its ten priority areas, notably in HIV/AIDS, diabetes, and food policies to combat cardiovascular diseases and tobacco control. In 2009 he became Director of the U.S. Centers for Disease Control and Prevention, and Acting Administrator of the Agency for Toxic Substances and Disease Registry (ATSDR), as appointee by President Barack Obama. Dr. Frieden has been a prominent figure in the U.S., UN, and CDC's global response to the West African outbreak of Ebola.

Keiji Fukuda

Fukuda, the WHO Assistant Director for General Global Health, is an American physician who specializes in influenza epidemiology and WHO's Special Representative for Antimicrobial Resistance. His parents were physicians who immigrated from Japan to Vermont. Dr. Fukuda took his BA from Oberlin College and medicine at the University of Vermont College of Medicine, taking his MD in 1983. He worked in southern India with indigenous tribes, furthering his interest in international health. He completed his internal medicine residency at Mount Zion Hospital in San Francisco, and obtained a Master of Public Health at the University of California at Berkeley. He worked in San Francisco for one year on leprosy and tuberculosis before moving to Atlanta, Georgia, where he undertook a two-year training program in the Epidemiology Intelligence Service at the CDC. Dr. Fukuda joined WHO in 2005 as a Scientist in the Global Influenza Program, then served as Coordinator from 2006 to 2008, greatly expanding its guidance related to seasonal avian and pandemic influenza. He helped manage the response to the influenza H1N1 pandemic, and participated in many field investigations including the earliest outbreaks of avian H5N1 influenza and the emergence of SARS. Dr. Fukuda was Special Advisor on Pandemic Influenza from 2005 to 2009. From 2010 to 2015, he served as Assistant Director-General for Health Security.

William Crawford Gorgas (1854–1920)

Dr. Gorgas, born in Mobile, Alabama in 1854, is a public health pioneer noted for his work in stopping epidemics of yellow fever and malaria. After medical school, he joined the U.S. Army and was appointed to the Reed Commission to study yellow fever. While stationed in Cuba, Gorgas collaborated with Juan Carlos Finley on studying and proving that the mosquito was the carrier of the diseases. When the Reed Commission proved the connection, Dr. Gorgas led the campaign to rid Havana of its regular epidemics of yellow fever. When that campaign was successful, Dr. Gorgas was transferred to Panama to exterminate the mosquitoes there. His work there stopped the spread of the dreaded diseases enabling completion of the Canal. He went on to be appointed Surgeon General of the United States Army. He died in 1920.

Lawrence Gostin

Associate Dean and Professor of Public Health Law at Georgetown University law center where he directs the O'Neill Institute for National and Global Health Law, Professor Gostin is also Professor of Public Health Law at Johns Hopkins University and the Director of the Center for Law and Public Health, a Collaborating Center with the World Health Organization and Centers for Disease Control. He is author of *Public Health Law: Power, Duty, Restraint.* Professor Gostin is also Visiting Professor of Public Health on the Faculty of Medical Sciences, a Research Fellow with the Centre for Social-Legal Studies at Oxford University.

Camille Guerin (1872–1961)

Guerin was a French veterinarian, bacteriologist, and immunologist, who, with Albert Calmette, developed the Bacillus Calmette-Guerin (BCG) vaccine for immunization against tuberculosis. He was born in 1872 in Poitiers, France. His father died of tuberculosis. Dr. Guerin studied veterinary medicine at the Ecole Nationale Veterinaire d/Alfort from 1892 to 1896.

In 1897 he joined the Pasteur Institute in Lille, France, where he began his work with Albert Calmette, first on the antivenom serum against snakebite and then on the vaccine against small-pox. He was promoted to head of the Lille laboratory in 1900, and then worked on a vaccine against tuberculosis in close association with Calmette until Calmette's death in 1933. In 1928, Guerin moved to Paris to become Director of the Tuberculosis Service at the Pasteur Institute and was named Vice-President of the National Defense Committee Against Tuberculosis. In 1948, he chaired the First International Congress on GCB. In 1949, he served as President of the Veterinary Academy of France, and President of the Academy of Medicine in 1951. In 1955, the French Academy of Sciences awarded him the Scientific Grand Prix. He died at age 89, in 1961, in Paris.

Alan Hay

Dr. Hay, of the World Influenza Center, studied biochemistry at the University of Aberdeen and began his study of viruses during his PhD research. He did two years of postdoctoral research at Duke University, then became a member of the MRC scientific staff at the National Institute of Medical Research, in London, until his retirement there in 2009. His expertise concerns the biochemistry of influenza viruses and their replication, particularly the means of transcription and replication of the virus genome; the antiviral action of the anti-influenza drug amantadine, and the proton channel function of the target M2 protein, as well as the molecular bases for resistance to antiviral drugs against the M2 and NA proteins. As Director of the WHO Collaborating Centre for Reference and Research on Influenza at NIMR, United Kingdom, from 1993, he researched the epidemiology and evolution of human and animal influenza viruses in relation to current changes in human viruses, and in the composition of influenza vaccines and the emergence of novel human viruses with the potential to cause a pandemic.

David K. Henderson

Dr. Henderson is the Deputy Director for Clinical Care and Associate Director for Quality Assurance and Hospital Epidemiology at the National Institutes of Health Clinical Center. Dr. Henderson joined the NIH in 1979 as the hospital epidemiologist. His research focuses on occupational and health care–associated infection with blood-borne infectious diseases, the threat of emerging antimicrobial resistant infections to public health. Dr. Henderson earned his undergraduate degree from Hanover College in Indiana. He took his medical degree from the University of Chicago's Pritzker School of Medicine and completed an internship in internal medicine and a two-year fellowship in infectious diseases at Habor-UCLA Medical Center in Los Angeles. He was assistant professor of medicine at the UCLA School of Medicine. Dr. Henderson is a Fellow of the Infectious Disease Society of America, and of the Society for Healthcare Epidemiology in America. He is the recipient of six NIH Director's Awards, a Clinical Center Director's Award, two Director's Merit Awards for Significant Achievement from the National Institute of Mental Health, and two Department of Health and Human Services Secretary's Distinguished Service Awards. He is the author of more than 150 articles and book chapters. He is an international speaker and consultant to the Centers for Disease Control and Prevention.

Donald A. Henderson (1928–)

Born in 1928 in Ohio, Henderson is an American physician, educator, and epidemiologist who directed the ten-year (1967–1977) international effort to eradicate smallpox worldwide through the WHO childhood vaccination programs. Dr. Henderson graduated from Oberlin College in 1950, and earned his MD from the University of Rochester School of Medicine in 1954 and was later a Public Health Service Officer in the Epidemic Intelligence Service of the CDC. He earned an MPH degree from the Johns Hopkins School of Hygiene and

Public Health in 1960. He served as the Chief of the CDC virus disease surveillance programs from 1960 to 1965, and there developed the proposal for a United States Aid for International Development (USAID) program to eliminate smallpox and control measles during a five-year period in 18 contiguous countries in West and Central Africa. It became the initiative for the WHO program to eradicate smallpox worldwide within a ten-year period. More than 10 million cases and two million deaths were occurring annually. He developed the key strategy of "surveillance containment." WHO staff and advisors in 73 countries worked closely with national staff, and the last case of smallpox occurred in Somalia in 1977. Smallpox is the first human disease ever to be eradicated, and its success became the impetus for the WHO's global programs on immunization targeting other vaccine-preventable diseases, including poliomyelitis, measles, tetanus, diphtheria, and whooping cough. After the smallpox campaign, Dr. Henderson served as Dean of the Johns Hopkins School of Public Health from 1977 to 1990. In 1991 he was appointed to the Office of Science and Technology Policy in the Executive Office of the President and, later, as Deputy Assistant Director and Science Advisor in the Department of Health and Human Services. In 1998, he became the founding director of the Johns Hopkins Center for Civilian Biodefense Strategies, now the UPMC Center for Health Security. After the 9/11 attack on the World Trade Center, HHS Tommy Thompson appointed Henderson to the Office of Public Health Preparedness, later the Office of the Assistant Secretary for Preparedness and Response, overseeing a $3 billion budget. He is the recipient of numerous awards, honor, and medals, the author of several books, and of many book chapters and scholarly journal articles.

Maurice Hilleman (1919–2005)

Born in 1919 in Montana, Hilleman was an American microbiologist who developed more than 40 vaccines, 14 of which

are routinely recommended in current vaccine schedules, and he developed eight for measles, mumps, hepatitis A, hepatitis B, chickenpox, meningitis, pneumonia, and *Haemophilus influenza* bacteria. He played a role in the discovery of the cold-producing adenoviruses, the hepatitis viruses, and the cancer-causing virus SV40. He is credited with saving more lives than any other medical scientist of the 20th century, and has been described as the "most successful vaccinologist in history." Hilleman graduated first in his class from the Montana State University in 1941, and won a Fellowship to the University of Chicago where he received his doctoral degree in microbiology in 1944. He joined the E.R. Squibb and Sons (now Bristol-Myers Squibb) where he developed several vaccines from 1958 to 1957. In 1957 he discovered the genetic changes that occur when the influenza virus mutates—known as gene shift and gene drift. His work on the Hong Kong pandemic won him the Distinguished Service Medal. He joined Merck and Company in 1957, where he developed 40 experimental and licensed animal and human vaccines. He was a vaccine pioneer who first warned of the possibility that simian viruses might contaminate vaccines, including SV40, a viral contaminant of the polio vaccine. At the time of his death, in 2005 in Philadelphia at age 85, he was Adjunct Professor of Pediatrics at the University of Pennsylvania in Philadelphia.

Edward Jenner (1749–1823)

Jenner was an English physician born in 1749. He is most noted as the medical pioneer who developed the smallpox vaccine. While apprenticed to a London surgeon, he heard a young milkmaid claim she could not get smallpox because she already had suffered a case of cowpox. He continued his studies, in 1770, with a London physician, John Hunter. In 1796, in his hometown of Berkeley, he began testing his process of vaccination and development of the smallpox vaccine. Based

upon his work, compulsory vaccination soon spread throughout Europe, paving the way for modern immunology. Jenner died in 1823.

Pearl Kendrick (1890–1980)

Dr. Kendrick is the American medical scientist most noted for developing the whooping cough vaccine. Born in 1890 in Wheaton, Illinois, she was struck with whooping cough—known to medical science as pertussis after the bacteria that causes it, *Bordetella pertussis*. In the 1940s, the disease was responsible for more infant deaths than polio, measles, tuberculosis, and other childhood diseases combined. Dr. Kendrick got her undergraduate degree in bacteriology at Columbia University in 1917, and worked for two years at the New York State Department of Health Laboratories. She earned her PhD in microbiology form Johns Hopkins University in 1932, and directed the Western Michigan Branch Laboratory in Grand Rapids, Michigan. During the Great Depression, funding was virtually nonexistent. She and her partner, Grace Elering, worked on their own time and assembled a group of local physicians to conduct a self-contained clinical trial. In 1936, First Lady Eleanor Roosevelt spent a day at her laboratory and helped find funding to add several workers to Kendrick's staff. Their vaccine proved effective and became the U.S. standard, and in 1958, the WHO designated it as the international standard.

Kamran Khan

Associate Professor, Department of Medicine, Division of Infectious Diseases in the Department of Health Policy, Management and Evaluation at the University of Toronto, Khan is also the staff scientist at the Li Ka Shing Knowledge Institute at St. Michael's Hospital in Toronto where he studies global migration patterns and infectious disease spread, international air travel, infectious disease pandemics, mass gatherings, immigrant and refugee health, tuberculosis, and has pioneered

mathematical modeling of infectious diseases. He directs the Bio.Diaspora Project, a multidisciplinary study of global population mobility via commercial air travel and its role as a conduit for the international spread of infectious diseases that have the potential to become pandemics.

Ron Klain (1961–)

Ron Klain was born in 1961 in Indianapolis. He graduated summa cum laude from Georgetown University in 1983, and magna cum laude from the Harvard Law School in 1987. He served as law clerk to Supreme Court Justice Byron White in 1987–1988, and from 1988 to 1992 as Chief Counsel to the U.S. Senate Committee on the Judiciary. He served as the Legislative Director for Rep. Ed Markey (D-MA), and in 1995, Senator Tom Daschle appointed him the Staff Director of the Senate Democratic Leadership Committee. He served as Chief of Staff to two vice-presidents, Al Gore (1995–1999) and Joseph Biden (2009–2011). In 2014, Klain was named by President Barack Obama to the newly created position of "Ebola response coordinator," less officially known as the Ebola Czar. He helps coordinate the nation's response to the Ebola epidemic.

Robert Koch (1843–1910)

Koch was born in 1843 in Clausthaj, Germany. In 1862 he began his study of medicine at the University of Gottingen where he was influenced by Professor Jacob Henie, who in 1840 had published his theory that infectious diseases were caused by living, parasitic organisms. Koch took his MD degree in 1866. In 1870 he volunteered for service in the Franco-Prussian War, from 1872 to 1880. He began research on anthrax and wanted to know whether the anthrax bacilli that had never been in contact with any kind of animal could cause the disease. He obtained pure cultures of the bacilli by growing them in the aqueous humor of the ox's eye, and noted they produced inside

themselves rounded spores that resisted adverse conditions, like the lack of oxygen. He grew the bacilli for several generations in the pure cultures and showed they could cause anthrax even though they had no contact with any kind of animal. In 1878 he studied diseases that caused bacterial infections of wounds. In 1880, he went to Berlin where he organized a laboratory where he refined the bacteriological methods and invented new methods, with his colleague Petri. In 1882 he discovered the tubercle bacillus. He was working on that when he was sent, in 1883, to Egypt as head of the German Cholera Commission where he discovered the vibrio that causes cholera and brought back pure cultures to Germany. He also studied cholera in India. In 1885, he was appointed Professor of Hygiene at the University of Berlin, and Director of the Institute of Hygiene. In 1891 he became Honorary Professor of the Medical Faculty of Berlin and Director of its new Institute for Infectious Diseases where he worked alongside such pioneers of bacteriology as Ehrlich, von Behring, and Kitasato where they carried out and published their epoch-making work on the immunology of diphtheria. Koch was the recipient of many prizes, medals, and honorary degrees from several universities. In 1905 he was awarded the Nobel Prize for Physiology or Medicine. He died on May 27, 1910, in Baden-Baden, Germany.

Joseph Lister (1827–1912)

Born in Essex, England, in 1827, Lister was the son of a successful wine merchant who had a deep interest in science and had invented the achromatic microscope that did not distort color. Lister took up his father's interest in science. He took a degree at the University of London in 1847, then after recovering from a bout of smallpox, he studied medicine there, taking his degree in 1852. He went to Edinburgh, Scotland, where he was assistant to Scottish Surgeon James Syme, whose daughter he later married, and who he succeeded in his laboratory upon Syme's retirement due to illness. In 1860, Lister was appointed

Professor at the Royal Infirmary, Glasgow, and made a member of the Royal Society, for his anatomical research. In 1877 Lister was made Chair of Clinical Surgery at King's College, London. He developed the process of aseptic surgery, more important to surgery than any other process except anesthesia. He served as President of the Royal Society, and in 1883, Queen Victoria elevated him to the peerage (Baron) and in 1897, as Lord Lister. He died in Kent, in February, 1912, at the age of 84.

Vivek H. Murthy

Dr. Murthy, Vice Admiral and Surgeon General of the United States, was appointed Surgeon General by President Obama in December 2014, in which capacity he oversees operations of the U.S. Public Health Service Commissioned Corp of more than 6,700 uniformed health officers serving in 800 locations around the world. Dr. Murthy, the son of immigrants from India, took his BA from Harvard University, and his MD and MBA from Yale. He joined the faculty of the Harvard Medical School as clinician-educator. He cofounded VISIONS, an HIV/AIDS education program in India and the United States, and led it for eight years establishing chapters with hundreds of volunteers in both countries. He also cofounded the Swasthya project, a community health partnership in rural India. As a research scientist, he conducted laboratory research on vaccine development, and is published in such noted medical journals as *Science*, the *Journal of the American Medical Association*, and the *Journal of the National Cancer Institute*. He cofounded and chaired a successful software technology company, TrialNetworks, to improve research collaboration and enhance the efficiency of clinical trials worldwide. He served as president of Doctors for America, a nonprofit comprised of some 16,000 physicians and medical students who work with patients and policy makers to build a high-quality, affordable health care system for all. As Surgeon General, he has made as his top

priority to improve vaccination rates and to make prevention and health promotion the backbone of a strong and healthy America.

Michael Osterholm

Dr. Osterholm is an internationally recognized expert in infectious disease epidemiology and a member of the National Academy of Science Institute of Medicine. He took his BA degree in Biology and Political Science from Luther College, Decorah, IA, in 1975, his MS in Environmental Health from the University of Minnesota in 1976, his MPH in Epidemiology from UMN in 1978, and his PhD in Environmental Health from UMN in 1980. His expertise is in disease surveillance, epidemiology, health communications, infectious diseases, food-borne infectious diseases, HIV/AIDS, influenza infectious diseases, STDs, policy, politics and public health preparedness, and vaccines. He has earned numerous awards. Dr. Osterholm is director of the Center for Infectious Disease Research and Policy (CIDRAP) and a national leader regarding the use of biological agents as catastrophic weapons targeting civilian populations. After 9/11 he served as Special Advisor to Secretary Tommy Thompson (USDHHS) on bioterrorism and public health preparedness. He serves on the editorial board of five journals and as a reviewer for an additional 24 journals. Dr. Osterholm serves on the CDC's National Center for Infectious Diseases Board of Scientific Counselors, and is former president of the Council of State and Territorial Epidemiologists, and for 24 years in various roles with the Minnesota Department of Health, and serves on the IOM Forum on Emerging Infections. He has served on the IOM Committee on Emerging Microbial Threats to Health and on the IOM Committee on Food Safety, Production to Consumption, and as reviewer for the IOM Report on Chemical and Biological Terrorism. Dr. Osterholm is a member of the American Society of Microbiology, and serves on the Public and Scientific Affairs

Board, the Task Force on Biological Weapons, and the Task Force on Antibiotic Resistance. He is a frequent consultant to the World Health Organization, the National Institutes of Health, the Food and Drug Administration, the Department of Defense, and the Centers for Disease Control and Prevention and is a Fellow of the American College of Epidemiology and the Infectious Disease Society of America. He has authored more than 300 papers and abstracts, and 20 book chapters.

Louis Pasteur (1822–1895)

Known as the "Father of Germ Theory," Pasteur was a French chemist, born in 1822. He, more than any other scientist of his time, proved that infectious diseases are caused by germs, and his work became the foundation of microbiology that is the cornerstone of modern medicine. He began his work studying diseases in silkworm, beer and wine diseases and alcohol contamination during fermentation. He moved from diseases of crops and animals to that of humans, first discovering the bacillus that causes rabies. He championed changes in hospital practices to minimize the spread of diseases caused by microbes. He was the first to prove weakened forms of microbes could be used to immunize humans against more virulent forms. He proved rabies was caused by a virus, and developed a vaccine against rabies. He developed the process of "pasteurization" by which harmful microbes in perishable foods could be destroyed using heat. He discovered germs could live without air, studied the causes of septicemia and gangrene and similar infections. He devised techniques to kill microbes and control contamination, demonstrating how to prevent contagious diseases. His method of sterilization revolutionized surgery and obstetrics. Pasteur died in 1895.

Peter Piot (1949–)

Codiscoverer of the Ebola virus, Dr. Piot was born in 1949 in Belgium. He earned his medical degree from the University

of Ghent and a PhD in microbiology from the University of Antwerp, Belgium. He served as a Senior Fellow at the University of Washington, in Seattle. He was codiscoverer, in 1976, of the Ebola virus in Zaire. In the 1980s he launched and expanded a series of collaborative projects in Africa: in Burundi, Cote d'Ivoire, Kenya, Tanzania, and Zaire. Project SIDA in Kinshasa, Zaire, was the first international project of AIDS in Africa and provided the foundations of our understanding of HIV infection in Africa. Dr. Piot served as Professor of Microbiology and of public health at the Institute of Tropical Medicine, in Antwerp, and the Universities of Nairobi, Brussels, and Lausanne. In 1992 he joined the Global Programme on AIDS of the WHO, in Geneva, as associate director. He is currently Executive Director of UNAIDS, since its creation in 1995, and Under Secretary-General of the United Nations. He has authored 16 books and more than 500 scientific articles. He has received numerous awards for scientific and societal achievement, and was knighted as a Baron by King Albert II of Belgium in 1995. He is a member of the Institute of Medicine of the National Academy of Sciences of the United States and of the Royal Academy of Medicine.

Ludwick Rajchman (1881–1965)

Dr. Rajchman was born in Warsaw, Poland, in 1881, then part of the Austro-Hungarian, Prussian, and Russian empires. He studied medicine in Cracow, 1900–1907, focusing on bacteriology. He became a fellow at the Pasteur Institute, 1907–1909, and a lecturer in microbiology at the Jagellonian University in Cracow. He moved to London in 1910, as lecturer in microbiology at the Royal Institute of Public Health, and conducted research at King's College Medical School. In 1914 he became head of the Central Laboratory on Dysentery in London, and while there took charge of epidemiological studies on the "Spanish flu" and on poliomyelitis. In 1918 he returned to Warsaw, founding the Polish Central Institute of

Epidemiology and later the State Institute of Hygiene, on the model of the Pasteur Institute, with the support of the Rockefeller Foundation. In 1920–1921, when a typhoid epidemic ravaged Poland, he contacted the League of Nations Epidemic Commission and organized its antiepidemic effort, and helped organize the effort when famine and typhus struck Russia in 1921. From 1921 to 1939, he served as Director of the League of Nations Health Organization. In 1945 he called for creation of an international brain trust and advised the United Nations Relief and Rehabilitation Administration, representing the UNRRA to the new Polish government in 1945. With the support of former U.S. President Herbert Hoover, he secured a special fund to establish UNICEF. In 1950, as the cold war heated up, he was forced to leave the United States, settling permanently in France, where he cofounded and headed the International Children's Center. He died in Chenu, France, in 1965.

Walter Reed (1851–1902)

Reed was born in Virginia in 1851, attended the University of Virginia to study medicine, and was its youngest-ever student in 1869. He served at the Bellevue Medical College and received his MD degree in 1873. He entered the U.S. Army in 1874 as an assistant surgeon. In 1889 he began pursuing medical research at Johns Hopkins Hospital, where the science of pathology and bacteriology were new fields, and published a number of papers that brought him attention. In 1898, when the Spanish-American war broke out, he was appointed Chairman of the Commission to study the propagation of the epidemic of typhoid fever and was noted for ground-breaking research. In 1899, Surgeon General George Sternberg appointed him Chairman of the Yellow Fever Commission. In 1900 he observed an epidemic of Yellow Fever at Pinar del Rio, and proved the disease was not transmitted by contact or contaminated clothing. Dr. Reed organized the

experiments at Camp Lazear that proved the mosquito was the carrier. After the commission work, Dr. Reed returned to Washington, D.C., as professor of bacteriology and clinical microscopy at the Army Medical School. In 1902, Harvard University conferred an honorary degree on him, and the University of Michigan made him an LLD. He died, much revered, in 1902.

Frederick C. Robbins (1916–2003)

Born in Alabama in 1916, Robbins graduated from the University of Missouri with a AB degree in 1936 and a BS in 1938. In 1940, he graduated from Harvard Medical School and served as resident physician in bacteriology at the Children's Hospital Medical Center in Boston, Massachusetts. In 1942, he left to serve in the U.S. Army with the Fifteenth Medical General Laboratory as Chief of Virus and Rickettsial Disease, serving in the United States, North Africa, and Italy, during which time he investigated infectious hepatitis, typhus fever, and Q fever and supervised the diagnostic virus laboratory. In 1945, he received the Bronze Star, and on discharge, in 1946, he held the rank of Major. From 1958 to 1950 he held a Senior Fellowship in Virus Diseases and worked with John Enders. While working with Enders, he studied cultivation of poliomyelitis virus in tissue culture, and also investigated the viruses of mumps, herpes simplex, and vaccinia. He went on to the faculty of the Harvard Medical School, and held positions at Boston Lying-in Hospital and at the Children's Medical Service at Massachusetts General Hospital. In 1958, he served as Chairman of the Committee on Medical Education of Western Reserve University School of Medicine. He was awarded several honorary degrees, and in 1961, elected President of the Society for Pediatric Research, and in 1962, a member of the American Academy of Arts and Science. In 1954, he shared the Nobel Prize in Medicine with John Enders and Thomas Weller.

Frederick F. Russell (1870–1960)

Dr. Russell was directly responsible for introducing the typhoid vaccine to United States Army troops in 1910. He was born in Auburn, New York, in 1870. He graduated from Cornell University and the College of Physicians and Surgeons of Columbia University, and also studied at the University of Berlin. He was commissioned in the U.S. Army Medical Corps where he began research on typhoid vaccinations. In 1907 he served as Curator of the Army Medical Museum and as instructor at both the Army Medical School and at George Washington University, from which he earned, in 1917, his Doctor of Science degree. The Surgeon General of the Army sent him to London and Berlin to observe vaccination experiments with live typhoid organisms to protect against the disease. He developed and implemented the Army's highly successful typhoid vaccination program. He led medical laboratories during World War I and in the Panama Canal Zone, and the Rockefeller Foundation's International Health Board hired him to develop the IHB's public health laboratory service. On resigning from the U.S. Army to join the Rockefeller Foundation, he was promoted to Brigadier General in the Medical Reserve Corps. In 1923, Dr. Russell was promoted as Director of the International Health Division of the Rockefeller Foundation. He promoted laboratories in public health diagnostic work that served as the basis for successful disease control programs. He continued medical research following his retirement from the RF, and in 1935, the National Academy of Sciences awarded him the Public Welfare Medal. He served four years as Professor of Epidemiology at Harvard University. He died at age 90 in 1960.

Albert Sabin (1906–1993)

Dr. Sabin was the Polish-born, in 1906, American physician and virologist who developed the first effective and widely used live virus poliomyelitis vaccine. Albert Sabin's family emigrated to the United States in 1921, settling in Paterson,

New Jersey. He entered New York University in 1923, then the medical school to study microbiology. He took his medical degree in 1931 and began research on the nature and cause of polio, a deadly viral infection. He joined the staff of the Rockefeller Institute in 1935, and in 1939 left to serve at the Children's Hospital Research Foundation in Cincinnati, Ohio. His research showed the polio virus grew not only in nerve tissue, but also in the small intestines. His research work was interrupted by World War II as he joined the U.S. Army's Epidemiological Board's Virus Committee in 1941, and served in Europe, Africa, the Middle East, and the Pacific theaters during which time he developed vaccines for encephalitis, sandfly fever, and dengue fever. At war's end Sabin returned to Cincinnati. He developed a weakened form of the polio virus that was incapable of producing the disease, and he and his research associates swallowed the avirulent viruses themselves before experimenting on other human subjects. A rival vaccine, developed by Jonas Salk, was being tested among American schoolchildren in 1954. Sabin's vaccine was first widely tested in Russia, Latvia, Estonia, Czechoslovakia, Poland, Hungary, and East Germany, from 1957 to 1959, and among persons in Sweden, England, Singapore, and the United States by the end of 1959. Problems of contamination of Salk's vaccine made the American medical community more receptive to Sabin's vaccine as it was free of dangerous viruses, administered orally, and effective over a long period of time and it was ultimately used in the United States and the rest of the world to eliminate polio. Sabin was research professor at the University of South Carolina until 1982. In 1980 he went to Brazil to deal with a new polio outbreak there. He retired in 1986, and died in 1993 of heart failure.

Jonas Salk (1915–1995)

Like Sabin, Dr. Salk was the son of Jewish immigrants. He was the first of his family to attend college and earned his medical

degree at New York University School of Medicine in 1939, and became the scientific physician at Mount Sinai Hospital. In 1942 he went to the University of Michigan as a research fellow to develop an influenza vaccine and went on to become an assistant professor of epidemiology and then headed the epidemiology department at Michigan's School of Public Health where he taught the methodology of vaccine development. In 1947 Salk became Director of the Virus Research Laboratory at the University of Pittsburgh School of Medicine, and with funding from the National Foundation for Infantile Paralysis (now the March of Dimes Birth Defects Foundation), Salk began developed techniques leading to the vaccine to wipe out the most frightening disease of the time, paralytic poliomyelitis. He composed a vaccine of "killed" virus, administering it to himself, his family and children, and staff volunteers. They all developed antipolio antibodies and experienced no negative reactions. In 1954, national testing began on one million children, known as Polio Pioneers. In 1955 the vaccine was announced as safe and effective, cutting the average annual cases of the disease from more than 45,000 to 910 by 1962. He founded the Salk Institute for Biological Studies in La Jolla in 1963, funded by a $20 million grant from the National Science Foundation. He spent his last years working on a vaccine against AIDS, but died, at age 80, in La Jolla in 1995.

Sahotra Sarkar (1962–)

Born in 1962, Sarkar is a philosopher of science, and a conservation biologist at the University of Texas at Austin. He is one of the founders of systematic conservation planning within biology, promoting use of multicriteria analysis and supervising creation of the ConsNet decision support system. His lab works on several neglected tropical diseases, like Chagas disease, dengue, leishmaniasis, and tick-borne diseases. Sarkar is known for his work on informational concepts in molecular biology. He is a noted critic of creationism and intelligent design.

He was born in India, where he lived until 1975. He took his BA from Columbia University, and a MA and PhD from the University of Chicago. He was a Fellow of the Wissenschaftskolleg zu Berlin, the Dibner Institute for the History of Science, and the Edelstein Centre for the Philosophy of Science. He was a Visiting Scholar at the Max Planck Institute for the History of Science in Berlin, and taught at McGill University before moving to Texas. He is the author of ten books.

Jeffrey Shaman

Shaman is Associate Professor of Environmental and Health Sciences at the Columbia University Mailman School of Public Health. He took his BA degree from the University of Pennsylvania in 1990, his MA from Columbia University in 2000, and his PhD from Columbia in 2003. His research focuses on climate, atmospheric science and hydrology, as well as biology and the study of environmental determinants of infectious disease transmission. He investigates how hydrologic variability affects mosquito ecology and mosquito-borne disease transmission, and how atmospheric conditions impact the survival, transmission, and seasonality of pathogens. He is currently working on development of systems to forecast infectious disease outbreaks at a range of time scales.

George Miller Sternberg (1838–1915)

Born in 1838 in New York State, Sternberg became a pioneering hygienist, epidemiologist, and served as Army Surgeon General of the United States. He began studying medicine at 19, with a doctor in New Germantown, New Jersey, and then at the College of Physicians and Surgeons at New York City, from which he graduated in 1860. With the outbreak of the Civil War, he was appointed assistant surgeon in the U.S. Army. He eventually served as postsurgeon at Barrancas, Florida, during an epidemic of yellow fever and contracted the disease there but survived it. He served as a member of the Havana Yellow

Fever Commission. In 1893 he was consulting bacteriologist to New York City when he was appointed Surgeon-General, the position he held until his retirement at the age limit in 1902. His work on the etiology of yellow fever disproved its then commonly held cause. He organized and appointed Major Walter Reed to head the Commission. In 1878 he was stationed in Walla Walla, Washington, where he experimented on various disinfectants, and later in Washington, D.C., and at Johns Hopkins University Hospital. He received the coveted "Lomb Prize" in 1886. He was a pioneer of scientific disinfection. As Surgeon General, he established the Army Medical School. He died in 1915.

Jeffrey Taubenberger (1961–)

Dr. Taubenberger was born in 1961 in Landstuhl, Germany, son of an American Army officer. He is an American virologist, and with Ann Reid, was the first to sequence the genome of the influenza virus that caused the 1918 pandemic. He is Chief of the Viral Pathogenesis and Evolution Section, Laboratory of Infectious Diseases, National Institute of Allergy and Infectious Diseases, National Institutes of Health. He moved to the Washington, D.C., area when he was nine, when his father was posted at the Pentagon. He completed a combined MD (1986) and PhD (1987) at the Medical College of Virginia. In 1988, he began training as a pathologist at the National Cancer Institute of the National Institutes of Health. In 1993, he joined a new lab at the Armed Forces Institute of Pathology to apply the current molecular techniques to the Institute's pathology work. In 1994 he was promoted to Chief of the Division of Molecular Pathology on the campus of the Walter Reed Army Medical Center, reporting directly to the Surgeon General of the Army. He began applying a technique called polymerase chain reaction (PCR); he and his team isolated morbillivirus DNA. He looked for an application of PCR to the immense warehouse of tissue samples at the AFIP, settling of finding remains of the

flu virus that caused the 1918 pandemic. Eventually the team isolated the genome.

Benjamin Waterhouse (1754–1846)

Born in 1754, Dr. Waterhouse was the first successful practitioner of vaccination for smallpox and among the first American colonists to receive extensive European medical education, studying in London and in Edinburgh. He received his MD from the Dutch University at Leiden in 1780. At the time, healers in the colonies were an eclectic variety of midwives, empirics, and apprentice-trained doctors. Dr. Waterhouse returned to the new American Republic in 1782. He became the first professor of the Theory and Practice of Physics at Harvard University. In 1798, Edward Jenner published his work on smallpox vaccination. Waterhouse studied vaccination, including exchanging letters with Jenner. In 1800, he obtained a sample of cowpox matter soaked with cowpox lymph and placed in a sealed glass vial. He vaccinated his children and servants who were experimentally inoculated with smallpox and found to be immune. He hoped, but was unable, to make vaccination universal in the United States, and one of his allies was Thomas Jefferson, who personally vaccinated members of his own household.

Waterhouse was notably impolitic and was eventually forced out of Harvard. After leaving there, he became a hospital surgeon with the U.S. military. He died at Cambridge, Massachusetts, at the age of 92, in 1846.

Thomas H. Weller (1915–2008)

Born in Michigan in 1915, Weller entered the University of Michigan in 1932, where his father had an appointment in the Pathology Department of the Medical School. He graduated in 1936 with an AB degree, and became interested in medical zoology. In 1936 he entered the Harvard Medical School, and did experimental research in the Department of Comparative

Pathology and Tropical Medicine. In 1939 he became a tutorial student by Dr. J. F. Enders, who introduced him to the field of virus research. In 1940, he took his MD degree and began clinical training at the Children's Hospital in Boston before being interrupted by military service in World War II, joining the Army Medical Corps in 1942, and was stationed at the Antilles Medical Laboratory in Puerto Rico as head of the Department of Bacteriology, Virology and Parasitology and attained the rank of Major. After the war he returned to the Children's Medical Hospital in Boston. In 1947 he joined Dr. Enders in organizing the new Research Division of Infectious Diseases at the Children's Medical Centre. In 1949 he moved to the Department of Comparative Pathology and Tropical Medicine at Harvard Medical School, eventually as Associate Professor. The department was renamed and transferred to the Harvard School of Public Health, where, in 1964, he became Richard Pearson Strong Professor of Tropical Public Health and head of the Department at the Harvard School of Public Health. In 1954, he joined John Enders and Frederick Robbins as recipient of the Nobel Prize for Medicine.

Nathan Wolfe

Dr. Wolfe is Chief Executive Officer of Global Viral Forecasting. He took his Bachelor's degree from Stanford in 1993 and his doctorate in immunology and infectious diseases from Harvard in 1998. He has authored more than 50 articles and chapters. He is credited with the first discovery of the evidence of natural transmission of retroviruses from nonhuman primates to humans. His work has been published in or covered by *Nature, Science, The Lancet, PHAS, JAMA, The New York Times, The Economist, Wired, Discover, Scientific American, NPR, Popular Science, Seed,* and *Forbes.* He has received funding support totaling more than $20 million from Google.org, The Skill Foundation, NIH, the National Science Foundation, the Bill and Melinda Gates Foundation, the National

Geographic Society, Merck Research Laboratories, and various branches of the U.S. Department of Defense. He has extensive consulting experience and served on a number of advisory and editorial boards. He has more than eight years' experience in biomedical research in Southeast Asia (Malaysia) and sub-Saharan Africa (Cameroon and Uganda). He founded and currently directs Global Viral Forecasting Initiative (GVFI), a pandemic early warning system that monitors the spillover of novel infectious agents from animals to humans, and coordinates activities of over 100 scientists and staff in countries around the world. He currently has active research and public health projects in Cameroon, China, Central African Republic, Democratic Republic of Congo, Gabon, Equatorial Guinea, Lao, Madagascar, Malaysia, and Sao Tome. He is the recipient of numerous awards, including the National Geographic Emerging Explorers Award, a Fulbright Fellowship, a NIH Director's Pioneer Award, and was named one of the Top 100 Agents of Change by *Popular Science* and by *Rolling Stone* magazines.

Michael Worobey

Dr. Worobey is Department Head and Professor of Ecology and Evolutionary Biology at the University of Arizona. He took his BS degree from the Department of Biological Sciences at Simon Fraser University, and his PhD from the Department of Zoology, University of Oxford, in 2001. He was a postdoctoral researcher in the Department of Zoology at St. John's College, University of Oxford, from 2001 to 2003. He uses an evolutionary approach to understand the origins, emergence, and control of pathogens, in particular RNA viruses and retroviruses, such as influenza virus. He integrates fieldwork, theory and methodology, molecular biology, and molecular evolutionary analysis of gene sequences in a phylogenetic framework. He investigates when, where, and how have AIDS viruses crossed into humans and spread worldwide; what can viral sequences

from different timepoints reveal about the tempo and mode of evolution; and how did the 1918 Spanish influenza pandemic emerge and why was it so severe?

Almroth Edward Wright (1861–1947)

Sir Almroth Edward Wright was a British bacteriologist and immunologist best known for advancing vaccination through the use of autogenous vaccines (prepared from bacteria harbored by the patient) and through antityphoid immunization with the typhoid bacteria killed by heat. He was born in 1861 in Yorkshire, England. Wright received his medical degree at Trinity College, Dublin, in 1883, and went on to study at Leipzig, Marburg, and Strasbourg and taught at several universities. In 1892 he was appointed professor of pathology at the Army Medical School, Nettley, where he developed a vaccine against typhoid that was tested on more than 3,000 soldiers in India and used successfully in the Boer War. As a result, Great Britain was the only combatant to enter World War I with troops immunized against typhoid fever, and as a result, fewer of its soldiers died from infection than from enemy fire. He served in France during the war investigating wound infections. In 1902 he became professor of pathology at St. Mary's Hospital in London where he conducted research until his retirement in 1946. Alexander Fleming was one of his aides. Wright developed vaccines against enteric tuberculosis and pneumonia. Sir Almroth Wright was knighted in 1906.

Raymond Zilinskas

Dr. Zilinskas is Research Professor at the Graduate School of International Policy and Management, Middlebury Institute of International Studies at Monterey, California, where he teaches courses on biological and chemical weapons and arms control and emerging issues in international public health. He is a clinical microbiologist, having graduated from the University of Southern California. In 1981–1982 he served in the

U.S. Office of Technological Assessment, and from 1982 to 1986 with the United Nations Industrial Development Organization. He is Professor of the Department of International Health, School of Hygiene and Public Health, at Johns Hopkins University. In 1993 he was a Fellow at the U.S. Arms Control and Disarmament Agency (ACDA), when he conducted biological inspections in Iraq. He is currently consultant to the United States Department of Defense's National Defense University. He is coeditor of the *Encyclopedia of Bioterrorism Defense* and author of *Biological Warfare: Modern Offenses and Defenses*, 1999, Lynne Rienner Publishers.

Organizations

This section lists and briefly discusses some major agencies and organizations involved, including federal governmental agencies, international agencies, and some important nongovernmental organizations (NGOs)—including what has become known as "think tanks," or centers for the study of public health and related health care issues. Each organization is listed in alphabetical order and is briefly described.

Agency for International Development (AID)

Begun in 1961, USAID is the lead U.S. government agency that works to end extreme global poverty and enable resilient, democratic societies to realize their potential. It has nearly 4,000 career employees and a budget of more than US$35 billion.

Agency for Toxic Substance and Disease Registry (ATSDR)

Based in Atlanta, Georgia, ATSDR is a federal agency begun in 1983 as a public health agency using the best science, and taking public health response action as well as providing trusted health information to prevent harmful exposure and diseases related to toxic substances. It is an agency of the U.S. Department of Health and Human Services.

American Association for the History of Medicine

This organization was begun in 1925 and has more than 1,300 members. It is dedicated to promote interest in the history of medicine and to encourage research and teaching in the field. It is housed at Virginia Commonwealth University.

American Medical Association

The AMA is the largest association of physicians, both MDs and DOs, and medical students in the United States. It was founded in 1847, and incorporated in 1897. Its stated mission is to promote and advocate on behalf of physicians and patients to address their day-to-day needs to shape a healthy future.

American Public Health Association

The APHA was founded in 1872. It is a Washington, D.C.-based professional organization, the largest association of public health professionals in the United States. It champions all people and communities, influences U.S. policy, brings together members from all fields of public health, and is dedicated to creating the healthiest nation on one generation. It is a 501 (c) (3) organization whose stated mission is to advance prevention, reduce health disparities, and promote wellness.

Association for Preventive Teaching and Research (APTR)

APTR is the national association for medical and health profession institutions and their faculty for advancing prevention and population health education and research. It was founded in 1942.

Association of Medical Microbiology and Infectious Diseases (Canada)

This organization was founded in 1977 and is Canada's national association that represents physicians, clinical microbiologists,

and researchers specializing in all fields of microbiology and infectious diseases through promotion of the diagnosis, prevention, and treatment of human infectious diseases.

The Bill and Melinda Gates Foundation

The Gates Foundation is the largest transparently operated private foundation in the world. Founded in 2000, its budget of more than US$37 billion is dedicated to education, health care, and ending poverty. It has 1,382 employees. It was first begun as the Gates Foundation (1994–1999) and is a 501 (c) (3) organization headquartered in Seattle, Washington.

Buffett Foundation

The Buffett Foundation is a private family foundation working to create transformational change to improve the world and the lives of the most impoverished and marginalized population. It was founded in 1999. It now is in partnership with the Bill and Melinda Gates Foundation, and focuses on food security, water security, conflict mitigation, conflict resolution, and postconflict development, and on public safety.

Center for AIDS Intervention Research

The Center is a multidisciplinary HIV prevention research center dedicated to the development, conduct, and evaluation of new strategies to prevent HIV among persons most vulnerable to the diseases. It established a postdoctoral research fellowship training program.

Center for Biologics Evaluative Research

This organization within the Food and Drug Administration was begun in 2006 and is comprised of six centers throughout the United States. It is responsible for assuring the safety, purity, potency, and effectiveness of biologics and related products, such as vaccines, probiotics, blood products, and cell, tissue, and gene therapies.

Center for Civilian Biodefense Strategies

Formed in 1998 to assemble a group of experts, the Working Group on Civilian Biodefense writes comprehensive papers on the medical and public health management of the six major bioweapons-related diseases. It publishes *Biosecurity and Bioterrorism*, a peer-reviewed journal on biodefense, and has lobbied to promote increased federal funding for biodefense. It was located at Johns Hopkins University, and is probably the nation's best known biodefense policy institute. In 2003 it announced it was leaving Johns Hopkins to launch a new biosecurity center at the University of Pittsburgh Medical Center and aimed at linking biodefense policy development with medical training, health care, and public health through UPMC's 19 health maintenance organizations and hospitals, and its connections with local health agencies. The move to UPMC was triggered by an unsolicited proposal to join in forming a university-based, integrated program of biodefense policy and practice, and to fully integrate biodefense policy with a mature health care system positioned to test and model best practices for biodefense-related medical training, health care delivery, and public health. UPMC established a generous endowment for the new center.

Center for Emerging Zoonotic and Infectious Diseases (at the CDC)

The National Center, part of the CDC, is committed to protecting people from domestic and global health threats, including foodborne and waterborne illnesses, infections that spread in hospitals, infections resistant to antibiotics, deadly diseases like Ebola and anthrax, illnesses affecting immigrants, migrants, refugees, and travelers, diseases caused by contact with animals, and diseases spread by mosquitoes, ticks, and fleas. The center has seven divisions that work with partners throughout the United States and around the world.

Center for Infectious Disease Research and Policy

The Center is a global leader in addressing public health preparedness and emerging infectious disease response. Founded in 2001, CIDRAP is part of the Academic Health Center at the University of Minnesota.

Center for Research on Influenza Pathogens (CRIP)

One of five Centers of Excellence for Influenza Research and Surveillance, CRIP is funded by the National Institute of Allergy and Infectious Diseases. Influenza viruses are human pathogens infecting up to 500 million people annually worldwide, with the most severe pandemic having an estimated 40 million fatalities. CRIP is a domestic and international animal influenza surveillance network combined with research of pathogenesis and host response, bringing together experts from diverse fields, including virology, immunology, molecular biology, veterinary medicine, ornithology and bioinformatics. It includes several leaders in influenza virus research. It spans all continents, allowing worldwide sampling and isolation of animal and human influenza viruses and early detection of emerging viruses that may cause pandemic threats.

Centers for Disease Control and Prevention (CDC)

Formed in 1946 and reformed as the Centers for Disease Control and Prevention in 1951, the CDC is an agency of the United States Department of Health and Human Services. Its stated mission is to protect America from health, safety, and security threats, both foreign and domestic, and whether diseases start at home or abroad, are acute or chronic, curable or preventable, human error or deliberate attack. It is the nation's health protection agency, protecting people from health threats by conducting critical science and providing health information that protects against expensive and dangerous health threats and responds when they arise.

Centers for Excellence for Influenza Research and Surveillance (CEIRS at NIAID)

As part of the National Institute of Allergy and Infectious Diseases, begun in 1997, this program continues and expands the Institute's animal influenza surveillance program, both internationally and domestically, and focuses on several high-priority areas of influenza research to provide the government with public health tools and strategies to control and lessen the impact of epidemic influenza and the increasing threat of pandemic influenza. The Institute expanded to organize the CEIRS in 2005 to improve control measures for emerging and reemerging influenza viruses, including the prevalence of avian influenza viruses in animals in close contact with humans, understanding how influenza viruses evolve, adapt, and transmit, and identifying immunological factors that determine disease outcome. The Centers will develop and implement a NIAID Pandemic Public Health Research Response Plan.

Commissioned Corps Readiness Force

Established by the Office of the Surgeon General (OSG) in 1994 to improve the HHS' ability to respond to public health emergencies, CCRF was transferred to the Office of Emergency Preparedness in 1997, and then transferred yet again to the DHS following the 9/11 terrorist attacks. It was transferred back to the OSG in 2003. In 2013, it was renamed the Readiness and Deployment Operation Group. It is a diverse team of more than 6,700 highly qualified public health professionals serving the underserved to fill essential public health leadership and clinical service roles with the nation's federal government agencies. They are the nation's "health first responders."

Eco Health Alliance

This international organization of scientists is dedicated to the conservation of biodiversity that for more than 40 years

has provided innovative research on the intricate relationship between wildlife, ecosystems, and human health. It works in the United States and more than 20 countries in Central and South America, the Caribbean, Africa, and Asia to research ways for humans and wildlife to share biospace for their mutual survival. It conducts research, education and training, working with conservation partners in more than a dozen countries at the local level to save endangered species, protect habitats, and protect delicate ecosystems to benefit both wildlife and humans.

Epidemic Intelligence Service (EIS)

EIS is a highly competitive, two-year postgraduate fellowship program of the CDC. Each class of 80 EIS officers is selected from highly qualified applicants who demonstrate interest in public health service. They work in subject areas of infectious and noninfectious diseases, global health, chronic diseases, injury prevention, or environmental or occupational health, and are assigned to CDC offices, other federal agencies, or state and local health departments.

European Centre for Disease Prevention and Control (ECDC)

As an independent agency of the European Union, ECDC's mission is to strengthen Europe's defenses against infectious diseases. It was established in 2005, and is headquartered in Stockholm, Sweden.

Food and Drug Administration (FDA)

The FDA, an agency of the DHHS first founded in 1906, is responsible for protecting and promoting public health by ensuring that food is safe and wholesome, that cosmetics will do no harm, and that medicines, medical devices, and radiation-emitting consumer products are safe and effective.

Global Vaccines.org

A nonprofit NGO, this organization was founded in 2002 and began operations in 2006, and is dedicated to creating low-cost vaccine technologies for the developing world. It was formed in partnership with the University of North Carolina at Chapel Hill, Baylor College of Medicine in Houston, and the WHO to develop vaccines that are effective and affordable in developing countries and sublicenses the new technologies and works with manufacturers in Africa, Asia, and Latin America that have been recognized by the WHO and focuses on dengue fever, polio, malaria, rotavirus, and HIV, diseases that hit the poorest people on earth the hardest with millions of new infections each year. Global Vaccines has 12 employees and an annual budget of US$2 million, and supports several preclinical projects in development.

Global Viral

This 501 (c) (3) nonprofit NGO supports and links worldwide research, data and policy leaders in a network aimed at global infectious disease. It was founded in 2007 and focuses particularly on zoonotic diseases.

Google.org

Google.org was founded in 2005 as the philanthropic arm of Google.com, the Internet search engine company. As of 2010, it has committed more than US$100 million annually in investments and grants to develop technologies that address global challenges and supports innovative partners through its grants. Annually it has donated an estimated 80,000 hours and distributed US$1 billion in products.

Health Alert Network

This network is CDC's primary method of sharing cleared information about urgent public health incidents with the CDC's network of public information officers, federal, state, territorial,

and local public health practitioners, clinicians, and public health laboratories. It is coordinated out of the CDC's Office of Public Health Preparedness and Response (OPHPR).

International Red Cross

The international, humanitarian institution based in Geneva, Switzerland, is a three-time Nobel Laureate. It was originally founded in 1863, reorganized in 1949, and expanded and governed by the Protocols of 1977. It responds quickly and efficiently to help people affected by armed conflict and disasters in conflict zones.

Lions Clubs International

This global leader in community service is a nonprofit NGO founded in 1917 and the first NGO partner of the UN. As of 2015 LCI had 1.4 million members in 46,000 clubs in more than 200 countries worldwide. It has long supported disaster relief and health programs, in particular, large-scale health programs. In 2013 it announced a new partnership with GAVI Alliance in support of the WHO's worldwide measles eradication program to deploy its network of more than 1.35 million volunteers to raise US$30 million to improve access to vaccines through the GAVI Alliance to save millions of children's lives through vaccination to increase immunization in the world's poorest countries, a fund-raising program called One Shot-One Life, and matched by a grant by the Bill and Melinda Gates Foundation bringing the total to US$60 million.

Médecins Sans Frontières (MSF) International

Also known as Doctors Without Borders, this international organization sends volunteer doctors, nurses, and other health-care providers to provide medical aid where it is most needed. They are neutral and impartial. In areas of armed conflict, they provide medical aid to any or all who need it. They were founded in 1971.

Metabiota

Metabiota is a pioneer in the field of comprehensive risk analysis to improve the world's resilience to epidemics. It assembles a worldwide network of on-the-ground field science experts to help countries, corporations, and government to manage and mitigate infectious disease outbreaks.

Metropolitan Medical Response System

As part of the Department of Health and Human Services, MMRS provides funding to designated localities to assist in planning, delivering, training, and purchasing equipment and pharmaceuticals, and conducting exercises. Founded in 2007, it is a medical reserve corps providing national leadership located in various metropolitan areas of the United States.

National Communicable Disease Center

NCDC is a coordinating center that supports research, surveillance, technical assistance, and operational program to prevent and control a broad spectrum of infectious diseases.

National Institute of Allergy and Infectious Diseases (NIAID)

NIAID was founded in 1965 as one of 27 institutes and centers that comprise the National Institutes of Health agency of the United States Department of Health and Human Services. NIAID's mission is to treat and prevent infectious diseases by leading research to understand, treat, and prevent infectious, immunologic, and allergic diseases.

National Institutes of Health

The NIH is a biomedical research facility primarily located in Bethesda, Maryland, and is an agency of the Department of Health and Human Services. It is the primary agency of medical research and scientific studies that turn discovery into health.

National Pharmaceutical Stockpile (NPS)

Housed within the CDC, NPS maintains large quantities of medicine and medical supplies to protect the American public if there is a public health emergency—terrorist attack, flu outbreak, earthquake, etc.—severe enough to cause local supplies to run out.

New York Influenza Center of Excellence (NYICE)

One of the Influenza Centers of Excellence, NYICE provides a collaborative, interdisciplinary approach involving investigators in the fields of immunology, biochemistry, medicine, pediatrics, statistics, and bioinformatics that is focused on issues of cross-protective immunity and virus adaptation to the mammalian host. NYICE investigators are performing in vivo studies of the viral factors that control host, range, and pathogenesis in humans.

Orthopoxvirus Genomic and Bioinformatics Resource Center

This center was established to provide informational and analytical resources to the scientific community to aid research directed at better understanding the poxviridae family of viruses, specifically as a result that concerns that viriola virus, the causative agent of smallpox, as well as related viruses, might be utilized as biological weapons. The National Center for Biotechnical Information at the National Library of Medicine holds a database and web applications that supports research on poxviruses that might be considered new and emerging infectious agents, such as monkeypox virus. It completes genome sequences of various genera, species, and strains of viruses.

Partners in Health

This NGO was formed in 1987. Its mission partners are in the United States, Madagascar, Nepal, Mali, Liberia, Burundi, Sierra Leone, Mexico, Guatemala, Chennai, and Lima. It provides

delivery in impoverished settings and advocacy on behalf of the destitute sick, enhanced by research that documents the need, monitors the impact, and demonstrates the benefits of their model of care. Its staff publish in the scholarly literature on health, human rights, anthropology, political economy, history, public health, and epidemiology of research conducted under the aegis of Harvard Medical School, the Harvard School of Public Health, and the Brigham and Women's Hospital.

Rockefeller Foundation

A philanthropic organization and private foundation based in New York City and founded by the Rockefeller family in 1913, its stated central mission over the past century has been to "promote the well-being of humanity throughout the world." Of note regarding health issues, it helped establish the London School of Hygiene and Tropical Medicine in the United Kingdom; the Johns Hopkins School of Public Health and the Harvard School of Public Health, two of the first such institutions in the United States, the School of Hygiene at the University of Toronto in 1927, and helped develop the vaccine to prevent yellow fever. As of 2009, its endowment was US$3.4 billion and its annual grants were more than $137 million. While it is no longer the largest foundation by assets, its preeminent legacy ranks it as one of the most influential NGOs in the world.

Rotary International (PolioPlus)

In 1985, Rotary International launched PolioPlus, a 20-year commitment to eradicate polio, one of the most ambitious humanitarian efforts by a private entity, and an exemplary paradigm for private–public collaboration in the fight against disease. By 1990 it was providing polio vaccine to children in developing countries, assisting health-care workers in the field and providing training for laboratory personnel to track the

polio virus and working with governments around the world, and with the WHO in eradicating polio.

Samaritan's Purse

Founded in 1970, Samaritan's Purse is an evangelical Christian humanitarian organization. Its headquarters are in Boone, NC, and it works in more than 100 countries around the world, and has affiliate facilities in Australia, Canada, Germany, Ireland, Hong Kong, the Netherlands, and the United Kingdom. Its field offices are located in 20 countries across five continents. It provides direct aid and program funding and has a reserve of more than US$300 million. Its World Medical Mission, the medical arm of Samaritan's Purse, was founded in 1977 to enable doctors to serve short-term assignments in overwhelmed missionary hospitals. Its medical mission in Liberia was one of only two medical NGOs active during the Ebola outbreak in 2014.

Skoll Global Threats Fund

This Fund has a stated mission to confront global threats imperiling humanity by seeking solutions, strengthening alliances, and spurring actions needed to safeguard the future. It works proactively to find, initiate, or cocreate breakthrough ideas and activities that will have large-scale impact, such as pandemics, whereby humans and animals increasingly share virulent viruses due to loss of green belts, global warming and poverty, raising the risk of highly disruptive pandemics. Tackling pandemics requires four things: good science, good business, international cooperation, and public awareness. The Global Pandemic Threats Fund assists to place better processes to be able to move more quickly when the next pandemic strikes.

Society for General Microbiology

Society for General Microbiology is a learned society based in the United Kingdom with worldwide membership in universities, industry, hospitals, and research institutes and is the largest

microbiological society in Europe, claiming 4000 microbiologists worldwide. It was founded in 1945.

State Center of Virology and Technology

Also known as the Vector Institute, it is a biological research center in Novosbirsk Oblast, Russia. It is Russia's version of the CDC and the U.S. Army Chemical and Biological Defense Command. Its research facilities have capabilities for all levels of Biological Hazard. It is one of two official repositories for the now-eradicated smallpox virus and is part of the system of laboratories known as the Biopreparat.

UN Educational, Scientific and Cultural Organization (UNESCO)

UNESCO was founded in 1945. It has 195 members and eight associate members, with 50 field offices around the world. Its headquarters are in Paris.

UN High Commission for Refugees (UNHCR)

UNHCR was established in 1950 by the United Nations General Assembly and mandated to lead and coordinate international action to protect refugees and resolve refugee problems worldwide. To safeguard the rights and well-being of refugees it strives to ensure everyone can exercise their right to seek asylum and resettle in another state, with the option to return home voluntarily, integrate locally, or to resettle in a third country, and to help stateless people. Since its inception it has helped tens of millions of people. It has a staff of more than 9,300 people in 123 countries to protect millions of refugees, returnees, and internally displaced and stateless people.

UN International Children's Emergency Fund (UNICEF)

UNICEF is a UN program headquartered in New York City that provides long-term humanitarian and developmental

assistance to children and mothers in developing countries. It was created by the UN General Assembly in 1946 to provide emergency food and health care to children devastated by World War II. It relies on contributions from government and private donors, and its total income as of 2008 was US$3,372,540,239. In 2013 it distributed more than $2.3 billion in supplies and vaccines. It has field staff in over 190 countries and territories.

UN World Health Organization (WHO)

The World Health Organization is a specialized agency of the UN concerned with international public health. It was formed in 1948 with headquarters in Geneva, Switzerland. Since its creation it has played a leading role in the eradication of smallpox, and its current priorities include communicable diseases, particularly HIV/AIDS, Ebola, malaria, and tuberculosis, the mitigation of noncommunicable diseases, sexual and reproductive health, development, aging, nutrition, food security, occupation health, substance abuse, and the development of reporting, publication, and networking. Its 2015/15 budget is about US$4 billion. About US$930 million are provided by member states and another US$3 billion from voluntary contributions.

United States Army Medical Research Institute of Infectious Diseases

USAMRIID was begun in 1969 to spearhead research to develop medical solutions—vaccines, drugs, diagnostics, and information—to protect military personnel from biological threats. Its labs have world class expertise in biological testing of vaccines and therapeutics, and a fully accredited animal research facility. It plays a critical role in the national preparedness for biological terrorism and warfare, and its research benefits civilians as well as military personnel.

Wellcome Trust

This U.K.-based health foundation is an independent global charitable foundation dedicated to improving health because good health makes life better. Its grants support biomedical science by investigating the fundamental bases of health and disease in humans and animals.

World Federation of Public Health Associations

This organization was founded and incorporated in Geneva, Switzerland, in May 1967 as an international, nongovernmental organization composed of multidisciplinary national public health associations. It is the only worldwide professional society representing and serving the broad fields of public health whose mission is to promote and protect global public health. It supports the establishment and organizational development of public health associations and societies through facilitating and supporting the exchange of information, knowledge, and the transfer of skills and resources and undertaking advocacy for public policies, programs, and practices that will result in a healthy and productive world. It is accredited as an NGO with the WHO, with whom it collaborates, and with the United Nations Economic and Social Council (ECOSOC).

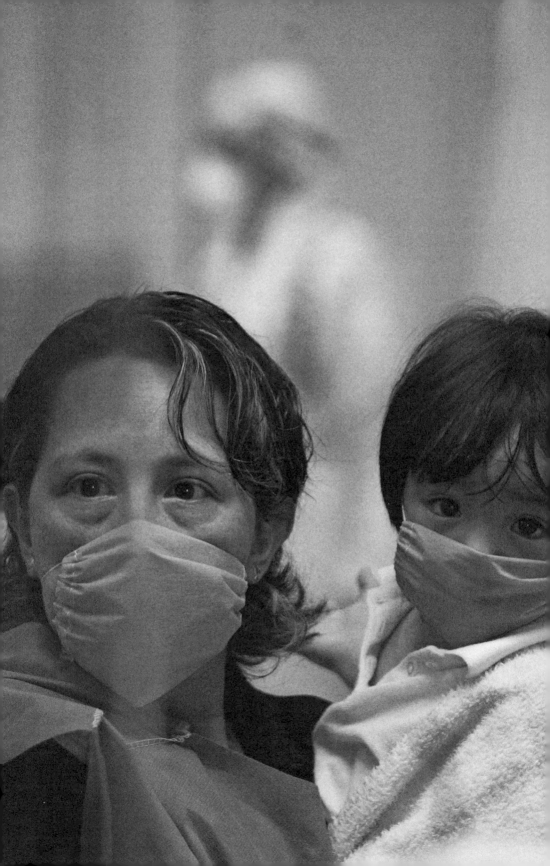

Health-related policy is advanced by enactment of laws, presidential actions, and court cases, among other means. This chapter presents data on health care matters relative to the past, present, or future threats of epidemics and pandemics. It presents trend data in tables, maps, and figures. In its second section, it presents synopses of actions in the form of legislative and judicial decisions, both national and international.

Data

Table 5.1 Timetable of the 2014 Ebola Pandemic

Table 5.1 presents the major events of the recent Ebola pandemic outbreak, from the first discovery of the disease in 1976, to its outbreak and spread in West Africa, to the efforts by the CDC, MSF, and WHO to contain it, to its officially being declared over in 2015.

Date	Development of the Outbreak
1976	Ebola is first discovered in the Democratic Republic of Congo. The disease remains a manageable problem for 40 years, endemic in Central Africa.
	2014 Ebola Pandemic Outbreak
December, 2013	Index patient, a two-year old child in Gue'cke'dov, Guinea. Disease goes undiagnosed for several months, spreads to other villages in Guinea.

(continued)

A woman and her child, both wearing protective face masks against swine flu, wait to be seen at the Naval Hospital in Mexico City on April 29, 2009. The swine flu pandemic was one of the most serious outbreaks of the influenza virus in 2009. (AP Photo/Eduardo Verdugo)

Table 5.1 (*continued*)

Date	Development of the Outbreak
March 7, 2014	Ebola spreads from Guinea to Sierra Leone and Liberia.
April 15, 2014	Guinea's minister of health believes (incorrectly) that Ebola is controlled.
June 21, 2014	MSF (Doctors Without Borders) says, "Ebola is out of control."
July 23, 2014	Nigeria is hit with its first case of Ebola
August 2, 2014	First Ebola patient arrives in U.S. for treatment (Dr. Kent Brantly, missionary doctor with Samaritan's Purse), evacuated from Liberia to Emory University Hospital in Atlanta. Then another missionary, nurse Nancy Writebol, joins him. Both are treated and survive.
August 6, 2014	CDC increases response to a level 1 category. CDC sends team of specialists to West Africa.
August 8, 2014	WHO declares Global Health Emergency; outbreak reaches 1,711 cases, with 932 confirmed deaths
August 18, 2014	Countries begin to screen travelers from the region. Ebola vaccines head to clinical human trials at NIH (Bethesda) and Glaxo-Smith Kline (at the University of Oxford)
September 12, 2014	Cuba sends 165 doctors to the region, the first country to do so in substantial numbers
September 16, 2014	U.S. commits $500 million to deploy 3,000 troops and supplies to West Africa. No funerals held in Liberia, Sierra Leone, and Guinea as all the dead in those countries are cremated.
September 30, 2014	U.S. receives first case of Ebola (Thomas Eric Duncan), admitted to Texas Health Presbyterian Hospital in Dallas, Texas.
October 08, 2014	Thomas Duncan dies of Ebola in Dallas, Texas.
October 12, 2014	Two nurses who treated Duncan diagnosed with Ebola. Amber Vinson is sent to Emory University Hospital in Atlanta. Nina Pham is treated at the NIH Hospital in Bethesda, Maryland. Both survive.
October 15, 2014	Aid is delayed from distribution due to government tensions in Sierra Leone
October 23, 2014	N.Y.C. receives its first patient, MSF doctor Craig Spencer, after arriving from Liberia, the region's hardest hit country. He survives.

Date	Development of the Outbreak
November 4, 2014	Cases in Sierra Leone increase 900%; in Liberia new cases slow.
2015	From 4,000 cases in the first few months of the outbreak, numbers swelled to more than 14,000 dead from Ebola. Cost estimate for the pandemic exceeds US$1 billion. Countries now officially clear of Ebola: Senegal and Nigeria.

Source: Table by author. Data from Time, Inc. *The Science of Epidemics,* 2014: 22–23.

Table 5.2 The Nine Deadliest Viruses

Table 5.2 lists and describes the nine deadliest viruses that cause pandemic disease outbreaks.

1. **Smallpox:** Estimated to have caused 300 million deaths throughout history to the 20th century. Eradicated in nature in 1977, the first major pandemic disease to be eradicated by a worldwide public health campaign of vaccination.

2. **Influenza:** Estimated to have killed 57 million since 1918; kills about 250,000 annually from seasonal flu outbreaks.

3. **HIV:** estimated to have killed about 39 million since 1981.

4. **Rotoviruses:** estimated to kill about 450,000 annually, mostly children, spread by oral exposure to infected fecal matter.

5. **Measles:** estimated to kill 122,000 annually in the 21st century, mostly children,

6. **Yellow Fever:** kills 122,000 annually in the 21st century, mostly in Africa, from severe fever and hemorrhaging jaundice.

7. **Dengue:** kills 22,000 annually, mostly children, from severe fever, hemorrhaging, vomiting, difficulty in breathing, and dehydration.

8. **Lassa virus:** kills 5,000 annually in West Africa; causes high fever, hemorrhaging, respiratory distress, and can cause deafness in survivors.

9. **Ebola:** Estimated to have killed more than 14,000 since 1976, 78 percent of which occurred in 2014; caused by animal-to-human and human-to-human direct contact with infected bodily fluids. It is named for the Ebola River in the Democratic Republic of Congo from whence it first emerged.

Source: Table by author, data from Time, Inc. *The Science of Epidemics:* 46 51.

Table 5.3 Chronology of U.S. Legislation Regarding USMHS/PHS

This table is a selected list of enactments that had a major influence on the Marine Hospital Service, the Public Health Service, and the National Institutes of Health.

1700s:

- July 16, 1798—"An Act for the relief of sick and disabled seamen" placed in the Treasury Department. A monthly hospital tax of 20 cents deducted from pay of merchant seamen, the first prepaid medical care plan is the United States (1 Stat. L 605).

- March 2, 1799—An act amending the law of 1798, extends USMHS to U.S. Navy, continued that service until June 15, 1943 (1 Stat. L. 729).

1800s:

- Act of April 29, 1878—the first Federal Quarantine Act to prevent the introduction of infectious diseases to the United States (20 Stat. L. 37).

- Act of March 3, 1879—law establishing a National Board of Health, the first organized, comprehensive Federal medical research effort (20 Stat. L. 484).

- Act of January 4, 1889—law establishing a commissioned officer corps of the MHS, and Dr. Woodworth assumed leadership of the MHS in 1871 (25 Stat. L. 639).

- Act of March 27, 1890—Congress gives MHS quarantine authority (26 Stat. L. 31).

- Act of February 15, 1893—a new Quarantine Act passed following outbreaks of cholera in Europe, strengthening the Act of 1878, giving federal government the right of quarantine inspection (27 Stat. L. 449).

1900s

- Act of March 3, 1901—appropriates funds to build and run the Hygienic Laboratory, to "investigate contagious and infectious diseases and other matters pertaining to public health" given the status in law (31 Stat. L. 1086).

- July 1, 1902—the Biologics Control Act, authorizes the PHMHS to regulate the transportation or sale for human use of viruses, serums, vaccines, antitoxins, and analogous products in interstate traffic or from foreign country into the U.S. (P.L. 57–57–244, 32 Stat. L. 728).

1910s:

- Act of August 14, 1912—changes name of PHMHS to PHS and broadens PHS research program to include "diseases of man" (37 Stat. L. 309).

- Act of October 27, 1918—PHS reserve corps established and funded to deal with the 1918 influenza pandemic and the need for a reserve corps to meet such emergencies (40 Stat. L. 1017).

1930s:

- Act of May 26, 1930—The Ransdell Act reorganizes, expands, and redesignated the Hygienic Laboratory as the National Institutes of Health, authorizing $750,000 to construct two buildings for the NIH and authorizing a system of fellowships (P.L. 71–251, 46 Stat. L 379).

- Act of August 14, 1935—The Social Security Act, which among other provisions authorizes health grants to states as an effective way to prevent the interstate spread of diseases and to improve state and local public health programs (P.L. 74–271, 46 Stat. L. 634).

1950s:

- Act of August 15, 1950—the Omnibus Medical Research Act, authorizes Surgeon General to establish the National Institute of Neurological Diseases and Blindness and the National Institute of Allergy and Infectious Diseases, replacing the National Microbiological Institute (P.L. 81–692, 64 Stat. L. 443).

1960s:

- Act of July 12, 1960—the International Health Research Act, authorizes the Surgeon General to establish and make grants for fellowships in the U.S. and participating foreign countries for use by public agencies or nonprofit institutions and agencies to facilitate the interchange of research scientists between the U.S. and participating foreign countries (P.L. 86–610, 74 Stat. L. 364).

- Act of August 27, 1964—Graduate Public Health Training Amendments extends the authorization for public health traineeships and grants to schools of public health, nursing, and engineering (P.L. 88–497, 78 Stat. L. 613).

1970s:

- July 12, 1974—The National Research Act of 1974 amends the PHS act, establishes a National Commission for the Protection of Human Subjects of Biomedical and Behavioral Research to make a comprehensive investigation of the ethical principles involved in biomedical and behavioral research (including psychosurgery and living fetus research), and establishes a permanent National Advisory Council for such research (P. L. 93–348).

Source: NIH Almanac. Legislative Chronology. Available online at http://www.nih.gov/about/almanac/historical/legislative_chronology.htm.

Table 5.4 An Overview of the HIV/AIDS Pandemic

Table 5.4 presents an overview of the deadly HIV/AIDS pandemic, including relevant demographic data and how the disease is transmitted.

AIDS by the numbers:

- An estimated 1.1 million people in the world have HIV, but only 84% have been diagnosed
- 37% are receiving regular medical treatment
- 33% are in HIV/AIDS anti-HIV drug therapy
- Only 25% have reduced HIV levels to be less infectious

AIDS in San Francisco, by contrast to the above:

- 94% have been diagnosed
- 58% are receiving regular medical treatments for AIDS/HIV
- 54% are on HIV drug therapy
- 52% have reduced levels to be less infectious

DEMOGRAPHICS OF HIV:	TRANSMISSION OF HIV:
76% of infected are male	53% male-to-male sex
44% of infected are black	27% male-to-female sex
33% of infected are white	15% injection drug use
24% of infected are female	
19% of infected are Hispanic	

Source: Table by author, data from Time, Inc., *The Science of Epidemics,* 2014: 106.

Table 5.5 Ebola Outbreaks in West Africa

Table 5.5 enumerates the cases and the deaths caused by the Ebola outbreak in the West African countries of Liberia, Sierra Leone, and Guinea, Nigeria, Mali, and Senegal, and the cases brought to the U.S. and U.K., as well as data for the last recorded cases in each country, signifying the end of the outbreak.

Country	Cases	Deaths	Last Update (as of May 2015)
Liberia	10,564	4,716	Outbreak ended May 9, 2015
Sierra Leone	12,492	3,904	May 6, 2015
Guinea	3,592	2,387	Outbreak ended May 5, 2015
Nigeria	20	8	Outbreak ended October 19, 2014
Mali	8	6	Outbreak ended January 18, 2015
United States	4	1	Outbreak ended December 21, 2014

Country	Cases	Deaths	Last Update (as of May 2015)
United Kingdom	1	0	Outbreak ended March 10, 2015
Senegal	1	0	Outbreak ended October 17, 2014
Spain	1	0	Outbreak ended December 2, 2014
Italy	1	0	Outbreak ended May 12, 2015
Total	26,684	11,022	As of May 9, 2015

Source: Table by author, data from WHO, and http://www.aim.org/special-report/ebola-pandemic-risks-and-realities.

Table 5.6 Major Epidemics in U.S. History

Table 5.6 lists the dates and locations of the major epidemics in United States history from colonial times to the last major highly deadly pandemic of influenza in 1918–1919 which took the lives of an estimated 650,000 persons in the United States.

Year	Disease/Epidemic	Area/Region of Outbreak
1637	Measles	Boston
1687	Measles	Boston
1690	Yellow Fever	New York
1713	Measles	Boston
1729	Measles	Boston
1732–1733	Influenza	U.S. and worldwide
1738	Smallpox	South Carolina
1739–1740	Measles	Boston
1747	Measles	Connecticut, New York, Pennsylvania, South Carolina
1759	Measles	North America
1761	Influenza	North America, West Indies
1772	Measles	North America
1775	Unknown Epidemic	New England
1775–1776	Influenza	Worldwide
1783	Bilious Disorder	Dover, Delaware
1788	Measles	Philadelphia, New York City
1793	Influenza (Putrid Fever)	Vermont

(continued)

Table 5.6 (*continued*)

Year	Disease/Epidemic	Area/Region of Outbreak
1793	Influenza	Virginia
1793	Yellow Fever	Philadelphia
1793	Unknown	Harrisburg, PA
1793	Unknown	Middletown, PA
1794	Yellow Fever	Philadelphia, PA
1796–1794	Yellow Fever	Philadelphia, PA
1798	Yellow Fever	Philadelphia, PA
1809	Yellow Fever	New York
1820–1823	"Fever"	Nationwide
1831–1832	Asiatic Cholera	Nationwide
1832	Cholera	New York City; other major cities
1837	Typhus	Philadelphia
1841	Yellow Fever	Nationwide/South
1847	Yellow Fever	New Orleans
1847–1848	Cholera	North America
1850	Yellow Fever	Nationwide
1850–1851	Influenza	North America
1852	Yellow Fever	Nationwide/New Orleans
1855	Yellow Fever	Nationwide
1857–1859	Influenza	Worldwide
1860–1861	Smallpox	Pennsylvania
1865–1873	Smallpox	Many cities

[Series of Recurring Epidemics of Typhus, Typhoid, Scarlet Fever, Yellow Fever struck especially in Philadelphia, New York City, Boston, New Orleans, Baltimore, Memphis, and Washington, D.C.]

1873–1875	Influenza	North America, Europe
1878	Yellow Fever	New Orleans
1885	Typhoid	Plymouth, PA
1886	Yellow Fever	Jacksonville, FL
1918–1919	Great Influenza	Worldwide

Source: Table by author, from similar table in: *Ancestors West,* SSBCGS, Vol. 20, No. 1, Fall, 1993, South Bend, Indiana.

Table 5.7 Quarantinable Diseases by Executive Order

The CDC has the legal authority to detain any person who may have an infectious disease that is specified by Executive Order to be quarantinable, if necessary. The CDC can deny ill persons with these diseases entry to the United States. The CDC can also have them submitted to a hospital or be confined to home for a certain amount of time to prevent the spread of the disease.

Cholera

Diphtheria

Infectious Tuberculosis

Plague

Smallpox

Yellow Fever

Viral Hemorrhagic Fevers

SARS

New types of Influenza that could cause a pandemic

Source: CDC, U.S. Quarantine Stations.

Table 5.8 Viral Hemorrhagic Fevers and Antibiotic Resistance

This table lists the most important viruses causing hemorrhagic fevers—highly contagious and deadly, with the potential to become pandemics. They are limited in ability to spread because they kill the infected vector so quickly; pandemic danger increases if they mutate to spread more efficiently. The antibiotic resistant diseases which have recently developed to alarming rates are noted as well as their drug resistance capacity makes them especially difficult to contain and control.

Ebola Virus Disease

Lassa Fever Virus

Rift Valley Fever

Marburg Virus

Bolivian Hemorrhagic Fever

ANTIBIOTIC RESISTANCE

- Microorganisms, often called "superbugs," contribute to reemergence of diseases currently well-controlled. Multidrug-resistant tuberculosis (MDR-TB) has been reported in nearly half-a-million cases per year worldwide, with the greatest number of cases in China and India. The WHO estimates 50 million people worldwide are infected, 79% of whom are resistant to three or more antibiotics.

(continued)

Table 5.8 (*continued*)

ANTIBIOTIC RESISTANCE

- Extensive drug-resistant TB (XDR-TB) was first identified in Africa in 2006 and was later discovered in 49 countries. The WHO estimates there are 40,000 new cases of XDR-TB per year.

- *Enterococcus* and *Staphylococcus aureus* have developed resistance to various antibiotics, like vancomycin. They have become important organisms in cases of health care–associated infections (HAI), typically spread in hospitals. Strains of methicillin-resistant *Staphylococcus aureus* (MRSA) in otherwise healthy individuals have become more frequent in recent years.

Sources: The World Health Organization, http://www.who/int/mediacentre/news/releases/2009/tuberculosis_drug_resistant_2009/tuberculosis_drug_resistant_20090302/en/index.html.

The Guardian, http://www.guardian.co.uk/society/2009/apr/01/bill-gates-tb-time-bomb-china

CNN.com, "Tuberculosis: A New Pandemic?" http://www.cnn.com/2008/HEALTH/11/17th.pandemic/index.html.

Table 5.9 Surgeon Generals of the United States Public Health Service

Table 5.9 lists the names of the Surgeon Generals of the U.S. Public Health Service. As the nation's "top doc," they led the agency most concerned with the controlling, preventing, or ending pandemic or epidemic outbreaks.

Years in Office	Surgeon-General
1871–1879	John M. Woodworth
1879–1897	John B. Hamilton
1897–1911	Walter Wyman
1912–1920	Rupert Blue
1920–1936	Hugh S. Cumming
1936–1948	Thomas Parran Jr.
1948–1956	Leonard Scheele
1956–1961	Leroy E. Burney
1961–1965	Luther L. Terry
1965–1969	William L. Steward
1969–1977	Jesse L. Steinfeld
1977–1981	Julius B. Richmond
1982–1989	C. Everett Koop
1990–1993	Antonia C. Muvello

Years in Office	Surgeon-General
1993–1998	M. Joycelyn Elders
1998–2002	David Satcher
2002–2009	Richard H. Carmona
2009–2013	Regina M. Benjamin
2013–to date	Vivek H. Murthy

Source: Table by author, data from: http://www.surgeongeneral.gov/about/history/index.html.

Table 5.10 Emerging Pathogens, Worldwide, 1930 to Present

Table 5.10 lists the most important and potentially deadliest or newly emerging viral, bacterial, or protozoal pathogens, their location of outbreaks, and their known vectors or carriers of the diseases that spread them to humans.

Year Microbe Was Identified	Name of Emerging Viruses	Origin/Location of Infection	Vector if Known
1933	Eastern Equine Encephalitis Virus	N. America, S. America and Caribbean	Wild birds/ mosquitoes
1943	California Encephalitis	Western U.S./ Canada	Rodents/ mosquitoes
1950	Hantaan Virus	Asia/E. Europe	Rodents
1956	Chikungunya Virus	Tropical Africa/Asia	Primate to human via mosquitoes
1957	Kyasanur Forest Virus	Asia/India	Rodents/bat tick
1958	Junin Virus	S. America/Argentina	Rodents
1960	La Crosse Encephalitis Virus	Canada/Alaska/ E. and W. U.S., Europe/Finland and East Africa	Chipmunk/ squirrel/ mosquitoes, rabbits
1966	Machupo Virus	S. America (Bolivia)	Unknown
1967	Marburg Virus	Germany/E. Africa	Primates
1970	Lassa Virus	Africa	Rodent
1973	Rotaviruses	Developing countries	Unknown
1974	Parvovirus B19	Global	Unknown

(continued)

Table 5.10 (*continued*)

Year Microbe Was Identified	Name of Emerging Viruses	Origin/Location of Infection	Vector if Known
1976	Ebola Sudan Virus	Africa (Sudan)	Animal source
1976	Ebola Zaire Virus	Africa (Zaire)	Unknown
1977	Seoul Virus	Asia/Europe	Rodents
1980	Human T-Lymphotropic Virus	Central Africa/Caribbean/NE South America co-evolving	Primates, now with humans
1983	HIV1	West Africa	African primates
1986	Human Herpesvirus 6 (HHV-6)	Global	Unknown co-evolving
1988	Hepatitis E Virus	Tropics/Asia/Africa S. America	Unknown, co-evolving
1989	Hepatitis C Virus	Global	Primates?
1989	Ebola Reston Virus	Asia/Philippines	Unknown
1991	Guanarito Virus	S. America	Rodent
1993	Sin Nombre Hantavirus	S.W. United States	Rodents
1994	Ebola Gabon	Gabon, Africa	Unknown
1995	Human Herpes Virus-8	Global	Unknown
1995–1996	Argentinean Hantavirus	Argentina	Person-to person?
1996	Ebola Gabon	S. Africa	Chimpanzees

Year	Emerging Bacteria
1975	Lyme disease (*Borrelia burgdorferi*)
1976	Legionnaire's disease (*Legionella pneumophila*)
	Acute and chronic diarrhea (*Cryptosporidium parvum*)
1977	Bowel infection (*Campylobacter jejuni*)
1978	Toxic shock syndrome (*Staphylococcus aureus*)
1982	Hemorrhagic colitis; homolytic uremic syndrome
1983	Cat scratch disease (*Afipia felis*), peptic ulcer disease
1984	Persistent diarrhea (*Enterocytozoon bieneusi*)
1985	Persistent diarrhea (*Cyclospora cayetanensis*)
1991	Atypical babesiosis (new species of babesia)

Year Microbe Was Identified	Name of Emerging Viruses	Origin/Location of Infection	Vector if Known
Year	**Emerging Bacteria**		
1992	7th Pandemic of cholera (*Vibrio cholerae* 0139)		
1993	Cat scratch disease (*Bartonella henselae*)		
1994	Flesh-eating bug (Beta hemolytic *Streptococcus*)		
Year	**Emerging Protozoa**		
1991	Conjunctivilis disseminated disease (*Encephalitozoon hellem*)		
1992	Disseminated disease (*Encephalitozoon cuniculi*)		

Source: Table by author, adapted from Appendix, Frank Ryan, *Tracking the New Killer Plagues*. Boston: Little, Brown and Company, 1997.

Table 5.11 Critical Pathogen Agents

Table 5.11 lists the critical pathogenic agents categorized by their ease of dissemination, morbidity and mortality rates, and their ability to cause major negative social impacts.

Category A Agents	Category B Agents
Variola major (smallpox)	*Coxiella burnetii* (Q fever)
Bacillus anthracis (anthrax)	Brucella species (brucellosis)
Clostridium botulinum toxin (botulism)	Alphaviruses, Venezuelan encephalomyelitis
Francisella tularensis (tularemia)	Eastern/Western equine encephalomyelitis
Filoviruses	Food or waterborne pathogens (B Subset)
• Ebola hemorrhagic fever	*Salmonella* species
• Marburg hemorrhagic fever	*Shigella dysenteriae*
Arenaviruses	*Escherichia coli* 0157:h7
• Lassa (Lassa fever)	*Vibrio cholerae*, and *Cryptosporidium*
• Junin (Argentina)	parvum
• Hemorrhagic fever/related viruses	

(*continued*)

Table 5.11 (*continued*)

Category C Agents
• Nipah virus
• Hantavirus
• Tickborne hemorrhagic fever viruses
• Yellow fever
• Multidrug-resistant tuberculosis

Category A agents are easily disseminated or transmitted person-to-person, have a high mortality and major public impact; can cause panic and social disruption; and require special action for public health preparedness.

Category B agents are moderately easy to disseminate; cause moderate morbidity and low mortality; require special enhancements of CDC's diagnostic capacity and enhanced disease surveillance.

Category C agents are emerging pathogens that could be engineered for mass dissemination because of their availability, ease of production and dissemination, and potential for high morbidity and mortality with special health impacts.

Source: Table by author, adapted from Appendix of critical biological agents, D.A. Henderson, on-line at: http://www.house.gov/science/full/dec05/henderson.htm. Accessed August 23, 2006; and information from Frank Ryan, *Tracking the New Killer Plagues.* Boston: Little, Brown and Company, 1997.

Table 5.12 Timeline of the Pioneers of Vaccines

Table 5.12 offers a chronology of the pioneers of modern medicine from the 1800s to the present time—doctors or medical scientists who developed vaccines to prevent or treat contagious diseases capable of causing epidemic or pandemic outbreaks.

Year	Pioneer and Development
1796	Edward Jenner develops the smallpox vaccine
1879	Louis Pasteur develops the first laboratory vaccine
1881	Anthrax vaccine developed by Pasteur
1884	Rabies vaccine developed for dogs by Pasteur
1885	Rabies vaccine developed for humans by Pasteur
1886	Pasteur Institute inaugurated
1890	Diphtheria vaccine developed by Drs. Emil Behring and Kitasato Shibasaburo
1897	Typhoid vaccine developed by Almroth Edward Wright

Year	Pioneer and Development
1900	Experimental tuberculosis vaccine developed by Albert Calmette and Camille Guerin
1921	Tuberculosis vaccine for human use developed and used, Calmette and Guerin
1932	Pearl Kendrick and Grace Eldering develop whooping cough vaccine
1944	Vaccine developed for Japanese encephalitis by Maurice Hilleman
1953	Adenoviruses identified
1954	Salk and Sabin begin development of polio vaccine
1957	The Asian influenza pandemic occurs, vaccines modified to new strain
1960	Polio vaccines developed by Salk and Sabin, and Simian virus identified
1961	Attenuated measles vaccine developed by Hilleman; Orthopox family of viruses identified and isolated
1962	Hilleman isolates mumps virus
1967	Mumps vaccine licensed
1968	Influenza vaccine modified for the Hong Kong flu pandemic
1969	Rubella (measles) vaccine licensed by Hilleman
1971	Measles, mumps, and rubella vaccines developed and spread widely
1974	Meningococcal polysaccharide vaccine licensed by Hilleman
1981	Hepatitis B and chickenpox virus strain licensed
1982	Hepatitis B vaccine licensed
1991	Chickenpox vaccine licensed
2005	Maurice Hilleman dies

Source: Table by author.

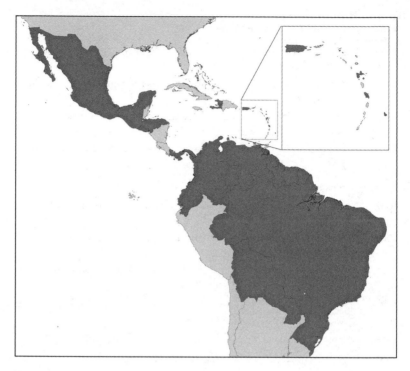

Map 5.1 Zika Outbreak, 2015–2016

Countries and territories with documented local transmission of Zika virus infection reported to the Pan American Health Organization—Region of the Americas, 2015–2016. (Hennessey, M., M. Fischer, and J. Staples. 2016. "Zika Virus Spreads to New Areas—Region of the Americas, May 2015–January 2016." *MMWR*, January 29, 65 (3): 56. http://www.cdc.gov/mmwr/volumes/65/wr/pdfs/mm6503e1.pdf)

The CDC's morbidity and mortality weekly report map shows the countries with the outbreak of Zika virus infections as reported to the Pan American Health organization. The map dramatically depicts the regional but nonetheless pandemic nature of the Zika virus outbreak.

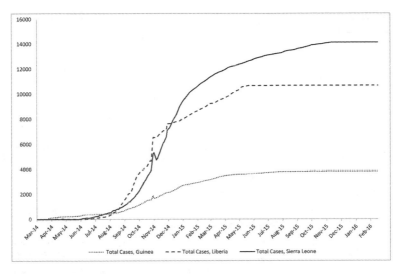

Figure 5.1 Ebola

Total suspected, probable, and confirmed cases of Ebola virus disease in Guinea, Liberia, and Sierra Leone, March 25, 2014 – February 14, 2016, by date of WHO Situation Report, n = 28603. (Centers for Disease Control and Prevention, 2014 Ebola Outbreak in West Africa, Updated February 17, 2016. http://www.cdc.gov/vhf/ebola/outbreaks/2014-west-africa/cumulative-cases-graphs.html)

The figure depicts in line-graph form the total suspected, probable, and confirmed cases of Ebola virus disease in the three West African countries with the most severe outbreaks: Guinea, Liberia, and Sierra Leone, as reported by the WHO in February 2016. It shows the dramatic spike in cases in all three countries over the one-year time span.

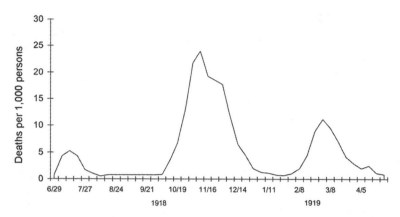

Figure 5.2 The 1918 Influenza Pandemic

Three pandemic waves: weekly combined influenza and pneumonia mortality, United Kingdom, 1918–1919. (Taubenberger, J.K. and D.M. Morens. 2006. "1918 Influenza: The Mother of All Pandemics." *Emerging Infectious Diseases*, January, 12 (1): 17. http://wwwnc.cdc.gov/eid/article/12/1/pdfs/05-0979.pdf)

This graph shows the three pandemic waves of the 1918 Influenza Pandemic—referred to as the "Mother of All Pandemics." It graphs the weekly combined influenza/pneumonia mortality rates in the United Kingdom, 1918–1919. The last two waves, in the fall and winter, show a much higher frequency of complicated, severe, and fatal cases, estimated worldwide to have caused 50 million deaths.

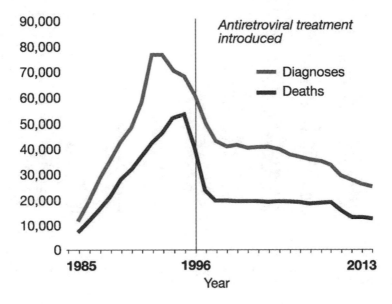

Figure 5.3 The Scope and Impact of HIV/AIDS in the United States

(Today's HIV/AIDS Epidemics, February 2016, Centers for Disease Control and Prevention. http://www.cdc.gov/nchhstp/newsroom/docs/factsheets/todaysepi demic-508.pdf)

Between 1980 and 2012, the deadly nature of HIV/AIDS declined markedly—by a more than two-thirds reduction in annual number of cases reported in the United States. The bar graph depicts cases of new HIV infections among various transmission categories, races, and ethnic groups. African Americans remain the most heavily affected, followed by Latinos.

Figure 5.4 World Prevalence of Tuberculosis

Per 100,000 people. (Data from the World Bank, http://data.worldbank.org/indicator/
SH.TBS.INCD/)

This bar graph demonstrates the fact that around the world the incidence of tuberculosis cases is still both severe and pandemic in nature. Although greatly reduced in the United States and Western Europe, tuberculosis is still a scourge in Africa, Asia, and Central and South America. The pandemic nature of tuberculosis cases is clearly linked to economic development.

Documents

The following are excerpts of important laws, cases, and related historical documents.

Letter from Lady Montagu Regarding Inoculation against Smallpox (1717)

In 1717, Lady Wortley Montagu accompanied her husband, the newly named British ambassador to the court of the Ottoman Empire, to Turkey where she observed the traditional process of variolation practiced by older Turkish women. She wrote her sister

about it, expressing her approval and intent to "spread the word" about variolation when she returned to Great Britain.

A propos of distempers, I am going to tell you a thing that I am sure will make you wish yourself here. The small-pox, so fatal, and so general amongst us, is here entirely harmless by the invention of *ingrafting*, which is the term they give it. There is a set of old women who make it their business to perform the operation every autumn, in the month of September, when the great heat is abated. People send to one another to know if any of their family has a mind to have the small-pox; they make parties for this purpose, and when they are met (commonly fifteen or sixteen together), the old woman comes with a nut-shell full of the matter of the best sort of small-pox, and asks what veins you please to have opened. She immediately rips open that you offer to her with a large needle (which gives you no more pain than a common scratch), and puts into the vein as much venom as can lie upon the head of her needle, and after binds up the little wound with a hollow bit of shell; and in this manner opens four or five veins. . . . The children or young patients play together all the rest of the day, and are in perfect health to the eighth. Then the fever begins to seize them, and they keep their beds two days, very seldom three. They have very rarely above twenty or thirty in their faces, which never mark; and in eight days' time they are as well as before their illness. Where they are wounded, there remain running sores during the distemper, which I don't doubt is a great relief to it. Every year thousands undergo this operation; and the French embassador (sic) says pleasantly, that they take the small-pox here by way of diversion, as they take the waters in other countries. There is no example of any one that has died in it; and you may believe I am very well satisfied of the safety of this experiment, since I intend to try it on my dear little son. . . .

Your Friend, &c.

Source: Melville, Lewis. *Lady Mary Wortley Montagu: Her Life and Letters (1689–1762).*

Arguments over a Smallpox Vaccine (1722)

The availability and use of a smallpox vaccine was vigorously argued among physicians, clergymen, public officials, and scientists. Some clergymen argued for its application as proof of God's providence in giving such protection, and some physicians argued against its application as an unproved experiment. The dispute is illustrated by a letter from a Boston physician, where the movement for inoculation had gained great support and practice, to Cadwallader Colden, a scientist and governor of New York. In the excerpt below, he comments on the ironies of the argument. The option of fleeing an epidemic was available more to the rich than the middle and lower classes, who invariably had to stay to work. Moreover, the upper class was more able to bear the cost of inoculation. Nobody escaped diseases, but, in fact, the rich had much better odds in dealing with them—illustrating the advantages of wealth and mobility in colonial America.

I oppose this novel and dubious practice not being sufficiently assured of its safety and consequences; in short I reckon it a sin to propagate infection by this means and bring on my neighbor a distemper which might prove fatal and which perhaps he might escape (as many have done) in the ordinary way, and which he might secure himself by removal in this Country where it prevails seldom. However, many of our clergy had got into it and they scorned to retract; I had them to appease, which occasioned great Heats (you may perhaps admire how they reconcile this with their doctrine of predestination).

Source: William Douglass to Cadwallader Colden, May 1, 1722, in Jared Sparks, ed., "Letters of Dr. William Douglas[s] to Dr. Cadwallader Colden of New York," in *Collections of the Massachusetts Historical Society*, series 4 (Boston, 1854), II, 170.

Newspaper Article on a Smallpox Outbreak in New York City (1731)

Many diseases plagued the colonists because of poor sanitation, ignorance of germs, and the prevalence of vermin and insects carrying

pathogens. Health problems afflicted all the colonists, but outbreaks of epidemics especially frightened them. With their crowded and unhealthy conditions, seaport cities especially suffered from outbreaks of cholera, yellow fever, typhus, and smallpox. Smallpox was a special case in that during the early 18th century, experiments in inoculation promised some protection. The death toll from a smallpox epidemic in 1731 is described below.

In the month of August last the Small Pox began to spread in this city, and for some weeks was very favourable, and few died of this Distemper, but as soon as we observed the Burials to increase, which was from the 23rd of August, in our Gazette, No. 305 we began to incert weekly, the Number both of Whites and Blacks that were buried in this City, by which account we find, that from the 23rd of August to this Instant, which is two months and 3 weeks, there was buried in the several burying Places of this City, as follows, viz.

Whites in all	478
Blacks in all	71
Whites and Blacks in all	549

Source: *New York Gazette,* No. 316, November 8–15, 1731.

The Scourge of Yellow Fever, Philadelphia (1793)

Matthew Carey, an Irish immigrant, gives an account of the great yellow fever epidemic in Philadelphia in 1793.

The symptoms which characterised the first stage of the fever, were, in the greatest number of cases, after a chilly fit of some duration, a quick, tense pulse–hot skin–pain in the head, back and limbs–flushed countenance–inflamed eye–moist tongue–oppression and sense of soreness at the stomach, especially upon pressure–frequent sick qualms, and retchings to vomit, without discharging any thing, except the contents last taken into the stomach–costiveness, etc. And when stools were procured, the first generally showed a defect of bile, or an obstruction

to its entrance into the intestines. But brisk purges generally altered this appearance.

These symptoms generally continued with more or less violence from one to three, four, or even five days; and then gradually abating, left the patient free from every complaint, except general debility. On the febrile symptoms suddenly subsiding, they were immediately succeeded by a yellow tinge in the opaque cornea, or whites of the eyes—and increased oppression at the præcordia—a constant puking of every thing taken into the stomach, with much straining, accompanied with a hoarse, hollow noise.

If these symptoms were not soon relieved, a vomiting of matter, resembling coffee grounds in color and consistence, commonly called the black vomit, sometimes accompanied with, or succeeded by hemorrhages from the nose, sauces, gums, and other parts of the body—a yellowish purple colour, and putrescent appearance of the whole body, hiccup, agitations, deep and distressed sighing, comatose delirium, and finally, death. When the disease proved fatal, it was generally between the sixth and eighth days. This was the most usual progress of this formidable disease, through its several stages. There were, however, very considerable variations in the symptoms, as well as in the duration of its different stages, according to the constitution and temperament of the patient, the state of the weather, the manner of treatment, etc. . . .

In some, the symptoms inclined more to the nervous than the inflammatory type. In these, the jaundice colour of the eye and skin, and the black vomiting, were more rare. But in the majority of cases, particularly after the nights became sensibly cooler, all the symptoms indicated violent irritation and inflammatory diathesis. In these cases, the skin was always dry, and the remissions very obscure.

The febrile symptoms, however, as has been already observed, either gave way on the third, fourth, or sixth day, and then the patient recovered; or they were soon after succeeded by a different, but much more dangerous train of symptoms, by debility,

low pulse, cold skin, (which assumed a tawny colour, mixed with purple) black vomiting, hemorrhages, hiccup, anxiety, restlessness, coma, etc. Many, who survived the eighth day, though apparently out of danger, died suddenly in consequence of an hemorrhage.

This disorder having been new to nearly all our physicians, it is not surprising, although it has been exceedingly fatal, that there arose such a discordance of sentiment on the proper mode of treatment, and even with respect to its name. . . . The honour of the first essay of mercury in this disorder, is by many ascribed to Dr. Hodge and Dr. Carson, who are said to have employed it a week before Dr. Rush. On this point, I cannot pretend to decide. But whoever was the first to introduce it, one thing is certain, that its efficacy was great, and rescued many from death. I have known, however, some persons, who, I have every reason to believe, fell sacrifices to the great reputation this medicine acquired; for in several cases it was administered to persons of a previous lax habit, and brought on a speedy dissolution . . .

An intelligent citizen, who has highly distinguished himself by his attention to the sick, says, that he found the disorder generally come on with costiveness; and unless that was removed within the first twelve hours, he hardly knew any person to recover; on the contrary, he says, as few died, on whom the cathartics operated within that time.

The efficacy of bleeding, in all cases not attended with putridity, was great. The quantity of blood taken was in many cases astonishing. Dr. Griffits was bled seven times in five days, and appears to ascribe his recovery principally to that operation. Dr. Mease, in five days, lost seventy-two ounces of blood, by which he was recovered when at the lowest stage of the disorder. Many others were bled still more, and are now as well as ever they were.

Dr. Rush and Dr. Wistar have spoken very favorably of the salutary effects of cold air, and cool drinks, in this disorder. The latter says, that he found more benefit from cold air, than

from any other remedy. He lay delirious, and in severe pain, between a window and door, the former of which was open. The wind suddenly changed, and blew full upon him, cold and raw. Its effects were so grateful, that he soon recovered from his delirium—his pain left him—in an hour he became perfectly reasonable—and his fever abated.

Source: Matthew Carey, *A Short Account of the Malignant Fever Lately Present in Philadelphia lately prevalent in Philadelphia: with a statement of the Proceedings that took place on the subject, in different parts of the United States—to which are added, Accounts of the Plague in London and Marseilles; and a List of the Dead, From August 1, to the middle of December 1793* (Fourth Edition, Improved Philadelphia: Printed by the Author. January 15, 1794), 13–16.

Winfield Scott on the Cholera Epidemic during the Black Hawk War (1832)

The influx of American settlers had pushed the Sauk and Fox Indians across the Mississippi River. Sauk warriors led by Black Hawk crossed the river into Illinois in 1831 and burned settlers' houses. Black Hawk returned a year later with some 2,000 of his people to settle in western Illinois and try to reclaim his former territory. Army troops and militia were sent to eject the Indians from Illinois. After several battles, the American force inflicted a decisive defeat on August 2, 1832. At the time, diseases killed far more people than did battle. When people gathered in close contact, whether Indians or soldiers, infectious diseases spread with fatal ease. This following excerpt shows how General Winfield Scott dealt with disastrous loss of life caused by disease. He arrived five days after the decisive battle of the Black Hawk War with his forces depleted by an epidemic of Asiatic cholera that had swept through his overcrowded troop transport vessels on the Great Lakes. One third of his men were dead or unable to serve, while many others had deserted for fear of contagion. In this excerpt from his 1864

memoir, Scott—referring to himself in the third person—reports that he single-handedly treated and cured many of his men as the ship's doctor retired to his bed drunk.

Ascending Lake Huron, the Asiatic cholera, the new scourge of mankind which had just before been brought to Quebec, found its way up the chain of waters, in time to infect the troops of Scott's expedition at different points on the lakes. In his particular steamer, the disease broke out suddenly, and with fatal violence. The only surgeon on board, in a panic, gulped down half a bottle of wine; went to bed, sick, and ought to have died. There was nobody left that knew anything of the healing art, or of the frightful distemper—only Scott, who, anticipating its overtaking him in the Northwest, had taken lessons from Surgeon Mower, stationed in New York—eminent in his profession, and of a highly inquiring, philosophic mind—in respect to the character, and mode of treating the disease. Thus he became the doctor on the afflicting occasion—no doubt a very indifferent one, except in labor and intrepidity. He had provided the whole expedition with the remedies suggested by Doctor Mower, which, on board his steamer, he applied, in great part, with his own hand to the sick. His principal success was in preventing a general panic, and, *mirabile dictu!* actually cured, in the incipient stage, by *command,* several individuals of that fatal preparation for the reception of the malady. It continued several days after landing, in July, at Chicago—then but a hamlet. As soon as the troops had become sufficiently convalescent they were marched thence across the wild prairies, inhabited by nomads of Potawatamies—Indians of doubtful neutrality. Scott preceded the detachments, and on arriving at Prairie du Chien, was glad to find that Atkinson, after a most fagging march of weeks and hundreds of miles, following the devious retreat of the Hawk, finally overtook him at the mouth of the Badaxe in the act of crossing the Mississippi, with his band, and in a gallant combat, killed many of his followers, made others prisoners, and dispersed the remainder.

Source: Winfield Scott, *Memoirs of Lieut.-General Scott, LL.D. Written by himself*, vol. 1 (New York: Sheldon & Co., 1864), 218–219.

Raphael Semmes's Account of an Epidemic aboard Ship during the Mexican War (1851)

As is often the case epidemics occur during a war, this article describes one such epidemic, referred to by the author as vomito, but likely a case of typhoid fever, or "ships fever" as it was then often called, during the Mexican War of 1851. The article vividly portrays the deadly and pernicious influence of the epidemic and the struggles, often in vain, to cope with the disease which at the time was little known or understood. It highlights the social impact of unchecked epidemic outbreaks.

When the norther has ceased to scour the coast in pursuit of victims, the vomito begins its more silent, but not less deadly, approaches. This scourge is not only the terror of the Americans and Europeans who trade with Vera Cruz, but is equally dreaded by the inhabitants of the interior of the country. When it prevails badly as an epidemic, almost all intercourse with the plateaus of the Cordilleras is suspended. Even the hardy arrieros, or mule-drivers, who are the common carriers of commerce, cease their regular visits to and from the infected city; when the whole interior of the country suffers more or less for want of its accustomed supplies. So pure and salubrious is the air of the upland regions, that an inhabitant of Puebla or Mexico, on descending to Vera Cruz, is more liable to take the disease than most foreigners. As Vera Cruz is the only seaport of any importance on the Mexican Gulf, and transacts three-fourths of the foreign business of the country, it is readily seen how pernicious an influence the prevalence of the vomito exercises on the pursuits of the mass of the population. Even the mines to which delay is death, in consequence of the vast amount of capital invested in them, not unfrequently suffer for want of quicksilver (used extensively for separating the precious metals, and almost all of which is imported from the mines of

Almaden, in Spain), and the necessary machinery—none of which is manufactured in the country—for carrying on their operations. Indeed, so seriously have the inconveniences of this epidemic been felt, that, on more than one occasion, the question has been discussed, of razing the city to the ground, and abandoning it altogether.

These various discussions will give the reader an idea of the terror with which the vomito inspires the inhabitants of the mountain slopes, and elevated plains, Experience would seem to show, that extreme heat alone does not produce yellow fever. There are many islands in the West Indies, farther south than Vera Cruz—the Danish island of Santa Cruz, for instance—where the disease is unknown. But what is more remarkable, this scourge does not prevail on the western coast of Mexico. Even the unhealthy town of Acapulco, which, according to the observations of Humboldt, has a higher mean temperature throughout the year, than Vera Cruz, is exempt from it. Malignant bilious and remittent fevers prevail here, but as yet there have been no well marked case of the vomito. Our squadron, which remained all the summer of 1846 in the vicinity of Vera Cruz—holding, of course, no intercourse with the shore—had no fever. The seamen were crowded in small spaces—there being as many as two hundred men on board a sloop-of-war of eight or nine hundred tons—were exposed to the same heat, somewhat tempered by the sea-breezes, slept in the open air on the decks, in their night watches, and were frequently drenched with rain, both day and night; and yet they experienced no inconvenience. And the reason, no doubt, was, that under Commodore Conner's excellent system of discipline, the between decks were kept dry and well ventilated; and the men, every evening, at sunset quarters, were required to exchange their lighter duck-frocks and trowsers for woolen ones. Many valuable officers and men fell a sacrifice, in the following year; but we were then in possession of the enemy's ports and coasts; and it was necessary to maintain a constant communication with the shore, and even to garrison many points. It would seem to follow, from all these facts, that. the vomito of Vera Cruz is local, and

must., therefore, be produced by malaria arising somewhere in the vicinity of the town.

The vomito of Vera Cruz resembles, in all its essential futures, that of Havana and New Orleans. It is the same gastro-nervous disease, and is accompanied by the same yellowness of the skin, irritation of the stomach, intense headache, pain in the small of the back, and vomiting. It sometimes prostrates, so powerfully, the nervous system, as to kill the patient in five or six hours; but its more general course is from two to five days. Women are less subject to it than men, and very young children are rarely attacked by it. It is most to be feared at the commencement and end of the rainy season; and the reason assigned is, that there is more putrefaction of vegetable and animal matter going on at these periods, in consequence of the prevalence of alternate rain and sunshine, than when it is raining constantly; as constant humidity, like constant drowth, retards decomposition. There is, no doubt, a barometric cause also, hitherto unnoticed, which operates more powerfully upon the nervous system, while the atmosphere is undergoing these changes. It is remarkable that the natives of Vera Cruz do not suffer from this disease, and that those who have had it once need not fear it a second time. But it is not a sufficient exemption for a stranger going to Vera Cruz, to have had it elsewhere. It seems to be modified in each particular place where it prevails, by local causes, more or less variant, and to require a new acclimation in consequence. Thus we see that the eastern coast of Mexico has as powerful a defender in the vomito, as in the norther; and it is well known that the inhabitants of the interior plains, at the period of our invasion, relied greatly upon the chances of our being cut off by this disease. On the other hand, General Scott gave it due consideration in the formation of the plan of his campaign, and endeavored to avoid so great a calamity.

Source: Raphael Semmes, *Service Afloat and Ashore during the Mexican War* (Cincinnati: Wm. H. Moore & Co., 1851), 112–116.

Massachusetts Law Requiring Vaccination of School Children (1855)

The Commonwealth of Massachusetts adopted the first law requiring that all children be vaccinated before enrolling in school. The text of that law is reprinted below, in its original and uncorrected form.

Chap. 0414 An Act to secure General Vaccination.

Be it enacted by the Senate and House of Representatives, in General Court assembled, and by the authority of the same, as follows:

Sect. 1. Parents and guardians of youth, shall cause the children under their care to be vaccinated before they attain the age of two years.

Sect. 2. The school committee of the several towns and cities, shall not allow any child to be admitted to, or connected with the public schools, who has not been duly vaccinated.

Sect. 3. The selectmen of the several towns, and the mayor and aldermen of every city, shall enforce the vaccination of all the inhabitants of said towns and cities; and every parent or guardian of youth who shall not cause his or her child or ward to be vaccinated, (the said child or ward being more than two years of age,) shall be liable to a fine of five dollars for each and every year's neglect, to be recovered on complaint of the selectmen of the town, or of the mayor and aldermen of the city, for the benefit and use of said town or city.

Sect. 4. The selectmen of the several towns, and the mayor and aldermen of every city, shall enforce re-vaccination whenever they shall judge the public health requires the same: provided, that none shall be required to be re-vaccinated who shall prove, to the satisfaction of said selectmen, or mayor and aldermen, that they have been successfully

vaccinated, or re-vaccinated, within five years next preceding; and any neglect of such requirement of the selectmen, or of the mayor and aldermen, shall render the person or persons guilty of such neglect, liable to a fine as above, to be recovered as aforesaid, for the use of said town or city.

Sect. 5. It shall be the duty of all incorporated manufacturing companies, of all the superintendents of almshouses, State reform schools, lunatic hospitals, and of all other places where the poor or sick are received, and of masters, of houses of correction, jailers, or keepers of prisons, the warden of the State Prison, and of the superintendents or officers of all other institutions supported wholly or in part by the State, to cause all the inmates of the above-named institutions to be properly vaccinated. And all persons hereafter received into such institutions shall be vaccinated immediately on their entrance, unless such persons can show sufficient evidence of previous vaccination within the term of five years.

Sect. 6. The towns and cities shall be at the expense of furnishing the means of vaccination to such of their own citizens as may be unable to meet the same. All public institutions and incorporated manufacturing companies, named in section five, shall provide the means of vaccination at the expense of said institutions and corporations.

Sect. 7. This act shall take effect on and after its passage. [Approved by the Governor, May 19, 1855.]

Source: The State Library of Massachusetts. "1855 Chap. 0414. An Act To Secure General Vaccination."

Act of March 3, 1891, Allowing Medical Exams by the USMHS

In 1891 Congress passed an immigration act expanding classes of exclusions, increasing penalties, and creating the position of

superintendent of immigration. The new law generally strengthened the enforcement process and lodged immigration matters squarely with the federal government. Section 8, cited below, gave the USMHS medical examination and quarantine control.

Sec. 8. That upon arrival by water at any place within the United States of any alien immigrants it shall be the duty of the commanding officer and the agents of the steam or sailing vessel by which they came to report the name, nationality, last residence, and destination of every such alien, before any of them are landed, to the proper inspection officers, who shall thereupon go or send competent assistants on board such vessel and there inspect all such aliens, or the inspection officer may order a temporary removal of any such aliens for examination at a designated time and place, and then and there detain them until a thorough inspection is made. But such removal shall not be considered a landing during the pendency of such examination. The medical examination shall be made by surgeons of the Marine Hospital Service. In cases where the services of the Marine Hospital Surgeon can not be obtained without causing unreasonable delay, the inspector may cause an alien to be examined by a civil surgeon and the Secretary of the Treasury shall fix the compensation for such examination. The inspection of officers and their assistants shall have the power to administer oaths, and take and consider testimony touching on the right of any such alien to enter the United States, all of which shall be entered on record. During such inspection after temporary removal the superintendent shall cause such aliens to be properly housed, fed, and cared for, and also, in his discretion, such are delayed in proceeding to their destination after inspection. All decisions made by the inspection officers or their assistants touching on the right of any alien to land, when adverse to such right, shall be final unless appeal be taken to the superintendent of immigration, whose action shall be subject to review by the Secretary of the Treasury. It shall be the duty of the aforesaid officers and agents of such vessel to adopt

due precautions to prevent the landing of any alien immigrant at any time or place other than that designated by the inspection officer, and any such officer or agent in charge of such vessel who shall knowingly or negligently land or permit to land any alien immigrant at any place or time other than that designated by the inspection officers, shall be deemed guilty of a misdemeanor punished by a fine not exceeding one thousand dollars, or by imprisonment not exceeding one year, or by both fine and such imprisonment.

That the Secretary of the Treasury may prescribe rules for inspection along the borders of Canada, British Columbia, and Mexico so as not to obstruct or unnecessarily delay, impede, or annoy passengers in ordinary travel between said countries; Provided, That not exceeding one inspector shall be appointed for each customs district, and whose salary shall not exceed twelve hundred dollars per year.

Source: 26 Stat. 1094; U.S.C. 101.

Walter Reed and the Eradication of Yellow Fever

The following document is from the Army Historical Foundation Museum and describes the work of Major Walter Reed and the Commission named after him, and the resulting eradication of yellow fever.

U.S. Army surgeon Major Walter Reed and his discovery of the causes of yellow fever is one of the most important contribution in the field of medicine and human history. During the Spanish-American war, more American soldiers died from yellow fever, malaria, and other diseases than from combat. After the war, the disease continued to ravage both Cubans and the American occupation force, prompting Army Surgeon General George M. Sternberg to appoint a commission in 1900 to investigate the cause of the disease and how to prevent its occurrence.

Known officially as the United States Army Yellow Fever Commission, it was known simply as the Reed Commission

for Major Reed, who was the chairman of the four-man body that included three other specialists in infectious disease: James Carroll, Aristides Agramonte, and Jesse W. Lazear, all of whom were contract doctors for the Army. Reed received his medical degree from the University of Virginia in 1869, the youngest student to complete the degree at the university's medical school to date. He received an additional degree in 1870 at Bellevue Hospital Medical College in New York. Reed's experience interning in hospitals in New York helped him develop a lifelong interest in public health. He joined the Army Medical Corps in 1875.

In a series of experiments, beginning in June 1900, the Reed Commission eventually proved that yellow fever was spread not by poor sanitation, but by female *Aedes Aegypti* mosquitoes, which carried the virus from person to person with their bites. To confirm their conclusions, the commission disproved the bacterial theory and direct contact as causes for spreading the disease by having volunteer soldiers wear soiled clothing that belonged to infected patients over a period of time.

While on leave in Washington, Reed tested the mosquito theory, which was hypothesized by Cuban physician Carlos Juan Finlay, by hatching eggs from Finlay's collection and having them feed on yellow fever patients, and then had them bite several volunteers, including Carroll, who recovered. Lazear was also bitten, though it may have been unintentional. His case was so severe that he died in September 1900. Upon returning to Cuba, Reed set up an experimental camp, Camp Lazear, in the jungle to continue the commission's work. Reed and his team systematically demonstrated that mosquitoes only picked up the yellow fever virus if they fed on a person during the first three days of infection. After a period of days of incubation, the mosquitoes could then pass on the virus to another human through a bite.

As a result of the Reed Commission's findings, the military governor of Cuba, Major General Leonard Wood authorized the Army's chief sanitation officer, Major William C. Gorgas to implement an experimental program of inoculations. However,

many of the volunteers died, prompting Gorgas to cancel the experiment. The only other solution was to eradicate the mosquitoes in Havana. Gorgas first enclosed yellow fever patients in screens to prevent mosquitoes from feeding and picking up the virus. He then ordered his team to fumigate every building in Havana and identified collections of water where mosquitoes might breed; he had those sources screened or drained, and even spread oil on the surface. As a result of these efforts, cases drastically fell and, by 1902, there were no reported cases. Malaria deaths decreased as well.

With Walter Reed's experiments and Gorgas's practical application of the Reed Commissions findings, the Army was able to curb and eventually eradicate yellow fever, paving the way for future operations where yellow fever was prevalent. Gorgas was able to implement a similar program during the building of the Panama Canal in 1904, which was crucial to the eventual completion of the strategically vital waterway in 1914.

Source: The Army Historical Foundation, https://armyhistory .org/major-walter-reed-and-the-eradication-of-yellow-fever. Used by permission.

Excerpts from *Jacobson v. Massachusetts* (1905)

Modern vaccination laws were first passed in the early 19th century, with Massachusetts enacting the first such law. It was eventually challenged in the courts. In Jacobson v. Massachusetts, *excerpted here, the Supreme Court ruled that a state statute that allowed localities to require vaccinations did not violate Jacobson's constitutional right, holding that public safety fit legitimately within the state police power.*

MR. JUSTICE HARLAN delivered the opinion of the Court:

We pass without extended discussion the suggestion that the particular section of the statute of Massachusetts now in question (137, chap. 75) is in derogation of rights secured by the preamble of the Constitution of the United States. Although

that preamble indicates the general purposes for which the people ordained and established the Constitution, it has never been regarded as the source of any substantive power conferred on the government of the United States, or on any of its departments. Such powers embrace only those expressly granted in the body of the Constitution, and such as may be implied from those so granted. Although, therefore, one of the declared objects of the Constitution was to secure the blessings of liberty to all under the sovereign jurisdiction and authority of the United States, no power can be exerted to that end by the United States, unless, apart from the preamble, it be found in some express delegation of power, or in some power to be properly implied therefrom. . . .

What, according to the judgment of the state court, are the scope and effect of the statute? What results were intended to be accomplished by it? These questions must be answered.

The supreme judicial court of Massachusetts said in the present case: "Let us consider the offer of evidence which was made by the defendant Jacobson. The ninth of the propositions which he offered to prove, as to what vaccination consists of, is nothing more than a fact of common knowledge, upon which the statute is founded, and proof of it was unnecessary and immaterial. The thirteenth and fourteenth involved matters depending upon his personal opinion, which could not be taken as correct, or given effect, merely because he made it a ground of refusal to comply with the requirement. Moreover, his views could not affect the validity of the statute, nor entitle him to be excepted from its provisions. *Com. v. Connolly; Com. v. Has; Reynolds v. United States; Reg. v. Downes.* The other eleven propositions all relate to alleged injurious or dangerous effects of vaccination. The defendant 'offered to prove and show be competent evidence' these so called facts. Each of them, in its nature, is such that it cannot be stated as a truth, otherwise than as a matter of opinion. The only 'competent evidence' that could be presented to the court to prove these propositions was the testimony of experts, giving their opinions. It would not have been competent to introduce

the medical history of individual cases. Assuming that medical experts could have been found who would have testified in support of these propositions, and that it had become the duty of the judge, in accordance with the law as stated in *Com. v. Anthes,* to instruct the jury as to whether or not the statute is constitutional, he would have been obliged to consider the evidence in connection with facts of common knowledge, which the court will always regard in passing upon the constitutionality of a statute. He would have considered this testimony of experts in connection with the facts that for nearly a century most of the members of the medical profession have regarded vaccination, repeated after intervals, as a preventive of smallpox; that, while they have recognized the possibility of injury to an individual from carelessness in the performance of it, or even in a conceivable case without carelessness, they generally have considered the risk of such an injury too small to be seriously weighed as against the benefits coming from the discreet and proper use of the preventive; and that not only the medical profession and the people generally have for a long time entertained these opinions, but legislatures and courts have acted upon them with general unanimity. If the defendant had been permitted to introduce such expert testimony as he had in support of these several propositions, it could not have changed the result. It would not have justified the court in holding that the legislature had transcended its power in enacting this statute on their judgment of what the welfare of the people demands." *Com. v. Jacobson.* . . .

The authority of the state to enact this statute is to be referred to what is commonly called the police power,-a power which the state did not surrender when becoming a member of the Union under the Constitution. Although this court has refrained from any attempt to define the limits of that power, yet it has distinctly recognized the authority of a state to enact quarantine laws and "health laws of every description;" indeed, all laws that relate to matters completely within its territory

and which do not by their necessary operation affect the people of other states. According to settled principles, the police power of a state must be held to embrace, at least, such reasonable regulations established directly by legislative enactment as will protect the public health and the public safety. *Gibbons v. Ogden; Hannibal & St. J. R. Co. v. Husen; Boston Beer Co. v. Massachusetts; New Orleans Gaslight Co. v. Louisiana Light & H. P. & Mfg. Co.; Lawson v. Stecle.* It is equally true that the state may invest local bodies called into existence for purposes of local administration with authority in some appropriate way to safeguard the public health and the public safety. The mode or manner in which those results are to be accomplished is within the discretion of the state, subject, of course, so far as Federal power is concerned, only to the condition that no rule prescribed by a state, nor any regulation adopted by a local governmental agency acting under the sanction of state legislation, shall contravene the Constitution of the United States, nor infringe any right granted or secured by that instrument. A local enactment or regulation, even if based on the acknowledged police powers of a state, must always yield in case of conflict with the exercise by the general government of any power it possesses under the Constitution, or with any right which that instrument gives or secures. *Gibbons v. Ogden; Sinnot v. Davenport; Missouri, K. & T. R. Co. v. Haber.*

We come, then, to inquire whether any right given or secured by the Constitution is invaded by the statute as interpreted by the state court. The defendant insists that his liberty is invaded when the state subjects him to fine or imprisonment for neglecting or refusing to submit to vaccination; that a compulsory vaccination law is unreasonable, arbitrary, and oppressive, and, therefore, hostile to the inherent right of every freeman to care for his own body and health in such way as to him seems best; and that the execution of such a law against one who objects to vaccination, no matter for what reason, is nothing short of an assault upon his person. But the liberty secured by

the Constitution of the United States to every person within its jurisdiction does not import an absolute right in each person to be, at all times and in all circumstances, wholly freed from restraint. There are manifold restraints to which every person is necessarily subject for the common good. On any other basis organized society could not exist with safety to its members. Society based on the rule that each one is a law unto himself would soon be confronted with disorder and anarchy. Real liberty for all could not exist under the operation of a principle which recognizes the right of each individual person to use his own, whether in respect of his person or his property, regardless of the injury that may be done to others. This court has more than once recognized it as a fundamental principle that "persons and property are subjected to all kinds of restraints and burdens in order to secure the general comfort, health, and prosperity of the state; of the perfect right of the legislature to do which no question ever was, or upon acknowledged general principles ever can be, made, so far as natural persons are concerned." *Hannibal & St. J. R. Co. v. Husen; Missouri, K. & T. R. Co. v. Haber; Thorpe v. Rutland & B. R. Co.* In *Crowley v. Christensen,* we said: "The possession and enjoyment of all rights are subject to such reasonable conditions as may be deemed by the governing authority of the country essential to the safety, health, peace, good order, and morals of the community. Even liberty itself, the greatest of all rights, is not unrestricted license to act according to one's own will. It is only freedom from restraint under conditions essential to the equal enjoyment of the same right by others. It is, then, liberty regulated by law." In the Constitution of Massachusetts adopted in 1780 it was laid down as a fundamental principle of the social compact that the whole people covenants with each citizen, and each citizen with the whole people, that all shall be governed by certain laws for "the common good," and that government is instituted "for the common good, for the protection, safety, prosperity, and happiness of the people, and not for the profit, honor, or private interests of any one man, family, or class of

men." The good and welfare of the commonwealth, of which the legislature is primarily the judge, is the basis on which the police power rests in Massachusetts. *Com. v. Alger.*

Applying these principles to the present case, it is to be observed that the legislature of Massachusetts required the inhabitants of a city or town to be vaccinated only when, in the opinion of the board of health, that was necessary for the public health or the public safety. The authority to determine for all what ought to be done in such an emergency must have been lodged somewhere or in some body; and surely it was appropriate for the legislature to refer that question, in the first instance, to a board of health composed of persons residing in the locality affected, and appointed, presumably, because of their fitness to determine such questions. To invest such a body with authority over such matters was not an unusual, nor an unreasonable or arbitrary, requirement. Upon the principle of self-defense, of paramount necessity, a community has the right to protect itself against an epidemic of disease which threatens the safety of its members. It is to be observed that when the regulation in question was adopted smallpox, according to the recitals in the regulation adopted by the board of health, was prevalent to some extent in the city of Cambridge, and the disease was increasing. If such was the situation,—and nothing is asserted or appears in the record to the contrary,—if we are to attach, any value whatever to the knowledge which, it is safe to affirm, in common to all civilized peoples touching smallpox and the methods most usually employed to eradicate that disease, it cannot be adjudged that the present regulation of the board of health was not necessary in order to protect the public health and secure the public safety. Smallpox being prevalent and increasing at Cambridge, the court would usurp the functions of another branch of government if it adjudged, as matter of law, that the mode adopted under the sanction of the state, to protect the people at large was arbitrary, and not justified by the necessities of the case. . . . In *Hannibal & St. J. R. Co. v. Husen,* this court recognized the right of a state to pass sanitary laws, laws for the protection of life, liberty, health,

or property within its limits, laws to prevent persons and animals suffering under contagious or infectious diseases, or convicts, from coming within its borders. . . . If the mode adopted by the commonwealth of Massachusetts for the protection of its local communities against smallpox proved to be distressing, inconvenient, or objectionable to some,—if nothing more could be reasonably affirmed of the statute in question,—the answer is that it was the duty of the constituted authorities primarily to keep in view the welfare, comfort, and safety of the many, and not permit the interests of the many to be subordinated to the wishes or convenience of the few. There is, of course, a sphere within which the individual may assert the supremacy of his own will, and rightfully dispute the authority of any human government,—especially of any free government existing under a written constitution, to interfere with the exercise of that will. But it is equally true that in every well-ordered society charged with the duty of conserving the safety of its members the rights of the individual in respect of his liberty may at times, under the pressure of great dangers, be subjected to such restraint, to be enforced by reasonable regulations, as the safety of the general public may demand. An American citizen arriving at an American port on a vessel in which, during the voyage, there had been cases of yellow fever or Asiatic cholera, he, although apparently free from disease himself, may yet, in some circumstances, be held in quarantine against his will on board of such vessel or in a quarantine station, until it be ascertained by inspection, conducted with due diligence, that the danger of the spread of the disease among the community at large has disappeared. The liberty secured by the 14th Amendment, this court has said, consists, in part, in the right of a person "to live and work where he will" (*Allgeyer v. Louisiana*); and yet he may be compelled, by force if need be, against his will and without regard to his personal wishes or his pecuniary interests, or even his religious or political convictions, to take his place in the ranks of the army of his country, and risk the chance of being shot down in its defense. It is not, therefore,

true that the power of the public to guard itself against imminent danger depends in every case involving the control of one's body upon his willingness to submit to reasonable regulations established by the constituted authorities, under the sanction of the state, for the purpose of protecting the public collectively against such danger.

It is said, however, that the statute, as interpreted by the state court, although making an exception in favor of children certified by a registered physician to be unfit subjects for vaccination, makes no exception in case of adults in like condition. But this cannot be deemed a denial of the equal protection of the laws to adults; for the statute is applicable equally to all in like condition, and there are obviously reasons why regulations may be appropriate for adults which could not be safely applied to persons of tender years.

Looking at the propositions embodied in the defendant's rejected offers of proof, it is clear that they are more formidable by their number than by their inherent value. Those offers in the main seem to have had no purpose except to state the general theory of those of the medical profession who attach little or no value to vaccination as a means of preventing the spread of smallpox, or who think that vaccination causes other diseases of the body. What everybody knows the court must know, and therefore the state court judicially knew, as this court knows, that an opposite theory accords with the common belief, and is maintained by high medical authority. We must assume that, when the statute in question was passed, the legislature of Massachusetts was not unaware of these opposing theories, and was compelled, of necessity, to choose between them. It was not compelled to commit a matter involving the public health and safety to the final decision of a court or jury. It is no part of the function of a court or a jury to determine which one of two modes was likely to be the most effective for the protection of the public against disease. That was for the legislative department to determine in the light of all the information it had or could

obtain. It could not properly abdicate its function to guard the public health and safety. The state legislature proceeded upon the theory which recognized vaccination as at least an effective, if not the best-known, way in which to meet and suppress the evils of a smallpox epidemic that imperiled an entire population. Upon what sound principles as to the relations existing between the different departments of government can the court review this action of the legislature? If there is any such power in the judiciary to review legislative action in respect of a matter affecting the general welfare, it can only be when that which the legislature has done comes within the rule that, if a statute purporting to have been enacted to protect the public health, the public morals, or the public safety, has no real or substantial relation to those objects, or is, beyond all question, a plain, palpable invasion of rights secured by the fundamental law, it is the duty of the courts to so adjudge, and thereby give effect to the Constitution. *Mugler v. Kansas; Minnesota v. Barber; Atkin v. Kansas.*

Whatever may be thought of the expediency of this statute, it cannot be affirmed to be, beyond question, in palpable conflict with the Constitution. Nor, in view of the methods employed to stamp out the disease of smallpox, can anyone confidently assert that the means prescribed by the state to that end has no real or substantial relation to the protection of the public health and the public safety. Such an assertion would not be consistent with the experience of this and other countries whose authorities have dealt with the disease of smallpox. And the principle of vaccination as a means to prevent the spread of smallpox has been enforced in many states by statutes making the vaccination of children a condition of their right to enter or remain in public schools. *Blue v. Beach; Morris v. Columbus; State v. Hay; Abeel v. Clark; Bissell v. Davison; Hazen v. Strong; Duffield v. Williamsport School District.* The latest case upon the subject of which we are aware is *Viemester v. White*, decided very recently by the court of appeals of New York. That case involved the validity of a statute excluding from the public schools all children who had not been vaccinated. One contention was

that the statute and the regulation adopted in exercise of its provisions was inconsistent with the rights, privileges, and liberties of the citizen. The contention was overruled, the court saying, among other things: "Smallpox is known of all to be a dangerous and contagious disease. If vaccination strongly tends to prevent the transmission or spread of this disease, it logically follows that children may be refused admission to the public schools until they have been vaccinated. The appellant claims that vaccination does not tend to prevent smallpox, but tends to bring about other diseases, and that it does much harm, with no good. It must be conceded that some laymen, both learned and unlearned, and some physicians of great skill and repute, do not believe that vaccination is a preventive of smallpox. The common belief, however, is that it has a decided tendency to prevent the spread of this fearful disease, and to render it less dangerous to those who contract it. While not accepted by all, it is accepted by the mass of the people, as well as by most members of the medical profession. It has been general in our state, and in most civilized nations for generations. It is generally accepted in theory, and generally applied in practice, both by the voluntary action of the people, and in obedience to the command of law. Nearly every state in the Union has statutes to encourage, or directly or indirectly to require, vaccination; and this is true of most nations of Europe. . . . A common belief, like common knowledge, does not require evidence to establish its existence, but may be acted upon without proof by the legislature and the courts. . . . The fact that the belief is not universal is not controlling, for there is scarcely any belief that is accepted by everyone. The possibility that the belief may be wrong, and that science may yet show it to be wrong, is not conclusive; for the legislature has the right to pass laws which, according to the common belief of the people, are adapted to prevent the spread of contagious diseases. In a free country, where the government is by the people, through their chosen representatives, practical legislation admits of no other standard of action, for what the people believe is for the common welfare must be accepted as

tending to promote the common welfare, whether it does in fact or not. Any other basis would conflict with the spirit of the Constitution, and would sanction measures opposed to a Republican form of government. While we do not decide, and cannot decide, that vaccination is a preventive of smallpox, we take judicial notice of the fact that this is the common belief of the people of the state, and, with this fact as a foundation, we hold that the statute in question is a health law, enacted in a reasonable and proper exercise of the police power."

Since, then, vaccination, as a means of protecting a community against smallpox, finds strong support in the experience of this and other countries, no court, much less a jury, is justified in disregarding the action of the legislature simply because in its or their opinion that particular method was—perhaps, or possibly—not the best either for children or adults. . . .

It seems to the court that an affirmative answer to these questions would practically strip the legislative department of its function to care for the public health and the public safety when endangered by epidemics of disease. Such an answer would mean that compulsory vaccination could not, in any conceivable case, be legally enforced in a community, even at the command of the legislature, however widespread the epidemic of smallpox, and however deep and universal was the belief of the community and of its medical advisers that a system of general vaccination was vital to the safety of all.

We are not prepared to hold that a minority, residing or remaining in any city or town where smallpox is prevalent, and enjoying the general protection afforded by an organized local government, may thus defy the will of its constituted authorities, acting in good faith for all, under the legislative sanction of the state. If such be the privilege of a minority, then a like privilege would belong to each individual of the community, and the spectacle would be presented of the welfare and safety of an entire population being subordinated to the notions of a single individual who chooses to remain a part of that population. We are unwilling to hold it to be an element in the liberty

secured by the Constitution of the United States that one person, or a minority of persons, residing in any community and enjoying the benefits of its local government, should have the power thus to dominate the majority when supported in their action by the authority of the state. The safety and the health of the people of Massachusetts are, in the first instance, for that commonwealth to guard and protect. They are matters that do not ordinarily concern the national government. So far as they can be reached by any government, they depend, primarily, upon such action as the state, in its wisdom, may take; and we do not perceive that this legislation has invaded any right secured by the Federal Constitution. . . .

We now decide only that the statute covers the present case, and that nothing clearly appears that would justify this court in holding it to be unconstitutional and inoperative in its application to the plaintiff in error.

The judgment of the court below must be affirmed.

It is so ordered.

Source: *Jacobson v. Massachusetts*—197 U.S. 11 (1905).

Excerpts from Clara Barton's Article on Yellow Fever in Cuba (1912)

The famous nurse and founder of the Red Cross, Clara Barton, vividly describes a Yellow Fever epidemic in Cuba in 1912. In addition to describing the suffering that ensued with the outbreak, she highlights the heroic efforts of the army chaplain to cope with the epidemic and serve the soldiers in his charge, even to the point of causing his own death. The article illustrates the fact that often such disease outbreaks, like that of Yellow Fever, took more lives than did battle during war.

Chaplain Campbell arrived in camp on the morning of August 3 and thereafter took charge, of course, of all matters of this kind. Although personally known to only a few of the officers and men he received a hearty greeting. After a hurried introduction

and a brief explanation of the situation, he pulled on his rubber boots and rubber coat and started out in the rain and mud to cheer the sick and get acquainted with the well. Inside of two or three hours he had said something to every man, and from that time until the end of his service he was busy caring for the sick, comforting the dying, and burying the dead.

Before we left the island to return to the States fourteen more deaths occurred in the Eighth, eight of them at Sevilla Hill and six at Siboney. Privates William K. Adams and Moses McDowell of Company H died Sevilla Hill August 3 and Sergeant Charles Thoman of Company A, Bucyrus, at the same place August 4. On the fifth Private George Coleman, of Company M, died at Sevilla, and Private Frank Gibler of Company I died and was buried at Siboney. There were three deaths again on the seventh of August, all of them at Siboney: Privates George L. Happer, of Millersburg, of Company H, Ora N. Royer of Company K, Alliance, and Corporal Dudley Wilson of Company G, Wadsworth. Captain John A. Leininger of Company F had been unfit for duty much of the time after landing but never went to the hospital. At length on the seventh of August it was thought best to send him into Santiago to the officers' hospital where it was thought he could have better care. We were shocked on the evening of the eighth when his colored servant came into camp with the news that the captain was dead. The officers of his company, with a detail of men, at once went into the city and carefully interred the remains in the Santiago cemetery.

Private Ebbie Bland of Company A died on the eleventh of August at Siboney. Private Irwin Lautzenheiser of Company D, Wooster, died at Sevilla Hill August 13. His brother, also a member of Company D, was with him during his sickness and at his death, which occurred only a few days before our departure for the north. Corporal John S. Lee of company G, a cousin of Captain Lee, died August 15 at Siboney, and on the sixteenth Corporal Charles E. Tarner of Company L died in the camp on San Juan Hill, only a few hours before the orders

for our embarkation were delivered. He was buried in the trenches—one of the last things the men of his company did before starting into the city. The next day before we went on board the Mohawk we learned that Ward A. Wilford of Akron, a member of Company B, had died on the sixteenth at Siboney. This made a total of twenty-two men whose bodies we left on the island of Cuba as we sailed away, the Eighth Ohio's contribution to its freedom from Spanish domination.

The death rate was not alarming. But the sickness was appalling. The percentage of sick reported each day by the regiments varied all the way from twenty to forty. Of those not reported sick a very large proportion were weak, emaciated, and unfit for duty. It is safe to say that if the emergency had arisen not five thousand men in that whole army could have marched five miles and carried their accouterments and a single day's rations. Just what ailed us it is difficult for us laymen to determine when the doctors disagreed so widely. Our surgeons did not believe it was yellow fever, and in this opinion they were supported by many, perhaps a majority of the surgeons on the island. But whatever name it may be designated it was an exceedingly debilitating and depressing ailment. Its victims lost appetite, ambition, and sometimes nerve. Many were afflicted with dementia of various degrees, and there were not a few sad cases of extreme insanity. And then there was before us continually the fear that after the whole army had become exhausted and enervated by this fever, whatever it was, when September came the genuine, unadulterated, sure-enough yellow fever would assail us, and then no man would have the physical strength to withstand the siege.

Source: Barton, Clara. *The Red Cross in Peace and War.* Meriden, CT: The Journal Publishing Co., 1912, pp. 569–575.

Charter of the World Health Organization (1946)

The United Nations, established after World War II, established as one of its agencies, the World Health Organization, which has

become the principal international agency concerned with public health. Excerpted below is the Constitution of the World Health Organization. Presented are its statement of principles and its first two Chapters.

The States Parties to this Constitution declare, in conformity with the Charter of the United Nations, that the following principles are basic to the happiness, harmonious relations and security of all peoples:

- Health is a state of complete physical, mental and social well-being and not merely the absence of disease or infirmity.
- The enjoyment of the highest attainable standard of health is one of the fundamental rights of every human being without distinction of race, religion, political belief, economic or social condition.
- The health of all peoples is fundamental to the attainment of peace and security and is dependent upon the fullest co-operation of individuals and States.
- The achievement of any State in the promotion and protection of health is of value to all.
- Unequal development in different countries in the promotion of health and control of disease, especially communicable disease, is a common danger.
- Healthy development of the child is of basic importance; the ability to live harmoniously in a changing total environment is essential to such development.
- The extension to all peoples of the benefits of medical, psychological and related knowledge is essential to the fullest attainment of health.
- Informed opinion and active co-operation on the part of the public are of the utmost importance in the improvement of the health of the people.

- Governments have a responsibility for the health of their peoples which can be fulfilled only by the provision of adequate health and social measures.

Accepting these principles, and for the purpose of co-operation among themselves and with others to promote and protect the health of all peoples, the Contracting Parties agree to the present Constitution and hereby establish the World Health Organization as a specialized agency within the terms of Article 57 of the Charter of the United Nations.

Chapter I—Objective

Article 1

The objective of the World Health Organization (hereinafter called the Organization) shall be the attainment by all peoples of the highest possible level of health.

Chapter II—Functions

Article 2

In order to achieve its objective, the functions of the Organization shall be:

(a) to act as the directing and coordinating authority on international health work;

(b) to establish and maintain effective collaboration with the United Nations, specialized agencies, governmental health administrations, professional groups and such other organizations as may be deemed appropriate;

(c) to assist Governments, upon request, in strengthening health services;

(d) to furnish appropriate technical assistance and, in emergencies, necessary aid upon the request or acceptance of Governments;

(e) to provide or assist in providing, upon the request of the United Nations, health services and facilities to specialized groups, such as the peoples of trust territories;

(f) to establish and maintain such administrative and technical services as may be required, including epidemiological and statistical services;

(g) to stimulate and advance work to eradicate epidemic, endemic and other diseases;

(h) to promote, in cooperation with other specialized agencies where necessary, the prevention of accidental injuries;

(i) to promote, in cooperation with other specialized agencies where necessary, the improvement of nutrition, housing, sanitation, recreation, economic or working conditions and other aspects of environmental hygiene;

(j) to promote cooperation among scientific and professional groups which contribute to the advancement of health;

(k) to propose conventions, agreements and regulations, and make recommendation with respect to international health matters and to perform such duties as may be assigned thereby to the Organization and are consistent with its objectives;

(l) to promote maternal and child health and welfare and to foster the ability to live harmoniously in a changing total environment;

(m) to foster activities in the field of mental health, especially those affecting the harmony of human relations;

(n) to promote and conduct research in the field of health;

(o) to promote improved standards of teaching and training in the health, medical and related professions;

(p) to study and report on, in cooperation with other specialized agencies, where necessary, administrative and social techniques affecting public health and medical care from preventive and curative points of view, including hospital services and social security;

(q) to provide information, counsel and assistance in the field of health;

(r) to assist in developing an informed public opinion among all peoples on matters of health;

(s) to establish and revise as necessary international nomenclatures of diseases, of causes of death and of public health practices;

(t) to standardize diagnostic procedures as necessary;

(u) to develop, establish and promote international standards with respect to food, biological, pharmaceutical and similar products;

(v) generally to take all necessary action to attain the objective of the Organization.

Source: World Health Organization, Basic Documents, Forty-fifth edition, October 2006; http://www.who.int/governance/eb/who_constitution_en_pdf. Used by permission of the World Health Organization.

The WHO's Global Immunization Vision and Strategy Program (2006)

In 2006, the WHO launched its global immunization vision and strategy program, herein excerpted and described.

Global Immunization Vision and Strategy (GIVS)

In response to challenges in global immunization, WHO and UNICEF developed the Global Immunization Vision and Strategy (GIVS). Launched in 2006, GIVS is the first ever ten-year framework aimed at controlling morbidity and mortality from vaccine-preventable diseases and helping countries to immunize more people, from infants to seniors, with a greater range of vaccines. GIVS has four main aims:

- to immunize more people against more diseases;
- to introduce a range of newly available vaccines and technologies;

- to integrate other critical health interventions with immunization; and

- to manage vaccination programs within the context of global interdependence.

Goals and Strategies

GIVS contains a number of ambitious immunization goals. In addition, it provides over two dozen strategies from which countries can choose for implementation according to their specific needs.

Progress

By 2010, GIVS had successfully become the global rallying point, and had been adopted by many countries as the overarching strategic framework for immunization. As such, it had been used for the creation of regional immunization strategies and by many countries to draw up comprehensive multi-year national plans for immunization.

A report on progress in implementing GIVS was presented at the 64th World Health Assembly in May, 2011. It highlights improvements in: routine immunization coverage; reaching more children with newly available vaccines; eliminating material and neonatal tetanus; reducing measles cases and deaths; using new vaccines against diarrhea and pneumonia thanks to innovative financing; and implementing advocacy events such as the regional immunization weeks to highlight the importance of vaccines and immunization in saving lives. The report also outlined further efforts needed to achieve the global immunization goals.

Source: Global Immunization Vision and Strategy Program, 2011. Available online at http://www.who.int/immunization/givs/en/. Used by permission of the World Health Organization.

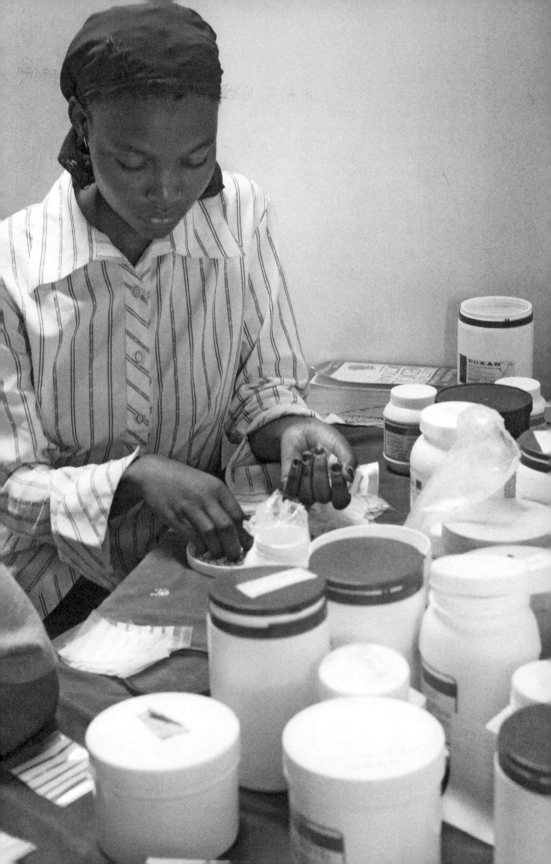

Introduction

This chapter lists and briefly discusses the major sources of information the reader is encouraged to consider. It begins with print sources, with scholarly books on the subject, with 125 cited and annotated. It follows with a listing of more than 40 scholarly journals in the field, each of which is briefly described. Finally, nonprint sources are covered. Again, more than 40 such sources are cited and described, including 36 videos and seven films. These nonprint sources often dramatically depict the issues and people involved, putting real "faces" to the numbers and statistics.

Selected Print Resources

Books

Aberth, John. 2011. *Plagues in World History*. Lanham, MD: Rowman and Littlefield.

This book is an authoritative and fascinating account of comparative world history of the disastrous effects of infectious diseases, including the bubonic plague, smallpox, tuberculosis, cholera, influenza, and AIDS. It

A woman prepares AIDS pills at Pepo La Tumaini Jangwani, a HIV/AIDS Community Rehabilitation Program, Orphanage and Clinic in Eastern Kenya. AIDS is particularly prevalent in Africa. Its high mortality rate can be mitigated by a complex "cocktail" of pills which require international aid to be available in Africa, and must be carefully monitored in their distribution and use. (Americanspirit/Dreamstime.com)

shows the impact of disease on human history and how humans influence disease through their cultural attitudes toward them.

Adams, Annmarie. 2009. *Medicine by Design: The Architect and the Modern Hospital, 1893–1943*. Minneapolis: University of Minnesota Press.

Reveals the impact of hospital design on early 20th century medicine and the importance of these specialized buildings in the history of medicine coping with diseases.

Alibeck, Ken. 1999. *Biohazard: The Chilling True Story of the Largest Covert Biological Weapons Program in the World— Told from the Inside by the Man Who Ran It*. On-line: Delton Press.

Discusses the U.S.S.R.'s bioweapons programs, scientific history, and the U.S.S.R.'s Manhattan Project— masquerading as a pharmaceutical company. They produced plague, anthrax, smallpox, Venezuelan equine encephalitis, and more.

Arnold, James, ed. 2014. *Health Under Fire: Medical Care During America's Wars*. Westport, CT: Greenwood Press.

This volume is a cross-disciplinary historical reference book that highlights the people, diseases, and innovations that impacted the health of soldiers and civilians during wartime, focusing on the United States from colonial times to the present. It includes primary source document synopses, eyewitness accounts, and statistics that bring the subject to life.

Barbour, Scott. 2010. *Is the World Prepared for a Deadly Influenza Pandemic?* San Diego: Reference Point Press.

A high school–level book that asks if the world is prepared specifically for an influenza pandemic.

Barde, Robert. 2008. *Immigration at the Golden Gate*. Westport, CT: Praeger.

> The role of Angel Island to guard the Western Gate to the United States, it shows how immigrants experienced the immigration process on the west coast, including health inspection and quarantine against Asiatic cholera, the plague, and other epidemics.

Barry, John. 2005. *The Great Influenza: The Epic Story of the Deadliest Plague in History*. New York: Penguin Books.

> The fascinating, detailed, and definitive story of the 1918–1919 influenza pandemic and the collision of science and epidemic disease.

Bazin, Herve. 2000. *The Eradication of Smallpox: Edward Jenner and the First and Only Eradication of a Human Infectious Disease*. Waltham, MA: Academic Press.

> The story of smallpox—its origins, the horror of the disease, and the millions killed and disfigured by it. Covers the life and work of Jenner to 1979 when the story culminates in the total eradication of an infectious disease.

Beveridge, William Ian Beardmore. 1977. *Influenza: The Last Great Plague*. Heinemann: Prodist.

> A basic history of the disease by the Australian animal pathologist on the faculty of the University of Cambridge.

Borowy, Iris, ed. 2009. *Uneasy Encounters: The Politics of Health and Medicine in China, 1900–1939*. Frankfurt: Peter Lang Publishers.

> This volume explores the multisided process of Western medicine arriving in China as part of missionary, foreign imperialist, and internal modernization efforts and how it interacted with Chinese practices and belief systems, describing key institutions and personalities, their motives and interests.

Breslow, Lester, ed. 2002. *Encyclopedia of Public Health*. 4 vols. New York: Macmillan.
 A reference set of four volumes covering all aspects of public health for the lay reader, selected for the Choice 2002 Award for outstanding academic reference.

Brock, Thomas. 1988. *Robert Koch: A Life in Medicine*. Madison: Science-Tech Publications.
 A volume in their series of scientific revolutionaries' biographical series. It is a thorough biography of his life and the importance of his work.

Bynum, W. F. and H. Bynum, eds. 2007. *Dictionary of Medical Biography*. London and Westport, CT: Greenwood.
 An impressive addition to the existing number of medical and scientific biography literature, it includes coverage across medical systems, time periods, and cultures.

Byrne, Joseph P., ed. 2008. *Encyclopedia of Pestilences, Pandemics and Plagues*. 2 vols. Westport, CT: Praeger.
 Presents a social, cultural, historical, and medical look at infections, diseases, and their place in human history from the Neolithic times to the present. A total of 300 entries cover individual diseases, major epidemics, environmental factors, and historical and cultural effects of diseases in a uniquely interdisciplinary way.

Caller, Anastasia. 2015. *A Possible Pandemic: Swine Influenza Encyclopedia*. On-line: Create Space.
 An independent encyclopedia about H1N1.

Cecchine, Gary, and Melinda Moore. 2006. *Infectious Disease and National Security: Strategic Information Needs*. Santa Monica, CA: The Rand Corporation.
 This report examines infectious diseases within the context of national security and assesses the need for and

adequacy of information to enable the U.S. policy makers to prevent and respond to such threats.

Chase, Marilyn. 2004. *The Barbury Plague.* New York: Random House.

The Black Death in Victorian San Francisco is the subject of this fascinating account of the outbreak of bubonic plague in San Francisco in 1900, and the effects on public health of politics, race, and geography. Chase shows how one city triumphed over one of the most deadly of all scourges.

Cook, Robin. 1988. *Outbreak.* Berkeley, CA: University of California Press.

This is a fictional thriller about a devastating plague sweeping the country and the CDC's efforts to battle it.

Cook, Robin. 1996. *Contagion.* New York: G.A. Putnam's Sons.

A best-selling fictional account for the millennium as a deadly epidemic is spread by microbes and sabotagers.

Craddock, Susan. 2000. *City of Plagues: Disease, Poverty and Deviance in San Francisco.* Minneapolis: University of Minnesota Press.

This is an absorbing look at the role of disease on health policy and the construction of race, gender, and class in urban development in 19th–20th century San Francisco. It brilliantly traces how the triad of power, knowledge, and space actually worked in a particular place.

Crosby, Alfred W. 2003. *America's Forgotten Pandemic.* 2nd ed. Cambridge: Cambridge University Press.

The influenza pandemic of 1918 is recounted from the course of the pandemic to its impact on American society. Crosby probes the curious loss of national memory of the

cataclysmic event. In this new edition, the preface looks at recent outbreaks of Asian flu and SARS and compares them to the 1918 outbreak.

Davies, Pete. 2000. *The Devil's Flu*. New York: Henry Holt and Company.
A gripping account of the 1918 pandemic, how it swept through the United States and European cities, and the "forgotten" tragedy that ensued.

Doherty, Pete. 2013. *Pandemics: What Everyone Needs to Know*. New York: Oxford University Press.
An authoritative monograph about pandemics by a Nobel Prize laureate, who writes in a calm, clear, authoritative voice about the complex subject.

Drexler, Madeline. 2002. *Secret Agents: The Menace of Emerging Infections*. New York: Penguin Books.
She looks at today's newly emerging infections and how they have increased in rate and geographic range, and why pathogens attack humans who cross paths with them. Drexler covers the food-borne, antibiotic-resistant, animal- and insect-borne diseases and bioterrorism.

Duffy, John. 1953. *Epidemics in Colonial America*. Baton Rouge, LA: Louisiana State University.
An excellent book on a little-known subject that affected the history of the United States in important ways, as Duffy aptly demonstrates.

Duffy, John. 1974. *A History of Public Health in New York City, 1866–1966*. New York: Russell Sage.
A colonial historian examines a century of public health policy and provisions in New York City—a pioneer of the public health movement that served as a model for most major cities in America.

Echenberg, Myron. 2007. *The Global Impact of Bubonic Plague.* New York: New York University Press.

> Echenberg tells the tale of 10 cities on five continents that were ravaged by bubonic plague, taking 15 million lives in Hong Kong, Bombay, Sydney, Honolulu, San Francisco, Buenos Aires, Rio de Janeiro, Alexandria, and Cape Town in Africa and Oporto in Europe.

Ellison, D. Hank. 2007. *Handbook of Chemical and Biological Warfare Agents.* 2nd ed. On-line: CRC Press.

> Extensively updated and revised, this second edition of a best-selling handbook goes beyond the "dirty 30" most commonly discussed agents, expands on existing classes, and increases the number of agents discussed. A good, comprehensive introduction to the topic.

Engel, Jonathan. 2006. *The Epidemic: A Global History of AIDS.* New York: Penguin Books.

> A sweeping look at AIDS, it covers the epidemic from all angles, and weaves together science, politics, and culture in a story of compelling human drama.

Etheridge, Elizabeth, 1992. *Sentinel for Health: A History of the Centers for Disease Control and Prevention.* Berkeley: University of California Press.

> Etheridge tells the amazing story of the CDC—its emergence from obscure origin to attain the scientific, social, and political prominence; its duels with deadly and often mysterious diseases; and the many talented, motivated people who at times clashed with each other.

Fairchild, Amy. 2003. *Science at the Borders: Immigrant Medical Inspection and the Shaping of the Modern Industrial Labor Force.* Baltimore: The Johns Hopkins University Press.

> In 1891 the public health service began examining all immigrants then entering for "loathsome and dangerous

contagious diseases." Fairchild offers new interpretation of the medical exams and the role played in the lives of some 25 million who entered the United States, with an emphasis on Southern and West Coast stations. She describes the large, scientific and medical bureaucracy confronting individual immigrants.

Faist, Thomas. 2000. *The Volume and Dynamics of International Migration and Transnational Social Spaces*. New York: Oxford University Press.
 A thorough study of migration decision making and the dynamics of international migration. The book tackles the important question of the process of migration in world politics, and offers a new theoretical approach to the process of migration.

Farley, John. 2004. *To Cast Out Disease: A History of the International Health Division of the Rockefeller Foundation, 1913–1956*. Oxford: Oxford University Press.
 Farley's book concentrates on the outcome of projects and the interpersonal dynamics between central and field office staff. It is a well-researched, highly readable story of the Foundation's role in the control and sometimes conquest of infectious diseases.

Fee, Elizabeth. 1987. *Disease and Discovery: A History of the Johns Hopkins School of Hygiene and Public Health, 1916–1939*. Baltimore, MD: The Johns Hopkins University Press.
 An interesting story of the development of the Johns Hopkins University School used as a platform to a broader investigation of early 20th century public health ideology in the United States.

Fenn, Elizabeth. 2001. *Pox Americana: The Great Smallpox Epidemic of 1775–1782*. New York: Hill and Wang.
 Professor Fenn is the first historian to delve deeply to examine how great and horrifying was the variola smallpox

epidemic and how it affected the outcome of the Revolutionary War in every colony and in the lives of everyone in North America. An innovative look at a mega-tragedy.

Fettner, Ann Gudicci. 1993. *The Science of Viruses.* New York: William Morrow.
An eminent medical writer explains in plain English what viruses are, what medicine is doing to combat them, and why they are more prevalent today despite medical advances.

Fox, Daniel, Marcia Maldrum, and Ira Rezals, eds. 1990. *Nobel Laureates in Medicine or Physiology: A Biographical Dictionary.* New York: Garland Press.
A thorough "dictionary" approach and format to present the biographies of the Nobel Laureates in Medicine from the inception of the prize to 1990.

Friedenberg, Zachary B. 2002. *Medicine Under Sail.* Annapolis, MD: Naval Institute Press.
This book is an important contribution to naval history. It examines health issues from individuals to widespread epidemics that affect seamen from the 15th to the 18th centuries. Seaman fight versus diseases and doctors who sought to keep them alive and healthy.

Friedman, Laurie S. 2008. *Pandemics.* San Diego, CA: Greenhaven Press.
An opposing viewpoints guide geared to high school students to help write persuasive essays—writing the critical essay.

Gallagher, Nancy. 1990. *Egypt's Other Wars: Epidemics and the Politics of Public Health.* Syracuse, NY: Syracuse University Press.
A volume in their contemporary issues in the Middle East series, Gallagher focuses on the 1940s, which saw widespread epidemics of malaria, relapsing fever, and cholera. She looks at not only the public health crisis, but also the

political problem and the combination of forces that put an end to the epidemics and placed public health at the top of the national political agenda.

Garraty, John A. and Mark C. Carnes. 1999. *American National Biography*. Vols 1–12. New York: Oxford University Press.
> Sponsored by the American Council of Learned Societies, this 12-volume series presents the biographies of different people who shaped America and its science written by experts in the field.

Getz, David. 2000. *Purple Death: The Mysterious Flu of 1918*. New York: Henry Holt and Company.
> A short but riveting account by a nonfiction writer aimed at young (high school) readers about the worst epidemic in U.S. history.

Gill, George. 1994. *The League of Nations: From 1929 to 1946*. Garden City Park, NY: Avery Press.
> This book is an illustrated history and chronology of the final years of the League of Nations during a time of political violence, growing nationalism, and war. It highlights pivotal incidents, key documents, and photographs to capture the spirit of the times.

Goodman, Richard E., et al. 2006. *Law in Public Health Practice*. Oxford: Oxford University Press.
> A thorough review of the legal basis and authorities for the core elements of public health practice, and a solid discussion of existing and emerging high-priority areas where law and public health intersect.

Gostin, Lawrence. 2008. *Public Health Law: Power, Duty, Restraints*. 2nd ed. Berkeley, CA: University of California Press.
> This widely acclaimed book develops a rich understanding of the limits of government's power and duties while showing law to be an effective tool of public health.

Greenfied, Kari Taro. 2006. *China Syndrome: The True Story of the 21st Century's First Great Epidemic*. New York: Harper.

An account of the outbreak of the SARS virus in China in 2003, this book deftly tracks the mysterious killer from the first victim to overwhelmed hospital wards and workers in labs to identify the virus, to the war rooms of the WHO in Geneva who battled SARS.

Guillet, Edwin C. 1937. *The Great Migration*. Toronto: Thomas Nelson and Sons.

An engaging story of the Atlantic crossing by sailing ship since 1770, it recounts how 11 million people between 1770 and 1890 came from the British Isles to North America. It tells the tale of the transition. It has a good discussion of the ravages of "ship fever."

Hardman, Elizabeth. 2011. *Influenza Pandemics*. Boston, MA: Lucent Books/Cengage.

An e-book in their world history series, this volume focuses solely on the influenza pandemic.

Hayes, J. N. 2010. *The Burden of Disease: Epidemics and Human Response in Western History*. New Brunswick, NJ: Rutgers University Press.

This revised edition provides a timely and sweeping approach to the history of disease, including a discussion of the evolution of drug-resistant diseases, an expanded coverage of HIV/AIDS, and a chronicle of 2000 years of western history from the prism of disease.

Hayes, Jon. 2005. *Epidemics and Pandemics: Their Impact on Human History*. Santa Barbara, CA: ABC-CLIO.

Written by a specialist in the history of science and medicine, the essays discuss pandemics and epidemics affecting Europe, the Americas, Africa, and Asia from ancient times to the present.

Hirst, Fabian. 1953. *The Conquest of Plague: A Study of the Evolution of Epidemiology*. London: Oxford University Press.
> Written for the layman, it explains epidemiology and the importance of science in conquering the bubonic plague and other epidemic deadly contagious diseases.

Holt, Joseph. 1892. *An Epitomized Review of the Principals and Practices of Maritime Sanitation*. Memphis: Concorde Republican Press Association.
> The papers of one of the earliest pioneers of American medicine, it describes research to discover effective germicides that enabled development of maritime sanitation that went beyond mere quarantine of ships, their crews and passengers, when disease outbreaks occurred on board ships transporting hundreds of immigrants from Europe to the United States.

Howard-Jones, Norman. 1975. *The Scientific Background of International Sanitary Conferences, 1851–1938*. Geneva: The World Health Organization.
> The book traces the history of sanitary conferences, the predecessors to the UN's, WHO's approach to international cooperation to combat disease epidemics from becoming pandemics.

Kahn, Laura H. 2009. *Who's in Charge?: Leadership During Epidemics, Bioterrorism Attacks, and Other Public Health Crises*. Westport, CT: Praeger Security International.
> This volume explores the crucial relationship between political leaders, public health officials, journalists, and others to see why leadership confusion develops. It examines five recent emergencies since 2001.

Karlan, Arno. 1995. *Man and Microbes: Disease and Plagues in History and Modern Times*. New York: Touchstone Books, G. P. Putnam's Sons.
> A respected science writer looks at AIDS, Lyme disease, and deadly hantaviruses among a few dozen new diseases. It answers where diseases come from, why old ones are

changing, and how humans created epidemics by transforming human environment and behavior.

Kaufman, Martin, Stuart Galishoff, and Todd L. Savitts, eds. 1984. *Dictionary of American Medical Biography. V11.* Westport, CT: Greenwood Press.

These volumes present more than 500 biographical entries of persons who made significant contributions to American medicine and public health from the 17th century through 1976.

Kawaoka, Yoshihiro. 2008. *Influenza Virology: Current Topics.* Portland, OR: Caister Academic Press.

A basic discussion, by the University of Wisconsin professor of virology, of the influenza virus, the molecular mechanism of interspecies transfer leading to the influenza pandemic in humans, and the molecular pathogenesis of influenza in poultry and animals.

Kelly, Howard, and Walter Burrage. 1971. *Dictionary of American Medical Biography.* Boston, MA: Milford House.

A thorough collection of biographical sketches of the more important pioneers of American medicine.

Kelly, John. 2006. *The Great Mortality: An Intimate History of the Black Death, the Most Devastating Plague of All Time.* New York: Harper Collins.

Kelly explains the terrible journey across Europe and the Asian continents in 1347 of bubonic plague. The book is an extraordinary account of one of the worst natural disasters in human history in which 25 million people died of the Black Death. A drama of courage, cowardice, misery, madness, and sacrifice, it illustrates the darkest days of the deadly pandemic.

Kilbourne, Edwin. 1987. *Influenza.* New York: Plenum Medical Book Company.

This book covers influenza pandemics from 1918 through the 1950s, including the outbreak of 1957, that of 1968,

to the present. It reexamines old questions about the nature of influenza and its epidemics in light of the dazzling advances in molecular biology in the past several years before its publication.

Kohn, George C. 2007. *Encyclopedia of Plague and Pestilence from Ancient Time to the Present*. 3rd ed. New York: Facts on File Library of World History.
 The book traces the history of infectious diseases from the 11th century BCE to recent SARS and avian flu epidemics. It presents concise descriptions of 700 epidemics listed alphabetically by location of outbreak.

Kolata, Gina. 1999. *Flu: The Story of the Great Influenza Pandemic of 1918 and the Search for the Virus That Caused It*. New York: Touchstone Books.
 An international best-seller, this book is a fast-paced and gripping account of the flu pandemic of 1918 written by an acclaimed science journalist, with an epilogue about the avian flu.

Koplow, David A. 2002. *Small Pox: the Fight to Eradicate a Global Scourge*. Berkeley: University of California Press.
 A clear, authoritative study of the long and fascinating history of the virus and an informative account of the political, biological, environmental, medical, and legal issues surrounding its eradication and whether the remaining lab-stored viruses should also be exterminated.

Kraut, Alan. 1994. *Silent Travelers: Germs, Genes, and the "Immigrant Menace."* Baltimore, MD: The Johns Hopkins University Press.
 Kraut weaves four themes: fear, advances in public health, development of institutions and policies in the progressive era, and acculturation, to treat the inescapable cultural conflicts around microbes and migration, with

a generous sympathy for both the public responsibilities and the private responsibilities at stake.

Kronenfeld, Jennie Jacobs, and Michael Kronenfeld. 2015. *Health Care Reform in America: A Reference Handbook.* 2nd ed. Santa Barbara, CA: ABC-CLIO.
> This handbook makes U.S. health care system understandable. It reviews the Affordable Care Act, describes past health care reform efforts, and covers the important organizations and people involved in the U.S. health care system.

Kuhnke, Laverne. 1990. *Lives at Risk: Public Health in Nineteenth Century Egypt.* Berkeley: University of California Press.
> It describes the introduction of western medicine into Egypt, Western-style schools of medicine, and medical and international quarantine boards, and how they both succeeded and failed. She relates the narrative to 20th century health issues in developing countries.

Kuriansky, Judy. 2016. *The Psychological Aspects of a Deadly Epidemic: What Ebola Has Taught Us About Holistic Healing.* Westport, CT: Praeger Press.
> Dr. Judy Kuriansky covers the psychological aspects affecting all epidemic episodes and relates how the current Ebola has lessons for how better to deal with pandemics.

Leavitt, Judith. 2006. *Sickness and Health in America: Readings in the History of Medicine and Public Health.* 3rd ed. Madison: University of Wisconsin Press.
> A highly regarded and used social history of medicine and public health in the United States, extensively revised and updated with 21 new essays, topics on HIV, epidemics, and public health reform.

Lee, Kelley, ed. 2008. *Health Impacts of Globalization: Towards Global Governance.* New York: Macmillan.

> Brings together an interdisciplinary group of researchers to analyze specific case studies that provide much needed empirical analyses of the impact of globalization of health. Lee provides illustrative coverage of the diverse health impacts of global change.

LeMay, Michael. 2006a. *Guarding the Gates: Immigration and National Security.* London and Westport, CT: Praeger Security International.

> This is the first history of American immigration policy post-9/11 environment to focus on the role of national security considerations in determining that policy. LeMay documents that this is not the first time America has worried about letting foreigners through our golden gates. The book's final chapter ties national security and immigration with necessary historical perspective.

LeMay, Michael. 2006b. *Public Administration.* 2nd ed. Belmont, CA: Wadsworth/Thomson.

> This basic textbook covering public administration focuses on public policy making and implementation and has several discussions relating to public health policy and implementation and the control of pandemic or epidemic disease outbreaks.

LeMay, Michael. 2007. *Illegal Immigration: A Reference Handbook.* 1st ed. Santa Barbara, CA: ABC-CLIO.

> This book provides an overview of America's attempts to deal with the problem of illegal immigration with an emphasis on post-1965. It discusses the crucial court cases, key actors and organizations, and proposed solutions.

LeMay, Michael. ed. 2013. *Transforming America: Perspectives on U.S. Immigration.* 3 vols. Santa Barbara, CA: ABC-CLIO.

These volumes present an extensive collection of original essays by scholars from all the social sciences and covers immigration issues and policies from colonial times to the present. Several essays deal with issues of public health and epidemic disease outbreaks and how they impacted immigration flows and policy reforms.

LeMay, Michael. 2015a. *Doctors at the Borders: Immigration and the Rise of Public Health.* Westport, CT: Praeger Press.

The book presents an extensive examination of the inherent interplay between immigration and public health. It focuses on the role of the Public Health Service doctors at three stations and how they and those stations played critical roles in the development of public health in the United States and elsewhere. It has a chapter dealing with the pandemics of the 19th century and the doctors who led the development of modern medicine.

LeMay, Michael. 2015b. *Illegal Immigration: A Reference Handbook.* 2nd ed. Santa Barbara, CA: ABC-CLIO.

In this second edition, LeMay covers illegal immigration to the United States, especially since 1970, in the library reference format. It has detailed discussion of the threat posed by epidemics in Third World countries, such as Mexico and Central America, which affects the policy reform issue.

LeMay, Michael, and Elliott Barkan. 1999. *U.S. Immigration and Naturalization Laws and Issues: A Documentary History.* Westport, CT: Greenwood Press.

This library reference volume presents synopsis of all the key laws and court cases throughout American history that have determined immigration and naturalization policy, including those that deal explicitly with the national government's role in protecting the nation from dangerous diseases entering with the migration flow.

Little, Lester K., ed. 2006. *Plague and the End of Antiquity: The Pandemics of 541–750.* Cambridge: Cambridge University Press.

 In this book, 12 scholars from various disciplines present a comprehensive account of the bubonic plague known as the black death: its origins, spread, and mortality as well as its profound economic, social, political, and religious effects.

Longwith, Jacqueline. 2012. *Pandemics.* Boston, MA: Greenhaven Press/Cengage.

 This book is one in a series that examines issues related to pandemics. In includes primary and secondary sources from a variety of perspectives, including eyewitness accounts and scientific journals.

Luckingham, Bradford. 1984. *Epidemics in the Southwest, 1918–1919.* El Paso, TX: The University of Texas at El Paso.

 This volume is devoted to the Influenza Pandemic of 1918 and its impact on America's Southwest by presenting local histories and original research.

Lynch, James P., and Rita Simon. 2003. *Immigration the World Over: Statuses, Policies and Practices.* Lanham, MD: Rowman and Littlefield.

 The authors present a good overview of comparative immigration policy and a discussion of how epidemics influence the migration flows, and how various countries erect barriers in their policy to protect against the spread of epidemics.

Macleod, Roy and Miltion Lewis, eds. 1988. *Disease, Medicine and Empire: Perspectives on Western Medicine and the Experience of Western Expansion.* London: Routledge Press.

 This volume is a collection of essays on the political, racial, military, and economic aspects of medicine

"overseas," especially in the 19th century. It examines European medicine in settler colonies. It explores the effects of epidemic disease and racial theories on the practice of medicine in the colonies.

Magill, Frank, ed. 1991. *The Nobel Prize Winners: Physiology or Medicine, V. 1, 1901–1944.* New Jersey: Salem Press.
This volume is a good, basic collection of the biographies of the doctors and pioneering medical scientists whose innovative work earned them the Nobel Prize for medicine.

McCullough, David. 1977. *The Path Between the Seas.* New York: Simon and Schuster.
This work is the definitive history of the building of the Panama Canal. It has an extensive discussion of the role of Dr. William Gorgas and the conquest of malaria and yellow fever epidemics through extermination of the mosquitoes that spread them, thereby making possible the successful construction of the canal.

McNeill, William. 1989. *Plagues and People.* New York: Anchor Books.
McNeill offers an interpretation of the extraordinary impact—political, demographic, ecological, and psychological—of diseases on culture. The book features smallpox and the conquest of Mexico, bubonic plague in China, and typhoid epidemics in Europe. It demonstrates that the history of disease is in many ways the history of mankind.

Mettenleiter, Thomas, and Francisco Sobrino. 2008. *Animal Viruses: Molecular Biology.* Norfolk: Caister Academic Press.
In 10 chapters, the authors describe the basics of the most interesting viruses of veterinary importance.

Miller, Debra. 2009. *Pandemics*. Boston, MA: Lucent/Cengage Learning.

> Aimed at students from middle school through high school age, Miller's book is a well-organized volume on the control and prevention of pandemics, and on the factors that facilitate the spread of disease.

Moote, Lloyd, and Dorothy Moote. 2004. *The Great Plague: The Story of London's Deadliest Year*. Baltimore, MD: The Johns Hopkins University Press.

> An historian and microbiologist couple relate the tale of London's deadliest year, in 1665, when nearly 100,000 people died of the plague. It details a story of two London's—the working poor and the rich—and how they became interdependent during 1665. It is a powerful narrative using original archival research.

Mullan, Fitzhugh. 1989. *Plagues and Politics: The Story of the United States Public Health Service*. New York: Basic Books.

> This is an authoritative history of the U.S. Public Health Service. It discusses the role of the PHS in preventing epidemics or controlling and mitigating outbreaks.

Neustadt, Richard, and Harvey S. Fineberg. 2003. *The Swine Flu Affair: Decision-Making on a Slippery Disease*. 3rd ed. Hawaii: University Press of the Pacific.

> This insightful volume is a reconstruction of the events leading up to land surrounding the swine flu immunization program by combining press accounts, hearings, official files, and interviews with participants.

Newton, David. 2013. *Vaccination Controversies: A Reference Handbook*. Santa Barbara, CA: ABC-CLIO.

> A library reference volume in the ABC-CLIO's series on Health, Wellness, and Public Health, it provides comprehensive coverage of the history and background of

vaccination issues in the United States and around the world with detailed examination of problems, issues, and controversies related to the use of the vaccination protocol.

Nohl, Johannes. 2006. *The Black Death: A Chronicle of the Plague.* Yardley, PA: Westholme Publishing.
 The book is an interesting historical and sociological study tracing the ebb and flow of European pandemics over centuries using contemporary accounts. Its geographical and historical sweep is broad, but it combines detailed accounts and overarching contemporary views of the plague in Europe which killed an estimated 40 million people in the 14th century.

Nuland, Sherwin. 1988. *Doctors: The Illustrated History of Medical Pioneers.* New York: Black Dog and Leventhal Publishers.
 This book is a National Book Award winner in which Nuland tells the extraordinary story of the development of modern medicine through compelling studies of the great pioneers and innovators of modern medicine. It brings the history of medicine to life.

Oldstone, Michael B. 1998. *Viruses, Plagues and History.* New York: Oxford University Press.
 Oldstone relates the compelling story of viruses and humanity; of fear and ignorance, of grief and heartbreak, and of bravery and sacrifice. It is an illuminating history of the devastating diseases that have tormented humanity throughout history, focusing on such famous killer viruses as smallpox, polio, and measles.

Oppong, Joseph. 2011. *Pandemics and Global Health.* New York: Chelsea House.
 This book is a volume in the Global Connections Series that is geared to middle-school readers. It presents a basic understanding of pandemics and their global impact.

Osborn, June E., ed. 1977. *Influenza in America, 1918–1976.* New York: Prodist.

> Based on a symposium held in 1977, this book discusses the various factors that led to the mass vaccination campaign against the swine flu pandemic in 1976 and provides a historical view of the flu in 1918 and its subsequent outbreaks.

Ostower, Gary B. 1996. *The League of Nations: From 1919 to 1929.* Garden City Park, NY: Avery Publishing.

> This is an authoritative look at the League of Nations, its founding post-World War I, and its inability to prevent World War II. Ostower discusses some of its nonpolitical successes, such as the health programs it fostered that promoted the global development of public health.

Paul, William E. 2008. *Fundamental Immunology.* 6th ed. New York: Lippincott, Williams and Williams.

> This is a basic textbook that defined the field of immunology. This sixth edition is thoroughly revised and updated, and it is a comprehensive text for clinical immunologists, microbiologists, and infectious disease physicians.

Payan, Tony. 2006. *The Three U.S.-Mexico Border Wars: Drugs, Immigration and Homeland Security.* Westport, CT: Praeger Security International.

> Payan traces the history of those policies to elucidate the evolutionary patterns and common threads that join them. He focuses on today's restrictive environment that in part reflects the fear of bioterrorism.

Peters, C. J. and Mark Olshaker. 1977. *Virus Hunters: Thirty Years of Battling Hot Viruses Around the World.* New York: Anchor Books, Doubleday.

> Dr. C. J. Peters was on the frontlines in the battle versus hot zone viruses. This book reads like a thriller: a first-person

account of what it is like to be a warrior in the hot zone and confront Ebola and other newly emerging pathogens.

Pitkin, Thomas M. 1975. *Keepers of the Gates: A History of Ellis Island*. New York: New York University Press.

This book is one of the better, extensive histories of Ellis Island. It has considerable discussion of the role of the USPMHS/PHS doctors serving at Ellis Island and the role they played in processing some 35 million immigrants while screening them to prevent the spread of infectious diseases or treating them at its quarantine hospital.

Porta, Miguel. 2008. *Dictionary of Epidemiology*. 5th ed. Oxford: Oxford University Press.

This volume is a newly revised and updated edition of a classic textbook sponsored by the International Epidemiological Association with contributions from more than 220 epidemiologists and others. It explains and comments on core epidemiological terms and other relevant scientific terms and idea.

Porter, Roy. 1999. *The Greatest Benefit to Mankind: A Medical History of Humanity*. New York: Harper Collins.

This is a lively, fascinating book charting the history of medicine; its culture and science, and its costs and benefits to mankind. The book provides a backdrop of wider religious, scientific, philosophical, and political beliefs and includes discussion of today's threats of Ebola and AIDS.

Power, J. Gerard and Theresa Byrd. 1996. *U.S.-Mexican Border Health Issues for Regional and Migrant Populations*. Los Angeles, CA: Sage Publications.

The nation's southern border is a volatile setting for infectious diseases due to Third World population movement. This book, edited by public health researchers, examines how cultural values of populations influence their

response to health messages, the complexity of health issues in the border region, and presents three models of health promotion tailored to it.

Preston, Richard. 1994. *The Hot Zone*. New York: Anchor Books.

Preston offers a riveting report on the nature of viruses and on the research to elucidate their mysteries, and the army's recent assault on such viruses in Africa and Germany, narrated in chilling, graphic detail.

Preston, Robert. 1997. *The Cobra Event*. New York: Ballantine Books.

This is a fictional account of a worldwide pandemic that is a gripping depiction of how a pandemic spreads and on its numerous impacts. It is based on real science and offers a realistic if chilling scenario of a pandemic outbreak.

Rondello, Kenneth C. 2016. *Epidemics and Pandemics: From Ancient Plagues to Modern Day Threats*. Westport, CT: Praeger.

Rondello is on the faculty of Adelphi University in Garden City New York and is a MD and MPH and serves as Chair of the Department of Allied Health and as director of the Department of Emergency Management. This book is a historical narrative of epidemics and pandemics and written in language accessible for the general audience reader.

Rosen, George and Elizabeth Fee. 2015. *A History of Public Health*. Baltimore, MD: The Johns Hopkins University Press.

This volume is a revised and expanded edition of the 1993 book. It presents a thorough and readable narrative history of the development of public health as a distinct subfield of medicine.

Rosenberg, Charles E. 1987. *The Cholera Years: The United States in 1832, 1849, and 1866.* Chicago: University of Chicago Press.

The classic epidemic disease of the 19th century, cholera's defeat reflects the progress of medicine by ending changes in American social thought. Rosenberg focuses on New York City. The book is carefully documented and full of descriptive detail, yet with an urgent sense of the drama of the epidemic years. It is an absorbing narrative for general readers.

Rosenberg, Charles E. 1992. *Explaining Epidemics and Other Studies in the History of Medicine.* Cambridge: Cambridge University Press.

Rosenberg presents a thorough and engaging narrative history of epidemics. Written by a practitioner, it contains his most important essays on the ideas, institutions, and uses of history as a resource for a discussion of the medical world.

Rosenberg, Charles E., and Janet Golden. 1992. *Framing Disease: Studies in Cultural History.* New Brunswick, NJ: Rutgers University Press.

This volume is a stimulating set of essays on disease as a biological event and a social phenomenon involving patient, doctor, family, employers, governments, and insurance companies. It illustrates how disease has been variously defined over time.

Rosner, David, ed. 1995. *Hives of Sickness: Public Health and Epidemics in New York City.* New Brunswick, NJ: Rutgers University Press.

Rosner collects essays by nine historians of American medicine, covering cholera, smallpox, typhoid, typhus and yellow fever, polio, and AIDS, aimed at anyone interested in American public health and the social history of New York City.

Ryan, Frank. 1997. *Virus X: Tracking the New Killer Plagues.* Boston, MA: Little, Brown and Company.

> Ryan is a renowned authority on diseases. He covers AIDS, Ebola, and Mad Cow diseases, and flesh eating viruses. He presents a radical new theory on the origin of deadly microbes, and the hot zones of today's most deadly viral outbreaks and the research labs, doctors, and scientists who are trying to control them.

Shah, Nayan. 2001. *Contagious Divides: Epidemics and Race in San Francisco's Chinatown.* Berkeley: University of California Press.

> Shah offers a thorough, authoritative history of the bubonic plague outbreak in San Francisco in 1900–1908. The book focuses on how racism, culture, economics, and politics impacted the efforts of the U.S. MHS doctors to cope with the outbreak. It is the definitive study of the topic.

Shilts, Randy. 2007. *And the Band Played On: Politics, People, and the AIDS Epidemic.* New York: St. Martin's Press.

> Shilts' book is a reprinting of his extensive, penetrating study of the AIDS pandemic and details how politics and sexual orientation biases hampered efforts to cope with it.

Silverstein, Arthur M. 1981. *Pure Politics and Impure Science: The Swine Flu Affair.* Baltimore, MD: The Johns Hopkins University Press.

> The author presents a detailed chronicle of the ill-fated swine flu immunization program written in part about the Neustadt-Feinberg report on the swine flu affair and how real, or not, actually was the swine flu threat.

Smith, Geddes. 1946. *Plagues on the US.* New York: Oxford University Press.

> This book is a well-told story of medicine's efforts— unsuccessful at the time—on controlling or preventing

communicable diseases. It is an important part of epidemiology written for the layman.

Stolley, Kathy and Stephanie Watson. 2012. *Medical Tourism: A Reference Handbook.* Santa Barbara, CA: ABC-CLIO.

The authors use a library-reference volume approach to the topic—a thorough discussion of the growth, since 2000, of the medical tourism industry, where Americans save 10 to 80 percent of the cost of medical care. It provides a historical background, discussion of issues, problems and solutions, and the key actors and agencies involved.

Time. 2014. *The Science of Epidemics: Inside the Fight Against Deadly Diseases from Ebola to AIDS.* New York: Time Magazine, Inc.

Written for the general reader, it discusses the invisible threat of microbes, how modern medicine is preparing for pandemics, and offers a thorough review of the Ebola outbreak, virus hunters, the deadliest viruses and how science solved the 1918 mystery, the deadliest plagues in human history, the 21st century pandemics, and the approaching "end of AIDS."

Tomes, Nancy. 1998. *The Gospel of Germs: Men, Women and the Microbe in American Life.* Cambridge, MA: Harvard University Press.

Tomes takes a look back to the first great "germ" pandemic in American history, and the revolution of 19th century bacteriology. She traces an awareness of the microbe that radiated outward from middle-class homes and crossed lines of class, gender, ethnicity, and race.

Walters, Mark J. 2004. *Six Modern Plagues and How We Are Causing Them.* Washington, DC: Island Press.

Walters tells a tale of each disease like a detective story. He traces the mystery through plants and animals, then the first human victims, and visiting government officials

who respond, or are slow to do so, and the scientists who ultimately explained what was happening.

Weber, Gustavis A. 1928. *The Food, Drug and Insecticide Administration*. Baltimore, MD: The Johns Hopkins University Press.
This book is a basic history of the Food, Drug and Insecticide Administration and traces the gradual expansion of their responsibilities and the science that made that work possible.

Weindling, Paul, ed. 1995. *International Health Organizations and Movements, 1918–1939*. Cambridge: Cambridge University Press.
Weindling presents a collection of original studies on the international health organizations operating between World War I and World War II and their many sided activities. It is a rich and complex historical investigation of relevance to today's issue of international health.

Weindling, Paul. 2000. *Epidemics and Genocide in Eastern Europe, 1890–1945*. Oxford: Oxford University Press.
The author provides valuable new insight of the connection between typhoid as a "Jewish disease" during World War I, and the gas chambers and other genocidal medical practices, how disease was racialized, and how gassing became the favored means of "eliminating typhus."

White, Phillip M. 2011. *American Indian Chronology: Chronologies of the American Mosiac*. Westport, CT: Greenwood Press.
A rich history of Native Americans, this volume covers medicine and details smallpox epidemics. It is concise and accessible for students, with primary source sidebars, a glossary, and a useful, annotated bibliography and index.

William, Ralph C. 1951. *The United States Public Health Service, 1798–1950*. Washington, DC: Shepperson.

The book provides a basic history of the Public Health Service and how it evolved. It is dated and better covered by the Fitzhugh Mullan book, but is a useful book on the early history of the Public Health Service.

Willrich, Michael. 2011. *Pox: An American History*. New York: Penguin Press.

An award-winning historian writes a gripping account of the smallpox epidemics that swept the United States at the turn of the 20th century. It is an authoritative account of the nation-wide fight against smallpox, and the "civil liberties" fight against mandatory vaccination, that is echoed in today's anti-vaccination movement.

Winslow, Charles E. 1980. *The Conquest of Epidemic Disease: A Chapter in the History of Ideas*. Madison: University of Wisconsin Press.

Winslow writes a thorough discussion of epidemic diseases using data and references from the Old Testament theory of disease as a punishment for sin to streamlined concepts of viral disease, and the views of the dissemination of viral infection.

Wolfe, Nathan. 2012. *The Viral Storm: The Dawn of a New Pandemic Age*. New York: St. Martin's Press.

Wolfe is an award-winning biologist and here tells the story of how viruses and human beings have evolved side-by-side throughout history. He details how HIV, swine flu, and bird flu have almost wiped us out in the past, and why modern life makes us especially vulnerable to the threat of a global pandemic.

Yam, Philip. 2003. *The Pathological Protein: Mad Cow, Chronic Wasting, and Other Deadly Prion Diseases*. New York: Copernicus Books.

Yam relates the fascinating and largely unknown story of prions—a new class of pathogens—their discovery and

the medical controversies about them. He is the well-respected editor at *Scientific American.*

Youngerman, Barry. 2008. *Pandemics and Global Health.* New York: Facts on File.

This book surveys pandemics throughout history. It takes a comprehensive look at how pandemics have threatened our world throughout human history and their spread and toll on human life and suffering from the Black Death in Asia and Europe to smallpox and polio outbreaks, to HIV and avian flu. It is a historical overview of infectious diseases and mankind's attempts to control them.

Zimmerman, Barry and David Zimmerman. 1996. *Killer Germs.* Chicago: Contemporary Books.

This is a comprehensive look at deadly viruses, killer parasites, flesh-eating microbes, and other pathogens. It offers a fascinating look at viruses, bacteria, fungi, protozoa, and their role in shaping human history. It includes a chapter on bioterrorism.

Scholarly Journals

American Journal of Bioethics is a journal published in 12 issues per year, covering ethics, philosophy, humanities, medical ethics, medicine, nursing, and allied health. It is published by Routledge, c/o Taylor and Francis Group, 7625 Empire Drive, Florence, KY, 1-800-634-7064, and Routledge, 8th Floor, 711 3rd Avenue, New York, NY 10017, 1-212-216-7800. http://www.tandfonline.com/toc/vajb20/current.

American Journal of Physical Anthropology, published as the official journal of the American Association of Physical Anthropology, is comprised of 14 issues per year, monthly in three quarterly volumes and two supplements on an annual basis. It contains articles, invited commentaries,

book reviews, and short communications about methodological and technical issues. Its editor-in-chief is Peter Ellison. http://www.wiley.com/WileyCDA/WileyTitle/productcite-AJPA.html.

American Journal of Preventive Medicine is a peer-reviewed journal of the American College of Preventive Medicine and Association for Preventive Teaching and Research. It is published by the University of Michigan School of Public Health, 1415 Washington Heights, Ann Arbor, MI 48109-2029, 734-936-1591. Its editor-in-chief is Matthew Boulton, MD, MPH; e-mail: ajpm@umich.edu.

American Journal of Public Health and the Nation's Health is a publication of the American Public Health Association. It is the preeminent peer-reviewed journal for public health workers and academics. It is published in 12 issues per year with an emphasis on research and practitioners' experiences with a historical context to new and old problems. http://www.apha.org/publication/american-journal-of-public-health.

American Journal of the Medical Sciences is a monthly journal that has been published since 1820, and is the oldest medical journal in the United States. AJMS is the official journal of the Southern Society for Clinical Investigation. Its peer-reviewed articles are on internal medicine and its subspecialties. Its editor-in-chief is David Ploth. It is published by the Medical University of South Carolina, Department of Medicine, 96 Jonathan Lucas Street, MSC 829, Charleston, SC. http://ajms@musc.edu.

American Scientist is a bimonthly science and technology magazine published since 1913 by Sigma Xi. Each issue has four to five feature articles by scientists and engineers. Its publisher is David Moran, Adjunct Professor at West Virginia University and its editor-in-chief is Jamie Vernon.

P.O. Box 13975, 3106 East NC Highway, Research Triangle Park, NC 27709.

Annual Review of Public Health has been published since 1980. It reports on significant developments in the field of public health, such as key developments in epidemiology and biostatistics, environmental health and behavior, health services, and public health practices. Annual Review, P.O. Box 10139, 4139 El Camino Way, Palo Alto, CA 94303-0139. http://www.annualreview.org/journal/publichealth.

Avian Diseases is the monthly journal, published quarterly, of the American Association of Avian Pathologists. http://www.aaapjournal.info/avdi.

Bioethics Issues is published by the Adelaide Centre for Bioethics and Culture. It is peer-reviewed. P.O. Box 507, Blackwood SA 5051, Australia. http://acbc@bioethics.org.au; www.bioethics.org/au/Resources. . ./Healthcare.html.

Bulletin of the History of Medicine is a quarterly journal and leading journal in its field for more than 75 years. Its peer-reviewed articles span the social, cultural, and scientific aspects of the history of medicine worldwide. Each issue contains book reviews. It is a publication of the American Association for the History of Medicine and the Johns Hopkins Institute of the History of Medicine. Johns Hopkins University Press, P.O. Box 19966, Baltimore, MD 21211-0966, 1-800-548-1784; e-mail: jrnlcirc@press.jhu.edu.

Bulletin of the League of Nations Health Organization was published quarterly by the League of Nations, Geneva, Switzerland. It is now archived by the National Center for Biotechnology Information, National Library of Medicine, at the National Institute of Health, Bethesda, MD. http://www.ncbi.nlm.nih.gov/pmc/articles/PMC1527741/.

Bulletin of the World Health Organization is an international journal of public health with a focus on developing countries that has been published since 1948. It has become one of the world's leading public health journals and is a monthly, peer-reviewed, open-access journal with its archives available free online. It is the flagship periodical of the WHO and draws on experts as editorial advisers, reviewers, and authors, as well as on external collaborators. http://www.who.int/bulletin/.

Canadian Journal of Infectious Diseases is the official journal of the Association of Medical Microbiology and Infectious Disease Canada and the Canadian Association for HIV Research. It is a major venue for the results of Canadian research and society guidelines. It is an open-access journal for peer-reviewed material pertinent to specialists and general practitioners on all aspects of infectious diseases and medical microbiology. Pulsus Group, Inc., 2902 South Sheridan Way, Oakville, Ontario, Canada, L6J726, 905-829-4770. http://www.pulsus.com/journals/journal Home.jsp?sCurrpg=journals.

Eurosurveillance is published by the European Centre for Disease Prevention and Control. It is a peer-reviewed journal of open access, a medical journal covering epidemiology, with a focus on topics of particular relevance to Europe. Established in 1995, it is jointly funded by the European Commission, Institut de veille sanitaire (Paris), and the Health Protection Agency in London. Since 2007, it has been published weekly by the European CDC. http://www.eurosurveillance.org/; www.eurosurveillance.org/Public/Articles/Archives.aspx.

The Forensic Examiner is the official, peer-reviewed journal of the American College of Forensic Examiners Institute. It has transitioned from the previously published journal to an online, continuously published journal and is

a leading forensic magazine. The Forensic Examiner, 2750 E. Sunshine, Springfield, MO 65804, 1-800-423-9737; e-mail: editor@acfel.com. http://www.theforensicexam iner.com/.

Global Post is an online U.S. news company focusing on international news, founded in Boston, Massachusetts, in January 2009. It often carries news items related to world health issues, epidemic and pandemic disease outbreaks, and world events impacting them. Its president and CEO is Philip Balboni, Global Post, The Pilot House, Lewis Wharf, Boston, MA 02110; e-mail: pbalboni@ globalpost.com. http://www.globalnewscenterprises.net/ contact/php.

International Journal of Contemporary Pediatrics is an open access, international, peer-reviewed, quarterly journal publishing original research in all areas of pediatric research and the health of infants, children, and adolescents, including infectious diseases, vaccines, allergy and immunology, critical care medicine, and so on. It publishes original research, reviews, insightful editorials, case reports, short communications, images in pediatrics, clinical problem solving, perspectives, and pediatric medicine. It is accessed on-line at http://www.ijpediatrics .com/?sec=about.

International Social Science Journal was founded at UNESCO in 1948. It is published quarterly. It brings together diverse communities of social scientists working in different problems and disciplines and in different parts of the world. It provides information and debate on subjects of interest to an international readership written by an equally international range of authors. It focuses on policy-relevant questions and interdisciplinary approaches to them. It serves as a forum for review, reflection, and discussion of relevant research and has thematic sections

comprised of commissioned articles and selected submissions from open calls. http://www.unesco.org/new/en/social-and-sciences/. . ./issj/social-sciences.

International Social Science Review is published twice per year (Summer/Winter). It is the peer-reviewed journal of Pi Gamma Mu, the International Honor Society in the Social Sciences. The Review typically has about four reviewed articles and 15 book reviews. http://wwwpigammamu.org/international-social-science-review.html.

JONA's Healthcare Law, Ethics and Regulation is a peer-reviewed journal providing information on the changing regulations affecting health care, and keeps its readers up-to-date on the dynamic and critical aspects of the profession. Discussions of current problems and trends in health-care law, and the ethics involved in ensuring quality patient care are its focus. Its editor-in-chief is Rebecca Cady, RN, SSN, JD. It is published at the Children's National Medical Center, 111 Michigan Avenue, Washington, D.C. 20010; e-mail: rfcmjd@aol.com. http://journals.lww.com/jonaslaw/pages/aboutthejournal.aspx.

Journal of African History publishes articles and book reviews ranging over the African past, from ancient times to the present. Historical approaches to all the periods cover social, economic, political, cultural, and intellectual history, and recent themes include labor and class, gender and sexuality, health and medicine, ethnicity and race, migration and diaspora, nationalism and state politics, religion and ritual, and technology and the environment. It is one of the Cambridge journals Online. http://journals.cambridge.org/action/displayJournal?jid=AFH.

Journal of Applied Microbiology (JAM) publishes high-quality research and review papers on novel aspects of applied microbiology, including environmental, food, agricultural,

medical, pharmaceutical, veterinary, soil, systematics, water, and biodeterioration. Articles concern research on all microorganisms, including viruses. It is the journal of the Society for Applied Microbiology. Its editor is Arthur Gilmour. http://www.sfam.org.uk/en/journals/journal-of-applied-microbiology.cfm.

Journal of General Virology is the official journal of the Society for General Microbiology. It is a peer-reviewed scientific journal covering research into viruses affecting animals, plants, insects, bacteria, and fungi including their molecular biology, immunology, and interactions with the host. It began in 1967 and is published monthly. Its editor-in-chief is S. Efstatious, University of Cambridge. http://www.editorialmanager.com/jgv/.

Journal of Global History is published three times per year and addresses main problems of global change over time, together with the diverse histories of globalization. It examines countercurrents to globalization. It seeks to transcend the dichotomy between East and West and to straddle traditional regional boundaries, relate material to cultural and political history, and overcome thematic fragmentation in historiography. It serves as a forum for interdisciplinary conversations across a wide variety of social and natural sciences. http://journals.cambridge.org/JGH.

Journal of Public Health Policy provides an accessible source of scholarly articles on epidemiology and social foundations of public health policy, rigorously edited, and progressive. It publishes articles from all over the world that inform policy in other communities, countries, or regions. It aims to be the platform for informed debates about public health policy globally. http://www.palgrave-journals.com/jphp/jphp/index.html.

Journal of the American Medical Association (JAMA) is a peer-reviewed medical journal published 48 times a year

by the American Medical Association covering all aspects of the biomedical sciences. It publishes original research and reviews, as well as ancillary content such as abstracts of the *Morbidity and Mortality Weekly Report*. It was founded in 1883. It editor-in-chief is Howard Bauchner of Boston University. It has English, French, and Spanish language editions. http://www.ama-assn.org/go/public ations/JAMA.

Journal of the Hong Kong Branch of the Royal Asiatic Society of Great Britain and Ireland has been published annually since 1961. It is a valuable resource for the study of Hong Kong and southern China, and is available online. http://hkjo.lib.hku.hk/exhitits/show/hkjo/browse Issue?book=b27720780.

The Lancet is a United Kingdom-based medical journal, published weekly, and in nine monthly special journals in the fields of global health, infectious diseases, and HIV. http://www.thelancet.com/.

Law and Social Inquiry is a quarterly, peer-reviewed academic journal published by Wiley-Blackwell for the American Bar Association since 1976. Its editor-in-chief is Laura Beth Nielsen. It publishes articles on law and sociology, economics, political science, social psychology, history, philosophy, and other social science and humanities disciplines. http://onlinelibrary.wiley.com/journal/10/1111/ (ISSN)1747-4469.

National Geographic is the official magazine of the National Geographic Society. It has been published monthly since 1888 and contains articles about geography, history, and world culture. As of 2015, it is circulated worldwide in 40 language editions and has a global circulation of 6.8 million per month, and its U.S. circulation is around 3.5 million per month. It is available in the traditional printed edition and as an interactive online edition. On

occasion, special editions are issued. http://ngm.national geographic.com.

Nature Medicine is a monthly peer-reviewed medical journal established in 1995 by the Nature Publishing Group. It contains research articles, reviews, news, and commentaries including basic research and early-phase clinical research covering all aspects of medicine. It is edited by Juan Carlos Lopez. https://www.nature.com/nm/index .html.

Nature Reviews Immunology is a monthly review journal covering immunology. It is part of the Nature Publishing Group/Macmillan Publishers and has been published since 2001. http://www.nature.com/nri/.

New England Journal of Medicine is a weekly general medical journal of the Massachusetts Medical Society founded in 1812 and is the oldest continuously publishing one. It is a very prestigious medical journal, now over 200 years publishing new medical research and review articles. The *NEJM* is located in Waltham, MA. http://www.nejm .org/.

New Scientist is a United Kingdom-based English language international science magazine founded in 1956, with an online edition begun in 1996. It is non-peer reviewed, publishing weekly, and covering a wide variety of current developments, news, reviews, and commentary on science and technology, including speculative articles ranging from the technical to the philosophical. It is based in London and publishes editions in the UK, the United States, and Australia. Its editor-in-chief is Sumit Paul-Choudhury. Its website is: http//www.newscientist.com/.

Philadelphia Medical Journal was a therapeutic monthly published by the Philadelphia Medical Publishing Company

from 1848 to 1922. Archives of its articles can be accessed at: http://www.collegeofphysicians.org/library. Original articles are from the University of Michigan.

Population Bulletin is a publication of the Population Reference Bureau. It is published four times per year and covers articles on international population trends and their implication. http://wwwprb.org/.

Proceedings of the National Academy of Sciences (PNAS) is the official journal of the United States National Academy of Sciences. It is an important scientific journal begun in 1915 and publishes research reports, commentaries, reviews, perspectives, feature articles, profiles, letters to the editor, and actions of the Academy. It spans biological, physical, and social sciences, with many in the biomedical sciences. It is published weekly in print and online in *PNAS Early Edition*. http://www.pnas.org/ and www.ncbi.nim.nih.gov/NCBI.

Public Health Reports is the official journal of the Public Health Service. It is peer-reviewed and appears in six issues per year. Its articles cover public health practices, research, viewpoints, and commentaries. Since 1999 it has been published by the Association of Schools of Public Health, United States Department of Health and Human Services, 200 Independence Avenue SW, Washington, D.C. 20201. http://www.ncbi.nih.gov/NCBI/literature/PubMedCentral; www.surgeongeneral.gov/Home/ReportsandPublications.

Science is a leading outlet for science news, commentary, and research. It is published by the American Association for Advancement of Science (AAAS). It is a peer-reviewed journal containing important original scientific research and research reviews. It covers the full range of scientific disciplines. It has been publishing since 1880. It is now

weekly and published in Washington, D.C., and in Cambridge, England. http://www.sciencemag.org/.

Science Daily has, since 1995, been publishing breaking news about the latest discoveries in science, health, the environment, astronomy, exo-planets, and so on. It is a news website. http://www.sciencedaily.com.

Scientific America is a monthly magazine of science and science-related news articles. It is a popular science magazine for general readers and has been published since 1845. It is published by the Nature Publishing Group in the United States. http://www.scientificamerica.com.

Social Science and Medicine is a biweekly, peer-reviewed academic journal covering social science research on health, including the disciplines of anthropology, economics, geography, psychology, social epidemiology, social policy, sociology, and health care practice, policy, and organization. It was established in 1967. It is currently edited by Ichiro Kawachi, S.V. Subramanian. From 1967 to 1977 it was published by Pergamon Press and was then split into six disciplinary-based parts. In 1982 they were merged back into one journal, again by Pergamon Press, but is now published by Elsevier. https://www.eksevuew.com/wps/find/journaldescription.cws_home.

Nonprint Sources

Films

After Armageddon, 2010, in color, 94 minutes. It is produced for television movie about a modern family in Los Angeles trying to survive the aftermath of a deadly flu pandemic. IMDbPro. http://www.youtube.com/watch?v=ot P80Z08lfg.

Contagion, 2011, is an American-made film thriller centering on the threat posed by a deadly disease and an international team of doctors contracted by the CDC to deal with the outbreak.

Doomsday, 2008, is set in Scotland which is quarantined following an epidemic.

Outbreak, 1995, is set in a future world devastated by a human-made deadly virus.

Smallpox, 2002, is a BBC fictional docudrama about a deadly smallpox pandemic.

28 Days Later, 2002, is a BBC-produced fictional horror film following the outbreak of an infectious "rage" virus that destroys all of mainland Great Britain.

28 Weeks Later, 2007, is a BBC fictional docudrama that is the sequel to 28 Days Later, ending with the evident spread of the infection to mainland Europe.

Videos

"American Death: The Influenza of 1918," 2010, is in color, a 60-minute PBS, American Experience documentary, now on DVD.

"Anatomy of a Pandemic," 2009, is a television documentary by CBS News Production, in color, 60 minutes. It concerns the swine flu pandemic and H1N1 outbreak and discusses how viruses mutate.

"Bamboo Invasion," 2013, is a documentary regarding the killer flu regarding the 1918 flu pandemic.

"Biomedical Weapons: A Modern Threat," 2003, is by Insight Media, in color, 25 minutes. It depicts how bioterrorists could make bioweapons via genetic engineering.

"Bioterrorism," 2001, by Insight Media, Alexander Street Press, in color, 50 minutes, about the anthrax attack.

"Black Dawn: The Next Pandemic," 2006, is in color and runs 52 minutes. It is a Fanlight Production of Canadian Broadcasting Corporation, IMDb, and is a starkly realistic depiction of life during the next pandemic.

"Building the Perfect Bug: Virology, Rogue Science, and Bioterrorism," 2012, is by Films Media Group, in color, 26 minutes. The program considers the controversial work of Dutch virologist Ron Fourchier, who purposely engineered a lethal, air-borne bird flu virus, published his findings, and openly shared his working methods. It asks the question, "Can the deadly microbes he created be contained?"

"Carbapenum-Resistant Enterobacteriaceae (CRE): A New Super Villain?" 2013, is in color and runs 10 minutes, produced by Envision, Inc. It deals with the recent acceleration of CRE infection in the United States and examines strategies to prevent its transmission. It discusses the use of antimicrobials, surveillance measures, and infection control techniques.

"Conspiracy: The Anthrax Attacks," 2004, by Insight Media, in color, 50 minutes.

"Dark Forest: Black Fly," 2013, is a 57-minute video in color by American Public Television and narrated by Mia Farrow. It covers river blindness transmitted by black flies and travels to frontline Uganda's fight to eradicate it.

"Ebola: Africa's Bloody Disease," 2014, is by Documentary Addict, in color, 47 minutes.

"Ebola Outbreak," 2014, in color, 57 minutes. A Frontline episode on the Ebola outbreak, it follows health officials

tracking the deadly disease and their efforts to stop its spread with special access to Sierra Leone. It shows how the outbreak endangers health-care workers and is overwhelming hospitals. Produced by Film Media Group.

"Ebola: The Plague Fighters," 2007, a PBS Nova production, the video is in color and runs 54 minutes. It is a documentary on the Hot Zone of the Ebola crisis and the after-effects of the terrifying virus with interviews of disease specialists.

"Ebola: The Search for a Cure," 2014, by Film Media Group is in color and runs 53 minutes. It is a video of a special episode of *Horizon*, a BBC production that looks at one of the most virulent infections known to science. It meets doctors and scientists from around the world looking for a cure and hears first-hand accounts of what it is like to actually catch and survive this terrible disease.

"Ebola: The World's Most Dangerous Virus," 2013, is in color and runs 50 minutes. By New Atlantis, it documents the viruses and biological weapons of the future. It enters the High Security Center Biologic, where they work on Marburg, influenza, dengue, yellow fever, Ebola virus, and HIV. It meets the WHO fighters against Ebola. http://greenroad.blogspot.com/2014/og/the-words-most-dangerous-virus; https://www.youtube.com/user/new atlantisline.

"End Day," 2005, a 56-minute color documentary by the BBC, it is a docu-drama depicting how civilization could be brought to an end. It aired on National Geographic and depicts various doomsday scenarios.

"Epidemic," 2007, is in four programs totaling 225 minutes. Its segments are on Ebola, AIDS, bird flu, and typhoid. Four 60-minute programs on DVDs.

"Epidemics: The Invisible Threat," 2014, is in color and runs 53 minutes, by Film Media Group. It covers the invisible threat of new viruses emerging from the animal kingdom in the past 60 years—some 350 new infections including SARS, H1N1, H5N1, and Ebola. It traces three new viruses from animals to humans: H7N9 flu virus in Asia, MERS virus in the Middle East, and Ebola in West Africa. In it, researchers stress the "one-health" approach crucial for prevention, habitat loss, and ecosystem breakdown and how human health is affected.

"The Fight Against Ebola," 2014, in color, 29 minutes. A *Storyline* production, it focuses on Monrovia and Liberia, Sierra Leone, Senegal, and Nigeria.

"Frontline: Hunting the Nightmare Bacteria," 2013, is in color and runs 60 minutes. It documents the alarming rise in hospitals across the globe of untreatable infection, fueled by decades of antibiotic overuse.

"The Great Fever," 2006, is an American Experience film, of a 60-minute PBS program produced by the WGBH Education Foundation, about yellow fever and the yellow fever commission.

"How Would a Global Pandemic Really Happen?" 2014, is a 52-minute color documentary by Journeyman Pictures. It depicts how an Ebola-like, global pandemic might actually play out.

"Interview: Dr. Alfred Crosby," 2009, in color, 7 minutes. It interviews Dr. Alfred Crosby, the author of *Epidemic and Peace, 1918: America's Forgotten Pandemic*. A PBS video production, part of a series of author interviews.

"Killer Outbreaks: The Everyday Turns Devastating," 2011, a color, 43-minute Discovery Channel program that looks

at symptoms, treatments, and sources of anthrax and *E. coli* and looks at the New York City case of anthrax, experimental treatment, and doctors who saved him. Investigators from the CDC track down the source of an *E. coli* outbreak.

"Killer Outbreaks: Terrorists Within," 2011, in color, a 43-minute Discovery Channel program that explores the symptoms, treatment, and sources of infections caused by bacteria in hospitals, especially military hospitals, and how they migrate to the United States, and the spread of MRSA across the United States.

"Micro-killers: Super Flu," 2005, is a National Geographic channel production, in color, 47 minutes, that is about the Asian bird flu epidemic; its outbreak, spread, and efforts to contain or control it.

"Mystery of the Flesh Eaters," 2011, in color, 8 minutes, is an ABC segment about the disease that attacks in the hot summer months, on the decade-long hunt by Dr. John Gerrod to track down the culprit microbe responsible for vectoring a virulent flesh-eating bacteria into humans.

"NOVA: Mass Extinction," 2006, in color, 60 minutes. Host Neil de Grasse Tyson is featured on this PBS production of a Discovery Science Universe program about the Permian extinction, which was the earth's most profound extinction.

"Pandemic: A Horizon Guide," 2009, is a color, 50-minute-long BBC documentary television episode about the threat of pandemic diseases.

"Pandemic Diseases: The Enemy of Man," 2013, is a color, 58-minute BBC worldwide feature-length special on the history of pandemic diseases.

"SARS: The True Story," 2003, is a color, 45-minute video of a BBC Horizon episode on its Science and Nature series that is about the SARS epidemic and attempts to quarantine it, and the global concern and unprecedented effort by the WHO to respond to the threat.

"Sierra Leone: Into the Hot Zone," 2014, is a 29-minute, color video by Film Media Group on the deadly Ebola outbreak in Sierra Leone. It looks at the doctors, nurses, and health workers on the frontline and their work to stop the spread of Ebola led by the International Red Cross, MSF (Doctors Without Borders), and the WHO and the crisis coordinating center established to cope with the West African pandemic.

"Surviving Ebola," 2015, is a 60-minute, color NOVA segment now on DVD, which reports from the hot zone, on medical teams as they struggle to cope with the flood of victim, to labs where scientists are racing to test vaccines to find a cure for the deadly Ebola disease.

"The Trouble with Anti-biotics," 2014, is a color, 54-minute video of a Frontline Production. It examines how antibiotics on the farm contribute to the growth of antibiotic-resistant bacteria and traces the history of their use, and the story of the "superbug" outbreaks. It is distributed by the Film Media Group.

"Tuberculosis: The White Death," 2011, in color, 60 minutes, is a video distributed by Films Media Group, which examines the history of tuberculosis (TB), focuses on Robert Koch's discovery of the tubercle bacillus, and explains the ongoing attempts to eradicate TB, and how the onset of AIDS and the evolution of multidrug-resistant strains of viruses have negatively affected treatment of TB.

"Virus Hunters," 2012, in color, 7 minutes, a segment of ABC on how effective our frontline defense is against bug

killers. Graham goes beyond the air lock to see where the world's deadliest viruses are studied.

Film/Video Contact Information

American Public Television, Public Broadcasting Service (PBS), www.pbs.org; 2100 Crystal Drive, Arlington, VA 22202 for episodes of programs on American Experience, NOVA, Nature, Frontline.

BBC, www.bbcamerica.com/videos; BBC America shop.

Discovery Channel, www.discovery.com/videos; www.discoveryeducation.com/.

Envision, Inc., https://envisioninc.net/programs; 644 West Irish Drive, Nashville, TN 37204; 866-321-5066.

Fanlight Productions, Canadian Broadcasting Corporation, http://www.fanlight.com/catalog/films; 1-800-876-1710; e-mail: info@fanlight.com.

Filmakers Library, http://www.filmakers.com; http://www.academicvideostore.com/filmmakers; 124 East Fortieth Street, No. 901, New York, NY 10016; 212-808-4980; e-mail: mailto.info@filmakers.com.

Meg Keller, Director of Marketing, Alexander Street Press, http://alexanderstreet.com; 3212 Duke Street, Alexandria, VA 22314; 703-212-8520 X116; e-mail: mkeller@alexanderstreet.com.

Films for the Humanities and Sciences, www.imdb.com/company; www.films.com/FilmMediaGroup; P.O. Box 2053, Princeton, NJ 08543-2053.

Films Media Group, www.films.com; 132 West 31st Street, 17th Floor, New York, NY 10001; 800-322-8755; e-mail: custserv@films.com.

First Run/Icarus Films, http://www.frif.com; 32 Court Street, 21st Floor, Brooklyn, New York 11201; 800-876-1710; 212-232-1660; e-mail: info@documentary.org.

3470 Wilshire Blvd. Suite 980, Los Angeles, CA 90010, 213-232-1669.

Insight Media, 2162 Broadway, New York, NY 10024; 800-233-9910; 212-721-6316; e-mail: insight-media.com/.

Alexander Street Press, http://alexanderstreet.com; 3212 Duke Street, Alexandria, VA 22314; 703-212-8520 X 313.

Journeyman Pictures, www.journeyman.tv; 46 High Street, Thames, Ditton Surrey, KTZ ORY, United Kingdom; +44 208 398 4616; e-mail: info@journeyman.tv.

National Geographic Society, 1145 17th Street, NW, Washington, D.C. 20036-4688.

National Geographic TV Production (NGTV), Channel .nationalgeographic.com; 800-627-5162; e-mail: cust serv@natgeovideos.com.

Storyline Productions, www.storylineproductions.com; 613-400-4247; Ottawa.

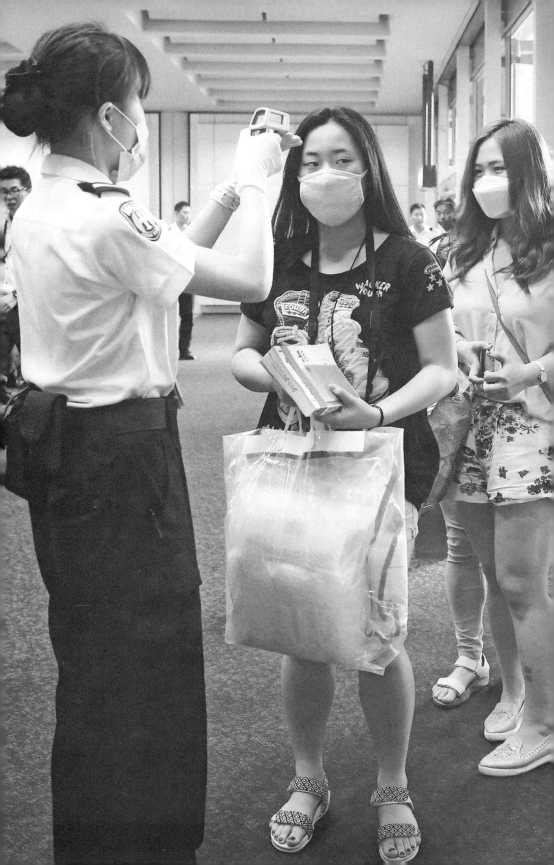

Below is a chronology of major pandemics of the past. Chapter Five also presents some other related chronologies.

Dates	Event [Name/Reason]	Pandemic/ Epidemic Disease	Estimated Deaths
13th century BCE	Ten Plagues of Egypt	Possibly smallpox, among others	Unknown
429–426 BCE	Plague of Athens	Probably typhoid	75,000–100,000
165–80 CE	Antonine Plague (Europe/Western Asia and Northern Africa)	Probably smallpox	30% of population
541–542	Plague of Justinian (Europe)	Bubonic plague	40% of population
1616–1619	New England region; Wampanoag people	Unknown; possibly yellow fever, bubonic plague, smallpox, chicken pox, or typhus	30–90% of population
1629–1631	Italian Plague	Bubonic plague	280,000
1663–1679	Europe (the Netherlands, England, France, Spain, Austria)	Bubonic plague	250,000

(*continued*)

Passengers flying from Busan, South Korea, receive temperature checks for MERS (Middle East Respiratory Syndrome) as they arrive at Hong Kong Airport on June 5, 2015. The current frenzy in South Korea over MERS brings to mind the other menacing diseases to hit Asia over the last decade— SARS, which killed hundreds, and bird flu. (AP Photo/Kin Cheung)

Dates	Event [Name/Reason]	Pandemic/ Epidemic Disease	Estimated Deaths
1738	Great Plague of 1738 (The Balkans)	Bubonic plague	50,000
1770–1772	Russian Plague	Bubonic plague	50,000
1798	United States establishes the U.S. Marine Health Services		
1816–1826	First cholera pandemic (Asia and Europe)	Cholera	100,000–120,000 per year (1 to 1.5 million total)
1829–1851	Second cholera pandemic (Asia, Europe, North America)	Cholera	100,000
1847–1848	Typhus epidemic of 1847 (Canada)	Typhus	20,000
1852–1860	Third cholera pandemic (Russia, Denmark)	Cholera	1,000,000+
1866	Pasteur Institute founded by Louis Pasteur		
1875	Fiji measles epidemic	Measles	40,000
1878	Yellow fever epidemic (South America, Caribbean and Southern United States)	"Yellow Jack" yellow Fever	Unknown
1878	United States Congress passes the National Quarantine Act		
1881–1896	Fourth cholera pandemic (India, Germany)	Cholera	9,000
1889–1890	Flu pandemic (Worldwide)	Influenza	1,000,000
1899	Yellow Fever Commission established in Havana, Cuba		
1899–1923	Fifth cholera pandemic (Europe, Asia, Africa)	Cholera	800,000
1902	USMHS and Public Health Service, expanded		
1900–1908	Third bubonic plague (San Francisco)	Bubonic plague	250

Dates	Event [Name/Reason]	Pandemic/ Epidemic Disease	Estimated Deaths
1912	USMHS renamed the U.S. Public Health Service		
1916	Polio outbreak (United States)	Poliomyelitis	27,000 paralyzed; 2,200 die
1918–1920	Spanish flu (worldwide)	Influenza	50,000,000– 75,000,000
1918	The League of Nations forms the Public Health Agency		
1948	United Nations formed (with agencies WHO, UNESCO, and UNICEF)		
1957–1958	Asian flu pandemic (Worldwide)	Influenza	2,000,000
1957	The WHO begins a global vaccination campaign against smallpox		
1968–1969	Hong Kong flu pandemic (Worldwide)	Influenza	1,000,000
1974	Smallpox epidemic (India)	Smallpox	15,000
1977	Smallpox eradicated worldwide by the WHO campaign		
1960 to date	HIV/AIDS pandemic (worldwide)	HIV/AIDS	30,000,000– 40,000,000
2002–2003	SARS (Asia)	SARS coronavirus	1,000
2008–2009	Zimbabwe cholera epidemic	Cholera	4,293
2009	Flu pandemic (Worldwide)	Influenza	14,286
2010 to date	Haiti cholera epidemic	Cholera	8,500
2011 to date	Measles epidemic (Congo)	Measles	4,500+
2014–2015	Ebola pandemic (West Africa)	Ebola	7,000+
2015	Swine flu outbreak (India)	Influenza H1N1 strain	1,800+

Sources

Ancestors West, SSBCGS, Vol. 20, No. 1, Fall, 1993, South Bend, Indiana.

Hayes, J. N. 2005. *Epidemics and Pandemics: Their Impacts on Human History.* Santa Barbara, CA: ABC-CLIO.

http://www.aim.org/special-report/ebola-pandemic-risks-and-realities.

http://www.avert.org/safricastats.htm.

http://www.cdc.gov/flu/pandemics/phase.htm.

http://www.cdc.ca/health/stry/2008/05/09/f-cholera-outbreaks.html.

http://www.cdc.gov/flu/pandemics/phase.htm.

http://www.cdc.gov/flu/spotlights/pandemic-global-estimates.htm.

http://www.cdc.gov/nip/diseases/measles/history.htm.

http://www.ecdc.europa.eu/.

http://www.doctorswithoutborders.org/press/releases/cfm?id=5132 HYPERLINK.

http://www.flu.gov/pandemic/history/.

http://www.globalsecurity.org/wmd/intro/bio_cholera.htm.

http://www.nationalgeographic.

http://www.ncbi.nih.gov/pmc/articles.

http://www.nationalgeographic.com/science/health-and-human-body/human-diseases/plague/article.html.

http://www.ph.ucla.edu/EPI/snow/pandemic1826–37.html.

http://www.redcross.org/news/globalreport/UNAIDS.

http://www.science.com/article.

http://www.science.nationalgeographic.com/science-health-and-human-body/human-diseases/plague-article.html.

http://www.unaids.org/globalreport/UNAIDS.

http://www.who.int/csr/disease/cfm?articleID.

http://www.who.int/en/.

http://www.who.intgho/data/viewebola-summary-
20150522?lang=en.pdf.

http://www.who.int/mediacentre/influenzaAh1N1_
presstranscript20090526.pdf.

http://www.who.int/vaccine_research/diseases/zoonotic/en/
index4.html.

Kohn, George C., ed. *Encyclopedia of Plague and Pestilence.*
New York: Facts on File, 1995: 360–372.

LeMay, Michael C., ed. *Transforming America: Perspectives on
Immigration.* Santa Barbara, CA: ABC-CLIO, Table 3.1:
51–52.

Time. 2014. *The Science of Epidemics.* New York: Time Inc.

Acute diseases are ones that exhibit rapid onsets of symptoms of the disease.

Adjuvants are chemical ingredients in sera used to prod the immune system to life.

Aedes aegypti is the breed of mosquito that carries and spreads yellow fever.

Aedes albopictus is the mosquito that is the vector that spreads dengue fever.

Agro-terrorist is a bio-terrorist who targets animal or agricultural food supplies or systems with the intent to cause animal or food diseases that disrupt the economy of the targeted nation.

AIDS/HIV is acquired immune deficiency syndrome, an often deadly disease caused by the human immunodeficiency virus, which attacks and weakens or kills the body's immune system that ordinarily attacks and destroys invading pathogens.

Amebiasis is an infestation with a protozoan parasite in the intestines or liver that can cause amebic dysentery.

Anopheles is a breed of mosquito that is the vector for (carrier of) the malaria bacillus.

Antigen drift is when a virus mutates such that the human immune system no longer recognizes it as a pathogen invading the body.

Antigen shift is a dramatic mutation of a virus such that the human immune system no longer recognizes the pathogen. It results in a significant increase in the morbidity and mortality rates of viral diseases.

Antiretroviral therapy (ART) refers to medication therapy (a "cocktail" of medications) designed to treat any of a family (Retroviridae) of RNA viruses, including ones that cause leukemia, AIDS, and the like.

Antivaccination Movement is a social movement found mostly in affluent areas in the United States comprised of persons who believe immunization shots are overused and teeming with toxins. They believe vaccinations cause autism, bipolar disorder, attention deficit hyperactivity disorder, allergies, and more. They are conspiracy theorists who believe compulsory vaccination programs are simply profit centers for Big Pharma.

Arthropod is an invertebrate animal of the large family Arthropoda, such as an insect, spider, or crustacean.

Autochthonous cycle pertains to organisms or organic sediments that are indigenous to a given ecosystem.

Avian flu, or bird flu, is a type of influenza that first appeared among wild or domestic birds before jumping to humans, spread by bird-to-human contact.

Bacillus is the germ that causes a particular disease in humans.

Bacterium is a microorganism (aka a germ) that can cause a disease in humans.

Biologics refers to vaccines, probiotics, blood products, cell, tissue, and gene therapies.

Biospace is where life naturally occurs, as in an ecosystem.

Bioterrorism refers to the use of engineered pathogens that have been weaponized.

Botulism is the poisoning that results from the toxin produced by botulinus bacteria.

Buboes are large, hard, painful swellings in the groin, armpit, or neck formed when the bubonic plague infection reaches the lymphatic system of the body.

Center for Biologics Evaluation Research (CBER) is comprised of six main centers for the U.S. Food and Drug Administration (FDA), part of the U.S. Health and Human Services, which are responsible for assuring the safety, purity, and effectiveness of biologics and related products (vaccines, live biotherapeutics or probiotics, blood products, and cell, tissue and gene therapies.

Chimera is a genetically engineered or altered virus that combines the strains and characteristics of two or more viruses to enhance its capability as a bioweapon; for example, combining a flu virus for its high morbidity rate and ease of spread with Ebola, or any hemorrhagic virus, for its high mortality rate.

Chlamydia trachomatis is a bacterium that causes trachoma, and the gonorrhea-like venereal disease.

Civet cat is a nocturnal, cat-like carnivore found in Africa, India, Malaysia, and China.

Conjunctiva is the mucous membrane lining the inner surface of the eyelid and covering the front part of the eyeball.

Conjunctivitis is an infection and resulting inflammation of the conjunctiva and is often a symptom of trachoma.

Contagious diseases are communicable diseases that are liable to spread from humans to humans from direct or indirect contact.

Controlled monitoring refers to a quarantine regime that includes frequent temperature checks and surveillance of Ebola-related symptoms to ensure a person returning from an area experiencing an Ebola outbreak is free of the disease.

Cordon sanitaire is a nation or region experiencing an epidemic or pandemic outbreak bans travel across international boundaries.

Coronavirus is a crown-shaped virus that infects the heart or pulmonary system.

DeCon suits are specialized clothing to prevent exposure to and infection by a highly contagious disease, such as Ebola. They are also known as hazmat suits.

Dengue is an infectious tropical viral disease transmitted by mosquitoes characterized by severe pain in the back and joints, and fever, aka breakbone fever.

Designer virus is one that has been bioengineered, a chimera, that combines two or more viruses to create a bioweapon that has enhanced morbidity and mortality rates.

Diastolic is the low number used when measuring blood pressure: 80 or lower is the normal range, 80–89 is borderline, 90–99 is high, and 100 or above is high stage II.

Dysentery refers to any of several intestinal inflammations characterized by abdominal pain and frequent and intense diarrhea with bloody, mucous feces.

Ebola virus is a newly emerged zoonotic virus, first discovered in 1976 in the Democratic Republic of Congo. Infection by it causes a rapid-onset hemorrhagic disease with a mortality rate of 50 to 70 percent. The virus is named after the Ebola River.

Ecosystem is one that comprises a community of animals, plants, and bacteria and its interrelated physical and chemical environment.

El Tor is the Asiatic cholera strain that migrated from China to South America in the infected bilge water of a Chinese vessel that dumped its waste water.

Endemic, a disease common or native to a particular area, always present but under control and manageable. It usually manifests with low morbidity and mortality rates.

Enteroviruses, like poliomyelitis, are ones that first infect the gastrointestinal system where they incubate and multiply, then spread to the lymph nodes and from there to the anterior horn cells of the spine, causing paralysis in about 10 percent.

They were first identified in 1962, in California. An epidemic of EV-D68, nonpolio enterovirus, has recently broken out in the United States.

Epidemic, an outbreak of a disease produced by some special cause not generally present in the affected area with higher than usual morbidity and mortality rates.

Epidemiology is the study of epidemic and pandemic diseases, their causes, and spread.

Epithelial cells are cells that are shed or come from the malignant tumor of the skin.

Erysipelas is an acute, infectious disease of the skin or mucous membranes caused by *Streptococcus* and characterized by local inflammation and fever.

Etiology is the assignment of a cause, as in the cause of a disease; the science of causes or origins.

Euthanization is any method of causing painless death.

EVD (Ebola Virus Disease) is one of the newly emerging viral diseases, occurring most often in Africa, especially West Africa, and likely passing from primates to humans. It has a high mortality rate (more than 50 percent).

Expanded Programme on Immunization (EPI) is the WHO's campaign to eradicate communicable diseases by a worldwide immunization effort.

Febrile seizure, also known as a fever fit or febrile convulsion, is a seizure associated with high body temperature but without any serious underlying health issue that most often occurs among children.

Filariasis is a disease caused by filarial worms transmitted by mosquitoes: the worms invade lymphatic vessels and lymphoid tissue causing chronic swelling of the lower extremities and other parts of the body.

First-responders refers to police, fire, local public health departments, EMS services, and local hospitals who are the first persons activated to deal with an emergency.

Foot-and-mouth diseases are diseases, like the so-called Mad Cow disease, that affect cattle making their meat unfit to consume.

Genome is one complete haploid set of chromosomes of an organism, the key to its genetic makeup.

Germ Theory is a theory of the causes of disease that led to bacteriology and the scientific approach to medicine, attributed to the pioneering work of France's Louis Pasteur and Germany's Robert Koch.

Germicides are any antiseptic used to destroy germs.

Global Pandemic Eradication Initiative (GPEI) is the worldwide program by the WHO, the CDC, and various NGOs to eradicate pandemic diseases by inoculation of vaccines against them.

Gulf War syndrome is a baffling set of symptoms or conditions exhibited by persons who fought in the Mid-eastern Gulf War.

Hajj is a mandatory religious duty for all Muslims to carry out at least once in a lifetime if they are physically and financially able. It results in the world's largest annual gathering and is a hotbed of infectious diseases as pilgrims from all over the world trek around barefoot in the heat and share tight sleeping quarters.

HAN (Health Alert Network) is a network of the CDC for sharing information about urgent public health incidents with public information officers; federal, state, territorial, and local health practitioners and clinicians; and public health labs.

Hantaviruses are single-stranded, enveloped, negative sense RNA viruses in the Bunyaviridae family that normally infect rodents and do not cause diseases in these hosts. Humans may become infected through contact with rodent urine, saliva, or feces. Some strains cause fatal diseases in humans.

Hematocrit refers to the proportion of red blood cells compared with all blood cells. It is also known as packed cell

volume, or the volume (percentage) of red blood cells in the blood. It is normally 45 percent for men and 40 percent for women. It is measured using a centrifuge for separating blood cells from the plasma.

Hemorrhagic pertains to bleeding or the abnormal flow of blood.

Herd-immunity is when a sufficiently large (usually more than 95) percentage of a population is immune to a disease by vaccination, inoculation, or by past exposure to the disease that resulted in a natural immunity.

Immunization is the medical practice of producing widespread immunity to a particular disease through inoculation or vaccination of a serum to create immunity in individuals, and by a public health vaccination campaign, among a population.

Immunology is the study of developing immunity to a disease-causing pathogen among individuals or a population.

Index case is the first or initial case of a disease that becomes an epidemic outbreak.

In situ means in its original place.

In vivo means occurring within a living organism.

Infections is the state of being infected by the presence in the body of bacteria, protozoans, viruses, or other parasites.

Jaundice is a condition in which the eyeballs, the skin, and the urine become unusually yellow as a result of a disease, such as yellow fever, as a result of increased levels of bile pigments in the blood; a disease causing hepatitis.

Jeyes fluid is a mixture of antiseptic fluid capable of decontamination of human waste.

MDGs refers to Millennium Development Goals, a set of goals established by the UN to end extreme global poverty by 2015 that include targeted reductions in the morbidity and mortality rates of malaria, tuberculosis, and HIV in sub-Saharan Africa.

MERS is Middle East respiratory syndrome, a recently emerging viral respiratory disease that was first reported in an outbreak in Saudi Arabia in 2012 that then spread to a regional pandemic outbreak infecting several Middle Eastern countries.

Microbe, a microscopic, that is, too small to be seen by the unaided human eye, living organism, such as a germ or virus.

Microcephaly is a condition in which the fetus develops with an unusually small brain size and capacity.

Mission complexity refers to the tendency or status of a bureaucracy to attempt to do too many things, thereby reducing its efficiency to do anything.

Mixing vessel is an animal that serves as secondary host to a virus wherein genes from one strain cross with those of another strain that then can infect humans; for example, pigs are host to bird genes where the flu virus crosses to strains that can infect humans. Camels are hosts to bat genes in which the MERS virus mixes to cross to humans.

MMRS (Metropolitan Medical Response System) is a federal funding program for designated localities to assist in maintaining plans, delivering training, purchasing equipment and pharmaceuticals, and conducting exercises to enhance local medical incident management and coordinate and respond to mass casualty events in the crucial first hours until external resources become operational.

MMWR is the CDC's Morbidity and Mortality Weekly Report that lists data compiled by the CDC from reports by the 50 states on a set of national diseases that the states are required to notify the CDC of occurrences.

Morbidity rate is the rate at which individuals in a population contract a disease during an epidemic or pandemic outbreak.

Mortality rate is the rate at which individuals who contract a disease during an epidemic outbreak succumb to or die of the disease—its killing or death rate.

MRSA (Methicillin-resistant *Staphylococcus aureus*) is a bacteria that is resistant to many antibiotics, especially related to skin infections, that can cause life-threatening bloodstream infections and surgical site infections.

Mutation refers to a sudden change or variation in some inheritable characteristic in a germ cell; an abrupt and permanent change in somatic cells, or in a virus.

Myopic is an abnormal eye condition causing near-sightedness.

National sovereignty is the right and power of a country to control its land area.

NDMS (National Disaster Medical System) is a federally coordinated system of medical response capability designed to supplement and integrate medical response capability by aiding state and local authorities responding to the medical impacts of major peacetime disasters, and support to the military and VA medical systems in caring for casualties evacuated back to the United States from overseas armed conventional conflicts.

Neurovirologic disorder is a disease of the nervous system caused by a virus.

NGOs (Non-governmental organizations) are organizations that are neither part of a government nor a conventional for-profit business. They may be funded by governments, foundations, businesses, or private persons. They are highly diverse and take different forms around the world. Some have charitable status, while others are recognized for social purposes for political, religious, or other interests.

Nipah virus is a bat to pig to human infection that emerged in 1990 in Malaysia. It did not go worldwide, but has the potential to do so.

Ornithology is the branch of zoology dealing with birds and bird diseases.

Orthopoxviruses are any of a group of various viruses, like chicken pox, cow pox, small pox, etc., that exhibit pox symptoms—that is, skin eruptions.

Pandemic is an epidemic of a disease that goes regional or even global in scope with very high morbidity and mortality rates.

Pandemic prevention involves cataloging new pathogens and containing them; for example, by stopping bush meat hunting, by addressing basic issues of development, such as rural poverty, and developing alternative sources of protein, like domestic animals, which are often rare in Central Africa.

Pandemic Severity Index is a measure of the severity of a particular pandemic outbreak based on a combination of its morbidity and mortality rates.

Pasteurization is the process of destroying disease-producing bacteria and checking the activity of fermentative bacteria, as in milk, beer, cider, etc., by heating the liquid to a prescribed temperature for a specific period of time.

Pathogens are natural agents of disease; germs and viruses.

Perinatal involves or occurring during the period closely surrounding the time of birth.

Pestilence is any virulent or fatal contagious or infectious disease; one of epidemic proportions, as bubonic plague.

Petechiae are small purple spots caused by bleeding into the skin from broken capillary blood vessels.

Phenotype database is a collection of data about the manifest characteristics of an organism, including anatomical traits that result from its heredity and environment.

Plague refers to any contagious, epidemic disease outbreaks that are deadly.

Pneumococcus is the bacterium that causes pneumonia and certain related diseases.

Poliomyelitis is from the Greek words for gray and marrow; it is an infection of the gray matter of the spinal cord.

Post-Ebola syndrome refers to the continuing manifestation of symptoms among survivors of Ebola when the presence

of the virus is no longer in the blood, for example, continued eye disorders.

Privies refers to toilets, especially outhouses.

Prophylactic is preventative or protective against a human disease.

Prophylaxis refers to watching for or guarding against disease.

Public health refers to the system or provision of health services by government, especially preventive health programs.

Pulex irritans is the human flea carrier of the plague.

Pull factors are aspects of the receiving nation that draw immigrants to them for permanent resettlement.

Pulmonary disease is any disease condition of the lungs.

Push factors are aspects of a sending nation that induce large rates of emigration.

Rapid testing devices are diagnostic instruments that can quickly test for the presence of a pathogen, such as using a pin-prick device to collect a drop of blood to determine if a specific pathogen or the antibodies against it are in the blood.

Rattus rattus is the common European black rat, found in abundance in urban areas, that is the carrier of fleas that transmit the bubonic plague bacillus.

Retroviruses are any family of RNA viruses, including ones that cause leukemia and AIDS.

Ricin is an extremely toxic protein found in the castor bean and isolated as a white powder; it agglutinates red blood corpuscles and has been used as a bioweapon.

Rickettsia are organisms or pathogens that cause typhus.

Salvarsan is a treatment for syphilis.

Sarin toxin is a highly toxic nerve gas that attacks the central nervous system quickly bringing on convulsions and death.

SARS refers to severe acute respiratory syndrome, a type of coronavirus viral respiratory disease of zoonotic (animal) origin first identified during a 2002 outbreak.

Schistosomiasis is a chronic, usually tropical disease, caused by schistosomes and characterized in humans by disorders of the liver, urinary bladder, lungs, or central nervous system.

Septicemic plague or pneumonic plague is when the plague bacillus becomes systemic caused by the presence of the pathogenic microorganisms and their toxic products in the human blood.

Sera is the plural of serum, a clear watery animal fluid of the blood, as serous fluid, and is used as a blood serum containing agents of immunity, taken from an animal (often a horse) made immune to a specific disease by inoculation to serve as an antitoxin and for diagnosis.

Ship fever pandemic (typhoid fever) 1847 was a notably severe outbreak of typhoid fever among immigrants, mostly from Ireland to Canada, in 1847, that killed an estimated 10,000 persons.

Spanish flu is the common but erroneously attributed name for the great influenza pandemic of 1918–1920.

Spillover event is when a disease makes the jump from animals to humans.

Sterilization is the process of killing germs on the surface of things by steam-heat or by the application of a germicidal agent.

Superbug is a bacterium that has developed drug resistance to previously effective antibacterial drugs and germicides.

Surge capacity is the ability to speed up the development and distribution of vaccines for rapid response to a newly emerging epidemic threat to prevent its becoming a pandemic.

Syndemic is being bound together or connected.

Toxin refers to any of various poisonous compounds produced by some microorganisms and causing certain diseases.

Trachoma is a highly contagious infection of the conjunctiva and cornea, caused by a bacterium, *Chlamydia trachomatis*, and

characterized by granulation and eventual scar formation that if untreated leads to blindness.

Trivalent is a type of flu shot that targets two strains of influenza A and one of influenza B.

Undocumented immigrants are persons who enter a country illegally, without proper papers, such as a visa, that allows them to legally remain in a country.

Vaccination is the process of inoculation of disease-related sera to induce immunization against the disease.

Vancomycin is a drug treatment for drug-resistant pneumonia that must be injected directly, and painfully, into the spinal cord.

Variola major is a viral disease characterized by pustular eruptions, and in the case of smallpox is its more virulent and deadly form.

Variola minor is the milder form of smallpox; less virulent and less deadly.

Vector is a carrier of diseases to humans, also called vermin, such as fleas, lice, rats, and various insects.

Vermin are assorted types of insect life that are carriers of diseases to humans.

Vibrio cholera is a short, flagellate, Gram-negative bacteria that causes cholera.

Vibrio comma is a short, Gram-negative bacteria that causes cholera.

Viral hemorrhagic fevers are caused by various viruses and manifest extremely high rates of mortality and high morbidity spread by contact with body fluids, for example, Ebola virus.

Virgin population is one with little or no immunity to a particular disease.

Virology is the study of viruses that cause human diseases.

Virus hunters are biologists who gather blood from animals in the wild to screen for unknown pathogens. They are leading

a revolution in epidemiology that seeks to predict and prevent rather than simply respond to pandemics.

Visa-overstayers refers to persons who enter a country as nonpermanent immigrants, for example, as students, tourists, temporary visitors, and so on, whose visa allows them to do so and remain in the country only for a prescribed time, and who subsequently and illegally stay beyond the time specified by the visa.

Xenophobia is an unwarranted or exaggerated fear of the foreigner.

Xenopsylla cheopis is the flea commonly infesting the black rat that carries the bubonic plague bacilli.

Yellow jack is another name for yellow fever, especially used in the Caribbean area and by sailors to refer to yellow fever striking at sea.

Yersinia pestis is the bacteria which causes the plague, also known as the Black Death.

Zika virus is a mosquito-borne virus that is newly pandemic in nature and can cause microcephaly, affecting the brain size and development of a fetus in a pregnant woman who is infected with the virus.

Zoonotic are germs or viral pathogens that arise first among animals and then spread as pathogens among humans.

Aberth, John, 277–278
Act of February 15, 1893, 25, 224
Act of March 3, 1891, 252–254
Act of 1798, 224
Act of 1873, 41
acute diseases, 5
 defined, 333
Adams, Annmarie, 278
adjuvants, defined, 333
Aedes albopictus, defined, 333
Aeges aegyptis, 8, 10, 40, 160–164, 255
 defined, 333
Affordable Care Act, 119
Africa, 77–78, 87, 92, 95, 102, 105, 118, 120–121, 146–147, 149, 162
Agency for International Development (USAID), 99, 136, 167, 203
Agency for Toxic Substance and Disease Registry, 94, 96, 179, 203

agro-terrorism, 76–77
agro-terrorist, defined, 333
AIDS/HIV, 40, 44, 56, 72, 84, 86–87, 89, 91–93, 117–121, 170, 188–189, 191, 226, 277, 283, 329
 defined, 333
air travel, 160–164
Alibeck, Ken, 278
amebiasis, defined, 333
American Association for the History of Medicine, 204
American Medical Association, 204
American Public Health Association (APHA), 204
American Revolution, 16
Angel Island, 29, 35–36, 279
 coping with epidemics at, 29
Anopheles, 160
 defined, 333

About the Author

Dr. Michael C. LeMay is professor emeritus from California State University-San Bernardino, where he served as director of the National Security Studies program, an interdisciplinary master's degree program, and as chair of the Department of Political Science and assistant dean for student affairs of the College of Social and Behavioral Sciences. He has frequently written and presented papers at professional conferences on the topic of immigration. He has also written numerous journal articles, book chapters, published essays, and book reviews. He has published in *The International Migration Review, In Defense of the Alien, Journal of American Ethnic History, Southeastern Political Science Review, Teaching Political Science,* and the *National Civic Review.* He is author of more than a dozen academic volumes dealing with immigration history and policy. His prior books on the subject are *Illegal Immigration: A Reference Handbook, 2e* (2015: ABC-CLIO); *Doctors at the Borders: Immigration and the Rise of Public Health* (2015: Praeger), series editor and contributing author of the three-volume series, *Transforming America: Perspectives on Immigration* (2013: ABC-CLIO); *Illegal Immigration: A Reference Handbook, 1e* (2007: ABC-CLIO); *Guarding the Gates: Immigration and National Security* (2006: Praeger Security International); *U.S. Immigration: A Reference Handbook* (2004: ABC-CLIO); *U.S. Immigration and Naturalization Laws and Issues: A Documentary History*, edited with Elliott Barkan (1999: Greenwood); *Anatomy of a Public Policy: The Reform of Contemporary Immigration Law* (1994: Praeger); *The Gatekeepers: Comparative Immigration Policy,* (1989: Praeger);

From Open Door to Dutch Door: An Analysis of U.S. Immigration Policy Since 1820 (1987: Praeger); and *The Struggle for Influence* (1985: University Press of America). Professor LeMay has written two textbooks that have considerable material related to these topics: *Public Administration: Clashing Values in the Administration of Public Policy* (2nd ed., 2006: Wadsworth); and *The Perennial Struggle: Race, Ethnicity and Minority Group Relations in the United States* (3rd ed., 2009: Prentice-Hall). He frequently lecturers on topics related to immigration history and policy. He loves to travel and has lectured around the world, and visited more than one hundred cities in 40 countries. He has two works in progress: *Winning Office and Making a Nation: Immigration and the American Political Party System* (under review, coauthored with Scot Zentner), and *From Open Door to Storm Door: The Cycles of Immigration Policymaking* (under review).